THE SCANDAL OF PLEASURE

Wendy Steiner

THE SCANDAL of PLEASURE

ART IN AN AGE OF FUNDAMENTALISM

THE UNIVERSITY OF CHICAGO PRESS
CHICAGO & LONDON

Wendy Steiner has written widely for the *New York Times, Independent, Times Literary Supplement, London Review of Books, Guardian,* and *Art in America.* She is the Richard L. Fisher Professor of English and Chair of the English Department at the University of Pennsylvania.

The University of Chicago Press, Chicago 60637
The University of Chicago Press, Ltd., London
© 1995 by The University of Chicago
All rights reserved. Published 1995
Printed in the United States of America

04 03 02 01 00 99 98 97 96 2345

ISBN: 0-226-77223-3 (cloth)

Library of Congress Cataloging-in-Publication Data

Steiner, Wendy, 1949-
 The scandal of pleasure : art in an age of fundamentalism / Wendy
Steiner.
 p. cm.
 Includes bibliographical references and index.
 1. Aesthetics. 2. Philistinism. 3. Pleasure. 4. Liberalism.
 5. Aesthetics, Modern—20th century. 6. Religious fundamentalism—
 Controversial literature. I. Title.
 BH39.S8146 1995
 111'.85'09045—dc20 95-18527

∞ The paper used in this publication meets the minimum requirements of the American National Standard for Information Sciences—Permanence of Paper for Printed Library Materials, ANSI Z39.48-1984.

To Emma, Emil, and Patrick

CONTENTS

List of Illustrations ix

Preface xi

INTRODUCTION

The Arts Embattled 1

ONE

The Perfect Moment 9

TWO

The Literalism of the Left 60

THREE

Fetish or Fatwa? 94

FOUR

Caliban in the Ivory Tower 128

FIVE

La Trahison des Clercs 163

CONCLUSION

Enlightened Beguilement 209

Notes 213

Index 239

ILLUSTRATIONS

1. Anne Carlisle (as Margaret and Jimmy) in *Liquid Sky* 2
2. Andres Serrano, *Piss Christ* 12
3. Alice Sims, from *Water Babies* 15
4. Poster for Robert Mapplethorpe exhibition, *The Perfect Moment* 17
5. Robert Mapplethorpe, *Self-Portrait* 18
6. Arrangement of the X, Y, and Z Portfolios at the Philadelphia ICA 19
7. Robert Mapplethorpe projected onto the outside of the Corcoran Gallery of Art 21
8. Signe Wilkinson, "Great idea, getting rid of all the fag art, Mr. Helms!" 23
9. Robert Mapplethorpe, *Jesse McBride* 27
10. Robert Mapplethorpe, *Self-Portrait,* from *X Portfolio* 45
11. Sally Mann, *At Twelve* 46
12. Sally Mann, *At Twelve* 47
13. Sally Mann, *At Twelve* 48
14. Sally Mann, *At Twelve* 50
15. Robert Mapplethorpe, *Thomas in a Circle* 52
16. Robert Mapplethorpe, *Orchid* 53
17. Andres Serrano, *Klansman (Great Titan of the Invisible Empire)* 70
18. The Parthenon 78
19. Elgin Marbles in the British Museum 79
20. Pablo Picasso, *Les Demoiselles d'Avignon* 84
21. Andy Warhol, *Beauty is shoe, shoe beauty* 86
22. Andy Warhol, *A la Recherche du Shoe Perdu* 87
23. Robert Mapplethorpe, *Tie Rack* 88
24. Quinlan Terry, *Richmond Riverside* 110
25. English National Opera production of Handel's *Xerxes* 111
26. Photograph of Heiddeger 178
27. Mark Tansey, *Derrida Queries de Man* 193

PREFACE

We live in an odd historical moment. Who would have believed even twenty years ago that it would be necessary to defend aesthetic pleasure, to insist that art is different from life, to champion freedom of speech and thought? The chapters that follow explore the situations that have forced us into these statements of the obvious: the controversies surrounding Robert Mapplethorpe, Salman Rushdie, pornography, political correctness, and the "scholar-scoundrels" Anthony Blunt, Martin Heidegger, and Paul de Man. These scandals have pitted expert against layperson and artist against politician. In the process, they have produced rather more heat than light. This book is an attempt to return reason to the debate and to make the case for that most discredited of ideologies, liberalism, without which aesthetic interpretation becomes grotesque.

My debts for this project are many: to David DeLaura for sanctioning the time in England that turned me to this topic; to the Alan G. Hassenfeld and the Richard L. Fisher chairs, which provided me the funds for my research; to my colleagues at the University of Pennsylvania, whose investment in social justice and academic integrity has netted them such adverse treatment by the media; to Roger Allen for advice on Islam, Arkady Plotnitsky on Heidegger, and Patrick T. Murphy and Judith Tannenbaum on Mapplethorpe; to Homi K. Bhabha for introducing me to the concept of the fetish; and to Mindy Plotkin for her excellent research assistance. None of these people, needless to say, should be held responsible for the faults of this book or the opinions it expresses.

Portions of this book have appeared in other publications: material from Chapter 1 in Irving Lavin, ed., *Meaning in the Visual Arts* (Princeton: Princeton University Press, 1995); parts of Chapters 2 and 5 in the *London Review of Books,* March 30, 1989, and May 27, 1993; and part of Chapter 2 in the *New York*

Times Book Review, September 19, 1991 (© 1991 by The New York Times Company). The poem in Chapter 4 by Ezra Pound, "In a Station of the Metro," is from Ezra Pound, *Personae,* © 1926 by Ezra Pound (New York: New Directions, 1971). All material has been used by permission.

INTRODUCTION
THE ARTS EMBATTLED

> Something is terribly wrong with a culture when it is inexplicable to the vast majority of its citizens.
>
> Christopher Martin

A few years ago, in a course on postmodernism, I arranged for a screening of the film *Liquid Sky.* A student who went to the film but not to my lecture wrote a letter to the dean saying that such films promote drug abuse, and having been down that sorry street he felt that the university should not present addiction in an attractive light. The dean sent a copy to my chairman, who asked me to supply the words necessary to placate the student, and I answered with a one-page explication of the film. The chairman and dean were satisfied, the student was not heard from again, and I was left wondering why an interpretation in any way answered the complaint, or whether the student simply gave up under the weight of authority.

These questions are particularly worrisome because *Liquid Sky* is so concise a presentation of postmodern concerns. Its heroine, Margaret, is a model who is besieged by seducers and rapists, a disreputable bunch who constitute, symbolically, a history of postwar artistic movements: a lesbian beat poet who ad-libs nightclub raps, deals in heroin, and abuses Margaret; a hippie acting professor who praises her dramatic talents to get her into bed; a failed filmmaker hooked on heroin who trades sexual insults with her; a disco punk who forces Quaaludes down her throat and then beats and rapes her; and an androgynous male model (played by the same actress who plays Margaret [fig.1]) who is a woman-hating narcissist. The Manhattan skyline alludes insistently to Andy Warhol's pop film *Empire,* and the action is punctuated with electric sculpture,

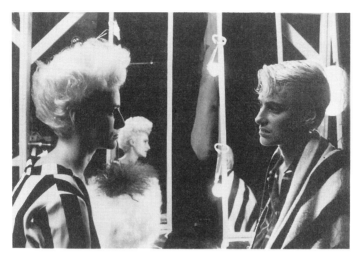

1. Anne Carlisle (as Margaret and Jimmy) in *Liquid Sky.*
Photo by Yuri Neyman. © 1982 Z-Films.

electronic music, psychedelic art, happenings, avant-garde fashion shows, and film crews who both direct the scene and play the audience within it. If we might read allegorically, the artistic and social movements of the postwar era have been a rape of the perceiver.

Margaret, a languid parody of a feminist, complains that "too many men are telling me what I want," and sees her life as an endless series of romantic disillusionments. Coming from Connecticut Mayflower stock, she grew up believing that her prince would be a lawyer who would give her kids and a barbecue, but instead she found men who wanted only to sleep with her. Then she was told that if she was an independent woman in New York, her prince would come: an agent who would get her roles. Instead she got seductions and false promises. She was told that to be a woman you must be free and equal, and so she decided to sleep with women. The only result was that now women were telling her what to do. By the time the movie starts, she has given up on her "teachers." Only some totally unimaginable prince can save her.

Right on cue, a spaceship lands on the rooftop opposite her apartment. A German scientist sets up his telescope across the street in the apartment of the male model's mother. She is a Jewish producer, he a German scientist; they take turns peering through the telescope at the astonishing sex scenes in Margaret's apartment. The scientist explains that the aliens in the spaceship feed off energy

released in heroin rushes and orgasms, with the result that the person producing this energy dies, pierced by a crystal dart. Margaret—too depressed for orgasms—does not know why her partners suddenly start dying and dematerializing, but she is glad they do, for this is the first power she has had over anyone. She assumes that some prince-like force is avenging her, and finally dons an extraordinary wedding gown, shoots herself with heroin (somehow she has figured out the connection), and is hypostasized into the alien craft.

Here we have all the ingredients of the postmodern romance: parody; voyeurism; fetishism; a pastiche of modes, stylistic levels, and aesthetic allusions; simultaneous humor and insensitivity about serious issues like the Holocaust, rape, and feminism; the collapse of binary oppositions, as with the identical male and female models; the equation of art with assault; the inclusion of the audience in the action and therefore in the ethical responsibility for what is represented; and the outrageous cost of ecstasy.

But saying all this, making it into a vision of postmodernism, does not answer the student who wrote the letter of complaint. For him, this postmodernism is insensitive and antisocial, and art that embodies it is too dangerous to be taught. The student believes in the power of art to control behavior; the professor, chairman, and dean believe in the power of art to describe the world and in the responsibility of teachers to inform students about such representations, and hence about that world. What happens to the student after learning is not the teacher's business; what happens to the world is beyond her control.

But no teacher can remain unaffected by the public's increasing resistance to such instruction. More and more, people do not wish art, criticism, and education to present reality as problematic. They feel injured, violated, by what seem to them callous images of cruelty and unfulfillment. As in *Liquid Sky,* art for them is no longer a realm of free play but a kind of rape.

The recent furor in Britain between the Prince of Wales and the architects is symptomatic. The Prince and the public dislike what they consider the inhuman buildings of "contemptuous professionals." A cartoon in the London *Independent* shows two architects commenting on a colleague: "No, he isn't prejudiced against Prince Charles—he hates *all* human beings." Christopher Martin quotes the theorist Leon Krier: " 'people want beauty around them. And everywhere they are denied it.' Instead they are given the neurotic expression of artists and architects who celebrate . . . the tensions and anxieties of their age. 'People may need these things sometimes, . . . but they also want harmony, reassurance, familiarity and beauty.' " [1]

Professors of twentieth-century art have learned to answer such complaints with a sympathetic prescription for fifty push-ups. Of course, postmodern art is much more than a reflection of troubled times, but in the face of inequality, nuclear menace, and environmental collapse, one cannot teach a view of art or views *in* art without in some way mentioning the world's disorder. Many artists and writers feel obliged to represent it. For example, Richard Rogers, who designed the Pompidou Center and the Lloyd's Building, insists that "architecture mirrors society; its civility and its barbarism. Its buildings can be no greater than the sense of responsibility and patronage from which they originate."[2] The curators of the infamous Robert Mapplethorpe exhibition likewise assert: "We at ICA do not believe it is our role to shelter the public from controversial or disturbing work."[3] An education in contemporary art seems like an arduous training in alienation. Aesthetic maturity is the ability to take contemporary art on the chin.

The reasoning here seems impeccable, and the moral stance is a dignified, existentialist stoicism. But the public resists. In a 1988 symposium at the Tate Gallery, Karen Phillips said to the architects in the discussion group: "I pity you in a way, because it must be very hard facing articulate non-experts who really think and feel that they have the right to criticise and comment, and can't any longer be shut up."[4] And the exhortations from the likes of former U.S. Education Secretary William Bennett are legion: that academia must give up its eccentric interests in minority art, esoteric theories, and leftist politics and teach the great books—those sentinels of value that improve the world rather than drag it down into the muck. However much academics have argued that only certain groups (male, white, etc.) are sanctioned in this classical heritage, the argument for a core of shared knowledge with a utopian bias has captured the imaginations of a good portion of the public.

Nonexperts are sometimes not content merely to criticize arts professionals. The Serrano and Mapplethorpe affairs made Senator Jesse Helms want to take decisions about artistic merit out of the hands of the academics and to punish them for past offenses. For originating the show, the Philadelphia ICA was threatened with censure and a five-year suspension of federal grants. The *New York Times* claimed the matter involved "issues of artistic freedom and censorship, the proper role of government in the arts and the right, if any, of taxpayers not to have to pay for art they abhor." But the exhibition was funded because "nationally respected art professionals" judged it superior to other proposals submitted to the NEA. One would not claim that the "suppression" of

those other projects constituted censorship of art. The real issue is censorship of the experts. Buried deep in the *Times* article is the familiar anti-academic prejudice. As a congressional aide put it, it's "Mom and apple pie against perversity. It's us against a bunch of smug Ph.D. types telling us what art is."[5]

Of course, the experts have just as little respect for the likes of Jesse Helms. Helms's list of censorable solecisms in art appears both hypocritical and unrealistic: "obscene or indecent materials including but not limited to depictions of sadomasochism, homoeroticism, the exploitation of children, or individuals engaged in sex acts," the denigration of the "objects or beliefs of the adherents of a particular religion or non-religion [or of a] . . . person, group, or class of citizens on the basis of race, creed, sex, handicap, age, or national origin."[6] In vain the expert asks whether there has ever been an artwork not guilty of one or more of these solecisms. In vain one explains that advocacy and representation are not the same thing. And certainly in vain one insists that aesthetic representation is a crucial stage in our understanding of such phenomena as sadomasochism or homo-eroticism, and that these phenomena require our understanding.

The gulf between academics and the laity seems unbridgeable. With the best of intentions, professors teach contemporary art with all its humor, paradox, and occasional provocation, hoping to promote pleasure and an understanding of the world through an understanding of a crucial part of it—representation. One of the most important purposes of art, they claim, is to sharpen and complicate our views, providing alternatives to simplistic ideas and revealing the inadequacy of unquestioned orthodoxies. But for opponents of the liberal academy, complexity and ambiguity are merely mystifications, and contemporary art in fact compounds social disorder. The world's ills should be overcome instead by the enforcement of hierarchies and systems inherited from the past, with art fulfilling its social mission by bolstering and justifying these systems.

Meanwhile, the academy not only disseminates the notion that contemporaneity is ambiguous and contradictory but attempts to model that complexity in the makeup of its faculty, students, and curricula. As this diversification increases, academics have been faced with a reality that sometimes frightens them. The late Professor Allan Bloom, for one, condemned cultural relativism as the destruction of knowledge, subtitling *The Closing of the American Mind,* "how higher education has failed democracy and impoverishes the souls of today's students."[7]

Literary theory has likewise become a target of such attacks. It is so inaccessible to the layperson that the public has trouble imagining any purpose in it at all. In the popular view, just as architects should concentrate on building pleasant buildings, professors should devote themselves to making us appreciate and understand beautiful artworks. Unfortunately, both these tasks are anything but straightforward.

The attempt of academics and art practitioners to understand their activity has been frenetic during the past few decades. Indeed, aesthetic theory over the past twenty years reminds me of a shooting gallery. Up pops a duck, only to be shot down and replaced by a new duck bearing a certain family resemblance. Formalism, structuralism, semiotics, Marxism, feminism, the New Historicism—the approaches keep perpetrating their little murders, transforming ducks who have barely shed their down into dead ducks piling up in English departments.

The culmination of this theorizing was deconstruction, which Bloom characterizes as "the last, predictable stage in the suppression of reason and the denial of the possibility of truth in the name of philosophy. The interpreter's creative activity is more important than the text; there is no text, only interpretation" (p. 379). Critics like Bloom treat deconstruction and multiculturalism as analogous errors in the steady decline of the humanities into the slough of "political correctness."

Academic theorists have recently been undercut by deconstruction itself. With the discovery of Paul de Man's collaborationist journalism during World War II, the ideological basis of deconstruction has become suspect. Is this theory merely an elaborate justification for political passivity? Are Marxists right in claiming that "deconstruction is the heir to that Nietzschean strain of irrationalist fatalism that reduces all thinking to the blind operation of tropes and self-engendered rhetorical forces beyond our power to control or comprehend"?[8] Or can we dissociate de Man's early politics from his late theories and argue that his political and scholarly activities are separate?

De Man is not the only academic to provide these questions. The case of Anthony Blunt likewise threatens the belief that scholarship and ideology are inseparable. As George Steiner writers, "think for a moment about a man who in the morning teaches his students that a false attribution of a Watteau drawing or an inaccurate transcription of a fourteenth-century epigraph is a sin against the spirit and in the afternoon or evening transmits to the agents of Soviet intelligence classified, perhaps vital information given to him in sworn trust by

his countrymen and intimate colleagues."[9] This compartmentalization belies our faith in the seamlessness of mental life, and the exposure of split figures like Blunt, Heidegger, and de Man provokes wrenching scandals in the academic world.

In short, it is not an easy time to be a specialist in the arts. Intellectuals are inclined to view the public as bigots or escapists, punishing art for real problems that they are unwilling to address. In turn, the public views the academy and the arts as inefficacious, morally suspect, and narcissistic. With the academic talent for self-flagellation, professors cannot help but recognize a certain justice in such claims. Buffeted from without by politicians and "the world" and from within by colleagues like Allan Bloom, undermined by history's revelations about de Man and Heidegger, and subject to bouts of uncertainty and self-contempt, intellectuals find the study of the arts a more and more depressing enterprise.

This is a far cry from the optimism with which I began my career. Then, I believed that criticism should model itself on science. It should have a framework of defined terms, accepted axia, and shared methods whose aim was to provide accurate descriptions of artworks and to reveal the principles underlying categories such as genres, styles, and forms. I was therefore much taken with semiotics and structuralism with their links to the Unified Science Movement, and though I denied that such views were formalistic in the strict sense, I had little patience with historical or biographical approaches. When people advocated art appreciation, I snottily replied that you not catch a physicist claiming he did his job because he liked light!

It was naive, no doubt, to look to semiotics for a scientific paradigm of art. The result was a parody of academicism: endless essays coining terms, proliferating typologies, using art merely to justify or exemplify the emergent categories. I have given up on being such a scientist. It has taken me a long time to admit that the thrust of criticism is the "I like," and whatever expertise I have accumulated conspires in this admission. The authority of one's institution of higher learning, one's academic credentials, one's ever-increasing experience may establish "objectively" one's claim to being an expert, but at the heart of any critical act is a subjective preference. To like, to find important, at this time and in such-and-such a situation: this is the essence of the critical act.

Somehow our culture has forgotten this fact. Outside of journalism, there is no sphere in which aesthetic value and pleasure are discussed with any regularity; indeed, most experts cringe at expressions of personal preference, insist-

ing on the objectivity of their judgments as if they were apodictic truths. As a result, the public is more and more alienated from arts professionals, and artistic controversies escalate into full-scale crises.

This book is an argument for the subjectivity of aesthetic response, an attempt to explain what it means to invest art with value and derive pleasure from it. It tries to demonstrate the utility of a liberal aesthetics in which art is neither identical to reality nor isolated from it, but a virtual realm tied to the world by acts of interpretation. Experiencing the variety of meanings available in a work of art helps make us tolerant and mentally lithe. Art is a realm of thought experiments that quicken, sharpen, and sweeten our being in the world.

This quickening, this pleasure, are the same for all who open themselves to art, whether expert or layperson. However presumptuous it may be to address both professionals and the general public, this book seeks to remind all parties in aesthetic experience of their common ground. It is an exhortation to the experts to develop an aesthetics adequate to the times we live in, and a plea to the public not to vilify those who have devoted their lives to understanding art. For a culture in which professionals feel no responsibility to the public and the public disdains expert opinion is a culture inhospitable not only to art, but to democratic debate and, ultimately, to freedom.

THE PERFECT MOMENT

In images, I intoned, beauty was the agency that caused visual pleasure in the beholder; and any theory of images that was not grounded in the pleasure of the beholder begged the question of their efficacy and doomed itself to inconsequence.

Dave Hickey

On the witness stand in Hamilton County, Ohio, a well-dressed woman, under oath, sat torturing a handkerchief. She herself was not on trial, but another museum director was—Dennis Barrie of the Contemporary Arts Center in Cincinnati. The woman, Janet Kardon, had curated an exhibition of Robert Mapplethorpe's photographs which eventually traveled to Cincinnati, where seven pieces were declared by the local authorities to be obscene. Both the art center and its director were defendants in "the first obscenity proceeding against an art gallery in American history." [1]

The prosecutor, Frank Prouty, asserted that these photographs of what the *New York Times* called "anal and penile penetration with unusual objects" [2] were without artistic value, an essential claim in obscenity charges. But Ms. Kardon disagreed. She pointed to Mapplethorpe's sensitive lighting, texture, and composition, calling "a self-portrait of Mapplethorpe with the handle of a whip inserted in his anus (Fig. 10) 'almost classical' in its composition. . . . [A]n image of a man urinating into another's man's mouth was remarkable because of the strong and opposing diagonals of the design. Another photograph demonstrated Mapplethorpe's fondness for 'an extremely central image,' she said. 'That's the one where the forearm of one individual is inserted into the anus of another individual?' Prouty asked. 'Yes,' she replied. 'The forearm of one individual is in the very center of the picture, just as many of his flowers occupy the center.'" [3]

This interchange is a moment in the history of art that deserves commemo-
ration. Seldom do we see an ideology so clearly in collapse, as strained and
tortured as the handkerchief in witness Kardon's fingers. Robert Hughes terms
this testimony "the demise of American aestheticism,"[4] "the kind of exhausted
and literally de-moralized aestheticism that would find no basic difference be-
tween a Nuremberg rally and a Busby Berkeley spectacular, since both, after all,
are examples of Art Deco choreography" (Hughes, p. 24).

The justice of Hughes's criticism is obvious, although now that he has
pointed out the formal correspondence between Nazi rallies and Hollywood
musicals I will never be able to look at *Babes on Broadway* in quite the same way.
But the fact is that none of the other specialists called to explain what made
these photos art did much better than Ms. Kardon, though they did not strain
credibility quite as severely as she did. Even Robert Hughes, by the end of his
subtle article, celebrates museums for their part in helping us see "why a draw-
ing by Pater or Lancret might be different from one of exactly the same subject
by Watteau: less tension in the line, a bit of fudging and fussing . . . differences
of intensity, meaning, grace" (Hughes, p. 27).

The Mapplethorpe affair marks not so much the demise of aestheticism as
a crisis in aesthetics as such. Neither the expert nor the layperson can say what
makes art art, and though aesthetics has always been an area of opinionated
speculation rather than scientific truth, there have been times of greater consen-
sus than today, and times when the lack of consensus has been less costly. At the
moment, the vacuum in aesthetic theory in America has propelled art into the
realm of politics, where the virtuality of art, its symbolic reality, its subtle con-
tradictoriness are simplified into a literalism that confounds practitioners, ex-
perts, and laypeople alike.

THE SENATE APPROPRIATES AESTHETICS

The scandal over Mapplethorpe began with the work of another photographer,
Andres Serrano. Serrano was awarded $15,000 by SECCA, the Southeastern
Center for Contemporary Art in Winston-Salem, N.C., in 1987—the same
year the Philadelphia Institute of Contemporary Art received $30,000 from the
National Endowment for the Arts to mount the Mapplethorpe exhibition. Ser-
rano's grant was part of a SECCA awards program also funded by the NEA, a
kind of artistic subcontracting which, some later felt, gave the NEA less control
over its funding than the public's best interests required. Serrano was one of ten

artists so honored in 1987. In addition to the money, his work would be featured in a catalogue and would become part of an exhibition traveling to Los Angeles, Pittsburgh, and Richmond.

The photograph that caused all the trouble (Fig. 2) was described in the *New York Times* as measuring "60 inches by 40 inches and show[ing] Jesus on the cross in a golden haze through a smattering of minute bubbles against a dark, blood-colored background. By slight twisting and considerable enlargement, the image takes on a monumental appearance and the viewer would never guess that a small plastic crucifix was used. The work appears reverential, and it is only after reading the provocative and explicit label that one realizes the object has been immersed in urine."[5] The "label," the provocative title of the piece, was *Piss Christ,* a pair of words quite ambiguous in their import, depending on whether "Piss" is taken as a noun, an adjective, an interjection, or a verb. But their juxtaposition was enough to make the Reverend Donald Wildmon of the American Family Association issue a statement in June 1989 charging Serrano with blasphemy. According to Wildmon, it was not the photograph in itself but the title that was provocative.[6] The work was attacked not for its appearance but for what Wildmon construed the title to mean.

Art critics defended the photograph as a comment on American superficiality,[7] and Serrano claimed he was attacking the debasement of religious symbolism in a commercial world.[8] He had turned to urine after blood and milk, he explained, because he needed to introduce yellow into his photographic palette.[9] Less formally, *Piss Christ* for him was an example of a "duality or contradiction between abstraction and representation, between transforming that little cross into this monumental and mysterious-looking object and then making you reconsider it in another context when you read the label." The label *is* the pivot. It is the old image of art as metamorphosis—the magical, but also grisly, thinking of Ariel in *The Tempest* as he comforts Ferdinand for his father's supposed death by singing of a "sea change" that transforms his father's corpse into a work of art: "Those are pearls that were his eyes. Look!"

Others did not see the magic in the sea change. The reaction of lawmakers was swift. Senator Jesse Helms (R – N.C.), who in 1975 had protested a $5,000 NEA grant to Erica Jong to write *Fear of Flying,*[10] stated that "Serrano is not an artist. He is a jerk."[11] Senator Alphonse D'Amato (R – N.Y.) sent a letter to Hugh Southern, the acting chairman of the NEA, asking for a review of funding procedures. He found *Piss Christ* "shocking, abhorrent and completely

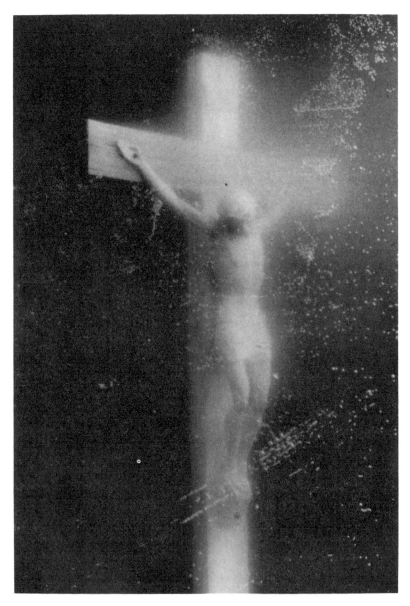

2. Andres Serrano, *Piss Christ.* Cibachrome, silicone, Plexiglas, wood frame. Private collection. Courtesy Paula Cooper Gallery.

undeserving of any recognition whatsoever. Millions of taxpayers are rightfully incensed that their hard-earned dollars were used to honor and support Serrano's work." [12]

Hugh Southern responded that he too found the photograph repugnant, but that the NEA charter forbids any interference in the content of the art it helps to fund. Mr. Southern was referring to a safeguard built into the legislation that established the NEA in 1965 during the Johnson administration, a safeguard that was designed to prevent government regulation of artistic freedom or the creation of officially sanctioned styles. The statute was worded: the government shall not "seek to restrict the freedom of the artist to pursue his goals in his own way." [13]

This legal separation of patronage from control seemed to carry no weight in Congress. Indeed, some lawmakers set themselves up as aestheticians to discredit the art they so deeply disapproved. Senator Gorton of Washington read a statement into the *Congressional Record* on May 31, 1989, diagnosing the ills of contemporary art as what the aesthetician Benedetto Croce called "the intellectualist error," a confusion of art and philosophy, of beauty and idea. The task of art, said Gorton quoting Croce, is not to expand concepts, unite the intelligible with the sensible, or represent ideas of universals. No, "aesthetic consideration . . . pays attention always and only to the adequateness of expression, that is to say, to beauty." [14] In this unlikely alliance with the arch-formalist Croce, the moralist Senator Gorton condemned Serrano for stating *any* ideas, and proposed that the NEA deprive SECCA of funding for five years or until such time as it demonstrated a more responsible attitude toward beauty.

Senators were not the only ones offended by *Piss Christ*. On May 11, 1989, the *Arizona Republic* editorialized: "What if it were the image of the Reverend Martin Luther King, Jr. in that jar of urine? Would the NEA for an instant consider underwriting the production of a blatantly racist or anti-Semitic work under the rubric of artistic freedom? . . . Only anti-Christian and anti-Catholic bigotry could be bankrolled with such impunity." [15] It is hard to predict how the NEA would have reacted to racist art, but the editorial was wrong to claim that contemporary works are unflattering only to Christianity. In the spring of 1988, a student at the School of the Art Institute of Chicago named David K. Nelson had painted the late, plump black mayor of Chicago, Harold Washington, dressed in ladies' frillies. The police impounded the picture, which was called "Mirth and Girth," after the city's black leaders complained. Then in the

summer, it was the Thai community's turn to be offended. The Art Institute of Chicago was exhibiting a stone lintel taken from a temple in Thailand, and protests continued until the museum agreed to return it to its home. Just before the Serrano controversy flared up, another Chicago Art Institute student caused a scandal by spreading the Stars and Stripes on the floor under a sign asking "What is the proper way to exhibit an American flag?" Veterans in the hundreds picketed, threw rocks and sticks, and phoned in anonymous death threats. It was certainly not only Christianity that came in for controversial artistic portrayal.

The law had already taken a tough stand on child pornography. The Supreme Court had ruled that states could ban works if they showed minors naked or involved in sexual acts.[16] Photographic labs in some states are required to report nude photographs of children to the authorities, and police have responded harshly. Alice Sims, a professional photographer, shot a series of images called "Water Babies" of her little daughter and a friend, nude and appearing to sprout out of flowers (fig. 3). The police raided her house on July 14, 1988, and seized not only the photographs but her children, who were kept in foster care overnight while Ms. Sims was accused of being an unfit mother. The state eventually dropped the case, but there were others, most notably that of Jock Sturgis, a well-known photographer of nudes. His home was raided in 1990, and his files of negatives were rifled and seized, along with many photographs. The costs of legal fees, the public embarrassment, and the interruption in his work temporarily brought his career to a standstill. If government could be so decisive in these cases, conservatives wondered, why should it not do something about obscenity in publicly funded art?

With annual visits to American museums rising from 300 to 500 million since 1970[17] and attendance at cultural events exceeding that for live sports,[18] the arts were becoming an increasingly important focus of public attention. In other areas of culture, citizens had been taking matters into their own hands. Complaints over Madonna's Pepsi commercial prompted its cancellation; an irate citizen of Bloomfield Hills, Michigan, organized a write-in campaign to tone down the vulgarity of the TV series *Married . . . with Children*. And after much public complaint, the Illinois legislature cut the state grant to the School of the Art Institute of Chicago from $70,000 to $1 in 1989.

Patrick Buchanan, in a rousing *Washington Times* article, added his voice to the steadily mounting outcry. "The downhill slide of American culture gathers momentum," he wrote. "In a year, we have seen Martin Scorsese's 'The Last

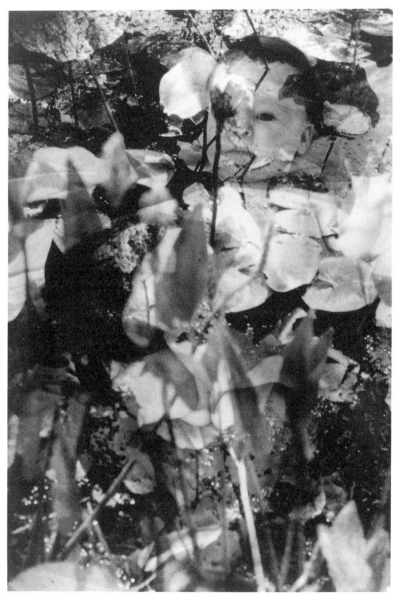

3. Alice Sims, from *Water Babies.* (1987)

Temptation of Christ'—portraying Jesus as an adulterous wimp—nominated for an Academy Award, and a modern art exhibit in Chicago where patrons were invited to walk on an American flag. Rising above New York's West Side Highway . . . is a 75-foot-high mural celebrating Marx, Lenin, Trotsky, Mao, Castro and Che. . . . American art and culture are, more and more, openly anti-Christian, anti-American, nihilistic." [19]

In this article, Buchanan laid out a detailed scenario explaining how leftists had seized control of the arts. While the right had been running the country and fighting communism abroad, the left had been quietly infiltrating culture. Buchanan quoted James Cooper, editor of the *American Arts Quarterly*, as saying that "American churches, business corporations, and government and education institutions have . . . meekly embraced without protest a nihilist, existential, relativist, secular humanist culture they profess to abhor. . . . Those who believe in absolute values such as God and beauty do nothing, and those who believe in existential humanism have captured the culture." In an unconscious echo of Chairman Mao, Buchanan concluded: "America needs a cultural revolution in the '90s as sweeping as its political revolution in the '80s."

If American culture looked like a leftist conspiracy to the right, for leftists the art crisis looked like the advent of totalitarianism. Serrano complained that he was being criticized by the very people who had been indignant at the treatment of Salman Rushdie.[20] In an article called "Mapplethorpe and the Ayatollah" Thom Nickels wrote that "deep down, something in this country wants to be like Iran; something that wants to bow down before an Ayatollah, to form strict and orderly lines in thought and behavior."[21] So threatening was the mobilization of rightist ire that the nation's art associations declared August 26, 1989, Art Emergency Day. In this context of fear, media hype, and ideological impasse, the Mapplethorpe scandal became the focus for rightist and leftist outrage alike. How resonant the title of the ICA exhibition: "The Perfect Moment" (fig. 4).

THE PERFECT MOMENT RUNS ON

Robert Mapplethorpe had his first one-man show in 1976, but he was already famous—or infamous—for his erotic photographs and his collages using cuttings of pornographic images. His flowers, figure studies, and portraits soon became equally well known, as his work was shown in museums and galleries around the world. In 1987, the year the Philadelphia ICA received an NEA grant to produce his retrospective, shows of Mapplethorpe's photos were held

4. Poster for Robert Mapplethorpe
exhibition, *The Perfect Moment.* Courtesy
Institute of Contemporary Art, Philadelphia.

in New York, New Orleans, Berlin, Cologne, San Francisco, Geneva, and
Milan. During 1988, by the time the ICA retrospective opened in December,
Mapplethorpe had had major exhibitions at the Stedelijk in Amsterdam, the
National Portrait Gallery in London, and the Whitney Museum of American
Art in New York. He was also dying of AIDS (fig. 5). Though he was able to
attend the Whitney show, he was too weak to visit the Philadelphia retrospec-
tive that was to make his name a household word throughout the Western
world. Mapplethorpe died on March 9, 1989, at the age of forty-two.

The Philadelphia ICA show was a *retrospective,* that is, a review of all the

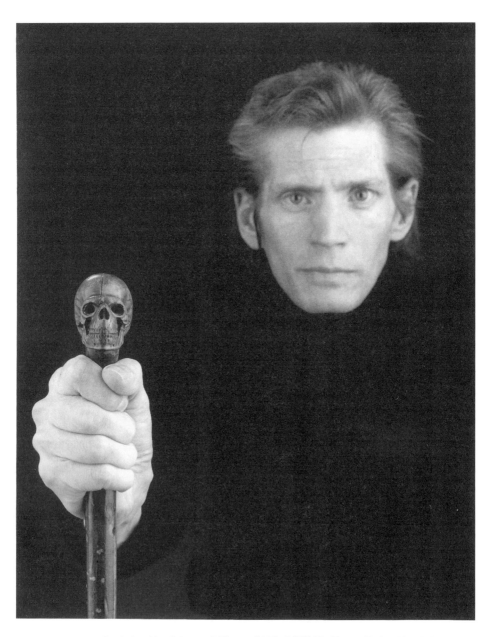

5. Robert Mapplethorpe, *Self-Portrait* (1988). ©1988, The Estate of Robert Mapplethorpe.

phases of Mapplethorpe's career. The various galleries to which the exhibition traveled were contractually obligated to present all the 175 photographs in the show, including the controversial X, Y, and Z Portfolios. These each consisted of 13 photographs: nude and sadomasochistic images in X, flowers in Y, and figure studies in Z. Though the portfolios were not shot at the same time, Mapplethorpe apparently saw them as parallel, the composition and sensuousness of the different subjects linking them in an overall artistic system. They were exhibited as three parallel rows of thirteen works, with flowers, figures, and sexual shots juxtaposed (fig. 6).

Realizing that the sadomasochistic works were potentially problematic, curators in all the venues took special care with their placement, warning that these works might not be appropriate for children, segregating the X, Y, and Z Portfolios in a special room, or placing them separately in closed cases. The show stopped for about a month and a half each in Philadelphia and Chicago, where the critics were largely enthusiastic and the public apparently unoffended.

On April 9, 1989, "The Perfect Moment" closed in Chicago, after which it was scheduled to reopen at Washington's Corcoran Gallery of Art on July 1.

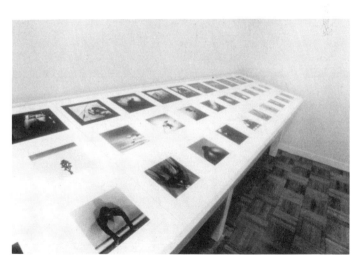

6. Arrangement of the X, Y, and Z Portfolios at the Philadelphia ICA. Courtesy Institute of Contemporary Art, Philadelphia.

Meanwhile, the scandal over Serrano's *Piss Christ* had broken and it took irate congressmen little time to discover that there was another NEA-funded project containing shocking subject matter. The NEA appropriation was at this point under periodic review, and Washington—indeed, the whole country—was being battered by Buchanan's "cultural revolution." Not wishing to focus still more attention on the NEA or endanger Congress's good will toward her institution, the Corcoran's director, Christina Orr-Cahall, canceled the Mapplethorpe show. Her gesture of appeasement, though it proved disastrous for herself and the Corcoran, was perhaps understandable. Two days later, on June 14, Representative Dick Armey (R – Tex.) and 107 other congressmen sent a complaint to the NEA for using federal money to support indecent art. Armey threatened to attack the NEA budget of $170 million if it did not act against art that failed to "pay respect to public standards of taste and decency." [22]

As a protest over the Corcoran cancellation, the laser artist Rockne Krebs designed an exhibition of Mapplethorpe slides to be projected on the outside of the gallery the day the exhibition would have opened (fig. 7). "If they can't be on the inside of the museum," said Bill Wooley, owner of the Collector Gallery and Restaurant, "they're going to be *on* the museum." The most controversial works were not projected. "As each dramatic image filled the enormous space next to the museum's main portal for about three to four minutes, the crowd turned silent, faces upturned. The last image was of the American flag, the sun's rays setting its star field aglow." [23]

Washington was to see more of Mapplethorpe's work than a slide show. The Washington Project for the Arts immediately offered to serve as an alternative venue for "The Perfect Moment," and funding came pouring in. The show opened at the WPA three weeks later than originally scheduled for the Corcoran, to enormous crowds. The Corcoran meanwhile lost 10 percent of its membership; its chief curator resigned; the students at the museum school mounted protests, some carrying placards reading "Mapplethorpe = Rushdie"; a major donor, the painter Lowell Nesbitt, cut the museum out of his will; and several artists scheduled to exhibit in later shows—Annette Lemieux, David Salle, Christopher Brown, and Ross Bleckner—withdrew, urging a general boycott of the institution. Ms. Orr-Cahal, replacing the Mapplethorpe show with a seemingly uncontroversial exhibition of Japanese photographs in America from 1920 to 1930, inadvertently plunged the museum into further debate, this time over government reparations to Japanese-Americans who were interned during World War II. By September, some curators and trustees were desperately pro-

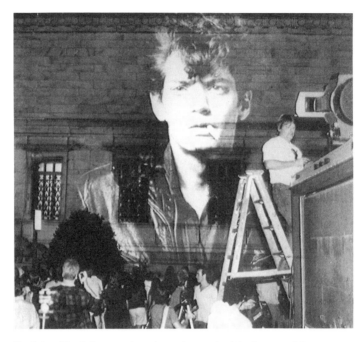

7. Robert Mapplethorpe projected onto the outside of the Corcoran Gallery
of Art, June 30, 1989. Michael Geissinger/NYT Pictures.

posing an exhibition containing Mapplethorpe's and Serrano's works in the
hope of recovering the museum's reputation. By December, Ms. Orr-Cahal was
forced to resign.

The arts community thus mobilized successfully to punish the Corcoran
for caving in to government pressure, though Jesse Helms's office was appar-
ently disappointed that the Mapplethorpe show had been canceled.[24] But the
community was less efficacious in controlling the real aggressors in the "war on
culture." Representative Sidney R. Yates (D – Ill.), who was perhaps the NEA's
staunchest supporter, introduced legislation forbidding the subcontracting of
NEA grants, so that the agency could exercise immediate control over all its
funding. This proposal was amended so that the NEA would allow subgranted
awards but had the responsibility of final approval and the power of veto. With
this rider, in late June the NEA appropriation was passed. The House proposed
to cut the $171 million budget by $45,000—the combined amounts the NEA

had given for the Serrano and Mapplethorpe awards—as a way of slapping the agency's hands.

Representative Yates defended the NEA in a report to congress. "Of the approximately 85,000 grants the NEA has made over the last 24 years, less than 20 have been found to be controversial for reasons of obscenity or pornography or racial degradation or frivolity. That's one quarter of one-tenth of one percent of all grants." [25] Members of the art world wondered whether such a record did not indicate too little risk-taking on the part of the NEA, but the congressmen who were meant to be reassured were not satisfied.

Not content with the symbolic $45,000 deduction, the Senate voted on July 19, in an amendment to the Interior Appropriations Bill, to bar the Philadelphia ICA and SECCA from receiving federal grants for five years and to bar the NEA from funding "obscene artwork." Senator Jesse Helms's amendment forbade NEA support, moreover, for "obscene or indecent materials, including but not limited to depictions of sadomasochism, homoeroticism, the exploitation of children, or individuals engaged in sex acts; or material which denigrates the objects or beliefs of the adherents of a particular religion or nonreligion; or material which denigrates, debases, or reviles a person, group, or class of citizens on the basis of race, creed, sex, handicap, age, or national origin." [26]

The cultural establishment's reaction to this sweeping prohibition was predictable, and at times quite entertaining. An editorial in the *Wall Street Journal* entitled "Artists Mugged by Reality" claimed that "Sen. Helms's language about 'race, creed, sex, handicap, age' sounds like the sort of pious liberal authoritarianism now popular at places like Stanford." [27] Any number of satirists pictured vice agents invading the world's leading museums to remove offending Old Masters. A cartoon in the *Philadelphia Daily News* by Signe Wilkinson (fig. 8) shows workmen emptying the frames of a Da Vinci and a Caravaggio and carting off Michelangelo's *David,* saying "Great idea getting rid of all the fag art, Mr. Helms!" [28] Another cartoon pictures a gallery staff member rushing over to Helms as he frowns at a picture frame: "No, Sen. Helms, that's not a Mapplethorpe—that's a mirror!" [29] And in a Washington *City Paper* spoof, a private dick hired to find "public dick," surveys the taxpayer-supported museums of the nation's capital for soft porn. "He wanted me to hunt beaver as well," says the gumshoe. "But I never heard of a Congress member getting bent out of shape over T & A. . . . Cheez Louise." [30]

More seriously, Senator Daniel Patrick Moynihan (D–N.Y.) announced

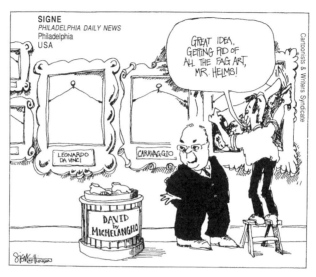

8. Signe Wilkinson, "Great idea, getting rid of all the fag art, Mr. Helms!" © Signe Wilkinson, Cartoonists and Writers Syndicate.

that he would vote against the entire appropriation measure. "Do we really want it to be recorded that the Senate of the United States is so insensible to the traditions of liberty in our land, so fearful of what is different and new and intentionally disturbing, so anxious to record our timidity that we would sanction institutions for acting precisely as they were meant to act? Which is to say art institutions supporting artists and exhibiting their work?"[31] Judith Tannenbaum of the Philadelphia ICA protested about the retroactive punishment of her institution for behavior which in every detail followed the NEA guidelines, and Sheldon Hackney, then president of the University of Pennsylvania, which houses the ICA, published an irate article in the *Chronicle of Higher Education* entitled, "The Helms Amendment Imperils the Basis of Intellectual Freedom."[32] The Whitney Museum of American Art ran a full-page ad in the *Washington Post* and the *New York Times* asking, "Are you going to let politics kill Art?"

As the vote on the appropriations bill approached in September, Helms and his allies redoubled their lobbying efforts. A mass mailing from Helms's finance

chairman urged donors to rush $29 to Helms to help him "stop the liberals from spending taxpayers' money on perverted, deviant art!"[33] Senator Helms circulated copies of seven of Mapplethorpe's photographs, without permission from the estate, to members of the House-Senate conference committee who would be voting on his amendment. Marked "For Members' Eyes Only," the envelopes contained "critic Jesse Helms's 'interpretations,' (e.g., 'this one shows one man holding another man's genitals'). Helms, who has himself staunchly opposed the distribution of pornography, resorted to the dramatic maneuver to underscore his belief that the art works are obscene."[34] This assumption—that one look at the pictures would settle the issue—would be echoed in the Cincinnati trial a year later, with a similarly unsuccessful outcome.

As Helms and others organized mail campaigns to blitz senators, Representative Dana Rohrabacher (R–Calif.), sponsor of equivalent legislation in the House, sent a letter to colleagues warning that if they voted against him, "Make no mistake about it, we will alert our members that you are on the record as supporting tax-sponsored pornography."[35] This threat led Representative E. Thomas Coleman (R–Mo.) to reply, "Anybody who tries to characterize my vote as a vote for pornography, you deal with me off the floor."[36] By mid-September, the debate in the House "got so fierce, you'd think this was Paris of 70 years ago when art lovers waged fist-fights over . . . Surrealism" (ibid.).

On September 13, the House voted 264 to 153 against the Helms amendment, and on September 29 the five-year bans on funding for the ICA and SECCA were defeated in the Senate. However, the symbolic $45,000 cut in the NEA budget was passed, a commission was set up to review standards for federal arts grants, the NEA was required to give thirty days' warning before awarding grants to the Philadelphia ICA or SECCA for the following year, and obscene art was banned from public funding. This was a one-year arrangement, pending the commission's findings, and eliminated all of Helms's prohibitions except that of obscenity. Proscribed were "works depicting sadomasochism, homoeroticism, sexual exploitation of children or individuals engaged in sex acts. To deny financing, endowment officials must also find a work lacks 'serious literary, artistic, political or scientific value.'"[37] Experts stated that this was the first time in the history of American aid to the arts that funding would be limited by content (ibid.). On November 1, the *Washington Post* reported that the value of Mapplethorpe's work was soaring—the more autobiographical the photograph, the higher the price.[38]

Through much of 1989, when the Mapplethorpe controversy was raging, the NEA had had only an acting director. The permanent replacement for this sensitive position, John Frohnmayer, was in place by late September. Frohnmayer stated during his confirmation hearings that he was opposed to the Helms amendment, but added, "Let me make it clear that I do not believe in funding obscene art. . . . But I do believe that there ought to be artistic freedom and tolerance."[39] A moderate, Frohnmayer's nomination was ratified, and he was installed as NEA director, vowing to work through negotiation rather than confrontation.

Virtually his first newsworthy act in office, however, was to rescind a grant to the Artists' Space in New York for a show called "Witnesses: Against Our Vanishing." It was about the influence of AIDS on aesthetics, culture, and sexuality, and Frohnmayer canceled it because a large portion of the content, he claimed, was political rather than artistic. "Any show that is primarily intended to make a political commentary must be privately funded," Frohnmayer told Elizabeth Hess of the *Village Voice*. And when she asked whether any exhibition about AIDS would not be political, he objected that it was a matter of tone.[40] Thus, though obscenity was the only legal ground for the cancellation of NEA funds, Frohnmayer was outlawing the AIDS project on the grounds of what amounted to "seditious speech."

It was actually the catalogue for "Witnesses" that Frohnmayer found so problematic. David Wojnarowicz—an artist who has since died of AIDS—had written an essay in it blaming public figures such as Jesse Helms, William Dannemeyer, Ed Koch, Alphonse D'Amato, Stephen Joseph, and John Cardinal O'Connor for supporting policies that he believed insured the spread of AIDS. On November 16, after visiting the show, Mr. Frohnmayer decided that it was not in fact seditious and reinstated the NEA grant, but he insisted that the funds not be used for the catalogue.

This reversal did little to improve the NEA's image in the arts community. Leonard Bernstein the day before had refused the National Medal of the Arts because of the NEA recommends the winners. And government harassment of the arts continued. In a non-NEA-related affair, David Hammonds's painting of a white-skinned, blue-eyed Jesse Jackson called *How Do You Like Me Now?* was refused a parks permit for exhibition.

Amid all this dissension, "The Perfect Moment" had finished its run at the Washington Project for the Arts and moved on to the Wadsworth Atheneum in

Hartford, Connecticut, where it appeared uneventfully between October 21 and December 24, 1989. The show then transferred to the Berkeley Art Museum until March 18, 1990. In each venue, the attendance and the media coverage were heavy, and in each, museum officials were careful to prepare audiences for the shocking nature of some of Mapplethorpe's photographs through signage and advance publicity. Curators also provided elaborate rationales for these works in terms of the history of photography, Mapplethorpe's artistic development, and the general climate of postmodern art.

These explanations were soon to be heard in court. For after "The Perfect Moment" left Berkeley, it opened in April at the Contemporary Arts Center in Cincinnati, Ohio, with the police its first visitors. Cincinnati, unlike Hartford or ultraliberal Berkeley, was not about to put up with obscenity, even if it appeared in a respectable art museum.

Cincinnati was already well known for its hard antipornography line. In 1956, Charles Keating had founded Citizens for Decency through Law, which was responsible for outlawing adult bookstores throughout the city. This was the same Charles Keating who was to be found guilty of massive mismanagement of funds in the Lincoln Savings and Loan scandal. But to return to obscenity—*Last Tango in Paris* was closed in Cincinnati, along with *Hair* and *Oh!, Calcutta!* and in the 1980s hard-core pornographic magazines were banned, and the Playboy TV channel was removed from the air. "Cincinnati by law has no peep shows, no adult bookstores, no X-rated theaters, no bars that allow nude dancing, no escort services, and no massage parlors. Residents cannot rent adult movies at Cincinnati video stores nor buy hardcore magazines like *Hustler*."[41] In 1990, the local antipornography group, Citizens for Community Values, was headed by a Presbyterian minister, the Reverend Jerry Kirk, and supported by the billionaire Carl Lindner and several members of the Cincinnati Bengals football team.[42]

Understanding the local climate, CAC director Dennis Barrie had tried to win court protection against a possible police raid in March, a month before the exhibition opened, but the judge dismissed his petition. On April 7, 1990, the police shut down the CAC for ninety minutes in order to videotape the exhibition, as a grand jury indicted the gallery and its director for pandering obscenity and using minors in nude poses (fig. 9). The trial was set for September, and the exhibition was reopened. Some 80,000 people out of a population of about 350,000 visited the show, and the picketing continued. Despite all the furor, the Boston ICA, the next and final stop for "The Perfect Moment,"

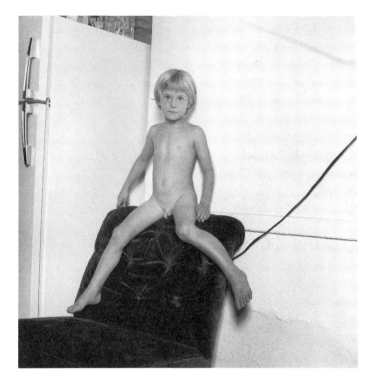

9. Robert Mapplethorpe, *Jesse McBride* (1976), The Estate of
Robert Mapplethorpe.

refused to cancel. The Boston exhibition proceeded from mid-June to August
31 with high attendance, after a Boston court declined a petition to close it.

But all was not quiet at the NEA. Congressional subcommittee hearings
were underway throughout the spring of 1990 about whether and under what
circumstances the agency should be reauthorized. Jesse Helms had demanded
details on specific NEA grants, and the American Family Association of Tu-
pelo, Mississippi, and the Traditional Values Coalition organized another
letter-writing campaign aimed at Congress. Representative Steve Gunderson
(R – Wisc.) reported, "For a guy who comes from a rural district in the Mid-
west, and in a year when we have a new farm bill, it's remarkable to get five to
ten times as much mail on this as any other issue." [43]

The pressure on lawmakers, the NEA itself, and arts organizations was un-

remitting. The chairman of the Cincinnati CAC resigned after receiving threat-
ening phone calls at his office. Reverend Louis Sheldon, head of the Coalition
for Traditional Values, printed half a million copies of a voters' guide for Cali-
fornia indicating how each state legislator, congressman, and senator voted on
"moral issues: homosexuality, abortion, pornography, religious issues, and the
family." [44] Without permission, Reverend Wildmon of the AFA used arbitrary
portions of David Wojnarowicz's photographs to campaign against porno-
graphic art—the same Wojnarowicz whose catalogue essay had struck John
Frohnmayer as seditious speech. Wojnarowicz later sued successfully for a
retraction by Wildmon, a restraining order on the pamphlet, and minimal
damages.

President Bush, in March 1990, had stated that he was "deeply offended by
some of the filth" [45] that masqueraded as art under federal funding, but that he
was against government censorship. But by June he was sounding much more
militant. William Safire asked in the *New York Times* why George Bush was
suddenly reversing himself on public funding of "obscene or sacrilegious art"
and on the flag amendment. "These questions have a common answer," Safire
concluded. "The 1990 midterm election campaign is under way." [46] When Pat-
rick Buchanan entered the presidential race in 1991, his virulent criticism of
the arts pushed Bush into an even more hard-line posture.

In the subcommittee hearings of 1990, various draconian proposals were
circulating. One suggested that 60 percent of NEA funds be allocated to state
art councils on the assumption that local authorities would not belong to the
morally bankrupt East Coast art establishment. Feeling the pressure, the NEA's
National Council voted against funds previously recommended by peer panel
for two projects at the Philadelphia ICA. "We felt this [grant] would be tweak-
ing the nose of Congress," explained Jacob Neusner, a council member. Judith
Tannenbaum of the ICA remarked, "they seem to be making a political deci-
sion having nothing to do with the content of the shows or the artistic value of
the projects. The whole thing is amazing." [47]

Among the other grants refused that day was one for the performance artist
Karen Finley, who, in a work called *Victims,* covered her naked body with
melted chocolate. The columnists Rowland Evans and Robert Novak pro-
claimed this chocolate-daubing a piece of classic pornography, but Finley ex-
plained that it had just the opposite meaning: "My work is against violence,
against rape and degradation of women. . . . When I smear chocolate on my
body it is a symbol of women being treated like dirt." [48]

For Finley, the actions of the NEA and the right confirmed the political analysis she was trying to portray in her performance art, which was then—in May 1990—showing at the Franklin Furnace in New York. After the attempt to "punish" the Philadelphia ICA, a spokesperson for Franklin Furnace wondered whether her space was in danger of being refused funding for future, unrelated exhibitions as well.[49] Such fears were well founded, as she discovered in July when the NEA conditioned a grant to the Furnace on its providing a description of its shows for the entire season.

The months leading up to the Mapplethorpe trial were thus full of threats, public gestures, pyrrhic victories, and a chill over the artistic community that was probably more powerful in its effects than the most repressive of actual measures. The anti-obscenity clause in the NEA appropriation bill for 1990 required grantees to sign a pledge not to produce obscene art with NEA funds. Joseph Papp and the *American Poetry Review* refused to accept their grants on these terms. The two grants denied to the Philadelphia ICA in the spring were reinstated in the summer, but the NEA at the same time established a content-review board to investigate allegations of obscenity from any reliable source. In August, the advisory council to the NEA recommended elimination of the anti-obscenity pledge, but John Frohnmayer refused to rescind it. The Rutherford Institute sued the NEA for hostility to religion in its award of $15,000 to David Wojnarowicz for "Tongues of Flame." As the Reverend Wildmon extended his campaign to the rock group 2 Live Crew's album *As Nasty As They Wanna Be,* it was no wonder that poet Allen Ginsberg said, "We are in a dead-end totalitarian ecological trap."[50]

It did no good for Representative Yates to point out the tiny percentage of controversial grants funded by the NEA, or for *Newsweek* to discover that the entire NEA budget was smaller than the amount the Pentagon spent each year on its military bands.[51] Clearly something was at stake that was not susceptible to rationality or a sense of proportion.

The left's contention was that the controversy was about the First Amendment guarantee of freedom of expression, whereas the right steadfastly denied this. For them, the issue was the use of taxpayer's money to fund art that the average citizen would find personally offensive and destructive of community values. This argument was endlessly repeated by conservative leaders. But with most of their evidence of public outrage in the form of constituents' letters that they themselves or right-wing groups had solicited in the first place, the left found this argument hard to take seriously. A Gallup poll published in *Newsweek*

on July 2, 1990, showed that 75 percent of Americans did not want anyone imposing new laws on what they could see or hear, and in a private poll commissioned by the CAC, of the 90 percent of Cincinnati residents who knew of the trial, 63 percent said that the city should not proceed with the prosecution (ibid.). Certainly, attendance figures at "The Perfect Moment" indicated wide interest in controversial art. "No matter what Sen. Jesse Helms (R., NC.) may think about Robert Mapplethorpe's photographs," wrote the *Philadelphia Inquirer,* "he will have to admit one thing. People sure do want to see them." [52]

Harvard law professor Kathleen M. Sullivan argued that the case against the use of tax money for controversial art was equally unfounded. "As Chief Justice William Rehnquist wrote for the Supreme Court in a unanimous 1983 opinion, neither by penalty nor subsidy may the Government 'aim at the suppression of dangerous ideas.' Indeed, the First Amendment has never been held to disappear just because the taxpayers are paying the tab. . . . If you wish to hold a rally or concert in a public park, you cannot be denied a permit because your ideas or songs are controversial—even though the taxpayers pay for the police who keep order at your event and for the sanitation workers who clean up the litter you leave behind. And editorials, however controversial, may not be banned from the public airwaves—even though the taxpayers foot the bill for the Corporation for Public Broadcasting." As to the argument that "government should not put its seal of approval on controversial art by paying for it," she continued, "to make art possible is not to condone it." Both pro- and anti-abortionists have demonstrated in the Washington Mall. "The only 'message' conveyed by such neutral and even-handed public subsidies is that, in the Government's house, all ideas are welcome." [53]

Others pointed out that tax funds are frequently used for unpopular purposes. "People offended by provocative photos," wrote Robert Brustein, director of the American Repertory Theater in Cambridge, Massachusetts, "unlike those who live near nuclear installations, can comfortably stay home." [54]

Brustein and the playright Joshua Goldstein had expressed the left's deepest fears in the Mapplethorpe affair the year before when they published the words of Adolf Hitler in the *New York Times:* "It is not the function of art to wallow in dirt for dirt's sake, never its task to paint men only in states of decay, to draw cretins as the symbol of motherhood, to picture hunchbacked idiots as representatives of manly strength. . . . Art must be the handmaiden of sublimity and beauty and thus promote whatever is natural and healthy. If art does not do this, then any money spent on it is squandered." [55]

Beyond totalitarianism, the left charged politicians such as Jesse Helms with prejudice against homosexuals and every kind of deviance from stereotyped American morality. David Ross, head of the Boston ICA, called the pressures leading to the Corcoran cancellation "institutionalized gay bashing."[56] Commentators repeatedly remarked on the odd coincidence that 1989 was the year in which Eastern Europe suddenly seized control of its freedom and America seemed bent on throwing its own away. For some, there was nothing innocent about the coincidence. According to Robert Hughes, Senator Helms and the rest attacked Mapplethorpe "to establish themselves as defenders of the American Way, now that their original crusade against the Red Menace had been rendered null and void by the end of the cold war and the general collapse of communism. Having lost the barbarian at the gates, they went for the fairy at the bottom of the garden."[57]

From the point of view of the right, this was just so much demagoguery. *Piss Christ* and Mapplethorpe's sadomasochism and child pornography were obscene prima facie. The more Senator Helms looked about, the more such art he found, from chocolate-covered nudists to pictures of men touching each other's private parts. There were lots of artworks to choose from; yet for some reason the system kept throwing up these deviant, shocking images and making his tax dollars pay for them. Clearly, those in charge of deciding what art should be funded, noticed, and praised had very different standards from his own. There was nothing inevitable about the promotion of obscene art. It was a conscious choice on the part of a leftist establishment who, having failed to achieve any material power to promote their political and social goals, had turned to the sphere of culture, where they were able to advance a moral permissiveness that violated Christian teaching. Government and the people needed to band together to define American culture. It was time to eliminate The Experts.

ART ON TRIAL

This was the conflict that was to be enacted in the Cincinnati courts—some version of "Hitler Meets the Marquis de Sade." As so often happens in fairy tales, the fascist bully was defeated by the refined aristocrat. But there were other scenarios in play. The prosecution repeatedly referred to the story of "The Emperor's New Clothes" in explaining the situation to the jury. "You are the townspeople," said prosecutor Frank Prouty, "who could tell the art-world emperors that they are not wearing any clothes at all."[58] Unlike the clash of

dictator and marquis, the denuding of expert authority was a plot that the courts left unresolved.

The Cincinnati trial lasted for two weeks, from September 24 to October 6, 1990. Just 7 of the 175 photographs in the Mapplethorpe show were charged with obscenity—two of children and five of sadomasochistic homosexuality. Dennis Barrie, director of the CAC, was indicted on two misdemeanor charges of pandering obscenity and illegal use of a minor in nudity-oriented material. If convicted, he could have been jailed for six months and fined $1,000 on each count. The gallery was indicted on the same charges and could have been fined $5,000 per count. In a hearing before the trial began, Hamilton County Judge David J. Albanese held that the five sadomasochistic images and the two photographs of children could be considered in isolation from the rest of the exhibition, despite the fact that obscenity law since Judge Woolsey's verdict on *Ulysses* in 1933 stipulated that a work had to be judged as a whole. But Judge Albanese—partly because the five SM shots were absent from the exhibition catalogue—decided that they were not integrated into the exhibition, each having a separate identity.[59] Several experts consulted by newspapers covering the trial agreed that Albanese's ruling was not consistent with applicable legal principles.[60]

During jury selection, the defense moved that jurors be limited to residents of Cincinnati, since obscenity determinations rest on "community standards." Judge Albanese, however, ruled that any of those in the Hamilton County pool were eligible, regardless of any differences in the mores of suburbanites and city-dwellers. After a selection process that the *New York Times* and *Philadelphia Inquirer* reported as heavily skewed toward prosecution interests,[61] a jury of four women and four men emerged, most of whom were from the suburbs. "A secretary, a sales clerk, a warehouse manager, a telephone repairman, a data processor, an x-ray technician, an engineer and a shipping worker, only three of whom had been to an art museum, were chosen to decide, among other things, what is art and what is not" (ibid., Wilkerson). If ever the alliance of government with the average American against the elitist art establishment were to be tested, this would be the case to do it.

The prosecution considered its case open-and-shut. Prouty called in three police officers who had temporarily closed the exhibition and videotaped it, in order to establish that the seven offending photographs were in the show at the CAC under the directorship of Barrie. The prosecution then submitted the seven photographs as evidence. "You're going to ask, 'Shouldn't we hear some-

thing more?' " said Prouty. "The pictures are the state's case." [62] The prosecution then rested. When the defense moved for a dismissal on the grounds that the state had presented no evidence, "Mr. Prouty . . . restated his contention that each photograph speaks for itself and that the jury will decide the merits." [63] Like Jesse Helms sending the Mapplethorpe photographs around Congress in sealed envelopes as proof positive of their obscenity, or Ralph D'Amato reacting to the words "Piss Christ" as an unambiguous religious slur, or the columnists Evans and Novak proclaiming that the smearing of a nude body with chocolate was obscene without considering Karen Finley's intended meaning, the prosecution in the Mapplethorpe trial assumed the photographs would indict themselves, that they did not require interpretation, and that their obscenity was a self-evident fact.

This belief in a prima facie, univocal meaning for art, evident to any "normal" person, seems to be one of the hallmarks of conservative thinking. In the Mapplethorpe trial, it proved to be completely untenable as an argumentative strategy. As the jury listened to witness after defense witness claim that the Mapplethorpe photographs were works of art, and as the initial shock at the images was replaced by a vast web of aesthetic interpretation, the jury members were forced to concede to the experts. Isabel Wilkerson of the *New York Times* concluded that "it was the jurors' admitted lack of exposure to art that worked for the defense in the end: The jurors deferred to the experts. . . . ' The prosecution basically decided to show us the pictures so that we'd say they weren't art when everybody else was telling us they were,' said one juror. 'We thought the pictures were lewd, grotesque, disgusting,' said another. 'But like the defense said, art doesn't have to be beautiful or pretty.' " [64]

When Prosecutor Prouty showed Janet Kardon the photographs and asked, "Would you call these sexual acts," she answered, "I would call them figure studies." [65] Artistic meaning, like all meaning, is a matter of interpretation. What the prosecution did not realize is that we react to interpretation; we judge interpretations; there is no such thing as a work that speaks for itself. Obscenity is thus always in the eye of the beholder, and what the beholder sees is subject to influence.

What intellectuals and arts professionals cannot understand is why conservatives—unlike the "average citizen" of Ohio—are so resistant to their influence. The explanation lies in the relations between fundamentalists and cultural liberals in America. The two have reached a severe impasse. As David Hoekema, a professor of philosophy, wrote in 1991, the conservative crusade against

the arts has been enormously enhanced by an "atmosphere of mistrust toward elite institutions. . . . if the attacks on the arts were not so closely congruent with a broader attack on the universities and on the leaders of contemporary intellectual life . . . the political rantings on the House and Senate floor would have drawn only a moment's attention in the media and in the committee rooms."[66]

Of course, one could claim that the assumptions behind an obscenity trial would inevitably lead to an acquittal. As Rachel Bowlby argues in a study of the *Lady Chatterley's Lover* trial, "The jury are supposed to decide, on behalf of the populus at large, whether this is an obscene book, whether it has this 'tendency to deprave or corrupt.' . . . If they *have* been depraved or corrupted, then . . . they are no longer in a position to judge the book: they have become depraved and corrupted. But they will not know this, because a depraved person is no judge of depravity. There could thus never . . . be such a thing as a fair trial for obscenity."[67] Though the words "deprave and corrupt" have been missing from American obscenity legislation for some time, the jurors may well have acquitted the CAC and its director because they came under the spell of Mapplethorpe's art. Another scenario for the Mapplethorpe trial is some version of the Fall of Man.

THE LAW ON PORNOGRAPHY

According to Walter Kendrick, a historian of pornography, "there has been censorship as long as there have been signs and representations. At no time in human history has the power to portray the world in words and pictures been granted unrestricted exercise."[68] If ever such a state of license were imaginable, however, it would be in America, where freedom of expression is such a basic assumption. But in fact, there is considerably more restriction on obscenity and certainly more fuss about it in the U.S. than in western Europe. Part of the problem lies in the very terms under which American speech is protected.

In "the cornerstone of modern obscenity law," *Roth* v. *U.S.*, 354 U.S. 976 (1957), the Supreme Court decided that obscene materials were not protected under the First Amendment. Justice Brennan explained that the protections of free speech and press were there to assure the "unfettered interchange of ideas for the bringing about of political and social changes desired by the people."[69] Since obscenity makes no contribution "as a step to truth," any benefit in protecting it is outweighed by morality.

Though obscene materials are those "appealing to the prurient interest,"

i.e., exciting lustful thoughts, the *Roth* Court deemed the simple presence of sex in art, literature, and scientific works an insufficient reason to deny them protection. "All ideas having even the slightest redeeming social importance— unorthodox ideas, controversial ideas, even ideas hateful to the prevailing climate of opinion—have the full protection of the guarantees" (Moretti, pp. 7– 8). Thus, when New York State denied Kingsley Picture Corporation a license to show the film of *Lady Chatterley's Lover* because it advocated adultery, which is immoral, the Supreme Court overturned the decision because immorality is not the same as obscenity and the First Amendment guarantees the freedom to advocate ideas (Moretti, p. 22).

In 1973, *Miller* v. *California,* 413 U.S. 15, altered the *Roth* results slightly. It ordered that obscene material need not be utterly without redeeming social value, but only without "serious value"; it gave examples of what was "patently offensive"; it prohibited only hard-core pornography and not other material that aroused the prurient interest; and it made obscenity a matter to be judged by state rather than national standards. The *Miller* decision produced a three-part test, which has been in effect ever since, for "works which, taken as a whole, appeal to the prurient interest in sex, which portray sexual conduct in a patently offensive way, and which, taken as a whole, do not have serious literary, artistic, political, or scientific value" (Moretti, p. 30). This was the standard applied in the Mapplethorpe case. The stipulation that the work be "taken as a whole" caused the controversy surrounding Judge Albanese's decision to treat the seven photos in isolation from the rest of the retrospective. And the exemption for works with artistic value was what led the defense to call in expert after expert to testify to the value of Mapplethorpe's photographs. Of course, the fact that the works were in an art gallery should have indicated, prima facie, that they had artistic value, if it were not for the fact that the climate in the U.S. is so distrustful of the experts who decide what should appear in those galleries in the first place.

Legal commentators point out that since *Miller* it is not easy to find a book, movie, or performance obscene. Daniel S. Moretti, (p. 99) cites the case against the film *Caligula,* which the Court determined to be prurient and offensive but at the same time to contain some political value in that it demonstrates that absolute power corrupts absolutely.

But the most confounding implication of American obscenity legislation is the notion that art advocates ideas in the first place, and that it can be shielded only on this ground. Entertainment value is not defensible; the promulgation

of ideas is. The problem is that one cannot always tell the two apart, as the
Supreme Court acknowledged in a 1943 opinion: "The line between the in-
forming and the entertaining is too elusive . . . what is one man's amusement,
teaches another's doctrine."[70]

Political groups, moreover, have found it useful to treat entertainment as
the assertion of ideas. When the TV character Maude had an abortion, anti-
abortionists argued before the Federal Communications Commission under its
fairness doctrine that "Maude had the abortion on CBS, so they should have
the right to reply on CBS."[71]

The notion that art advocates ideas is apparent to everyone but aestheti-
cians. Sir Philip Sidney's dictum that "the Poet in nothing lyeth for he nothing
affirmeth" carries little weight today, despite the Crocean senator, and "art for
art's sake" is considered as misconceived as "dirt for dirt's sake" is unprotected.
Even the philosopher Arthur Danto takes this position in discussing Serrano's
Piss Christ and the flag installation at the School of the Art Institute of Chicago:

People responded indignantly and directly, by confrontations, demonstrations, protests. It
would have been absurd to argue that they ought not to have done this on the ground that
the objects were art. Art has the privileges of freedom only because it is a form of expression.
And to be seriously interested in making an expression is to be seriously prepared to endure
the consequences of making it. . . . It is healthy for art to vacate the position of pure aes-
theticism in which conservative critics seek to imprison it, and to try to affect the way view-
ers respond to the most meaningful matters of their lives. . . . Art has been primarily aesthetic
only throughout a very brief interval of its history of political, moral and religious engage-
ment. As taxpayers our interest is solely in everyone's freedom to participate in the thought
of the age.[72]

Certainly one applauds such a hearty striding forth into the postmodern
sunset, a world where people take what art says seriously, and artists stand up
like heroes against the consequences of their speech. Never mind that there are
few groups less financially able to withstand the legal actions leveled against
them or manage without the grants denied them than artists. And never mind
that there are few artists less likely than postmodernists to make statements that
the courts will consider "a step toward truth." As Amy Adler states, "post-
modern art rebels against the notion that a work of art be serious or that it have
any traditional 'value' at all. *Miller,* then, mirrors Modernist notions of art and
evaluates contemporary art by the very standard which that art seeks to defy."[73]

For Adler the art-as-statement doctrine is a modernist conception of art,

whereas for Danto it is a postmodern one. This interpretive discrepancy itself signals the problem. What is said in art—like what is said *of* it—is ambiguous, needs construal, and is interpreted according to the interests of the interpreter. There is no art valued solely for the ideas it contains. Moreover, it is often very hard to tell whether an artwork is registering an idea or advocating it, and by the time one figures that out in a given instance, the idea has often ceased to matter. That is not to say that art is "pure form," but it is equally silly to believe that art is a bunch of fighting words that should be met with law suits, police closures, and blacklisting. Further, the consequences artists suffer now seem excessive. If Andres Serrano does not persecute Jesse Helms for his politics, why should Jesse Helms persecute Serrano for his art? The imbalance of power in the clash between artist and government removes the parallelism necessary for a fair fight.

It is also imprecise to argue, as Rochelle Gurstein does, that with the verdict in favor of Mapplethorpe, "the concept of obscenity, at least as formulated by the law, can apparently be relegated to the dustbin of history."[74] It is not the concept of obscenity but the concept of obscene art that is being discarded. And so it should be. The law says that obscenity has no artistic value. Art has artistic value. Therefore art cannot be obscene. It is only the literalism promoted by the law, the conservatives, and, surprisingly, members of the cultural establishment like Danto, that would make artistic obscenity thinkable. This is not to say that art with sexual subjects (or political subjects for that matter) is necessarily good. But to say that a work is not good is different from saying that it is not art or that the public should not be allowed to see it.

For if Danto is right that art conveys ideas which carry real consequences that artists should be prepared to suffer, then we must conclude that Salman Rushdie's situation is normal and acceptable. It is becoming all too normal, I am afraid, but this does not make it acceptable to me. I have heard perfectly enlightened Englishmen argue that Rushdie should not have published his book because it led to rioting and deaths. Under such reasoning, the Bible should have been suppressed as well, since it is "responsible" for immeasurable violence and suffering.

The opposite point of view, that art has *no* effect in the realm of deeds, is equally problematic. Robert Hughes (p. 24), in arguing against the association of artistic value with artistic ideas, says, "The most celebrated, widely reproduced, and universally recognizable political painting of the twentieth century is *Guernica,* and it didn't change Franco's regime one inch or shorten his life by

so much as one day." The manifest truth and untruth of this statement are inescapable, for the effect of *Guernica* on conditioning world opinion about Franco was incalculable, and it remains, as much as the most complex treatise on the subject, an affecting dramatization of a point of view. But more than this, it is an imaginary triumph over or compensation for the horrors it condemns. It is a wish fulfilment, a piece of pleasure, a "world instead."

But this world is merely virtual. Forgetting that fact is akin to childishness or insanity or fundamentalism. There is great value and power in the virtual; it is a realm we all inhabit and need. So important is it that artists and scholars have spent years of their lives responding to *Guernica*. This appreciation or opposition is the appropriate way to answer art; censorship and destruction are inappropriate.

Thus, when Justices Douglas and Black dissented from the *Roth* obscenity decision because it punished people for thoughts provoked rather than overt acts, they were making a profoundly important distinction. As Justice Douglas stated, "The legality of a publication in this country should never be allowed to turn either on the purity of thought which it instills in the mind of the reader or on the degree to which it offends community conscience. By either test the rule of the censor is exalted and society's values in literary freedom are sacrificed" (Moretti, p. 8).

The government has by now set up two studies on the effects of pornography on behavior—the Commission on Obscenity and Pornography whose report appeared in 1970, and the so-called Meese Commission (1986)—neither of which could establish a firm connection between pornography and antisocial conduct. Indeed, evidence actually suggests that exposure to pornography and a healthy sex life are connected (Moretti, p. 45). The sociologist Carole Vance claims that no responsible study has ever established that pornography produces violence toward women.[75] It may incite sexual feelings toward women, but as Judge Frank in the *Roth* decision claimed, if pornography leads to normal sex, it cannot be socially harmful because without sex the human race would disappear!

Pornography and pornographic art are important because they mark the bounds between thought and deed, and like every such liminal zone they are fraught with fear—fear that fantasies will come true, will invade the world of public action—and the opposite fear, that there will be no such crossover, that the pleasure and energy and justice of this zone will have no realization outside it.

The first fear is apparent in Richard Nixon's response to the 1970 pornography commission report. Pornography is morally bankrupt, he declared, because "if an attitude of permissiveness were to be adopted regarding pornography, this would contribute to an atmosphere condoning anarchy in every other field—and would increase the threat to our social order."[76] Pornography is not only a symbol of anarchy, but, as Walter Kendrick points out, in fundamentalist conservatism it is an unleashing "that immediately turns into wantonness of every other kind, including the promiscuous redistribution of property."

The second fear—that pornographic power will never exceed the realm of fantasy—can be seen in Walter Kendrick's thinking. If the 1970 report is right that there is "no correlation between lewd representations and lewd acts," Kendrick says (pp. 216–17), they "must also agree that there is no predictable correlation between any image and any act." This outcome Kendrick is willing to accept in principle, but not in fact. "The sealing up of art in a museum where only art was to be found would easily eliminate the need for court trials and book burnings," he writes. "It would also, however, remove the last vestiges of art's legendary power to move and alter a nonartistic audience. . . . not until the dawn of the post-pornographic era did public and elite reach a final consensus that art was only art when it had nothing whatever to do with the nonartistic world" (p. 225). Kendrick notes that even the various legal decisions enlarging the sphere of permissible art have protected art at the expense of defanging it. Aesthetic value has become the province of experts cloistered in universities, teaching ignorant children, or trotted out into courtrooms to instruct the "lay" judge. "The legal process may have gained in wisdom as a result," concludes Kendrick (p. 195), "but as the freedom of literature grew, its power diminished, until it seemed that 'literary value' was a synonym for impotence."

Think of this observation from the expert's point of view—the professional who feels that he or she must justify unconventional art on the grounds that it is ultimately ineffectual and irrelevant. What a terrible farce, to stand before a class, impassioned about a work whose political implications one must ignore or deny for fear of appearing to advocate them, whose appeal to desire and passion one must bypass for fear of inciting prurience or justifying rape, and whose aesthetic lineage and form one must downplay or risk appearing a mere aesthete. If the law has rendered aesthetic "ideas" indistinguishable from real-life advocacy, the professionalization of art commentary has removed art from a vital place in public life. In either case, experts find themselves in a completely untenable position, unable to operate from the assumption that art is virtual

speech and hence unable to say anything true or important about it. The expert, in every case of recent aesthetic controversy, becomes the focus of public fear about this threatening nonthreat, art.

PHOTOGRAPHY AS SPECIAL PROBLEM

None of the arts provokes these fears more urgently than photography. The photographic arts belong to reality in a way more literal than any other aesthetic representation. As Rudolf Arnheim explains, photography by definition represents not the general nor the characteristic but what is peculiar to one moment of time. It embraces accident, since not everything in the lens's view can be controlled. It represents a fragment of a larger world, and so it always implies that world, of which it is a sample or an accidental element. Its imperfection is a sign of the victory of reality over the artist's efforts. When we think of the time of a photograph, says Arnheim, we are thinking not of a period in its maker's career but the time of the subject represented. The premise of photography is that an artist inhabited some reality at a particular moment—intruded himself into it—but that reality was not created by him. "The glove near the wastepaper basket must have been dropped by a customer; it was not placed there by an artist as a compositional touch. We are on vacation from artifice."[77] As a result, says Arnheim, photography may be a revolt against form, the characteristic of all traditional art.

Andy Grundberg, the former photography critic for the *New York Times,* argues that photography is so rooted in actuality that it is "especially vulnerable to a criticism based solely on the contents of an image. It is the most stylistically transparent of the visual arts. . . . the subject matter of photographs is often mistaken for their meaning and value."[78] For Grundberg, the subject matter of photography has always been problematic because of the simultaneous realism and artifice of the art. It is a metamorphic endeavor, an art of transformation. "Graffiti and gutter trash have been turned into painterly abstractions; the sick, mad and dispossessed have been shown in poses that mimic Renaissance compositions."[79]

But not everyone reads this glorious transmutation as a good thing. Susan Sontag in particular finds it pernicious. In her 1977 book *On Photography,* she argues that "photographic images tend to subtract feeling from something we experience at first hand and the feelings they do arouse are, largely, not those we have in real life."[80] Photography "recycles" the real, transforming its meaning and moral force into the "interesting." "The photographic recycling makes

clichés out of unique objects, distinctive and vivid artifacts out of clichés. Images of real things are interlayered with images of images" (p. 175). Like the characters in Don DeLillo's *White Noise* who respond more strongly to simulacra than the reality they represent, viewers of photographs are in Sontag's opinion trained away from reality while assuming they are coming ever closer to it.

An art that is indistinguishable from its real subject or an art that blocks out reality—photography is an archetype of our conflicting fears of aesthetic liminality. This ambivalence in part accounts for its power in surrealism, when nudes were photographed in forests or living rooms. As Arnheim points out, since such scenes were known not from reality, but only from the vision of painters such as Manet, the reality of the photographed scene was transformed into a dream or a threatening hallucination. The intrusion of proscribed or shocking realities into acceptable reality is one of the oldest tricks of photography, which might be defined as an art of conflicted response.

Painting, in contrast, is an art in which nudity can exist relatively unremarked. The cloak of the aesthetic, in Sir Kenneth Clark's classic formulation, transforms the naked into the nude.[81] In the last century, public theaters could overcome the prohibition against nudity on stage by showing *tableaux vivants* or *poses plastiques,* in which unclothed actors imitated the poses in paintings. Clever entrepreneurs took advantage of this fine point. As Richard D. Altick notes, "what had seemed . . . a well-meant effort to popularize fine art by putting it on the stage was in danger of degenerating into a mild form of striptease."[82]

The subtle distinction between high painting and pornography is apparent in Mark Twain's description of Titian's *Venus of Urbino.* "There the Venus lies for anybody to gloat over who wants to—and there she has a right to lie, for she is a work of art and art has its privileges. . . . Without any question it was painted for the bagnio and it was probably refused because it was a trifle too strong. In truth, it is a trifle too strong for any place but a public art gallery."[83] One treats nakedness differently in painting than in real life, but photography—so much closer to reality than painting—raises all the difficulties of the live stage.

Moreover, photography's very status as an art is questionable. Photographs permeate our environment in cities and on roadways as commercial advertising, integrating reality and capitalist exhortation at every turn. It is no wonder that Senators Helms and D'Amato have trouble distinguishing representations of sadomasochistic sex from the advocacy of sadomasochistic sex when the normal

function of photography in the "real world" is to promote products. Moreover, virtually everyone in our culture takes pictures. They form part of each person's history, part of family life and the compact of love it represents. The contrast between these naive documents and art photography is sometimes shocking and at other times minimal. Everybody takes pictures.

Photography is also a relatively new art. As Carole Vance points out, it lacks the prestige, the resources, and the authority surrounding painting or sculpture.[84] It is also a kind of cuckoo, stealing into the nests of other arts—a masquerade of painting that has alienated painting from ordinary reality. Robert Hughes states the common belief that because of the greater documentary power of photography, painting shredded its contract[85] to transmit cultural values, represent reality, and function as a form of social discourse. Since no manual technique could match the accuracy, detail, and ubiquity of photographic images of reality, the story goes, painting simply gave up and entered the dehumanized realms of abstraction, surrealism, Pop, minimalism, and conceptualism. And now photography, ensconced in painting's place, responsible for giving us the real world, tries to turn the world upside down with images of things we have never seen or wanted to see—the private, deviant, outlaw world of sadomasochistic homosexuality!

This betrayal happens, too, just at a moment when the balance among the arts is again changing. If average citizens are still reading books, their passions are shifting to the visual media. The Meese Commission, Walter Kendrick notes, recommended that verbal pornography not be controlled because "the absence of photographs necessarily produces a message that seems to necessitate for its assimilation more real thought and less almost reflexive action than does the more typical pornographic item." After hysterical book-banning, suddenly the most puritanical censors have abandoned the crusade against verbal filth as quite unnecessary. Kendrick concludes that "Inadvertently, the commission ratified America's transformation into a post-verbal culture. Or rather, it stamped approval on America's split into a two-class culture, the top that reads and the bottom that does not or cannot."[86]

This is the picture that emerges by our day: that photography is intensely realistic and yet transforms reality into art; that it is not quite legitimate as an art and yet is more potent than either painting or literature; and that it exercises its power especially over that fearsome part of the population known as "the masses." This sector represents not only the Other waiting to overtake establishment power but also that part of ourselves that chafes against restraint.

At this point, the conservative fear of photography's power is reinforced by the radicals' faith in that power. "A camera in hand," says David Wojnarowicz, can create a historical record that contests the official history of "rich white owners of mass media." It can keep our needs on view in a culture that tries to legislate them into invisibility. It can provide the information about AIDS to mobilize the money and public opinion to save lives.

A camera in hand can create a socially divine moment in late twentieth-century style and methods of communications. A camera in hand can produce images of authenticity that break down the walls of state-sanctioned ignorance in the forms of mass media/mass hypnosis and stir people to do what is considered taboo and that is to *speak*. . . . Describing the once indescribable can dismantle the power of taboo. . . . To keep silent even when our individual existence contradicts the illusion of the One Tribe nation is to lose our identities and possibly our lives.[87]

To claim that photography is evidence against the "One Tribe Nation" is to find it efficacious in reality. By witnessing a reality different from the one officially sanctioned—which Wojnarovicz describes as a Christian fundamentalist myth of shared values—photographs can change reality, giving authority to other viewpoints.

If photography reveals the divergence of opinion from what is officially sanctioned, then pornographic photography does so even more emphatically. As Eleanor Heartney wrote in a special issue of the College Art Association's *Art Journal,* "The opposition to pornography, whether it comes from feminists or from the American Family Association, is grounded in a kind of utopian thinking that celebrates a homogeneous and dissent-free model of society. Pornography . . . is a reminder of disruptive realities. . . . it is no coincidence that the artists who have been the primary targets of the right's ire—Robert Mapplethorpe, David Wojnarowicz, Andres Serrano, Karen Finley, Holly Hughes, 2 Live Crew—are representatives of marginal groups and 'deviant' outlooks."[88] When the tony prosecution lawyer in the *Lady Chatterley's Lover* case appealed to the jury: "Is it a book that you would ever wish your wife or your servants to read?" the working-class 1960s jurors apparently laughed in his face.[89] Pornography undermines the premise of a unified nation.

Pornographic photography does so, moreover, because it interrogates the very act of viewing, making the viewer self-conscious, drawing the photographer's role as viewer into the dynamics of the work, and questioning the subject's role as victim or accomplice in the viewing. It adds to the threatening

realism of any photograph a thematization of the act of looking—of voyeur-
ism, peeping, leering, examining, adoring. "Almost from the moment of the
medium's birth in 1839," writes Andy Grundberg, "photographers have been
fascinated with the contradictory but inherent eroticism of the camera's dis-
embodied gaze." [90] This theme arises in film and painting as well, but contem-
porary photographers have pressed it especially hard, particularly those con-
cerned with gender issues.

It is a central issue in self-portraiture. The photographer Dorit Cypis, for
example, asked four female artists to photograph her as she posed naked, and
then presented the results as her own work. Mary-Charlotte Domandi com-
ments: "Can a woman be a visual subject without giving up her own sense of
self? . . . How do women perceive themselves while they are being looked at?
A work from 1989, *Yield the Body,* . . . is both Cypis's self-portrait, and even
more subtly, a self-portrait of each of the other photographers; it is also an
exploration of how a woman looks at another woman's body." [91]

Carolee Schneemann has encountered considerable opposition to just such
images. "If my paintings, photographs, film and enacted works have been
judged obscene, the question arises: [. . .] Is this because my photographic
works are usually self-shot, without an external controlling eye? And are these
works obscene because I posit my female body as a locus of autonomy, pleasure,
desire; and insist that as an artist I can be both image and image maker, merging
two aspects of a self deeply fractured in the contemporary imagination?" [92]

The application of this thinking to Robert Mapplethorpe's work is obvi-
ous, as Mapplethorpe, with bullwhip sticking like a devilish tail from his rectum
(fig. 10), turns round to the camera—to us—acknowledging the fact that we
are looking, that he knows we know his pleasure and his pain. But do we know
what our pleasure and pain in the viewing might be, how we place ourselves
vis-à-vis this sight, this fact? This work is confrontational, teasing, searching.
And it obviously causes certain parts of the population extreme anxiety.

In the self-portrait, the capacity for equal knowledge on the part of viewer
and subject is definitional, though Mapplethorpe's shock tactics depend on an
initial disparity between them. But in nude photographs of children, the in-
equality of understanding is acute and troublesome. Sally Mann's remarkable
collection *At Twelve* (1988) revolves on this issue, as does the commentary sur-
rounding it by Mann herself and the fiction-writer Ann Beattie. In *At Twelve,*
Mann photographed her own daughter and other girls on the cusp between
childhood and adolescence, and in the process revealed every fear we have

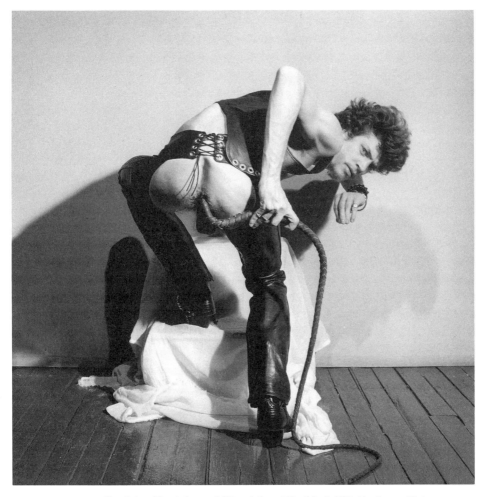

10. Robert Mapplethorpe, *Self-Portrait,* from *X Portfolio.* © 1978, The Estate of Robert Mapplethorpe.

about the discrepancy between the knowledge of subject, photographer, and viewer.

Mann begins, "What knowing watchfulness in the eyes of a twelve-year-old . . . at once guarded, yet guileless. She is the very picture of contradiction: on the one hand diffident and ambivalent, on the other forthright and impatient; half pertness and half pout. She disarms me with her sure sense of her

11. Sally Mann, *At Twelve* (1988), p. 30. © Sally
Mann, Courtesy Houk Friedman, New York.

own attractiveness and, with it, her direct, even provocative approach to the
camera." [93]

Mann takes this ambivalence through a spectrum of possibilities. She pho-
tographs a twelve-year-old seated facing away from us, unaware that her naked
breast is visible through a gap in her tank top (fig. 11). Is this unfair? She has
girls posing in women's finery—a prom dress or a suit that is too mature but yet
fits their bodies, to show us the theatricality of the age and the medium. Else-
where, Mann poses a girl against a blood-stained mattress cover spread on the
line to dry (fig. 12). The twelve-year-old stretches a scarf across her breasts
triumphantly, in a wrenching image of innocent corruption. One girl poses
beside her mother's boyfriend and another in the strangling embrace of a shad-

12. Sally Mann, *At Twelve* (1988), p. 21. © Sally Mann, Courtesy Houk Friedman, New York.

owed father (fig. 13), hinting at a darkness in their lives that undermines all fantasies we hold of their unclouded childhoods. "These girls," Ann Beattie comments in her introduction, "have seen enough of the postures and affectations of adults to approximate or mimic them successfully. . . . Is the world in which the girls exist really an innocent world in which a pose is only a pose?" [94] Is a photograph, we might add, really part of an innocent world of art in which a pose is only a pose? Are there not poses that are reality?

Beattie, clearly fascinated by Mann's pictures, is also frightened by them, and that fear has to do with some sense of fair play that they threaten. Painted subjects are not real to us in the same way, and painters seldom contrast a subject's innocence to our knowledge. As a result, Beattie ties herself up in knots

13. Sally Mann, *At Twelve* (1988), p. 52. © Sally Mann, Courtesy Houk Friedman, New York.

trying to save the girls and the pictures. She says that some girls who posed unknowingly by a vagina-shaped scar in a tree "transcend their proximity to the tree in part because we *want* them to transcend it." [95] The problem is one of morality, an ethical proposition that those who pose, those who make themselves available to our view, becoming objects, be able to support the consequences of our thoughts upon that viewing. It is a piece of tremendous delicacy, this reasoning. But further, it is a question of whether we ourselves as viewers can face the disparity between our thoughts and theirs, our response and their intention.

Even more shockingly, can we accept the possibility that there is no such disparity, that our belief in it springs from a desperate fiction of innocence that we displace onto these children. "[T]hey are children, after all," says Beattie; "we still feel an urge to protect them. While for them looking into a camera lens is analogous to looking into a mirror, what they mirror for the viewer, with

their attitudes and their dead-on eye contact, is us. We are their mirror, they are ours." [96]

Instead of this subtle investigation of our attitudes to children's sexuality and to the meaning of our gaze, the subject of children' photography has been made virtually identical to that of pornography, exploitation, and assault. The law, as we saw before in the outrageous persecution of Jock Sturgis and Alice Sims, takes a much stricter view of the representation of naked children than it does of naked adults. In Ohio, where the Mapplethorpe trial occurred, a statute prohibits the possession or viewing of "any material or performance that shows a minor who is not the person's child or ward in a state of nudity" [97] without parental permission. When the parents of both the children Mapplethorpe photographed provided depositions indicating that the pictures were taken with their knowledge and consent, the charge of child-exploitation collapsed, despite the testimony of Judith Reisman, a "media expert" and former songwriter for *Captain Kangaroo,* that the display in museums of photographs of nude children could be used by sex-offenders to make other children cooperate.

Lawrence A. Stanley objects to such reasoning: "if the subjects depicted in nude photographs are in no way forced to pose nude and are in no way harmed by their interactions with the photographer, then what is in the mind of the photographer or the viewer is of no consequence. Moreover, [. . .] an indictment of a photograph on the basis of what a photographer or viewer thinks about that photograph could indict *all* images of children. . . . It is this attempt to control thoughts, rather than punish misdeeds, that is most chilling in the current climate." [98] Thoughts alone do not figure in a real world of injury, culpability, and punishment, in which gay photographers are not automatically child molesters.

The danger of the chilling effect Lawrence A. Stanley describes is not just that it attempts to control the thoughts of photographers. Sally Mann describes how her fears of prosecution for photographing her own children led her to refuse the publication of pictures in another collection, *Immediate Family.* Her children were very upset, worrying that she was ashamed of them. And when the *Wall Street Journal* published a nude photograph of one of them with black bars over her eyes, nipples, and genitals, the girl wrote the newspaper a letter saying "I don't like the way you crossed me out." [99] She then began covering herself up and for a while would not let her mother photograph her nude. This is both her loss and ours; puritanical censorship led to this child's shame at her own body and deprived the world of works that provoke thoughts we may need

to think. It is hard to believe that any of Mann's pictures could lead to child abuse, but they *could* lead viewers to think about their feelings on the subject.

Otherwise, we have the grim picture Mann annotates in *At Twelve* of a girl posing, buttoned up, with her relatives ranged suspiciously behind the camera to make sure that nothing improper happens (fig. 14). The image that results is the most disturbing in the whole collection. The girl stands before her barn, in parallel with the deer carcasses hanging from the ceiling. Mann describes her own nervousness at the censorious family. "As I pulled [the girl's] jacket back, to separate her white-shirted figure from the darkness of the shed, I thought I might have heard a murmur. After a few minutes I relaxed enough to identify the prevalence of the V shapes in the scene and without thinking I asked Kelly to spread her legs. This time the murmur was audible, but I could see that the picture was complete." [100] Despite Mann's intent, the presence of the moral

14. Sally Mann, *At Twelve* (1988), pp. 38–39. © Sally Mann, Courtesy Houk Friedman, New York.

watchdogs made her composing of the scene a symbolic victimization of a child "shot" by a photographer.

If we turn to Mapplethorpe's photographs we can see how he compounded these various sins against viewing. He has two shots of children with genitals on view, but the children are so young and the shots so seemingly spontaneous that it is hard to believe that these in themselves were the cause of all the trouble. Rather, Mapplethorpe marshaled all the frightening ambivalence photography could offer in his gay, sadomasochistic images.

In doing so, Mapplethorpe undercut Rudolf Arnheim's contrast between photography and painting. Mapplethorpe's images seem the antithesis of the accidental—obsessively controlled, shot inside in a studio, meticulously composed. They do not "capture a fleeting moment" so much as mimic or mock archetypal forms and classical poses—Vitruvian Man, Greek statuary, renaissance nudes (fig. 15). They do not stand as fragments or samples of a larger reality around them but as images complete in themselves, a centripetal world of art that seeks perfection, conquering reality in the name of art rather than documenting nature's factual imperfection. Mapplethorpe's work is timeless rather than marked by any temporality of its subject, and it constantly makes us aware that an artist has created it. His collages, sometimes three-dimensional, sometimes mirrored, make photographs into sculptures and incorporate the viewer in the work.[101] Far from a revolt against form, Mapplethorpe has created some of the most formalist art in the contemporary canon. In fact, most critics who dislike his work find it close to fashion photography and a hot-house aesthetics that seems precious and overdone at this point in aesthetic history. In all these respects, as Janet Kardon has written, "Mapplethorpe dissolved the boundaries between photographs, painting and sculptures. He made photographs not just a means of conveying visual information, but allowed it to achieve a monumentality we associate with paintings."[102]

The one respect in which Mapplethorpe's photographs do exploit what is most typical of the medium is his choice of low-life subjects. The sadomasochistic works are the prime example, but the lushness of all his images conveys some hint of transgression. It has been endlessly commented that Mapplethorpe's flowers (fig. 16) look like genitalia[103]—they *are* the genitalia of plants, after all—and that the formal beauty of his work is part of a program meant to show the sensuality of all experience.[104] These photographs are not merely an aesthete's art but a hedonist's art; they not only deliver pleasurable images but raise the spectre of unlimited pleasure.

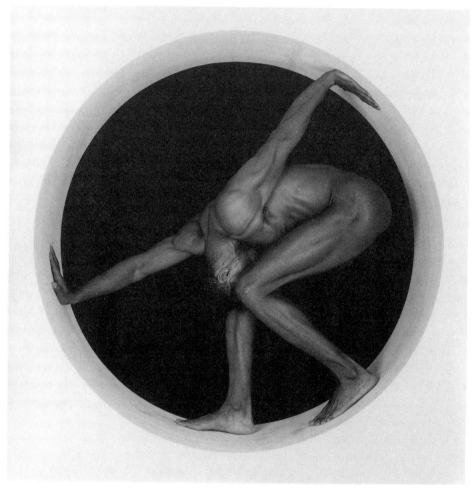

15. Robert Mapplethorpe, *Thomas in a Circle* (1987). © 1987, The Estate of Robert Mapplethorpe.

AND SO, WHAT IS ART?

If ever an audience inexperienced in art were to suffer a baptism by fire, it was the Mapplethorpe jury, who were presented with an extreme—and perhaps almost too obvious—challenge to viewing. Their vindication of Mapplethorpe's work as art, given the disorder of current aesthetic thinking, is either

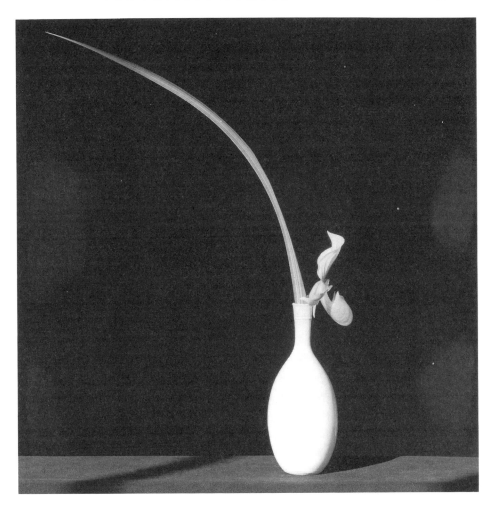

16. Robert Mapplethorpe, *Orchid* (1982), The Estate of Robert Mapplethorpe.

one of the miracles of contemporary culture or a triumph of the last lingering
shreds of authority among the experts. If one could only believe the conclusion
of the Cincinnati lawyer Edward Marks, that the outcome of the trial "shows
that human beings, even if drawn from a vacuum, who had never seen the ex-
hibit, who hadn't been to a museum in years and were about as homogenized a
jury as you can get, that they can learn something. They learned what art is." [105]

And what, according to the expert witnesses, is art? For Robert Sobieszek, curator of photographs for the Los Angeles County Museum of Art, a photograph is art if it is in a museum; "it's intended to be art, and that's why it's there." [106] The intention is presumably that of both the photographer and the curator, and so art becomes a proposition made by an artist (his *being* an artist is the proposition, in effect) and confirmed by an expert. After this proposition has been confirmed, the question is no longer, "Is this art?" but "Is this good art, or lasting art?"

Andy Grundberg calls this definition of art—if it is in an art museum it is art—a tautology, implying that it gets us nowhere. But the tautology is one of the primary strategies of modernism—for example, Duchamp's gesture of placing a urinal on display, which became art by being isolated from its normal context, put on view, and thus made comparable to other works of art. The idea here is that art is art not by virtue of its formal or thematic fineness but by virtue of the fact that someone—here, the artist—proposes to call it art. Compared to the urinal, Mapplethorpe's photographs, which make so many gestures toward recognizable aesthetic qualities of composition and lighting, seem a relatively easy proposition to accept. But the tautological argument always returns to the question of the expert's judgment. If you trust experts, then a work placed in a museum is art just by virtue of its being there. Otherwise, it may be a scam.

We have already seen that Janet Kardon claimed the Mapplethorpes were art because they had certain formal qualities that experts could recognize as artistic, regardless of the subject matter that was so formed. This, of course, is the justification for the authority of experts: that they have the experience, the training, and the sensitivity about formal issues to distinguish art from non-art. Interestingly, though, this is an issue having to do not with whether a photograph is art but whether it is good art. No photograph, just as no urinal, is without form. Moreover, all photographs are symbolic structures. Whether their form is innovative, especially pleasing, responsive to a tradition, or perfectly appropriate to their content may determine whether experts find them worthy of entering a museum. But the decision about worthiness is not ontological. Unworthy art is still art. Thus, the formal argument is a matter of quality, not ontology. The tautological argument which it supports turns out to be the same. The fact that a photograph ends up in a museum does not prove that it is a work of art, but rather that an expert thought it was a "good" work of art.

In other words, the jurors did not learn what makes art art, but rather what makes certain experts *like* Mapplethorpe's art enough to put it in an exhibition.

This may sound like hairsplitting, but it is a crucial distinction. The Mapplethorpe trial, because of the framing of obscenity law, made the question "what is art?" replace the question "why do we (or they) like this art?" And thus, the experts' partiality, their contextuality, their humanity were all elided into a true-false issue—art or non-art?—which obscured the real issues of the case.

The analogy between photograph and urinal works only up to a point, however. For though urinals are man-made, formed objects, they are not inherently symbolic structures. They do not represent anything, although they can always be made to do so. Photographs do represent, and as we have seen, they represent with a peculiarly strong reality claim. But not all photographs are art. Photographs serve many functions: as historical documents, ceremonial signs of authority, family records, commercial inducements, and art. Works of art may incidentally serve other functions, but insofar as they are art they must primarily serve as relatively self-contained symbolic structures with only a virtual relation to the world.

When Ms. Kardon found the photographs valuable for "portraying a part of the artist's life and society in the late 1970s, a moment in history that will probably never happen again,"[107] or when Martin Friedman defended them as reflections of the world we live in, or when Dennis Barrie found a tortured image "an excellent example of an artist working through these issues,"[108] they were not explaining what art was. They were explaining some of the things they liked Mapplethorpe's art for doing, or things they thought the jury would like it for doing. One of the jurors, James Jones, caught on to this way of talking when he said, "It surprised me completely that they did those kind of things [in the sadomasochistic photographs]. So that was an education in itself."[109] An artwork may educate us, but that education does not in itself make the work art. It may have a great deal to do, however, with some people's declaring it good or bad art. The Mapplethorpe trial was constantly portraying what was really a matter of ideological preference as the question, "Is this art?"

As the testimony piled up, the assortment of tasks that Mapplethorpe's five sadomasochistic photographs were said to perform became really impressive. They caused introspection; created a "tension between the physical beauty of the photograph and the brutal nature of what's going on in it";[110] and consti-

tuted a "healing diary." [111] And to their formal virtues were added others: the technical virtue of beautiful printing and high-quality paper and the historical virtue of belonging to a tradition of work by distinguished photographers. All of these are worthy traits, of course, but none is either definitional of art or unassailable as a criterion for good art. And all of them reinforce the puritanism that brought the museum to trial in the first place.

This puritanism led to some extraordinary claims in court. The CAC's director, Dennis Barrie, swore under oath that the works are "striking, not titillating." [112] This may well be the case for some viewers, but one cannot be sure that *no one* finds Mapplethorpe's images exciting. The jury was also reassured that the photos are a record of a peculiar moment in sexual history "that will probably never happen again." [113] This is a comforting claim, and certainly AIDS must have curbed the ubiquity of the wild homosexual behavior of the 1970s, but it is surprising that people as sophisticated as these experts would assume that gay sadomasochism has been utterly eradicated. This strategy turns sadomasochism into a kind of dodo, safely and educationally immured in art.

Over and over, the jurors heard that "Art is not always pleasing to our eyes. Art is to tell us something about ourselves and to make us look inside ourselves and to look at the world around us." [114] Or else they were told to judge the quality of the works by "look[ing] at them as abstract, which they are, essentially." [115] All these characterizations ignore the naughtiness, the wicked humor, the irony, the titillating contradictoriness, the perversity of these works of art. The photographs are camp and confrontational. They are rude. They put the viewer on the spot—Oh, you're so shocked, are you? Then why are you still looking? There is a pleasure in being shocked, in being ridiculed for one's conventionality, in looking at a piece of wit in which the absolutely most proscribed taboo is presented as formally pleasing.

I like all these provocations in Mapplethorpe's SM photographs, particularly the fact that he links them to classicism, that sacred cow of the traditionalists. Mapplethorpe reminds us that our most respectable model of beauty emerged in a society that loved the body, and that enacted on that body practices which many of us do not care to imagine. His photographs are thrilling not only because their classicized poses and compositions are very beautiful, but because they attach the poise and calm of classicism to an intense eroticism.

Perhaps most of all, I like Mapplethorpe's fearlessness in dramatizing his difference from me and from all those whose appetites have not led their bodies

such a chase. Mapplethorpe stands there, a self-proclaimed devil, and warrants my right to enjoy my own deviltries, cautious as they may be. I am not sure that the aesthetic pleasures he provides are my favorites—Rabelais is not always my cup of tea—but I would not deny them. The point is that everything that involves aesthetic judgment involves a personal revelation of preference, of pleasure, and Mapplethorpe's photographs—formalist masterpieces that shatter formalism—raise us to this realization.

We could explain the various preferences expressed during the trial, if we knew enough about the expert interpreters and were not afraid of being simplistic or intrusive. Thus, Janet Kardon would value Mapplethorpe's formal refinement perhaps because she was trained up in the heyday of modernist criticism. The poet Richard Howard would approve Mapplethorpe's photos as "emblems of contested morality," [116] because as a gay New Yorker he is interested in such contests. Elizabeth Friar Williams would value Mapplethorpe for revealing the strategy of the censor, "who, repressing his or her own 'unacceptable drives,' seeks powerful laws to insure that they will never be stirred by 'dirty' or 'perverse' erotic or aggressive stimuli," [117] because she is a psychotherapist concerned about the mental health of her society. And if one reads Camille Paglia's mytho-sexual-literary *Sexual Personae* one learns why she applauds Mapplethorpe's "beautiful decadence." [118] If one were gay or had AIDS, one would perhaps approve of Mapplethorpe for being among the first to take on the power to control his own representation. [119] And if one had the liberal taste and good sense of the critic Peter Schjeldahl, one might appreciate Mapplethorpe's art, indeed art in general, "as not only a refined pleasure but also an oracle of worldly change, a redeemer of all things debased, and a cosmopolitan communion." [120]

Mapplethorpe himself liked his sadomasochistic photos because "there was a feeling I could get looking at pornographic imagery that I thought had never been apparent in art. And I thought if I could somehow retain that feeling . . . if I could get that across and make an art statement, do it in a way that just kind of reached a certain kind of perfection, then I would be doing something that is uniquely my own." [121]

Paul Theroux explores this relation between interpretation and individual predilection in his novel *Chicago Loop*. His protagonist, Parker Jagoda, is a psychotic yuppie who puts personal ads in the papers to root out women who, as he sees it, are just asking for the degradation he gives them. He also enacts

fetishistic, sadomasochistic scenarios in hotels with his wife, who is a model and part of the Chicago art scene. They go to the Robert Mapplethorpe exhibition, and Parker is appalled. "He did not want to stop and examine these pictures. . . . it was naked men embracing, and naked men pointing, and naked men as silhouettes, and some hugging lamp-posts." Parker comes up with a raft of criticisms of the photographs—that they are reductive, contextless, unreal, sexual boasting, about victimization. " 'It's crap,' Parker said. 'And the people at this exhibition are just as bad. They're the kind of people who put personal ads in the paper saying they're interested in leather and watersports and could they please have an enema slave.' " [122]

Though Parker's ads are never so explicit, he comes closer to describing himself here than the rest of the gallery crowd. A photographer friend of Mapplethorpe's who is talking to Parker and his wife defends the pictures as realistic, beautiful, and not about victimization. "My pictures are about pleasure," he says. "Ditto Mapplethorpe." [123]

Parker is unconvinced. Soon after this, pursuing his cruel ways, he kills a woman he picks up by biting through her neck, becoming a "Chicago *loup*" in fact. When he realizes what he has done, he is filled with horror and remorse. To bring back his victim, he becomes her, making his wife brutalize him in one of their theatrical encounters in a hotel, and then dressing as a woman, walking the night streets of the Loop, a target for men. "He wanted real fear, real pain, the sense of being trapped and victimized by someone who was wolfish and unpredictable" (p. 109). He remembers Mapplethorpe's pictures, and realizes that they were about him. "Parker returned to the exhibition and saw the men in leather and the nudes and the slave collars and the bloody genitals and the swollen flesh, and it seemed to him now that the photographs had a dignity and a directness that he had not seen before. They had pathos, they had humour, they did not seem freakish; some seemed to Parker tragic." [124] Though one would not wish to go to such lengths in order to appreciate Robert Mapplethorpe's art, Theroux reveals my point with particular force: that artistic appreciation is a function of identity and experience.

But one need not literally become what an artwork represents in order to find it good. This is the great fear of fundamentalists who condemn "obscene art." They believe that appreciating it is *being* it, and they fear that the seductiveness of this art will transform them against their will. Even the most liberal of us have had this anxiety. Despite our knowing the difference between a story and reality, art and real life, we have at times been unwillingly "invaded" by

works of art. I remember seeing Liv Ullmann cut her labia with a piece of bro-
ken glass in Bergman's *Cries and Whispers,* and wishing that this image had not
been added to my imaginative store. The degradation scene in the film of John
Boorman's *Deliverance* is another I could have done without. But the first and
by far the most horrendous of such invasions came when I was eight years old
and watched the death camp episodes of *The World at War* on the family tele-
vision set. And this was reality. I have lived through all kinds of virtual horrors
without having my response to real-life tragedy blunted. The violence that I
have witnessed, the accidents, the death of loved ones, the desperate misfortu-
nes of the heart have shaken me more than the strongest artwork, and I am sure
that is the case for most people. We should not fear art either for corrupting our
reality or blunting it.

What art *can* do, and do very well, is show us the relation between what we
respond to and what we are, between our pleasure and our principles. As a
result, it inevitably relates us to other people whose pleasures and principles
either do or do not coincide with our own. Comparing one's pleasures with
others' makes one compare ideologies. That is one of the reasons why people
read reviews.

Conservatives understand this fact best. As Allen Wildmon, Reverend
Donald Wildmon's spokesman and brother, asserts, "The whole bottom line
here is, whose set of values is going to dominate in society? . . . Somebody's
values are going to dominate. Is it going to be a humanistic set of values, or a
Biblical set of values?" [125] I think it is time that experts publicly unveiled their
partisan assumptions, if they want to preserve a place for those much-maligned
humanistic values. It is time for the experts to explain not only what art is but
why they value it.

THE LITERALISM OF THE LEFT
FEAR OF FANTASY

Rap music is really rape music.

Sheila James Keuhl

True fetishes are the objectivized forms of our desire—this sentimental ambivalence, a tender sphinx which one nourishes always at the center of oneself.

Michel Leiris

The Mapplethorpe case has much to teach us about art. We might draw from it, in particular, two ideas that are central to this book. First, art is an inherently paradoxical phenomenon whose meaning is always open to varying interpretations. Second, those interpretations, though always socially and historically grounded, are also personal, proceeding from a primal yawp of pleasure. Critics are people licensed to express their pleasure, their desire, their values in public judgments of art, and they are licensed to do so not only because they are knowledgeable technicians but because their personal take on the world and on art is deemed useful by those who are not critics.

In the Mapplethorpe trial, the prosecution lost because it acted as if these two facts were not the case. It assumed that the photographs were unambiguous (that they would "speak for themselves") and that the usefulness and authority of arts professionals had been so thoroughly eroded by the "culture wars" that the jury would simply ignore the experts' opinions. In light of the shocking nature of the photographs and the inadequacy of some of the expert testimony, the defense's victory was little short of a miracle.

However, the current hostility to pornographic art like Mapplethorpe's cannot be explained simply through conservative fundamentalism. Leftists are exerting a similar pressure to take art as real-world speech, to see it as dangerously efficacious, and to condemn the experts who argue for its virtuality. Some

champions of the rights of women and minorities have been as eager to control art as Jesse Helms or Pat Buchanan.

In 1992, for example, Catharine MacKinnon and her law students forced the cancellation of an exhibition at the University of Michigan called *Porn' im'age'ry: Picturing Prostitutes,* because they considered it dangerous to women. The show contained photographs and installations by seven women artists, two of whom had been prostitutes. It was a feminist exhibition exploring an aspect of female experience. And yet MacKinnon, in her feminist zeal, saw fit to close it down.

It took people little time to connect MacKinnon's actions to the Ayatollah's *fatwa* and the Helms amendment. The organizer of the prostitution show, Carol Jacobsen, claimed that "MacKinnon's position is analogous to a right-wing fundamentalist who bans a book without reading it," [1] and David Mendoza, executive director of the National Campaign for Freedom of Expression, said that "the notion that art should be censored because some find it offensive is the position taken by Jesse Helms. For MacKinnon to condone this outrageous assault on the free expression of ideas . . . is a sorry example to set for students of the law." [2] One of the oddest developments in contemporary criticism is this unholy alliance between the far left and the far right.

If liberals are irritated by right-wing fundamentalists, they tend to be paralyzed by feminist and minority extremists who engage in such literalism. For the political aims of liberals and leftists—equal opportunity, the integration of all people into mainstream society, and the promotion of civility and respect—are the same. Moreover, all but the most formalistic critics believe that language and the arts do have some effect on reality. As Dave Hickey states, "*images can change the world*. I have seen it happen . . . so I know that images can alter the visual construction of the reality we all inhabit, can revise the expectations that we bring to it and the priorities that we impose upon it . . . can entail profound social and political ramifications." [3]

Recent scandals in American public life have reinforced this belief in the power of description. The Anita Hill–Clarence Thomas affair is a case in point. This controversy was experienced as a specifically verbal event. Thomas's offense was not a physical transgression "but a verbal one masked in pornographic language," says Paula Giddings. [4] It depended on Hill's word against Thomas's, and on the unspeakability of certain words, especially "race." "The word 'racist' and not the thing," says Claudia Brodsky Lacour, "the potential verbal weapon and not the actual injustice it signifies, was the object of concern." [5]

The focus on language turns clichés and stereotypes into weapons. In *Race-ing Justice, En-gendering Power,* Toni Morrison claims that the racial stereotypes evoked during the Senate hearings determined Thomas's "victory." The two traditional images of American blacks, she says, are the harmless, servile guardian and the dangerous, sexual subversive. As the Senate committee and the television audience tried to pick which cliché to assign to Hill and Thomas, Thomas complained that they were "lynching" him. By introducing this metaphor, he figured himself as a racial victim and Hill as a racial traitor, and the outcome after that was predictable.[6] Morrison's explanation is meant to correct the impression that the Hill-Thomas scandal was a matter of American puritanism about sex. What she gives us instead is an image of America as a land of puritan "readers," a nation of literalist decoders, swayed by the overwhelming power of images, beset and besotted by the Word.

The idea that reforming stereotypes will reform reality is a constant refrain in feminist discussions of rape. Typical examples are Helen Benedict's *Virgin or Vamp,* an analysis of the press's coverage of rape cases, and Gregory M. Matoesian's *Reproducing Rape,* a sociolinguistic study of rape trials. The prevalence of the crime and the fact that less than 5 percent of rapists are believed to be clinically psychotic during assault provide the grounds for a feminist account of sexual assault: that "male violence constitutes a socially structured mode of domination in which rape and the fear of rape produce and reproduce patriarchal social organization—sustaining female subordination to males."[7]

The next step in the argument is most famously made in the work of Catharine MacKinnon and her co-polemicist, Andrea Dworkin. They and an army of feminist journalists, artists, and scholars blame art, the media, and language itself for reinforcing the patriarchal ideology promoting rape. "Rape and sexual violence against women are reproduced and legitimated through culturally mediated interpretative devices which justify, excuse, and glorify male violence against females," writes Gregory M. Matoesian; "patriarchal myths severely constrain the contextual discovery and reporting of rape by blaming the victim, by limiting our perception of rape to 'real' rapes, that is, to the cultural stereotype of the rapist as a violent stranger jumping out of the bushes and attacking a woman, and by rationalizing rape through culturally approved sexual scripts which define males as aggressive and females as passive." Matoesian even claims that the defense's cross-examination is a symbolic reenactment of the rape itself: "Trial talk is the incarnation of rape."[8]

The same myths, according to Benedict, determine the way newspapers

cover rape. Since most crime reporters and editors are men, rape is presented to the public from an overwhelmingly "male perspective." Benedict cites as typical the *New York Post* reporter Bill Hoffman's comment on the Jennifer Levin case: "It was sex, tits and ass, and a strangling—we knew it would sell." [9] With such attitudes abroad, many feminist polemics turn into attacks on clichés as such. Get the clichés and you get the crime. (It is perhaps useless to observe that "patriarchy" is as offensively oversimplified a cliché as "virgin" or "vamp.")

As with rightist fundamentalism, the critique of patriarchy depends on the equation of words and deeds. "The analysis of ideology is fundamentally concerned with *language*," Matoesian claims, "for language is the principal medium of meaning (signification) which serves to sustain relations of domination. . . . 'Language is not only an instrument of communication or even of knowledge,' writes [Pierre] Bourdieu, 'but also an instrument of power. One seeks not only to be understood but also to be believed, obeyed, respected, distinguished.' " [10]

One may seek to be believed through language, but surely one's success is not thereby preordained. Language and other modes of representation do not guarantee prejudice against women, and though some usages manifest patriarchal attitudes, the disappearance of these usages would not eradicate the injustice, violence, and inequality women suffer. It is surely a sign of the powerlessness people now feel—after so much equal-rights activism and legislation have still not rid America of sexism (or racism)—that the attack has switched to a critique of language.

Still, there is hardly an academic who has not adjusted his or her language with the aim of promoting social justice. Ever since the 1960s, when feminists such as Adrienne Rich proclaimed that English enshrined patriarchal beliefs in its use of the masculine pronoun for the general case, we have been dutifully using "his or her" in order to "disempower patriarchy." Our phrasing is clumsy, the linguistic reasoning behind it we know to be fallacious, and it is all too clear, as Barbara Ehrenreich reminds us, that "verbal uplift is not the revolution." [11] Yet we go on inserting our "diversity pronouns" and accepting whatever term for African-American has been certified nonracist this year because of a desire to signify good intent, to act out justice, to compensate for past harm.

The reform of language is a gesture of civility, but civility—good manners—is almost always a mask or mitigation for some inequality. The man who calls a female a "woman" rather than a "lady" is, just like his forefathers who used that now proscribed word, making it easier for her to open a heavy door. To believe that in the process women's actual strength increases is to be fatuous.

Hence Robert Hughes can scoff, "the usual American response to inequality is to rename it, in the hope that it will then go away. . . . We want to create a sort of linguistic Lourdes, where evil and misfortune are dispelled by a dip in the waters of euphemism." [12]

But some changes in representation have undoubtedly altered reality. History and fiction by and about women have given women a new understanding of themselves as individuals and as a group. The practical effects, in terms of new career choices, self-presentation, and self-assertiveness are hard to estimate, but few would be willing to argue that the changed representation of women is important within the representational sphere alone.

Scores of recent novels, from Alice Walker's *The Color Purple* to Gloria Naylor's *Linden Hills,* depict this process of change. They imply a realm of "social reality"—attitudes, stereotypes, ideology—lying somewhere between fiction and the material world, that is instrumental in empirical reality. We can see this notion at work in Catharine MacKinnon's definition of feminism as the "belief that women are human beings in truth but not in social reality." [13] By changing "social reality," the theory goes, one will change the material facts of women's existence.

For conventional liberals, this hypothesis is at best dubious. As MacKinnon argues, "Liberal morality cannot deal with illusions that constitute reality because its theory of reality, lacking a substantive critique of the distribution of social power, cannot get behind the empirical world, truth by correspondence." [14] A liberal might recast the problem as MacKinnon's: a naive nominalism on her part and an illogical account of causality.

The Case Against Pornography

The clash between liberal and feminist, subdued when it comes to language reform and the recovery of women's history, explodes on the issue of pornography. And it is here that liberals who may consider themselves feminists are brought up short by the very reasoning that led them to cooperate in the reform of "patriarchal" language and historiography. Pornography is a fictive rather than instrumental use of language, they claim, and aesthetic representation is not the same as action. But for many feminists this is a meaningless distinction. MacKinnon and Dworkin argue, on the contrary, that pornography directly causes women (and some men) physical harm. On this basis, they come up squarely against what MacKinnon calls "that First Amendment bog, the distinction between speech and conduct." [15]

Pornography is a genre of fiction often protected under the First Amendment, but it would not be protected if anyone could demonstrate that it causes physical harm or interferes with the rights and freedoms of individuals. The Lockheart Commission, set up by Richard Nixon to establish just this causality, was unable to do so. It reported in 1970 that "extensive empirical investigation, both by the Commission and by others, provided no evidence that exposure to or use of explicit sexual materials plays a significant role in the causation of social or individual harms such as crime, delinquency, sexual or nonsexual deviancy or severe emotional disturbances. . . . [In fact,] sex offenders have seen markedly *less* of such materials while maturing." [16] The commission called for the repeal of all legal restrictions on obscene materials, with the result that Nixon ignored its findings altogether. Perhaps with this history in mind, the Meese Commission, reporting to President Reagan in 1986, asserted that although it had also been unable to establish a definitive connection between pornography and antisocial behavior, it believed this connection to be indisputable. [17]

The Meese Commission, of course, is not alone in this belief. It is a cultural cliché. At a Unesco conference on the sex trade and human rights held in Brussels in 1993, "The experts . . . pointed to pornography, peep shows, 'sex tours' and other products of the multibillion-dollar sex industry, which they said have normalized the open buying and selling of sex and have eroded taboos against sexual exploitation of children." [18] Nevertheless, Carole Vance, a sociologist who is an expert on the pornography debate, reports that *no* research has thus far been able to establish a scientifically compelling connection between pornography and violence against women, and that blaming pornography for rape or child abuse makes as much sense as holding films like *Bonnie and Clyde* responsible for bank robbery. [19]

In order to maintain her position against these uncooperative data, Catharine MacKinnon has been forced to attack the very idea of causality. As she explains, "the view became that pornography must cause harm like [*sic*] negligence causes car accidents or its effects are not cognizable as harm. The trouble with this individuated, atomistic, linear, isolated, tort-like—in a word, positivistic—conception of injury is that the way pornography targets and defines women for abuse and discrimination does not work like this. It does hurt individuals, just not *as* individuals in a one-at-a-time sense, but as members of the group 'women.'" [20] In this statement, we can see the thinking that makes stereotypes such an urgent area of concern.

According to the anti-pornographers, pornography's "causality" works as follows. Pornography presents women subordinated, degraded, and brutalized. "Pornography, like rape," says Susan Brownmiller, "is a male invention, designed to dehumanize women, to reduce the female to an object of sexual access."[21] The word "pornography" in fact becomes an active verb: in the film *Deep Throat,* Linda Marciano (a.k.a. Linda Lovelace) was "pornographed."[22]

In MacKinnon's definition, pornography is "the sexually explicit subordination of women through pictures or words that also includes women presented dehumanized as sexual objects who enjoy pain, humiliation, or rape; women bound, mutilated, dismembered, or tortured, women in postures of servility or submission or display; women being penetrated by objects or animals." Further, MacKinnon and Dworkin argue that any sexuality, never mind any representation of it, is degrading to women. "[T]he possible varieties of interpersonal engagement [in sex], including the pleasure of sensation or the experience of intimacy, does not, things being as they are, make sex empowering for women." The sexual liberation of women, they find, is a male plot to make women more accessible for sex,[23] and Dworkin, in her book *Intercourse,* goes so far as to argue that all intercourse is rape.

The reactions to this position have been predictably hostile. Robert Hughes states that "such grotesquely expanded views of criminal assault reduce women to victims without free will, deprived equally of the power of assent or of denial, mere dolls tossed around in the ideological flurries of feminist extremism."[24] And Carole Vance, situated more than Hughes within the ethos of feminism, objects that "Sexuality is simultaneously a domain of restriction, repression and danger as well as a domain of exploration, pleasure and agency. . . . to speak only of sexual violence and oppression ignores women's experience with sexual agency and choice and unwittingly increases the sexual terror and despair in which women live."[25]

The anti-pornography movement aims at reforming representation to create a sphere of female equality. In such thinking, if women are never *shown* as raped or sexually exploited, they will never *be* raped or exploited. Symbolic reform, presented this way, seems hopelessly fatuous, but it is easy enough to account for the reasoning behind it. Vast industries in America operate under just such assumptions—most notably, advertising and politics. Considering that "reality" in the spheres of consumerism and government is largely a matter of the manipulation of images, it is not surprising that feminists should argue for the improvement of women's condition through image-management.

Accordingly, Susan Kappeler claims that pornography is not just a passive mirror of sexuality, but a creator of it. "Sex and sexual practices do not just exist out there, waiting to be represented; rather, there is a dialectical relationship between representational practices which construct sexuality, and actual sexual practices, each informing the other. . . . Representations are not just a matter of mirrors, reflections, key holes. . . . they have a continued existence in reality as objects of exchange; they have a genesis in material production." [26] MacKinnon argues that "the experience of sex in pictures and words is an experience of sex," and, in fact, that all sex is a matter of symbolism, for "sex in life is no less mediated than it is in art. Men have sex with their image of a woman. It is not that life and art imitate each other; in this sexuality, they *are* each other." [27] "Pornography is not imagery in some relation to a reality elsewhere constructed. It is not a distortion, reflection, projection, expression, fantasy, representation or symbol either. It is sexual reality. . . . Gender is what gender means. It has no basis in anything other than the social reality its hegemony constructs." [28] In this nominalist ethos, "rap music is really rape music." [29]

Nothing could be further from the classic defense of pornography, that representation causes no danger because it mimics reality, rather than creating it. The title of Edward de Grazia's study of pornography cases, *Girls Lean Back Everywhere,* comes from just such a justification of sexual representation, and was formulated by a woman: Jane Heap, the editor of *The Little Review.* Heap was brought to trial for publishing the Nausicaa chapter of *Ulysses,* in which a young woman displays her drawers to the masturbating Leopold Bloom. "Girls lean back everywhere," Heap stated in her defense, "showing lace and silk stockings; wear low-cut sleeveless blouses everywhere . . . and no one is corrupted." [30]

But for the likes of Dworkin and MacKinnon, this argument misses the point. Reality needs to be changed, not imitated. The advancement of women's rights depends on men not thinking of women as sexual objects, and women not thinking of themselves this way either. True children of the advertising era, they believe that representation will reform thought. Rather than trying to alter behavior directly, anti-pornographers go after its symbolic representation in visual and verbal art.

Pornography has always presented a special problem in the differentiation of art from reality, since its effects are not the "ideal stasis" or hypostasized "disinterested interest" of high art, but, at least in part, an actual physiological response. In *A Portrait of the Artist as a Young Man,* for instance, Stephen Dae-

dalus contrasts the equilibrium of aesthetic experience to the desire evoked by pornography; laboratory studies test for the effects of violence in pornography by counting erections. In this respect at least, it is not trivial to say, as Mac-Kinnon does, that pornography "is a sexual reality." [31]

But if we consider that laughing, crying, screaming, and accelerated heart-rate are all "real" effects produced by art, pornography ceases to be a special case. And there is no indication that such physiological responses to art produce any predictable reactions after the viewing or reading is over. It is perhaps the particular physiological effect of pornography—sexual excitement—that offends the anti-pornographers. We can only speculate as to why they find pornography dangerous enough to outlaw, while ignoring the provocation of clothes or cosmetics.

Anti-pornographers point out in their defense that the prurience of pornography depends on inequality, that pornography exploits social injustice. It makes inequality into sex, says MacKinnon, sexualizing racial hatred and showing orgasm as a response to bigotry. It is thus an instruction manual for oppression and a diagram for female degradation, as an abused woman testified in the Minneapolis hearings for MacKinnon and Dworkin's anti-pornography ordinance. Not only does pornography associate inequality with the gratification of sexual desire, but it actually promotes that inequality. "Women in our hearings testified to the use of pornography to break their self-esteem, to train them to sexual submission, to season them to forced sex, to intimidate them out of job opportunities, to blackmail them into prostitution and keep them there, to terrorize them and humiliate them into sexual compliance, and to silence their dissent. We heard testimony that it takes coercion to make pornography." [32]

This final point, that photographic and cinematic pornography involve real women who are "forced," in MacKinnon's view, either through physical or economic "coercion," to become pornographic models or actresses, is the strongest claim for the fluidity of the distinction between fiction and reality in pornography. Unlike pornographic writing or painting, the camera arts demand actual women (and men) and actual sex. In the famous case of *Deep Throat,* the cornerstone of MacKinnon and Dworkin's crusade against pornography, the filmmakers allegedly used drugs and hypnosis to coerce Lovelace into performing physically injurious acts.

In this respect, pornography reveals, yet again, the special position of photography among the other arts. Even the anti-pornography Meese report exempted the printed word from prosecution, on the grounds that books require

thought whereas pictures evoke a "reflexive reaction."[33] But not just any pictures evidently produce this reaction. Anti-pornographers seldom complain about the content of paintings and sculptures, which involve enough child nudity and heterosexual and homosexual lubricity to keep a world of "perverts" and masturbators entertained. Not just the visuality but the actuality of the photographic subject makes the camera arts the prime target of anti-pornographic activism.

We have already seen that the physical presence of the photographic subject is an integral part of the meaning of photographs by Mapplethorpe, Mann, and Serrano. In Mapplethorpe's self-portrait with the bullwhip, the fact that the subject is the actual photographer looking at his viewers is crucial. Part of the meaning of Serrano's Ku Klux Klan series (fig. 17) is that Imperial Wizards stood in full regalia before a photographer of color. With Sally Mann's photographs, her and our understanding of her children's poses is unbearably strained by the fact that *they* had an understanding of the poses, too. Their reality as people contends with their representation as subjects.

With such cases in mind, who would deny that the real ejaculations in pornographic movies complicate the distinction between simulated and real intercourse, acting and prostitution, or fiction making and pimping or rape? When Dworkin and MacKinnon insist that pornography is an eight-billion-dollar-a-year industry in which rape, battery, and sexual harassment are performed for gain,[34] the word "performed" appropriately compresses the meanings of "represented" and "made real."

It is one thing to argue that a model or actress was coerced into sex, however, and quite another to claim that the resulting pornography *causes* rape. The first allegation falls within existing legislation against assault; the second concerns the representational sphere covered by the First Amendment. Fired with indignation at what they consider a masquerade of crime in "speech," Dworkin and MacKinnon have not hesitated to advocate the limitation of expression. They have proposed legislation which was passed and then overturned in Indianapolis, Minneapolis, Cambridge (Mass.), Los Angeles, and Bellingham (Wash.), called the Act to Protect the Civil Rights of Women and Children. On the one hand, this ordinance would permit suits against producers of pornography who force a person to appear or who use the person's image or name without consent. On the other, it would allow an assault victim to sue a producer of pornography whose product "caused" her to be attacked. In 1992, MacKinnon proposed a similar Pornography Victims' Compensation Act to

17. Andres Serrano, *Klansman (Great Titan of the Invisible Empire)* (1990). Cibachrome, silicone, Plexiglas, wood frame. Private Collection. Courtesy Paula Cooper Gallery.

Congress in which the victim of sexual assault could recover damages against the producer or distributor of pornography which had "caused" the assault.

Carole Vance compared the Pornography Victims' Compensation Act to holding the publishers of *Das Kapital* liable for strike-related violence, and Leanne Katz, executive director of the National Coalition against Censorship, held that "The central theory, that there should be a legal cause of action for what is 'caused' by exposure to ideas, is a truly terrifying prospect. . . . It negates all that we know about the complexity and ambiguity of the human animal, and all that we love about the complexity of visual images and the written word. . . . If [a criminal] says the video made him do it, and we believe it, we're as psychotic as he is. To make someone else responsible disregards his personal responsibility for his acts, and permits the demonizing, eventually, of art and information and entertainment."[35] Robert Hughes deplores this dispersal of personal responsibility and the corollary belief that we are the victims of commercial and ideological forces. This "maudlin narcissism" and "cultural triviality" are the subjects of his scathing critique in *Culture of Complaint.*

A LITERALIST FICTION

Hughes's words are harsh, but not nearly as harsh as the ones Andrea Dworkin writes in her novel *Mercy.* For Dworkin depicts female experience as one continuous male assault, in which violent pornography is not just documentary realism but reality as such. In taking this position, she might seem to belong among a host of postmodern authors—Norman Mailer, Philip Roth, Truman Capote, to name just a few—who interweave fact and fiction so thoroughly as to stupefy the positivist reader. The aim of these writers is to show that the distinction between art and life is ambiguous, that we understand reality through fictive tropes, and that a great value of art lies in instructing us in this paradox. But Dworkin's novel is quite a different matter. Far from postmodern undecidability, it indulges in a shocking and ultimately self-subversive literalism.

Dworkin, who describes herself as "a woman determined to destroy the pornography industry,"[36] argues that the free-speech defense of pornography supports the right of those who have money—pornographers and their audience—to "buy speech," over the rights of women both in pornography and outside it who have been "disenfranchised from the system."[37] Accordingly, in *Mercy* she gives voice to the disenfranchised, creating a character, like herself,

called Andrea, who tells us the story of her life. *Mercy* is a *Bildungsroman* explaining why Andrea now kills men.

"I was born in 1946," she says, "after Auschwitz, after the bomb, I never wanted to kill, I had an abhorrence for killing but it was raped from me, raped from my brain; obliterated, like freedom. I'm a veteran of Birkenau and Massada and deep throat, uncounted rapes, thousands of men, I'm twenty-seven, I don't sleep." [38] Brutally attacked and cruelly disillusioned in each of the novel's eleven chapters, Andrea goes from a child raised among liberal Jews in Camden, N.J., to an alcoholic bag lady who kills bums as they sleep in the streets of New York. *Mercy* is a monologue that almost makes her deviance seem normal; its voice speaks *in extremis* out of a pain so compelling that patience and reason appear obscenely insensitive responses. Andrea's experience is meant to stand as that of all women and to constitute an unassailable argument against the attempt to coexist peaceably with men.

Bracketing Andrea's monologue are a short prologue and epilogue, each called "Not Andrea," in which feminist voices express the very calm and temperance that Andrea's pain invalidates. "As a woman of letters, I fight for my kind, for women, for freedom," says the speaker in the prologue. "The brazen scream distracts. The wild harridans are not persuasive. . . . I will not shout. This is *not* the ovens" (p. 3).

This moderate point of view gets short shrift in *Mercy.* For Dworkin's book denies measure, denies the difference between the metaphorical and the literal. In *Mercy,* women's experience *is* the ovens; women *are* the mass suicides of Massada. Andrea is not a persona or a character but Dworkin herself; art *is* life. Pornography is evil because it condones and incites the rape of women. Representation is power. All men's behavior toward women is finally rape: "your heartbeat and his heartbeat can be the same heartbeat and it's still cunt" (p. 224).

This degradation, for Dworkin, is inevitable, however women may strive against it: "My mother named me Andrea. It means manhood or courage. It means not-cunt. . . . This one's someone, she probably had in mind; a wish; a hope; let her, let her, something. . . . Don't, not with this one. Just let this one through. Just don't do it to this one. She wrote: not-cunt, a fiction, and it failed. . . . My mama showed that fiction was delusion, hallucination, it was a long, deranged lie designed to last past your own lifetime" (pp. 225–26). Men's fictions of bondage and rape are the truth; women's fictions of liberation and equality are lies. Representation is power only if you are a man.

But *Mercy* itself is meant to provide a new representational strategy. Andrea's language is lyrical and passionate—a cross between the repetition of the early Gertrude Stein and, ironically, the unfettered flights of Henry Miller. She describes sexual violence in graphic terms, risking the prurience of the pornography she deplores. But unlike any anti-pornography that I know, *Mercy* defeats prurience. It is to pornography what aversion therapy is to rape. The titillating language of violation—"one hand's holding my neck from behind and the other's pulling off my T-shirt, pulling it half off, ripping it" (p. 207)—becomes noxious with Andrea's terror and pain and the inhuman viciousness and betrayal of the men she has trusted. Her stylistic breathlessness—repetition, rhythm, loss of control—conveys not rising passion but the desperate need to have the violence end. For "terror ain't esthetic. It don't work itself out in perfect details picked by an elegant intelligence and organized so a voyeur can follow it" (p. 160).

Andrea writes to change reality: "I have to be the writer [my mother] tried to be—Andrea; not-cunt—only I have to do it so it ain't a lie. . . . [I'm] just going to bleed all over you and you are going to have to find the words to describe the stain, a stain as big as [my] real life, boy; a big, nasty stain; a stain all over you, all the blood you ever spilled; that's the esthetic dimension" (p. 232). In this way, Andrea says, she is giving men the choice to be human or not, and turning women's weakness and loss into gain: "the less, the more, you see, is the basic principle, it's like psychological jujitsu except applied to politics through a shocking esthetic" (p. 236).

The ambition, the verbal brilliance in this "shocking esthetic" are profoundly affecting, and the repulsiveness of the "Not Andrea" voice in the epilogue is the great scandal of our time—reason's inability to offer an acceptable answer to the pain that everywhere surrounds us. This weakness is almost the undoing of liberalism: in the Mapplethorpe debacle and Salman Rushdie's collision with Islam, in the sordid mess of the political correctness debate, in the failure of communication between feminists inside the system and those outside it. "You have a right to hate liberals," says Andrea; "they make promises they cannot keep. They make you believe certain things are possible: dignity in the world, and freedom; but especially equality" (p. 167).

But surely the logical response to this situation is to work harder on behalf of liberal principles rather than to give them up. Dworkin's argument may be moving, but it is also intolerant, simplistic, and often just as brutal as what it

protests. For Andrea advocates nothing short of killing men. The last chapter ends: "I went out; at night; to smash a man's face in; I declared war. My *nom de guerre* is Andrea One; I am reliably told there are many more; girls named courage who are ready to kill" (p. 333).

One cannot take refuge here in the liberal position that statements in literature are not equivalent to statements in the real world. Dworkin has erased the boundary between the two spheres, declaring the distinction a male trick to justify pornography and rape. If her book cannot be absolved of murderous intent through special pleading—the invocation of that very magic circle around art that she has worked so hard to deny—we must accept that we are reading a political manifesto justifying and inciting illegal acts. We are caught in a bind. We must either deplore Dworkin's duplicity, which would be unfeeling, or consider her a criminal, which would mean that we were assenting to a literalism that is the undoing of liberal aesthetics.

If the anti-pornography thesis requires full responsibility for speech, it is wise to consider whether Dworkin and MacKinnon themselves exercise this responsibility. Here political critique blends into literary or rhetorical criticism, I am afraid, and in this respect, both writers give me pause. Dworkin's Andrea is an extremely unstable protagonist/narrator, shifting levels of literacy from slum child to educated bourgeoise at the drop of a hat. Andrea's believability, the reasonableness of her response in each case of rape and degradation, and her degree of responsibility each time are questionable. We might try to account for her variability by imagining Andrea as a composite woman—a series of lives fused into one to represent the female condition. But if so, this fictional generalization is hard to reconcile with the demand that we take Andrea's experiences each time literally and attribute them to their author. (Dworkin has stated in interviews that various episodes are, in fact, autobiographical.)

With MacKinnon, the question of verbal control is even more urgent. Her prose is laced with rhetorical excesses presented as simple fact. *Playboy,* she writes, "takes a woman and makes her sexuality into something any man who wants to can buy and hold in his hand for three dollars and fifty cents." Or, "pornography terrorizes women into silence."[39] MacKinnon pounds us with these metaphors, as if repetition alone will turn them into literal truth. But the fact remains that the *Playboy* reader is holding only a representation in his hands, and that people—not dirty magazines—terrorize women. If MacKinnon is going to posit a world in which representation is literally efficacious

and therefore in need of regulation, then she and the others who will be doing that regulating must be very skilled indeed. Otherwise, they will condemn the wrong representations and unwittingly loose "harmful meanings" into the world themselves.

In saying this, I am, of course, speaking partly in MacKinnon's voice, since I am suspicious of such fundamentalist turns of speech as "harmful meanings." Walter Kendrick describes the mentality that underlies them as "the old fear that representations direct our lives in ways we cannot govern or even understand. . . . [N]othing much has changed between Plato in the fourth century B.C. and the Women Against Pornography more than two thousand years later." [40] The fear of words and fantasies is rampant in leftist and rightist circles alike—a fear of the ungovernability of ambiguity, of the fearsome paths one might travel because of the free-floating signifier or the unanchored dream.

The damage to artists and to the public that can arise from this fear is apparent in the case of Eli Langer. Langer is a Canadian painter in his twenties, whose first show became a test for Bill C-128, a 1993 child pornography law inspired by the MacKinnon-Dworkin campaign. Without having used children or even photographs as models, Langer pictures imaginary children in various states of dress and undress, often looking threatened or fearful. Some are alone; some are with an adult; but none is overtly engaged in sex. The most explicit of the paintings shows a nude girl sitting on a man's chest.

However, according to Bill C-128, no one under the age of eighteen can be represented nude or in a sexual posture, whether in art or not. Accordingly, in 1994, Langer's works were confiscated by the Toronto police and put on trial for obscenity, with the possibility that they could be destroyed if found to be in violation of the law. Bill C-128, we should note, obtains in a country in which the age of legal consent for sex is fourteen. Here the *representation* of sex involving fourteen-year-olds is a crime when the *act* of sex involving them is not. Some of Langer's figures are younger than fourteen, to be sure, but in the overall framing of the law, fear of fantasy has swamped common sense.

Thus, artists work nowadays in a climate of literalist hysteria on the part of political conservatives and reformers alike. Under the circumstances, it is necessary to remind ourselves of certain aesthetic principles obvious to anyone who has experienced art, but so often assaulted these days that they require restatement. First, art is inherently paradoxical in its mode of signifying, and second, out of this paradox arises its unique value and pleasure.

AESTHETIC PARADOX

Art is different from events and statements in extra-aesthetic reality. Its meaning is invariably complex and ambiguous, and this is so because art refers to reality by resembling it. A Degas painting of a ballet dancer, for example, looks to some degree like a ballet dancer, and *War and Peace* is to some degree like our experience of political and domestic life. Though abstract painting may look very little like reality, even the most extreme examples still evoke some image of a visual field. A super-realist canvas, in contrast, may look very much like reality, but it is still a flat surface covered with paint and hence not that reality at all. Art evokes reality by being like it but not identical to it.

In semiotics, a sign that resembles what it represents is called an "icon," and the special feature of an icon is that it also signifies itself.[41] For it shares, through resemblance, some traits with whatever it signifies. Art is therefore a sign that points both outside itself and toward itself.

Insofar as art refers to a similar reality, one can easily confuse it with that reality. But as Magritte shows in his famous painting of a pipe with the words "Ceci n'est pas une pipe," there is always a difference between a painted pipe and a real one, between art and its extra-artistic meanings. Even the words in Magritte's painting are not identical to the same words used in a real situation. For the self-referential side of the aesthetic paradox "infects" art's relation to reality. The word "Ceci" ("This"), for example, though directly under a painted pipe, refers not only to that painted pipe but to itself as a word, to real pipes, to the painting as a whole, and to the encounter the viewer has with the painting. This interference and complication in reference create art's self-enclosure—the "magic circle" around the artwork that produces an intensity and breadth and over-determination of meaning seldom found elsewhere.

Because art acts both as a sign of reality and as a self-contained entity, it creates a confusion between meaning and being and has a necessarily ambiguous relation to the extra-artistic world. It appears to provide a particularly intense experience of reality while not belonging to that reality in a straightforward manner. This virtuality in art is essential, no matter how much a given work may tend to diminish one side of the paradox or the other. It accounts for the "power" of good art to make us think and feel intensely, and perhaps to reconsider our understanding of the world in the process. A good deal of our pleasure (and displeasure) in art results from this experience of virtual power.

But whatever effect art has, it never has literal control. However much we may give ourselves up to art or be moved by it, we can always withdraw our-

selves from it, too, because it is only a virtual experience of power. We must never lose sight of this fact. The scandals examined in this book all involve someone collapsing the doubleness of aesthetic reference, taking art as identical to reality, and its power as identical to coercion.

I hasten to add, however, that the possibility of this error is an essential part of the experience of art. Being moved by art means having real reactions to unreal events; art would be of little importance otherwise. Artists glory in this knife-edge between the artificial and the existential, finding ever new ways to narrow the divide.

As a result, however troublesome aesthetic paradoxes have become in our day, there is nothing new about the ambiguity between sign and thing or meaning and being in culture. John Milton, for one, shows how easy it is to trip over these contradictions. In the *Areopagitica,* he claims that the realm of books and ideas is utterly distinct from the realm of commodities and possessions: "truth and understanding are not such wares as to be monopolised and traded in by tickets and statutes and standards." But just a few pages later, he speaks of "the importation of our richest Merchandise, Truth."[42] "Property" itself contained this contradiction as the seventeenth century wore on, with Locke defining it as people's "life, liberty, and estate."[43]

As the "Age of Mercantilism" proceeded, international trade encouraged this confusion. Ships transported exotic objects from all over the world to the great European centers, lifting them out of their contexts of origin and, in the process, transforming them into objects of exchange. Wealthy collectors then bought them and assembled them in their curio cabinets, the ancestors of the modern museum.[44] The economic value of curios increased through their displacement, and their meaning shifted drastically as well, as they became regarded as "priceless treasures." Whatever their individual function and significance may have been in their place of origin, they now lay beside each other on silk or velvet cushions—"precious" and "beautiful" in their own right.

The legacy of this transformation is our museum culture, which, like every other area of aesthetics, is currently the center of controversy. Movements are afoot everywhere to undo the vast commerce in cultural objects, to repatriate art and heal the wounds in national identity caused by its removal.

The peculiar status of art is reflected in the law. The Riga Treaty of March 12, 1921, ending the war between Russia and Poland "gave formal recognition to two principles, first, that 'works of art,' however they are defined, may be subject to different rules from other kinds of property, and second, that removal

of such objects, even under the authority of what was at the time a legitimate government, may not give the new owners good title." [45] What kind of property is it whose ownership is not subject to the contracts of purchase and sale? According to the Unesco Intergovernmental Committee for the Return or Restitution of Cultural Property, the removal of national art is "la privation d'un avoir qui est une privation d'être." [46] Art collapses property and identity, having and being. It is both a commodity and an object beyond price. It is valuable both "in itself" and as an expression of the culture that produced it.

The Elgin Marbles are perhaps the most famous example of such a dualism. The conflicting status of the Marbles as national symbol and isolated art commodity is reflected in their two physical configurations. Originally, they encircled the Parthenon, forming a convex, outward-directed adornment, a mythological representation of the military triumph of the Athenians (fig. 18). In the British Museum, they have become concave, directed inward, enshrined within walls rather than surrounding a shrine, protected now rather than exposed (fig. 19). Transformed from a glorification of national identity to a national glory, the Marbles change their shape to signal art's paradoxes.[47]

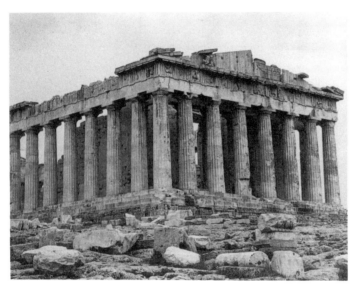

18. The Parthenon.

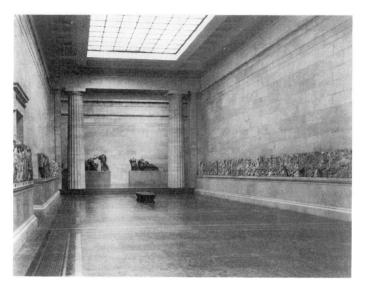

19. Elgin Marbles in the British Museum. © The British Museum.

In our day, both critics and the general public have become suspicious of theories that value art as an object independent of its referential context. We saw, for example, how Janet Kardon's defense of Mapplethorpe's photograph of "fisting" on the grounds of the centrality of its image struck almost everyone as derisory. The widespread distaste for formalism and the demand for the return of national art are closely related. Many critics link formalist decontextualizing with expatriotism, the displacement of peoples, colonialization, and even slavery. Thus, the "recontextualization" of art going on in all the historicist movements—feminism, African-American studies, the New Historicism per se— serves as a symbolic attempt to redress past uprootings of people.

"Retentionists" have derided this attitude as a kind of nostalgia. They argue that the return of the Elgin Marbles would lead to the return of *every* foreign artwork, "till England, denuded of every possession which God and her forefathers gave her, shall stand up naked and not ashamed in the midst of a Salvation Army clamour—clothed only in self-righteousness and self-applause and the laughingstock of the whole world."[48] One imagines huge caravans of art crisscrossing the world to undo all decontextualizations, to put everything

back in its place. But why does this strike us as such an undesirable, indeed ridiculous outcome? What would be wrong with a purely racinated world of art?

It is obvious that the artwork, at home everywhere because rooted no-where, has become an image of the mobility and internationalism of modern life. A totally local siting of art is as unlikely as a return of everyone to the country of his or her ancestors, if there were such a single place for most people. Thus, the double nature of art, rooted in its time and culture and yet separated from it, finds a poignant parallel in modern identity—mobile, eclectic, inter-national, but yearning for a lost connection to home.

Art can return to its nation of origin, but its identity will have changed in the meantime. The paradoxical nature of the artistic icon destabilizes its mean-ing, opening it to ever new contexts of interpretation and amassing a history of interpretation around it. Art's openness allows it to give profound meaning to a changing world, but also to stand apart as a flexible system of meaning and value. Its duality permits us to enter a fictive work and adapt it to the real needs and interests of the moment, to achieve insight into reality by freeing us from real constraints. The multifarious pleasures of art derive, one way or another, from this paradox.

AESTHETIC PLEASURE

The second principle in need of reiteration is that the pleasures of art, however scandalous they have come to be seen, are valuable and worth protecting. And here I would like to posit a crude generalization: that one of the major differ-ences between modernism and postmodernism lies in the stress each one placed on the two sides of the aesthetic paradox. The earlier part of the twentieth century, the one associated with the term "modernism," valued art for its self-reference and separateness from reality, whereas the later part of the century, the "postmodern," has valued art more for its connection to reality. Many people in our day present this switch as a move away from personal gratification to social responsibility, as if the involvement with art "for its own sake" were some kind of illegitimate self-indulgence. The magic circle around the work of art—the frame, the *limen,* the *claritas* of Stephen Dedalus's Aquinas—is now stigmatized, and those who take intense pleasure in art and value it accordingly are said to "fetishize" it. It is a sign of the puritanism of American culture that the nearest we come to a word for intense aesthetic pleasure is so distinctly

negative a term. Part of my aim in this section is to reveal the hysteria behind
the current condemnation of aesthetic pleasure.

Despite the fact that "fetish" is a derogatory term for most critics, the con-
cept offers certain indispensable insights into the nature of aesthetic pleasure.
First, if we view the artwork through the prism of the fetish, we realize that the
work takes on its special value because its audience treats it in a special man-
ner—makes it into a fetish—and not because the work "contains" this value.
It is important to acknowledge this power in the perceiver. We saw with the
Mapplethorpe trial that some viewers found his work valuable whereas others
did not, and that some who had found no value in it came to change their
minds. One of the major functions of critics and teachers is to help others invest
art with value, in effect, to help them to "fetishize" it.

The history of the word "fetish" is also instructive. It derives from the Por-
tuguese *feitiço* and was applied first by fifteenth-century Portuguese traders to
describe the cult objects of West Africa used in witchcraft.[49] It then entered
other European languages in the eighteenth century with the new study of
comparative religion, where a fetish was a statue or other object thought by a
"primitive" people to be the dwelling place of a powerful spirit.[50] In these
usages, "fetish" involves a discrepancy between those who believe in the fetish
object and those looking at it "from the outside," who judge the fetishist de-
luded, primitive, or "pagan." The fetishist's error supposedly lies in the habit of
fetishizing per se, but in fact it consists in choosing the "wrong" fetishes. Those
same Portuguese traders, after all, protected themselves from harm by wearing
medals of Catholic saints and bowing down before holy relics.

The fetish, like art, has been a target for Protestantism, which linked it to
relics and other "primitive" or corrupt idols. It has also come into direct colli-
sion with capitalism. There the denial "that any material object has a special
capacity of spiritual mediation," according to Hal Foster, contains a hidden
economic agenda: "to denounce as primitive and infantile the refusal to assess
value rationally, to trade objects in a system of equivalence—in short to submit
to capitalist exchange" (Foster, p. 8). Capitalism, then, reviled religious fetishes
in preparation for the day when the commodity would emerge as the fetish par
excellence. As history shows, those most critical of a given fetish are often those
most anxious to displace it with one of their own.

In the work of Marx and Freud the fetish is a distinctly negative term. For
both thinkers, it involves a confusion of the power an object represents with the

object itself, the taking of a sign for a thing. In Marx's commodity fetish, goods are mistaken for the social values they signify; in Freud's erotic fetish, an object associated with sex becomes itself an object of desire.[51] Aesthetic fetishism for a Marxist or a Freudian would be an error or dysfunction in which "real" value is lost, usurped by a mechanical or demonic substitute.

The forces unleashed in this substitution can be fearsome. "Freud argued that in experiences of the uncanny, which he related specifically to castration anxiety and its fetishistic defense, animate and inanimate states are confused, things are consumed by representations, once homey images return as *unheimlich,* and a whiff or whisper of death hangs over the scene."[52] This picture of the uncanny resembles the anti-pornographic and "politically correct" view of "dangerous art"—brutal, corrupting, irresistible—in which the thing-world is "consumed by representations." Indeed, leftist literalists operate with an utterly naive conception of art as magic, directly efficacious in reality and requiring stringent regulation if society is to be "protected."

In this literalism, this fundamentalist scare story, the artwork is not invested by its audience with a virtual power, but possesses, itself, a power that we cannot control. This book contests such a view of art as emphatically as it does the opposite notion, that the power art *does* have—to give pleasure through its virtuality—is unimportant or illegitimate. To return the topic of pleasure to aesthetics we must reconceive the power of art as neither a formalist enthrallment nor a fundamentalist nightmare.

To lay out this "middle way," it is important to understand how we have ended up in a situation where only the extremes present themselves. We return, then, to the rough contrast posited earlier between modernism and postmodernism, and here the concept of the fetish can again be enlightening. In its doomed substitution for lost value, and in its confusing of sign and thing, the fetish is a very suggestive analogue for the decadent view of art. The sense of living at the end of an age, of making do with diminished possibilities, blossomed in the Aestheticism of the late nineteenth century. The response of the Decadents to the "departure of the gods" and the resultant ungroundedness of meaning was to turn to art as a repository of value, a substitute for what was missing in other areas of life. Their legacy to the twentieth century was an exaggeration of art's separation from normal reality—the belief in art for its own sake, a realm of perfection precariously tottering on the real.

Oscar Wilde saw the naughty wit in such extravagant claims for art. But his paradoxes gave way in modernism to a kind of desperate literalism. If history

and culture were nothing but a wasteland, *The Waste Land* could still redeem us. Though modernism bemoaned the inefficacy of art's consolation for loss, at the same time the whole effect of the movement and its criticism was to induce in its audience an overdetermined, self-reflexive aesthesis in which value, intensity, and meaning would be caught in the work, reinforcing each other to produce a sphere of heightened experience. Here the difference between sign and thing was all but obliterated. "A poem should not mean," wrote Archibald MacLeish in *Ars Poetica,* "But be."

It is no coincidence that Pablo Picasso's first major step into modernism, the famous *Demoiselles d'Avignon* (fig. 20), was inspired by fetish objects—the African masks that he first saw on a trip to Spain in 1905. These stylized, awe-evoking images Picasso translated into the heads of his prostitutes, the Demoiselles who pose like strange amalgams of goddesses, statues, and machines in a nowhere space of cubist facetting—a brothel, a gallery, an unrealizable virtuality. Picasso, according to his friend, the poet Paul Eluard, "created fetishes, but these fetishes have a life of their own. They are not only intercessionary signs but signs in motion. What we call the magic of design, of colors, has begun again to nourish everything that surrounds us and ourselves as well." For Eluard, Picasso transformed primordial African fetishes into modern European ones through the "magic of design and color."[53] Manna lay not in religion anymore, but in self-contained, dynamic form.

This projection of value into form is one of the most characteristic moves of modernism. It entailed a belief in art's universality and independence from context, since design principles were thought to transcend any given context. Thus, the English critic Clive Bell, who taught that the cause of the aesthetic emotion was "significant form," claimed that "great art remains stable and unobscure because the feelings that it awakens are independent of time and place, because its kingdom is not of this world."[54]

To explore this extreme position, modernist artists and critics concentrated on the materiality of medium and style and on everything about the work that made it a self-enclosed artifact rather than a part of the world. Aesthetic meaning and value were said to exist *in* the artwork, unaffected by such social factors as the artist, the audience, or historical reality. The artwork was directly analogous to a religious fetish, a vessel of manna-like value that both preserved that value and locked it away through the work's esoteric difficulty. To experience this power and beauty, the reader or viewer had to become an adept, initiated into a mysterious, hermetic world.

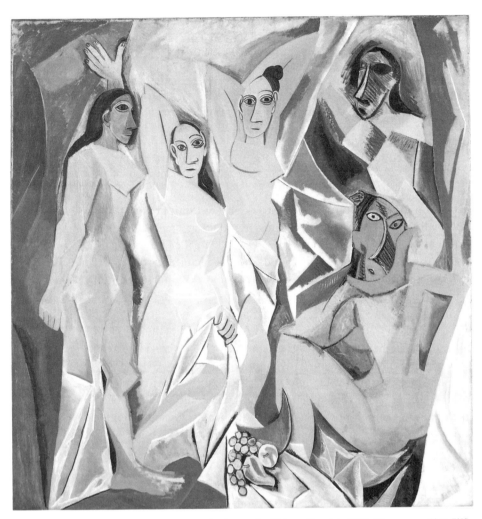

20. Pablo Picasso, *Les Demoiselles d'Avignon* (June-July 1907). Oil on canvas, 8′ × 7′8″.
The Museum of Modern Art, New York. Acquired through the Lillie P. Bliss Bequest.

Modernist criticism provided the dogma for this quasi-fetishism and in-
sured its observance. Clive Bell's "significant form" found its American echo in
Clement Greenberg's influential teaching that painting achieved "purity" in-
sofar as it represented the two-dimensionality of paint and canvas. Formalism

was equally dominant in literary criticism, for example, in the Moscow Linguistic Circle's notion that "literariness" consisted in an estrangement from normal meaning created by poetic form. The German *Textkritik* and French *Analyse de texte* paralleled such thinking, but perhaps the most entrenched movement of this sort in the century was the American New Criticism, whose dominance in literature departments resembled Greenberg's in art history, controlling American pedagogy and scholarship from the 1930s well into the 1960s. William K. Wimsatt's "intentional fallacy" and "affective fallacy," for example, denied that a work's meaning lay in its author's intent or its audience's response, but in the artistic work alone, and Cleanth Brooks's "heresy of paraphrase" locked that meaning in the text as its unique formulation. Isolated, reified, untranslatable, decontextualized, and unchanging, artistic meaning for the New Critics was a manna that could only be pointed to, communed with, and, ultimately, worshiped in the act of appreciation.[55]

The New Critics and other formalists, of course, never referred to their approach as fetishism. They would have been horrified at the idea. What they thought they were doing was explaining art's particular pleasure through its difference from normal experience. It took figures like Michel Leiris and Georges Bataille to champion fetishism openly. They "and fellow members of the Collège de Sociologie, intent on shattering the complacencies of bourgeois civilization, recuperated fetishism as a form of transgressive idolatry. Strengthening its status as a perversion (more than the surrealists ever dared) . . . [they] transformed fetishism, along with a host of other de-repressed pathologies, into a positive theoretical praxis."[56]

But whereas Leiris and Bataille attacked the bourgeois culture of their day through the shock value of fetishism, more recent critics have argued that modernism is bourgeois insofar as it is fetishistic. Postmodernists, neo-Marxists, and feminists, despising modernist self-reflexivity, have launched an all-out attack on aesthetic fetishism as such. And it is this attack that fuels the anti-pornography movement.

The postmodern reaction against modernism helps explain why the romance so often turns up in parodic form in contemporary fiction. It is about the behavior surrounding the fetish—the Holy Grail or beautiful princess or self-understanding that seem so precious to the quester that they nullify all quotidian contingency. In such postmodern fictions as Thomas Pynchon's *V.,* the quest for value is constantly interrupted by fetishistic substitutes that both are

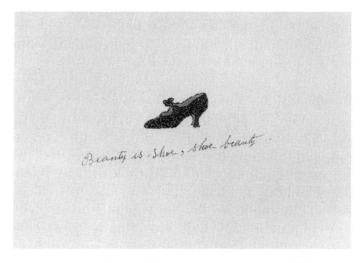

21. Andy Warhol, *Beauty is shoe, shoe beauty* (1995),
(detail of fig. 22). © 1995, The Andy Warhol Foundation for the
Visual Arts, Inc.

and are not what characters are seeking. Thus, metaphor, allegory, and ulti-
mately art are shown to be inappropriate as solutions to loss. Mere imitations of
something that may not exist, they are bound to disappoint us.

Useful as this instruction might have been, however, it is now somewhat
dated. One need not deny or deconstruct aesthetic pleasure at this point in
order to prevent people from falling into idolatry. (This was one of Paul de
Man's mistakes, as we shall see in Chapter 5.) Who would advocate art for art's
sake anymore, or art as religion? The delusion of such an attitude is rendered
unforgettable in Andy Warhol's phrases, "Beauty is shoe, shoe beauty" (fig. 21)
or "A la Recherche du Shoe Perdu" (fig. 22). In jokes like this, Warhol manages
to mock the modernist extremes of aesthetic fetishism while still finding in-
tense value in art. Reacting against modernist purism, he "underlined art's
mercantile role and implicity undermined the traditional artist's romance of
spiritual purity,"[57] but he also produced works of art that are collected and
loved, and that laugh away the depersonalizing threat of mechanical
reproduction.

Insofar as we equate eros with pleasure, art is an erotic substitute, but one
that need not entail the self-delusion and obsessiveness of real sexual fetishism.
Mapplethorpe's art, in many ways, is an allegory of this idea. As a student, he

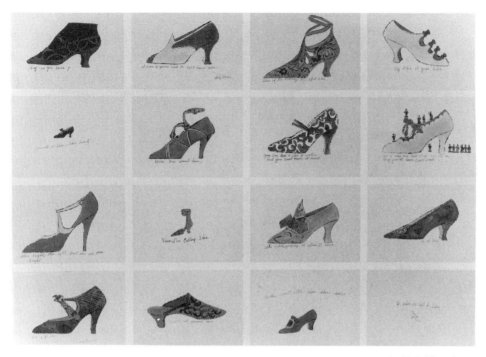

22. Andy Warhol, *A la Recherche du Shoe Perdu* (1995). © 1955, The Andy Warhol Foundation for the Visual Arts, Inc.

assembled fetishes as such, which he composed into altarpieces (fig. 23). Full of Catholic imagery, phallic symbolism, aesthetic stylization, and camp, they combine stereotypes of aestheticism in an approach inspired by Andy Warhol.

When Mapplethorpe photographs the body builder Lisa Lyons and male models, he pictures bodies turned into aesthetic objects, and when he poses himself with the famous bullwhip or female makeup or even the death's head, he is representing identity as acting, as role-playing. He creates a double-level artwork—an artificial representation of what is already an artistic representation—art made out of nature aestheticized. Moreover, when he photographs the leather and violence and degradation of gay sadomasochism, Mapplethorpe is showing the difference between real fetishism and art, even an art that uses fetishism as its subject. To derive pleasure from art, one does not have to delude oneself, but one does have to live with paradoxes.

A more troublesome criticism of aesthetic pleasure is the leftist claim that

23. Robert Mapplethorpe, *Tie Rack* (1969). © 1969,
The Estate of Robert Mapplethorpe.

"wasting life in wonder" is politically suspect. Fredric Jameson, who reads post-modern art such as Warhol's as the epitome of the commodity fetish (rather than its ironic critique), states that "every position on postmodernism in culture . . . is also ultimately a political stance on the nature of multinational capitalism today."[58] This is supposed to have the force of revelation: that pro-gressive as we might have thought ourselves in touting postmodernism, all we were doing was living out one aspect or another of "late capitalist" ideology. I find myself unsurprised by this contention, and also unashamed.

The implication is that there is a more humane and progressive alternative available in Marxism, and yet not only has history resoundingly rejected this alternative, but its advocates in the West are themselves suspect. "The roots of the Marxists' critique of postmodernism," Linda Hutcheon says, "are in Ador-no's tireless stressing of the powers of recuperation of the fetishistic 'culture industry'. . . . Yet . . . the very academics and scholars who take this position are themselves part of the 'teaching industry' or the Ideological State Apparatus of education, and *that* cannot be separated from the culture industry."[59] Of course, the value of a criticism is not necessarily undermined by the taint of its proponents, and the spectacle of the millionaire Marxist academic does have its ironic charms. Still, pointing out the connection between aesthetic pleasure and capitalism does not fill me with self-loathing. Mercantilism may confuse having and being, but it did not invent the confusion, which is an inevitable concommitant of the iconic structure of art.

Much more worrisome is the feminist critique of aesthetic pleasure. As the beautiful object of the male gaze, woman has perennially served as an analogue to art. Like a hermetic modernist artwork, she is seen as narcissistic and self-obsessed. "Woman is a field of vision, woman is her own landscape," writes a master of postmodern fetishism, John Hawkes.[60] According to some feminists, the experience of traditional art amounts to a seduction by a beautiful object, and the magic circle around decontextualized art is the unreal space of ro-mance.[61] The woman as artwork is an object to contemplate, deracinate, and manipulate, but in many romances she also conspires in her own objectifica-tion, creating an ambivalent identity for herself as both transcendent value and mere commodity.

The prurient possibilities in this duality are obvious in Michel Leiris's idea of the "hidden lubricity" of the museum. "Nothing seems more like a whore-house to me than a museum," he writes. "In it you find the same equivocal aspect, the same frozen quality. In one, beautiful, frozen images of Venus,

Judith, Susanna, Juno, Lucrèce, Salome and other heroines; in the other, living women in their traditional garb, with their stereotyped gestures and phrases."[62] In *Ulysses,* when Leopold Bloom takes brief refuge in a museum, Stephen Dedalus's friend Buck Mulligan suggests a lustful rather than aesthetic motivation: "His pale Galilean eyes were upon her [a statue's] mesial groove. Venus Kallipyge. O, the thunder of those loins! The god pursuing the maiden hid."[63] Though one can, like Philip Fisher, picture the walk through a museum as the passage of art history from period to period and movement to movement,[64] Brian De Palma uses such a walk in *Dressed to Kill* to symbolize the stalking of lust. The association of aesthetic response with sexual violence and objectification is all-pervasive in our culture.

Harold Rosenberg writes that nonseductive art is a contradiction in terms and that the call to purge art of its sensuality is always an expression of misogyny. Periods better disposed toward women are not afraid to see art as seduction. Thus, the "odalisque is a favorite theme of romantic painters because, like the artists themselves, she attracts through a combination of intimate appeal and public display."[65] But however supportive this view of art and women is meant to be, it merely reaffirms their association with sexual temptation and male fantasy.

This idea is the theme of John Fowles's novel, *The Collector.* Its protagonist is an amateur butterfly-collector who kidnaps an art student called Miranda. His notion of love is the ownership of a beautiful static object. To enjoy her, he must capture her, taking her out of her context as if she were an exotic curio and locking her into a basement room where she eventually sickens and dies. Meanwhile, however, she has absolute power over everything but her freedom. Miranda is thus an exact symbol of the decontextualized art object whose isolation creates her power to enthrall.

But Fowles never lets us forget the impotence of this power. "I hate people who collect things, and classify things and give them names and then forget all about them," Miranda says. "That's what people are always doing in art"; collectors are "anti-life, anti-art, anti-everything."[66] Refusing to make love to her, the collector forces her to pose for pornographic pictures. He experiences climax as he looks at these arrested images of imprisoned beauty.

Fowles's picture of aesthetic perversity finds an analogue in the theories of Laura Mulvey, whose "Visual Pleasure and Narrative Cinema"[67] has had an incalculable influence on feminism, film studies, art history, and literary theory. Mulvey's article explicitly describes filmic perception as fetishism. Just as femi-

nist extremists invest pornography with an extraordinary power over reality, Mulvey's critique invests the cinema with the power of a Freudian fetish. Hollywood cinema, she says, is a magic realm of wish-fulfillment in which male fears of castration are deflected onto a castrated woman who is "coded for strong visual and erotic impact . . . to connote *to-be-looked-at-ness*" (p. 19). The classic Hollywood film is *un*realistic in that it pursues "aims in indifference to perceptual reality, and motivate[s] eroticised phantasmagoria that affect the subject's perception of the world to make a mockery of empirical objectivity" (p. 18). Conventional cinema induces the pleasures of fantasizing. It should be reformed, says Mulvey, in order to function as a critique of such pleasures.

Mulvey goes on to explain that the pleasure of cinema results from its fetishistic mitigation of loss, as when it transforms the female star into an overvalued cult object that is "satisfying in itself" (p. 21). What Mulvey envisions as an alternative is unclear, but she is absolutely sure about what she does *not* want. "It is said that analysing pleasure, or beauty, destroys it. That is the intention of this article. The satisfaction and reinforcement of the ego that represent the high point of film history hitherto must be attacked" (p. 16). The only way to control aesthetic pleasure for the dedicated fetish-buster is to destroy beauty.

Thus, for many artists and theorists, the experience of art is necessarily pornographic, sadistic, and ultimately destructive of women. Women who cooperate in this exploitation are surely self-destructive, and a female critic who does so would seem to be in a doubly impossible position—destructive of women in general and of herself in particular. Feminist and New-Historicist contextualism attempt to discredit approaches that turn art and women into captive commodities for a lifelessly objectifying male gaze.

Yet even the most fetishized art can belie the simplicity of such claims, because commodities and people, objects and subjects, are dynamically related. George Etherege, for example, plays on the word "property" in *The Man of Mode:*

> *Dorimant:* You mistake the use of fools: they are designed for properties and not for friends.
>
> *Mrs. Lovitt:* The old and the ill-favoured are only fit for properties, indeed, but young and handsome fools have met with kinder fortunes.[68]

Here beauty transforms the mere prop into the center of attention, stage scenery into actor, property into friend. Though the statement is as arch and equivocal as everything else in this play about the aestheticizing of life, it is still

telling. To see art as the enactment of a one-way power relation is adequate neither to women nor to art. No one is innately, inevitably, or uninterruptedly a victim, and there is no way to experience art—however minimalist it may be—that does not involve both mastery and submission on both sides. The wonder that overtakes us in great art need not diminish women nor preclude political relevance.

No writing demonstrates this claim so well for me as the following passage from Toni Morrison's *Beloved*. Here, the slave woman Sethe selects Halle as her husband, disappointing four other male slaves who want her. Sethe and Halle consummate their marriage in a cornfield. "Halle wanted privacy for her and got public display. Who could miss a ripple in a cornfield on a quiet cloudless day?" The four "boys" sit pouring water over their heads, watching the "confusion of tassels in the field below." But that night, everyone feasts on the new corn felled by the disturbance in the field. One boy parted

the hair to get to the tip, the edge of his fingernail just under, so as not to graze a single kernel.

The pulling down of the tight sheath, the ripping sound always convinced her it hurt.

As soon as one strip of husk was down, the rest obeyed and the ear yielded up to him its shy rows, exposed at last. How loose the silk. How quick the jailed-up flavor ran free.

No matter what all your teeth and wet fingers anticipated, there was no accounting for the way that simple joy could shake you.

How loose the silk. How fine and loose and free.[69]

If you cannot have consummation in a cornfield, you can at least consume its traces in fallen corn. In this book about the need to remember and yet not to let memory consume you, this scene stands out as a victory, a turning of loss into pleasure through symbolism and substitution, the tropes of life and art. The sexuality of this feast and its joy are neither male nor female, but some extraordinary merging of the two. There is no violence, objectification, or exploitation in either the act represented or the reading of it. The passage is a small excess, a present from Morrison to us. It teaches how art can mitigate loss—joyfully, wryly—and I find it a miracle, worthy of wonder.

Criticism is a less perfect piece of substitution, to be sure, but its connection to history and memory is equally close. To register an aesthetic meaning is a public act of remembering, a tiny piece of the complex process by which works enter a culture and unfold in the history of interpretation. To succumb to art, and yet to know that its power lies in the process of surrendering, is not

to undermine but to value both art and audience. For though reading is neither straightforward nor practical—or perhaps *because* it is neither—it is not a negligible feat we all perform, this fetishizing of art.

Postmodernists like Andy Warhol and Toni Morrison have instructed their audiences in the folly of literalism and the pleasure that can arise instead for the enlightened, but still beguilable, interpreter. It is this latter approach to aesthetic fetishism—an enlightened beguilement (rather like William Blake's "wise innocence")—that is the ideal of this book. To engage with an artwork's connection to ideologies—benign or hurtful—and still feel the work's brilliant virtuality: this is aesthetic experience at its fullest. It is this paradox that experts spend their lives exploring, and that they should be equipped to explain.

However, even the most eloquent spokesman for aesthetic paradox—a Salman Rushdie, for example—may not convince a stubbornly literalist audience. And the fallout from such a failure may be ghastly—deaths, riots, political repression. As we shall see in the next chapter, the stakes in the struggle for enlightened beguilement are now anything but trivial.

CHAPTER THREE

FETISH OR FATWA?

So where do we turn, we who see the limits of liberalism and fear the absolutist demands of fundamentalism?

Homi K. Bhabha

RUSHDIE K. MAPPLETHORPE

On a drizzly July afternoon in 1992, the *Times Literary Supplement* held its nine-tieth anniversary celebration in a central London square where the Westminster School plays cricket. A brief security check at the gate gave way to quantities of champagne and chatter and goose bumps. The real chill set in, though, when I found myself standing next to Salman Rushdie. Pretending to be unfazed, and idly calculating the angle of potential sniper fire, I turned to introduce myself.

"I'm writing part of a book on *The Satanic Verses,*" I ventured. "I wonder if we could meet sometime to talk about it."

"I'm here now," he replied. "Shoot."

All thought of aesthetic paradox evaporated in that high-risk cricket pitch. "Doesn't it make you nervous, standing outside in such an open place?"

"I would be if there weren't so many 'guests' here from the Special Branch. After all, Margaret Thatcher is number one on the IRA hit list and she still appears in public. So why shouldn't I?"

He sounded like someone trying out an argument rather than stating a con-viction, but I said I guessed he was right. "Did you know," I asked, changing the subject, "that protesters at the Mapplethorpe trial held up placards reading, 'Mapplethorpe=Rushdie'?"

"No, I didn't. And how did the trial come out?"

"They won," I answered. "The good guys, I mean. They often do win, you know."

He raised a power fist and grinned. And then, like most Englishmen I've met, he set out to explain cricket.

The point is that despite the events that have written him into world history, Salman Rushdie, in literary terms, is ordinary. The aesthetic liberties he took in *The Satanic Verses* are the same ones taken by thousands of other writers. It is just that somewhere along the line, Rushdie lost his artistic license.

Rushdie's case has provoked an international debate on the nature of that artistic license, the special status of aesthetic meaning as a realm of free play. This idea normally lurks in the back of our minds as a few imprecise echoes of German philosophy, surfacing under duress in freshman essays and inspirational speeches. The worldwide defense mounted on Rushdie's behalf has revealed how contradictory and fragile a notion it is. The scandal over *The Satanic Verses* has produced as much confusion among artists, experts, and the general public as the Mapplethorpe affair.

The picketers outside the Cincinnati trial were not the only ones to equate Rushdie's case with the American arts crisis. In the United States, nearly everyone considered the Rushdie affair "a pretty obvious call," [1] and therefore liberals used the analogy as a sure way to validate artists under rightist fire. During the troubled summer of 1989, Robert Brustein claimed that "Once we allow lawmakers to become art critics, we take the first step into the world of Ayatollah Khomeini, whose murderous review of *The Satanic Verses* still chills the heart of everyone committed to free expression." [2] J. Anthony Lukas flew from an authors' rally for Rushdie in New York to a veteran's rally against the installation "What Is the Proper Way to Display an American Flag?" in Chicago. "The events on Michigan Avenue," he mused, "were ample evidence that the 'Rushdie affair' was no exotic literary cause célèbre. We hadn't waited long for an echo deep in the American heartland, a somber warning that many of our fellow citizens are as willing as the mullahs in Teheran to silence dissident voices that offend their sacred symbols and beliefs." [3]

The two scandals overlapped in time as well as import. On September 26, 1988, as the curators at the Philadelphia ICA were assembling "The Perfect Moment," Viking Penguin published *The Satanic Verses* in Britain, and in November, a month before the Mapplethorpe exhibition opened, Rushdie's book was awarded the Whitbread Prize for the year's best British novel. The positive reception both artists received gave no warning of the troubles to come. Asked in a prepublication interview about violence that might possibly arise from his book's release, Rushdie replied that "it would be absurd to think that a book

can cause riots. That's a strange sort of view of the world." [4] This strange view of the world was soon to become reality.

THE FATWA

The trouble began in early October, when India banned *The Satanic Verses* as blasphemous. South Africa, Pakistan, Saudi Arabia, Jordan, Egypt, Somalia, Bangladesh, Sudan, Malaysia, Indonesia, and Qatar followed suit. On January 14, 1989, the novel was publicly burned in Bradford, a northern English City with some 50,000 Muslim citizens. And on February 12 and 13, huge riots protesting the novel broke out in Islamabad and Kashmir.

Meanwhile in Iran, the Ayatollah Khomeini, in his eighties and suffering from cancer, had been behaving more and more erratically. In early February, he reportedly threatened to have the producers of an Iranian radio broadcast executed "for airing an interview in which a woman said that she had taken a soap-opera star for a role model rather than the prophet Mohammad's daughter, Fatima. Four officials of the state-run radio were subsequently tried by an Islamic court, flogged and imprisoned for up to five years each." [5]

Under the circumstances, Rushdie's persecution was almost inevitable. On Tuesday, February 14, Valentine's Day, the Ayatollah Khomeini's now infamous *fatwa* was read over Radio Tehran.

> In the name of God Almighty . . . I would like to inform all the intrepid Muslims in the world that the author of the book entitled *The Satanic Verses,* which has been compiled, printed and published in opposition to Islam, the Prophet and the Koran, as well as those publishers who are aware of its contents, have been sentenced to death. I call on all zealous Muslims to execute them quickly, wherever they find them, so that no one will dare to insult the Islamic sanctions. Whoever is killed on this path will be regarded as a martyr, God willing. [6]

February 15 brought a violent anti-Rushdie demonstration at the British Embassy in Tehran, a universal ban on Viking books in India, and the offer of a $1.5 million reward for Salman Rushdie's murder. The figure was almost immediately increased, and has been quoted as anything from $2 to $3 million. On Thursday, February 16, Rushdie and his then wife, Marianne Wiggins, went into official hiding under the protection of Scotland Yard, as a Pakistani ex-governmental minister predicted that "the man will be murdered within three months." [7]

Rushdie was not the only potential target of violence. Bomb threats at Viking Penguin's offices in Manhattan suspended business for the rest of the week, and a national bookstore chain, Waldenbooks, removed *The Satanic Verses* from its shelves. These businesses were anxious not to repeat the mistake of Pan-Am, which had ignored threats against its employees before the Lockerbie disaster in December of 1988. And here is the first of a number of coincidences surrounding the Rushdie affair. *The Satanic Verses,* which is about two actors who fall out of a plane after a terrorist explosion, was almost suppressed by the fallout from a real terrorist explosion, Lockerbie. On Friday, February 17, B. Dalton, Barnes and Noble, and Coles followed Waldenbooks' ban, and the Canadian government put a temporary halt on the novel's importation on the suspicion that might be hate literature.

By their action, the large book chains at one stroke eliminated *The Satanic Verses* from one-third of the country's bookstores, and from virtually all of those in small towns and suburbs. Though they soon rescinded their decision under pressure from their own authors and from public figures, the power of the chains was dramatized as never before. Months later, in an article called "From Rushdie to Mapplethorpe, the arts are under siege," Stephan Salisbury wrote: "what the Rushdie controversy shows in general is that the marketplace, rather than promoting diversity, gradually is beginning to thwart it. Moreover, the episode is a strong reminder that constitutional guarantees of freedom of speech and the press mean nothing if publishers refuse to publish, distributors refuse to distribute, or booksellers refuse to sell. These are tough times for writer, artist, and audience." [8]

In America, after some initial caution, authors rallied to Rushdie's support, but in London the response of intellectuals was more complex. Though editorial pages were jammed with letters venerating Rushdie as a victim of terrorism and a martyr to freedom of expression, almost as many condemned him as an insensitive opportunist more willing to sacrifice lives than royalties. Muslim opinion in the West was also divided, with some publicly proclaiming their willingness to murder Rushdie and others criticizing the Ayatollah for sentencing him without a trial and for punishing fiction-writing with death.

In Britain, the foreign secretary, Sir Geoffrey Howe, despite his support for the author after the *fatwa,* complained indignantly that *The Satanic Verses* compared Britain to Nazi Germany, and Tory opinion represented Rushdie as an arrogant upstart insufficiently appreciative of the virtues of his adoptive country. "He joined the absurdly and pretentiously titled 20 June group of anti-

Conservative writers who railed and wailed against Thatcher," wrote Norman Tebbitt, former Tory chairman, in September 1990, "and he upheld the ridiculously self-important Charter 88 group whose theme that Britain's democracy is seriously flawed seems more attractive to foreigners sheltering here from the despotism of their homelands than to the British."[9] Even some fellow writers, such as the late Roald Dahl, accused Rushdie of a sensationalism and opportunism that get "an indifferent book on the top of the list."[10] Britain's Chief Rabbi, the Archbishop of Canterbury, former U.S. President Jimmy Carter, John Le Carré, and the rightist's rightist, Pat Buchanan, all proclaimed that *The Satanic Verses* was offensive and should not have been published.

Whatever initial pride Rushdie may have taken in the attention accorded his book soon turned to irritation and outrage. He said in an interview just before he entered hiding, "Frankly, I wish I had written a more critical book,"[11] a remark widely cited as proof of his incorrigible hostility to Islam. But after a weekend in hiding, Rushdie decided that diplomacy might be in order and issued an apology: "As author of *The Satanic Verses* I recognise that Moslems in many parts of the world are genuinely distressed by the publication of my novel. I profoundly regret the distress that publication has occasioned to the sincere followers of Islam. Living as we do in a world of many faiths this experience has served to remind us that we must all be conscious of the sensibilities of others."[12] On February 19, this barbed apology was indignantly rejected by Iran's fundamentalist authorities.

The political response to the *fatwa,* meanwhile, was mounting. The member states of the European Community withdrew their ambassadors from Iran, though most were returned within a month. President Bush chastised the Ayatollah for his "deeply offensive behavior"—a reprimand almost as severe as the threat issued by Sir Geoffrey Howe, that if harm befell Rushdie, "a very grave situation would be transformed into a very serious matter."[13] On February 22, the official publication date of *The Satanic Verses* in the U.S., Senator Daniel Patrick Moynihan proposed a motion condemning as state-sponsored terrorism the Iranian *fatwa,* and asking the president to act in case of violence to Rushdie or his publishers. Cosponsors of the bill were Senators Helms and D'Amato, who just a few weeks later would be urging American politicians to censor state-supported art!

On February 23, *The Satanic Verses* returned to U.S. bookstores, and though plans for the paperback edition were supposedly shelved, rioting, fire-bombings, and demonstrations continued from Bombay to Berkeley. The death

toll in Pakistan and India was estimated at twenty-two people, with injuries in the hundreds.

As fundamentalist politicians in Iran used the Rushdie affair to gain ground over their moderate opponents, the West was trapped in impotent fear. Security costs at Viking were projected at $2 million per year. "The idea that a dictum from 10,000 miles away can turn Americans into jelly is repulsive," fulminated a *Philadelphia Inquirer* editorial.[14]

Closer to Iran, the anxiety was greater still. The British authors Tariq Ali and Howard Brenton described an all-pervasive "climate of fear." The British Library locked *The Satanic Verses* in its "restricted" cases, in the company of pornographic and inflammatory works. "Bookshops are frightened to display or even sell *The Satanic Verses*," wrote Ali and Brenton, who were forced to change the title of their play *The Mullahs' Night Out* to *The Iranian Nights* because the cast at the Royal Court Theatre were afraid of attack.

Once rock-solid minds have crumbled in the press, with all kinds of specious arguments for banning the book, or for the cessation of its publication. Critics are afraid to appear on TV arts shows. The Labour Party cancelled a debate in the House of Lords on a motion in support of Rushdie, under pressure from the Foreign Office. Some people I know are even afraid to read the bloody book on the underground, presumably in fear of marauding hit squads from Tehran patrolling the Circle Line.[15]

I myself remember reading "the bloody book" on the Circle Line, but I took the precaution of removing its dust jacket beforehand.

The fear was not unjustified. Death squads were reportedly abroad in London, working, it was said, from the Iranian Embassy itself. Mobs in Nigeria vowed death to the novelist Wole Soyinka after he spoke up publicly in Rushdie's support, and in Egypt similar threats were directed against Naguib Mahfouz. In March, two moderate Muslim religious leaders were killed in Brussels after expressing opposition to censorship.

Neither did matters improve with the passing of time. In July 1991, the Italian translator of *The Satanic Verses* was knifed and beaten in Milan. His Japanese counterpart, Hitoshi Igarashi, was stabbed to death nine days later. Igarashi had undertaken the task of translating Rushdie's novel after five other translators had refused. "I get lots of strange calls," he had noted, "but I don't mind because I've done nothing wrong."[16] Two years later, Rushdie's Norwegian publisher was shot and badly wounded. In the attention surrounding Salman Rushdie, these martyrs of the *fatwa* are too often forgotten.

Another unfortunate by-product of the affair was the public battering of the American intelligentsia. This development began almost as soon as the *fatwa* was announced, with reports that the American television networks were having trouble finding writers willing to comment on the situation. When such "normally loquacious" authors as Arthur Miller and Norman Mailer refused to appear on TV, Leon Wieseltier, the literary editor of *The New Republic,* complained that "the people who are now not speaking out because it's dangerous are the very people who make a career of speaking out when it's not dangerous." [17]

This criticism, widely repeated, found its mark. Within a week, demonstrations sprang up everywhere. The most publicized was a rally in the streets of New York's SoHo district attended by twenty-one American authors, among them Norman Mailer, Joan Didion, and Susan Sontag. They read passages from *The Satanic Verses,* delivered speeches, and in the process expounded a dogma of writing as doctrinaire as the extremest of fundamentalisms. Mailer proclaimed that "the Ayatollah has offered us an opportunity to regain our own frail religion—which happens to be faith in the power of words and our willingness to suffer for them." [18] Christopher Hitchens connected this suffering to Holocaust Jews: "it is time for all of us to don the yellow star and end the hateful isolation of our colleague." [19] In a tribute in the *New York Times Book Review,* Thomas Pynchon thanked Rushdie and Marianne Wiggins "for recalling those of us who write to our duty as heretics, for reminding us again that power is as much our sworn enemy as unreason, for making us all look braver, wiser, more useful than we often think we are." [20]

Faith in the power of words and the willingness to die for them, solidarity with persecuted coreligionists, and the duty of heresy against tyrannies of power and unreason—with these tenets of belief American writers affirmed their anti-fundamentalist fundamentalism. It took considerable courage—if not bravado—for them to do so, and their brief hesitation was surely more a sign of rationality than of cowardice.

But the damage had already been done. Jonathan Yardley, book-review editor for the *Washington Post,* accused these writers of crass self-serving: "the appropriation of Rushdie as a 'symbol' of repression that does not in fact exist in this country was opportunistic and vulgar. . . . Salman Rushdie has become . . . an instrument through which others can advance . . . their own interest." [21] Such charges and countercharges were flying about in the nation's review pages, and would be echoed among academics in angry scholarly arti-

cles.[22] The Ayatollah's decree could not have come at a worse time for American arts and letters, already beleaguered by rightist criticism. "It's probably too late to keep the myth of the cowardly intellectual from becoming lore," wrote Richard Cohen in the *Washington Post,* "one of those non-facts that will be cited years from now, probably for political reasons. After all, the myth is just too American, too much a part of conservative dogma and just the thing we are preconditioned to accept. Most intellectuals are left of center and stereotyped as being detached from reality—willing, for instance, to propose forced busing while putting their own kids in private schools."[23] As with the Mapplethorpe controversy, the worldwide clash between liberalism and totalitarianism re-echoed in local American disputes over the ethical stance of the intellectual.

The ensuing months—now years—since the *fatwa* have brought Rushdie little relief. Marianne Wiggins emerged from hiding in July 1989, and announced the couple's divorce. Rushdie has reportedly not been able to see his son since he went into hiding. Though the Ayatollah Khomeini died in June 1989 (three months after Mapplethorpe), the *fatwa* was reaffirmed by the leaders who followed him, and in December 1990, representatives of the British Muslim community actually flew to Tehran to ask that the *fatwa* not be lifted. That Christmas, fearful, demoralized, and exhausted, Rushdie announced that he had returned to the Muslim faith. He promised not to publish *The Satanic Verses* in paperback, nor to authorize any further editions. "I do not agree," he said, "with any statement in my novel *The Satanic Verses* uttered by any of the characters who insults the prophet Mohammad, or casts aspersions upon Islam, or upon the authenticity of the Holy Koran, or who rejects the divinity of Allah."[24]

The Western response to this recantation was predictably split: that Rushdie was finally exercising some wisdom, or that he had caved in. "The prospect of being murdered does, no doubt, concentrate—and influence—the mind wonderfully," said one letter to the London *Independent.* "But how sad, how sad."[25] The Muslim response, or at least the one reported in the West, was more united: Rushdie's recantation was rejected out of hand in both Iran and Britain, and with redoubled denunciations of his perfidy. Perhaps this outcome was inevitable, since only eleven months earlier he had spelled out, in italics, "*I am not a Muslim.*"[26]

Rebuffed by Islam, Rushdie allowed *The Satanic Verses* to appear in paperback, with ensuing sales in the millions of copies. He remains in hiding, appearing occasionally in public under heavy security. Hardly a member of liter-

ary London has not attended a party with him and his bodyguards among the guests. And of course, the persecution of writers continues. In the spring of 1992, an Egyptian judge sentenced Alaa Hamed and the publisher of his book, *A Distance in Man's Mind,* to eight years in prison for blasphemy.

THE SATANIC OFFENSE

Even before the publication of *The Satanic Verses,* Rushdie was no stranger to censorship, intolerance, and general opprobrium. When he returned to the East after graduating from Cambridge University, Pakistani authorities censored his production of Edward Albee's *The Zoo Story* for containing the word "pork," and interfered with an article he wrote about his first impressions on coming back home. Disgusted, he returned to England, tried fiction-writing, and eventually produced the prize-winning *Midnight's Children* (1981). He was almost sued for this book by no less a personage than Indira Gandhi, on the grounds that the character representing her son claimed she was responsible for her husband's death. Fortunately for Rushdie, Mrs. Gandhi was assassinated before the suit could be pressed. Neither was Prime Minister Benazir Bhutto of Pakistan pleased about appearing as the virgin Ironpants in Rushdie's next novel, *Shame* (1983). *The Satanic Verses* was simply the next step in the history of Rushdie's provocations.

We need only read *The Satanic Verses*—a surprisingly rare act, compared to the frequency of judgments made about it—to see why it caused such offense. It begins with two Indian actors—one anglicized, one not—whose highjacked plane explodes over the coast of England. Whirled through the air in each other's arms, they miraculously land unhurt—"geworfen," as Heidegger might say, into experience. "To be born again . . . first you have to die,"[27] the narrator muses. The two "deaths" here come in the form of geographical and cultural displacement, an abrupt dislocation into an alien world. The actors repeat Satan's fall, and thus enter, as the epigraph by Daniel Defoe informs us, Satan's "vagabond, wandering, unsettled condition."

One of the actors is Gibreel Farishta, whose name means "Angel Gabriel." Gibreel has been a superstar in countless Bombay "theologicals." Falling, he sings: "O, my shoes are Japanese,/ These trousers English, if you please./ On my head, red Russian hat;/ My heart's Indian for all that" (*SV,* p. 5). In the haunting essay, "Imaginary Homelands," Rushdie says that these words might as well be the theme song of the displaced hero of *Midnight's Children* as well.[28]

They are a cosmopolitan jingle about the condition of postmodernity in which we are all composite identities oppressed by nostalgia for a univocal homeland.

The other fallen actor is Salahuddin Chamchawala, whose father's name is Changez. Changez holds a magic lamp as a family legacy for his son, and though he stands for the past and tradition, his name expresses the imperative to change. Changez has sent his son to school in England where the boy "mutated" into Saladin Chamcha, an imitation Englishman who becomes a successful actor capable of assuming a thousand and one voices. He plays in a television show called "The Aliens" with his co-star Mimi Mamoulian, the epitome of a postmodern woman. Mimi is at ease with *Finnegans Wake* and "conversant with post-modernist critiques of the West, e.g. that we have here a society capable only of pastiche: a 'flattened' world" (*SV*, p. 261). Fleeing his alien identity, Chamcha has married a tony English orphan named Pamela Lovelace—her name combining the victim in Samuel Richardson's *Pamela*[29] and the actress-victim in *Deep Throat*—whose voice bespeaks tweeds and dogs and country-house weekends. Chamcha prospers, in flight from his father and India and all that he came from.

But Chamcha's colonization by the West is not total. For he is also loved by an Indian woman named Zeeny Vakil—an art historian, a physician, and a believer in the essential hybridity and ecclecticism of modernity. A wise man has told Chamcha about two opposing theories of the mutability of the self. According to Lucretius, if a being steps out of its limits, its old self dies, but for Ovid, the soul, though infinitely malleable, always remains the same. As the action of the book begins, Chamcha believes that Lucretius must be right, as he turns into a foul, goatish devil. By the end, however, Ovid prevails. Chamcha returns to Bombay, and reconciles himself with his dying father. He accepts his full name Salahuddin, decides he need no longer be an actor, and having rubbed the magic lamp of his heritage, he finds that Zeeny is back, with her love for the "mongrel soul."

It was love, too, that caused Gibreel Farishta to leave his Indian home in the fateful airplane. He had lost his faith in Islam during a recent illness, and during his first act of apostasy—public pork-eating—he had fallen in love with Alleluja Cone (originally "Cohen"), an Englishwoman who had conquered Mount Everest. Throwing his career in theologicals out the window, Gibreel flies off in search of Alleluja on a jet named "Bostan"—signifying self-restraint, penitence, gratitude, and justice. The number of his flight, Air India 402, how-

ever, suggests the Indian legal statute #402 proscribing imposture and fraud.[30] This is, in short, a conflicted flight. Torn apart by extremists' bombs, the plane of contradiction cracks in two, hatching Gibreel and Chamcha, who land, new-born, in England. What follows is the main action of the novel—a series of fantastic, irreverent, and sometimes blasphemous episodes in London and ancient Arabia.

The passengers on the flight have spent many anxious hours, threatened by a Canadian woman festooned with grenades, like so many breasts on an Eastern fertility goddess. Thus, it is possible that the entire action of the book—from the fall from the Bostan, to the metamorphosis of Chamcha into a goatish Satan, Gibreel's apocalyptic rampages about London blowing the horn of the Angel Gabriel, and the story of the prophet "Mahound"—are just a nightmare induced by the trauma of the highjacking. Or one could, suspending disbelief, decide that the fall does "take place," along with a good deal of the London narrative, but that the historically distant episodes set in the days of Mohammad are the delusional fantasies of Gibreel as a paranoid schizophrenic. Or one could decide that every episode, including the scenes from the actors' pasts and the highjacking, is equally compounded of realistic and fantastic elements. How fictive one judges the various episodes to be, and what one understands by the word "fiction" in the first place will determine whether one takes *The Satanic Verses* as blasphemous, but like so many postmodern novels—Barth's or Pynchon's or the recent Roth's—the book makes the job of distinguishing the "real" from the "imaginary" all but impossible.

The episode in *The Satanic Verses* that has caused most offense is the historical digression into the time of "Mahound," a thinly disguised image of the Prophet Mohammad. The name "Mahound" has itself provoked outrage. In medieval Christian mystery plays, Mahound was an evil friend of Pilate or Caesar or Herod,[31] associated with Satan and the hounds of Hell. Moreover, Rushdie's Mahound lives in a country called Jahilia, which means "ignorance." It is a land made of sand—shifting and constantly in danger of melting away. The prostitutes in the Jahilian brothel adopt the names of Mahound's (and Mohammad's) twelve wives for purposes of sales promotion. Rushdie calls their brothel "Hijab," meaning veil, the covering meant to protect the purity of Islamic women.

As if these "violations of civility"[32] were not enough, Rushdie gives Mahound's scribe his own name, and provides this "Salman" with a little experiment. Mahound, to whom God or Gabriel reveals the inspired word, dictates it

in turn to his scribe. Salman substitutes a synonym here, a little slip there, until, more adventurously, he alters the sense of whole verses. To his surprise, when he reads the altered words back to Mahound, the Prophet does not notice the difference. Salman comes, understandably, to worry about the purity of the inspired word. "So there I was, actually writing the Book, or rewriting, anyway, polluting the word of God with my own profane language" (*SV*, p. 367). He realizes that Mahound will kill him when he discovers the trick, because "It's his Word against mine" (*SV*, p. 368).

There could hardly be a more direct attack on a fundamentalist construal of the holy word. The Koran itself insists on the divine source of Mohammad's recitation: "He does not speak out of his own fancy. This is an inspired revelation. He is taught by one [Gabriel] who is powerful and mighty." [33] Just as Gabriel taught Mohammad on the mountain, Rushdie's Gibreel is climbing Mount Cone—Alleluja!—at the time the Jahilia episode is narrated.

The tone of the Jahilia section has given almost as much offense as its content, for the narrator speaks like a cheeky teenager: "There is a god here called Allah (means simply the god). Ask the Jahilians and they'll acknowledge that this fellow has some sort of overall activity, but he isn't very popular: an all-rounder in an age of specialist statues" (*SV*, p. 99). Rushdie uses this tone elsewhere when writing without the mask of a narrator. In a review of the novel *Vineland* by the reclusive Pynchon, he said, "So he wants a private life and no photographs and nobody to know his home address, I can dig it. I can relate to that (but, like, he should try it when it's compulsory instead of a free choice option)." [34] It is not surprising that those shocked by the Mahound section should take its tone as Rushdie's, and not a "voice" created in the text.

The Jahilian narrator may not be respectful, but he puts his finger on the crux of the "satanic verses" episode: the switch from polytheism to monotheism, from diversity to homogeneity, from a mongrel to a pure belief. "Why do I fear Mahound?" the grandee of Jahilia asks himself. "For that: one one one, his terrifying singularity. Whereas I am always divided, always two or three or fifteen" (*SV*, p. 102).

The actual "satanic verses" are two lines that were revealed to the Prophet Mohammad in order to strike a compromise with the authorities who wished at least some of their local gods to be included in Islam. "Have you thought upon Lat and Uzzah, and Manat, the third, the other?" Rushdie's Mahound recites, echoing Mohammad in the Koran (*SV*, p. 114). Then, in verses no longer found in the Koran, Mahound (and supposedly Mohammad) praises

these goddesses of the Sun, Venus, and Fortune[35]: "They are the exalted birds, and their intercession is desired indeed" (*SV*, p. 114). Mahound, like Mohammad, soon regrets these words, believing that Satan inspired them, and has them removed. Instead of praising the goddesses, the Koran asks, "Is He to have daughters and you sons? This is indeed an unfair distinction! They are but names which you and your fathers have invented: Allah has invested no authority in them."[36]

In *The Satanic Verses,* Mahound's withdrawal of the "satanic" lines becomes an excision of difference, a totalizing desire for one and only one source of power and authority. And because the gods eliminated were female, Rushdie treats the story as an instance of Islamic sexism. There is certainly ample evidence of antifeminism in the Koran (as in the Old and New Testaments), e.g., "Those that disbelieve in the life to come call the angels by the names of females."[37] The character Salman is outraged at such prejudice: "What finally finished Salman with Mahound: the question of the women," he says, complaining about Mahound's womanizing. "The point about our Prophet, my dear Baal, is that he didn't like his women to answer back" (*SV*, p. 366).

The Jahilia episode begins with a crucial locus of man's inhumanity to woman—the biblical story of Hagar. The Jahilians are celebrating the anniversary of Ibrahim, Hagar, and their son Ismail's arrival in the valley, after which the patriarch proceeded to abandon his wife and child. "And left, the bastard. From the beginning men used God to justify the unjustifiable" (*SV*, p. 95). Since Ismail is Gibreel's real name, we can see the rebellious actor as the exiled child of patriarchal religion.

In defending *The Satanic Verses,* Rushdie reaffirms his feminist critique of Islam. "I thought it was at least worth pointing out that one of the reasons for rejecting the goddesses was that *they were female.* The rejection has implications that are worth thinking about. I suggest that such highlighting is a proper function of literature."[38]

The title of the novel has also inflamed critics. "Satanic verses" may refer to the two lines deleted from the Koran, or the entire Koran, since the character Salman suspects that it is not inspired scripture. Or the title can be taken to mean that Rushdie's novel is itself made up of satanic verses, two lines blown up into a diabolic parody of the whole Koran. Far from proof of Mohammad's wisdom and God's justice, the "Satanic Verses" thus construed would present Islam as born in a moment of subversion and flowering in the secular chaos of contemporary London.

Other Muslim critics complained that Rushdie had lost his sense of the supernatural,[39] lapsed into nihilism,[40] and produced hate literature,[41] playing into the hands of those who had "not yet laid the ghost of the crusades to rest."[42] He had, moreover, betrayed his own people (the same accusation lodged against Philip Roth after *Portnoy's Complaint* and *Goodbye Columbus*). As Edward Said ventriloquizes, "there rises the question that people from the Islamic world ask: Why must a Moslem . . . represent us so roughly, so expertly and so disrespectfully to an audience already primed to excoriate our traditions, reality, history, religion, language, and origin? Why . . . must a member of our culture join the legions of Orientalists in Orientalizing Islam so radically and unfairly?"[43]

Some commentators have even condemned *The Satanic Verses* on the grounds of its style, as an "incoherent fantasy."[44] "His attempt to mix normalcy and fairy tale myths created by him," wrote Professor Syed Ali Ashraf, director-general of the Islamic Academy in Cambridge, "[does] not carry conviction. . . . Rushdie is thus a practitioner of black magic who turns things upside down."[45] All in all, as Ralph Ellison and Joseph Brodsky said of the *fatwa,* the Islamic world has given the book "a rather harsh review."[46]

It is interesting that Rushdie's magic realism was considered almost as offensive as his blasphemy. Rushdie describes magic realism as a development from Surrealism reflecting a Third-World consciousness in which corruption, conflict, and pain are always extreme. He adopted the style, he says, because he believed that fiction and politics are inseparable. "If one is to attempt honestly to describe reality as it is experienced by religious people, for whom God is no symbol but an everyday fact, then the conventions of what is called realism are quite inadequate. . . . A form must be created which allows the miraculous and the mundane to co-exist at the same level."[47]

The mixture of wisdom and nonsense in this statement is arresting. Certainly, magic realism combines realism and the fantastic, but Rushdie's devastatingly parodic fantasies about ancient Arabia bear no resemblance to the fantasies of the faithful. His writing has much more to do with First-World high art than the mind-set of the Third World—with the fantasy-life of a political satirist than the imagination of the pious believer. The novel is elitist, posing problems to the average reader beyond anything in, say, the work of Gabriel Garcia Márquez. This is not to say that *The Satanic Verses* is not a good novel or that it should be banned or censored, but Islamic critics were right to find not only its content but its form provocative.

But perhaps the most often repeated criticism of Rushdie by Muslims and non-Muslims alike is that he knew exactly what he was doing and hence is responsible for the deaths, the riots, and the threats against his life. Certainly Rushdie knew that the book would be controversial; he built this idea into the novel itself. After naming Mahound's Koran-distorting scribe after himself, Rushdie wrote, "Your blasphemy, Salman, can't be forgiven. . . . To set your words against the Words of God" (*SV,* p. 374). In *Shame,* Rushdie even seems to have imagined his future house arrest in the forced seclusion of the mothers (sic) of the character Omar Khayyam.[48] And in *The Satanic Verses,* he writes that the anglicized Chamcha "had begun to hear, in India's Babel, an ominous warning: don't come back again. When you have stepped through the looking-glass you step back at your peril. The mirror may cut you to shreds" (*SV,* p. 58). Lewis Carroll, always an important influence, became an inspired prophet for Rushdie in "the crazy, upside-down logic of the post-*fatwa* world."[49]

But however knowing or, indeed, prophetic Rushdie might have been, he claims to have been astonished by the catastrophes that followed his book's publication: "to write a dream based around events that took place in the seventh century of the Christian era, and to create metaphors of the conflict between different sorts of 'author' and different types of 'text'—to say that literature and religion, like literature and politics, fight for the same territory—is very different from knowing, in advance, that your dream is about to come true, that the metaphor is about to be made flesh, that the conflict your work seeks to explore is about to engulf it, and its publishers and booksellers; and you."[50] Rather than assuming that Rushdie knowingly provoked the *fatwa,* it seems more reasonable to see him as controlled by what Christopher Hitchens calls the "law of unintended consequences."[51] Otherwise, as Rushdie himself insists, one ends up blaming the crime on its victim.

Even when Rushdie is not pictured as a villain, *The Satanic Verses* is caught in a language of textual culpability: "Because of a novel by Anglo-Indian writer Salman Rushdie . . . six people died in rioting in the last week, and scores of others were injured."[52] For some of the most moderate of Rushdie's detractors, this causal connection between book and death is the bottom line. Remove the book and you prevent deaths. But one might just as easily say that *because* of the Koran (or the Old or New Testaments, for that matter), countless thousands, even millions, have died. Should these books never have been disseminated?

Rushdie was taking quite a risk—if only in aesthetic terms—by writing *The Satanic Verses,* for his aim was to explore precisely this cusp between art and

politics. In a sense, the novel is about the very controversy it provoked. In a pre-*fatwa* interview, Rushdie pointed out that though Mohammad had shown his tolerance to opposing ideas in having only five or six people executed after he re-took Mecca, among them were two writers and two actresses who had performed satires. "Now there you have an image that I thought was worth exploring: at the very beginning of Islam you have a conflict between the sacred text and the profane text, between revealed literature and imagined literature." [53]

In effect, Rushdie is now in hiding and others are maimed or dead because he pressed one of the world's sorest bruises: the incompatibility between revelation and imagination, or in political terms, totalitarianism and liberalism. If liberalism welcomes diversity and disjunction, fundamentalism casts these out in the name of purity, creating a system of inside and outside—the pure within, the barbarian without. Liberalism wants everyone inside, allied by a premise of solidarity overarching unlimited, nonviolent disagreement. The novel is an artistic structure with specifically these liberal traits. In Rushdie's case, it is a magic-realist hybrid of countries, centuries, and ontologies—a mongrel artform for mongrel identities in a mongrel world. From such a perspective, the contemporary novel is not just a work of art, and the postcolonial migrant experience is not just a minority reality. Both become archetypal expressions of liberalism, and register an ideological shift that fundamentalisms of all sorts find threatening.

PASTICHE LONDON

Rushdie himself embodies this mongrel experience. Born in Bombay of Muslim parents, educated in England, rebuffed in Pakistan after his return to the East, he has spent most of his adulthood as an expatriot in London. *The Satanic Verses,* as we have seen, is set in London and Bombay, with Mohammad's Arabia thrown in for good measure.

It may be hard for a Westerner to grasp the significance of ancient Arabia and contemporary Bombay in the novel, but it is relatively easy to see how Rushdie's adopted London comes to symbolize postcolonial diversity. London is a museum world, and the museum, like the cathedral or the palazzo in their day, is the dominant symbol of our postmodern times. A museum is an imposing assemblage of bits and pieces, history for attention-deficit amnesiacs. Likewise, London is an institutionalized pastiche. A fusion of past and present, of disjoint classes, races, and nationalities, London embodies the two central traits of artis-

24. Quinlan Terry, *Richmond Riverside*
(1983–1988). From *What Is Classicism?*
(London: Academy Group), p. 44.

tic pastiche: incongruous conjunctions, as in Peter Ackroyd's "historical" nov-
els and biographies, and unabashed simulation, as in Quinlan Terry's "Geor-
gian" mansions, built circa 1988 (fig. 24).

Still surrounded by remnants of its imperial past, England is obsessed with
fakery, revival, and historical disjunction. In recent years the British Museum
has run two major exhibitions on aesthetic fakes scrutinizing "the art of decep-
tion." [54] The largest development schemes in the capital are mock Venetian
piazzas and Roman squares. A night at the English National Opera may feature
Macbeth warbling Verdi with a chorus of pixies and stormtroopers, or *Xerxes*
(fig. 25) set in an eighteenth-century French tea garden with everyone sitting
in deck chairs reading the papers. Peter Ackroyd's simulations of Wilde and
Chatterton and Hawksmoor have become best sellers, and a characteristic April

25. English National Opera production of Handel's *Xerxes*, Act 2 (1988).
Photo by Zoe Dominic.

Fool's joke in the *Independent* was a report that a cleaning of the *Mona Lisa* revealed her enigmatic smile to be seventeenth-century overpainting on an ugly frown.

Pastiche in London is political gunpowder; it explodes into controversies revealing the parlousness and poignancy of national identity. *The Satanic Verses* is the most prominent example, but less violent instances turn up everywhere. When the *Oxford Dictionary of Modern Quotations* appeared, the BBC report of the event stressed the incongruity between such phrases as "We are a grandmother" or "Cowabunga" and the venerable university that had amassed the entries. Eric Hobsbawm's phrase "the invention of tradition" reveals the recent provenance of rituals that the public takes as the immemorial foundation of its identity. Attempts to bypass such traditions, for example, the *Independent*'s policy of not covering the royal family, merely verify the importance of these historical vestiges.

The Prince of Wales's speeches on architecture stress the authority of tradition. He charges the "monstrous carbuncle" of modernist architecture with turning London into a pastiche, and in the process, the class ideology hidden in the word surfaces. For a pastiche is a violation of decorum, a mixture of unre-

lated elements, like the humble macaroni pie or *pasticcio* that gave it its name. Pastiche is comic, light, low, and shamelessly imitative, whereas classicist purity is tragic, deep, noble, and innovative within established norms. Pastiche is democratically diverse and tolerant of inconsistency. It is the clownish face on social justice, a joke with deep seriousness.

London institutions split along the divide between classicism and pastiche: neoclassicist versus postmodern architecture (or modernism versus neoclassicism if you talk to the architectual establishment), the Royal Opera Company at Covent Garden versus the English National Opera at the Coliseum. The experimental, popularly priced, English-language ENO produces exuberant pastiche productions, whereas Covent Garden, with triple the entrance prices, attempts fidelity to the original conception, conserving rather than recreating the past. On the musical stage, audiences take a *Journey to the Forbidden Planet* of pastiche, with English performers imitating 1950s American rock singers imitating an earlier sci-fi movie which itself took off *The Tempest.* In no other country would the audience, gyrating in the aisles, still be able to catch the barrage of Shakespearean allusions.

British fiction is equally split between the traditionalists and the pasticheurs, and no one is quite sure who the innovators are and who the throwbacks. Queenie Leavis warned in 1980 that

the England that bore the classical English novel has gone forever, and we can't expect a country of high-rise flat-dwellers, office workers and factory robots and unassimilated multi-racial minorities, with a suburbanized countryside, factory farming, sexual emancipation without responsibility, rising crime and violence, and the Trade Union mentality, to give rise to a literature comparable with its novel tradition of a so different past.[55]

The novel has adapted to the changing British reality either by preserving traditional form with a new content, as in the work of Kingsley Amis, Margaret Drabble, and Anita Brookner, or by producing a host of camp imitations and revivals, such as the novels of Peter Ackroyd, D. M. Thomas, John Fowles, A. S. Byatt, Martin Amis, and Salman Rushdie. Even as traditional-seeming a novelist as Kazuo Ishiguro takes up the theme of historical disjunction in *The Remains of the Day,* in which a butler who has embodied the values of old, aristocratic England finds himself forced by his new American master to learn to "banter." A. S. Byatt's *Possession,* which succeeded *The Remains of the Day* for the Booker Prize, is full of quasi-nineteenth-century letters and poems; it is a love story between present and past.

Revivals and adaptations have been among the most successful plays on the London stage: Christopher Hampton's reworking of Laclos's *Dangerous Liaisons;* Timberlake Wertenbaker's *Our Country's Good,* which conjures up an eighteenth-century staging of Farquhar's *Recruiting Officer;* or Richard Nelson's *Two Shakespearean Actors,* in which the Bard is enacted in the contrasting American and British thespian styles of the last century. America, with its big money, constant change, and absence of historical depth, is the ever-present symbol of pastiche gone wrong, flattening the past into a gaudy, meaningless junk-heap.

At the same time, there is a price to pay for diversity. British fears of a lurking "other" erupt in strange scandals. Every few months a new tale of child abuse or Satanism takes over the media—not isolated acts but the work of whole communities. In each case, it appears for a while as if Britain is overrun with deviants, and then the charges are dropped and the whole episode is declared an error—the product of hysterical social workers or the tabloid press.

Spy scandals cast up the same spectre of aliens living unsuspected in our midst—figures like Anthony Blunt, so respectable as to confuse the whole issue of treason. Is Peter Wright as spycatcher a greater danger to British security than his quarry? Or, as Tom Stoppard's *Hapgood* and Alan Bennett's *Single Spies* ask, is a false semblance so unusual or improper? With enigmas popping up at every turn, the English have learned a tolerance for large-scale uncertainty that makes the paradoxes of aesthetic pastiche seem a rather tame affair.

In terms of political self-image, Britain lives with a crushing disjunction between its past imperial glory and its present postcolonial slump. There is a special poignancy, then, in its wrestlings with pastiche. Though many citizens would concur with Timothy Garton Ash's depiction of the nation as "middle-sized, middle-aged, not without education, spirit, and charm, but slightly out of trim, rather down at heel and struggling to keep up in competitive company,"[56] their self-image still contains a hint of the old glory. If the Tory and the Labour Parties are now hybrids, they once reflected rather clearly the class structure of Britain. If London is now a multiracial agglomeration, it was once a capital populated with *Englishmen.* All that is mixed was once pure, the mythology asserts, or at least pur*er,* less contradictory.

But since this past is now lost, the only way to keep it before us is through pastiche. The mixing of past and present, the humorous and sometimes violent forays into fakery and revival, are the only adequate expression of the postmodern, postcolonial afterworld of contemporary London. As the nineteenth-century poetess in *Possession* says, "It may be that your diligent reconstitution—

like the restoration of old Frescoes with new colours—is our way to the Truth—a discreet patching." [57] By now though, the patching is anything but discreet and the Truth it leads to may be indistinguishable from the patchwork—a conclusion that does desperate violence to the historical consciousness that is such a crucial part of British identity. In light of all this, *The Satanic Verses* may be one of the most normative works of British fiction of the past decade.

"In Good Faith," the moving speech Rushdie wrote for the first anniversary of the *fatwa,* states in the clearest terms his sense of the political and aesthetic importance of pastiche.

Those who oppose [*The Satanic Verses*] most vociferously today are of the opinion that intermingling with a different culture will inevitably weaken and ruin their own. I am of the opposite opinion. *The Satanic Verses* celebrates hybridity, impurity, intermingling, the transformation that comes of new and unexpected combinations of human beings, cultures, ideas, politics, movies, songs. It rejoices in mongrelisation and fears the absolutism of the Pure. Melange, hotch-potch, a bit of this and a bit of that is *how newness enters the world.* It is the great possibility that mass migration gives the world, and I have tried to embrace it. *The Satanic Verses* is for change-by-fusion, change-by-conjoining. It is a love-song to our mongrel selves.[58]

Conservatives and fundamentalists are not the only ones to feel threatened by pastiche. "In a world in which stylistic innovation is no longer possible," says the Marxist scholar Fredric Jameson, "all that is left is to imitate dead styles, to speak through the masks and with the voices of the styles in the imaginary museum." [59] One of Rushdie's goals, I think, is to change this image of late-modern exhaustion into a positive state—to show, in the midst of fakery and mongrelization, "how newness enters the world." [60]

EXILE, MIGRATION, AND THE POSTCOLONIAL EXPERIENCE
Rushdie speaks at various times of his attempt to fill with art the "God-shaped hole" left by his loss of faith. He presents art as surrogate religion, and in this way he recapitulates the classic fetishistic bind of embracing a presence that memorializes what is lost. In Rushdie's case, this hole is left not only by the loss of faith but by the loss of a homeland. In *Shame,* he wrote, "I tell myself this will be a novel of leavetaking, my last words on the East from which, many years ago, I began to come loose." [61] And yet he went on to write *The Satanic Verses,* and will no doubt keep recreating that world, returning to it and remak-

ing it in fiction. The migrant, in creating and recreating an "imaginary home-land" and in creating and recreating himself, becomes a fiction-maker, a fetish-ist, and a quasi-work of art. Comparing himself to Omar Khayyam, the Persian poet of *The Rubaiyat* who supplies the name for one of *Shame*'s main characters, Rushdie writes, "I, too, am a translated man. . . . It is generally believed that something is always lost in translation; I cling to the notion—and use, in evi-dence, the success of Fitzgerald—Khayyam—that something can also be gained." [62]

Rushdie claims that his first literary influence as a child was the film of *The Wizard of Oz,* with its magic formula, "There's no place like home." As he read the Oz books and saw Dorothy returning to this fantastic land each time, he realized that Oz had finally *become* her home. "The imagined world became the actual world, as it does for us all," [63] he wrote, for once we leave behind our childhood we learn that there is no such place as home except what we create. Here migration becomes an allegory of maturation, and fiction-making a spe-cial case of homemaking. In fiction, Rushdie invents "imaginary homelands, Indias of the mind." [64]

Rushdie's constant aim is to redeem the fallen, split, exiled state of the migrant, presenting it not as a loss but as a source of newness. This redemptive mission links him to Warhol and Morrison, rather than to those on both the right and left who consider the advent of a pastiche world as an occasion of pain and alienation. In Rushdie's view, migrant dislocation is regrettable, but only insofar as it entails an encounter with the injustice and violence of those in power. Racism, privilege, and intolerance—the hangovers of colonialism—are the real dangers.

In *Midnight's Children,* Rushdie personifies colonialism in the wealthy Briton, William Methwold. Methwold is forced to sell his estate to the hero's father when Indian independence is imminent. He does so on the condition that the house remain unchanged in every detail until Independence, and that the family live with him in the months till then, taking cocktails without fail at 6:00 P.M., and performing all the other rituals of colonial existence.

Colonialism produces a split identity in both the colonizers and the colo-nized. As a symbol of this division, Methwold's hair is parted in the center, "one of those hairlines along which history and sexuality moved." [65] Women find the gorgeous part irresistible, and it precipitates an infidelity that engenders the book's hero, born of two incompatible worlds. But the part proves to be a mere fantasy based on power. On Independence Day, Methwold removes his bifur-

cated wig, along with his colonial authority. But the breach is not healed. With her part dividing violent streaks of white and black hair, Indira Gandhi takes the colonialists' place after Independence, ordering mass executions and the sterilization of political enemies as "emergency measures."

The splits within colonialist and postcolonialist oppressors split their victims as well: Gibreel and Chamcha and virtually all the characters in *The Satanic Verses*. Rushdie treats the suffering of these victims with humor—after all, such is the human condition as he presents it—but this humor does not indicate a benign resignation. His anger is evident as he shows the police in *The Satanic Verses* arresting Chamcha as an illegal alien after his fall, and beating and demeaning him in the paddy wagon, forcing him to eat his goatish excrement. Though their surnames are Bruno and Novak and Stein, they see themselves as guardians of English purity, and contribute to the bestialization of Chamcha as he changes into an eight-foot, horned, brimstone-breathed Satan. As a fellow immigrant tells Chamcha, "They have the power of description, and we succumb to the pictures they construct" (*SV,* p. 168).

Described by the establishment, the migrant is a beast, a monster, the embodiment of evil. Described by himself, he is a shape-shifter, a Joycean dream figure. Rushdie's sources—Lewis Carroll, Joyce, Apuleius, Borges, Pynchon— are artists of metamorphosis and exile. Exiles are like the modern work of art—constructions, forms isolated from their native land and tradition. But in coming to grips with their own artificiality, exiles realize that all realities are constructed, and this, Rushdie claims, is a discovery essential to democracy.

The belief that the exile is the consummate democratic citizen lies behind all of Rushdie's fiction and criticism. "That is what the . . . disruption of reality teaches immigrants," he wrote in a review of Gunter Grass,

> that reality is an artifact, that it does not exist until it is made, and that, like any other artifact, it can be made well or badly, and that it can also, of course, be unmade. What Grass learned on his journey across the frontiers of history was Doubt. . . . he suspects all total explanations, all systems of thought which purport to be complete. . . . To experience any form of migration is to get a lesson in the importance of tolerating others' points of view. One might almost say that migration ought to be essential training for all would-be democrats.[66]

From migration to the constructedness of reality, to doubt, to democracy—this is the archetypal plot traversed in the postmodern novel or the postmodern life. It allows for change, tolerance, and redescription. In *The Satanic Verses,* angels are defined as those who doubt (*SV,* p. 92).

The difficulty with embracing doubt, this middle state, is that it requires tremendous energy. Nothing stays in place; the reality one constructs so laboriously out of scraps and pieces constantly falls apart and needs to be reconstituted. Likewise, some reviews of *The Satanic Verses* complain about the rigors it imposes on its audience. "The reader," Jonathan Yardley stated, "is too much aware of the author so busily at work: leaping back and forth between 'real' worlds and dreams, moving his characters across the vast gameboard he has constructed, demanding that we gasp and applaud at his ability to shoot off firecrackers. In the end, though, what he produces is not astonishment but exhaustion." [67] Even for the most receptive audience, irony and relativism can become a wasting diet.

The individual caught in this shifting indeterminacy is as hard to read as *The Satanic Verses.* Thus, the Pakistani movie *International Guerrillas* shows Rushdie as an agent of British intelligence in smart Western dress and an intellectual's glasses slashing away with a sword at crucified Muslims.[68] British conservatives, in contrast, see him as a militant anticolonialist. And what is he? He is both anticolonial and anti-Islam, or neither. Like the patriarch in *Midnight's Children,* he is caught between belief and unbelief. He attacks the Tory Party with the same ferocity he expends on Islam. In denouncing imperialism, he embodies all its stereotypes—"the London address, the Jewishness of the publisher, the large advance, the author's Booker Prize, his membership in the Royal Society of Literature." [69] Like every "middle" that should logically be excluded, like every cake eaten and had, like every postmodern both/and, Rushdie sets off explosions—not only firebombs and bullets, but explosions of language that punch craters in thought. As Gerald Marzorati notes, Rushdie "has reopened one of our great cultural questions: how and why does fiction mean so much?" [70]

LIBERALISM AND AESTHETIC PARADOX

Thus, Rushdie leads us back to the theme of this study—that art's power comes from its contradictoriness. It both is and is not a part of reality; it both is and is not a representation of reality; it both acts on and is irrelevant to politics and history. Irritating as such contradictions are, unless we maintain both sides of them we end up with a grotesque view of both art and life. By equating literature with politics, Iran and the whole Middle East have turned reality into a Wonderland world where novels cause riots and writers must hide in fear of their lives. At its crises, *The Satanic Verses* depicts reality just this way. A hallu-

cinatory party at a film studio in London ends with characters enacting movie plots. The treatment of colored immigrants as less than human turns them literally into beasts. Literalism, the collapse of paradox, becomes the greatest threat to peace and sane reading.

Rushdie spells out the paradoxical relation between fiction and reality in his own novels. "Once upon a time," he writes in *The Satanic Verses, "it was and it was not so,* as the old stories used to say, *it happened and it never did*" (*SV,* p. 35). *Midnight's Children* opens, "I was born in the city of Bombay . . . once upon a time. No, that won't do, there's no getting away from the date . . . August 15, 1947. And the time? . . . On the stroke of midnight. . . . Oh, spell it out, spell it out: at the precise instant of India's arrival at independence. . . . thanks to the occult tyrannies of those blandly saluting clocks I had been mysteriously handcuffed to history."[71] Once upon a time—he was handcuffed to history. Rushdie evokes and erases literary convention to enter history, but makes history too fantastic to seem anything but fiction.

Does reality itself aspire to the state of fiction? In *Midnight's Children,* Rushdie describes India as a country obsessed with correspondences, a reality hungry for form and metaphor. But then, it is so new a sovereign state that its existence, he claims, is an act of communal conjuring. "A nation which had never previously existed was about to win its freedom," says the narrator of *Midnight's Children,* "a mythical land, a country which would never exist except by the efforts of a phenomenal collective will—except in a dream we all agreed to dream."[72] For Rushdie, political realities are the products of mass imagining.

In his children's fable, *Haroun and the Sea of Stories* (1990), Rushdie presses this point with some bitterness. Haroun's father, Rashid, is a great storyteller whose services are much sought after by politicians. For no one believes what the politicians say. The more they pretend to be telling the truth, the more everyone knows they are lying. "But everyone had complete faith in Rashid, because he always admitted that everything he told them was completely untrue and made up out of his own head. So the politicos needed Rashid to help them win the people's votes."[73] Politicians need mythmakers. Art, because of its disconnection from truth, has more power over a populace than the words of those whose connection to truth runs through self-interest.

The trouble is that today the artist—like Rashid, whose stories have stopped flowing—can redescribe reality only by offending the "politicos" and the people alike, because the truth of things makes for damning and also unsa-

tisfying art. Instead of a definitive, secure world, we have the parallax shifting of pastiche. "People do not perceive things whole," says Rushdie; "we are not gods but wounded creatures, cracked lenses, capable only of fractured perceptions. . . . Meaning is a shaky edifice we build out of scraps, dogmas, childhood injuries. . . . Writers are no longer sages, dispensing the wisdom of the centuries."[74] If history is always ambiguous, reality always an idiosyncratic patchwork, and the visionary a mere recorder of this state of affairs, the whole notion of authority is undercut, and the politician becomes just another partial describer, but one with the power to impose his descriptions on those less powerful. The artist, insofar as he or she can overcome the general paralysis of such a worldview, exerts power through form, and through the honesty of the fictive lie.

Like all paradoxes, this one is delicate, and in pushing both sides of it as violently as he does, Rushdie runs the risk of looking as if he merely wants to have things both ways. Critics have argued that Rushdie aligns himself with those who believe literature is socially engaged, but when his work is taken that way he defends himself by saying that he is a writer who just wants to get on with his art.

One could, of course, concur. On the one hand, in his much-quoted 1984 essay "Outside the Whale," Rushdie claims uncategorically that "works of art, even works of entertainment, do not come into being in a social and political vacuum; . . . the way they operate in a society cannot be separated from politics, from history. For every text, a context."[75] Arguing against George Orwell's disillusioned quietism, in which we are "inside the whale" (the world-process) and simply record it, he insists that there is no whale, no inevitable system that removes our ethical freedom like an engulfing womb. "Where Orwell wished quietism, let there be rowdyism; in place of the whale, the protesting wail."[76]

But on the other hand, Rushdie insists on a whole series of subtle and not-so-subtle distinctions between art and the world. If one imagines and represents the words of those who insulted the Prophet, one is not thereby insulting the Prophet oneself.[77] Exposing the rigidity and sexism of Islam in a fiction is not the same as trying to destroy the faith: "The idea that this is somehow an attack on . . . religion shows an absolute failure to understand what fiction is."[78] After all, the names are changed, and most or all of the action takes place as dream or delusion. "*The Satanic Verses* is art, not theology," he continues.[79] "Fiction uses facts as a starting-place and then spirals away to explore its real concerns, which

are only tangentially historical. Not to see this, to treat fiction as if it were fact, is to make a serious mistake of categories. The case of *The Satanic Verses* may be one of the biggest category mistakes in literary history." [80]

The formulations writers have offered in Rushdie's defense do little to rationalize this perplex. The Hungarian Georg Konrad says, "It is absolutely irrelevant what is in your novel because a novel cannot be the object of any moral or legal judgment." [81] The Englishman Graham Swift calls the work of literature "creative expression, which does not argue, state or assert, so much as make. A novel exists, *lives* in the minds of its readers." [82] The Nigerian novelist Ben Okri explains that "Writers are amongst other things the dream mechanism of the human race. Fiction affects us the way dreams affect us. They share the same insubstantiality. They both have the capacity to alter reality." [83]

These sentences are so easy to accept and so difficult to understand! We embrace them because we have been brought up in a paradox, a contradiction so blatant as to be indistinguishable from religious dogma. The artwork maintains this paradoxical ontology, like Tinkerbell, only if we believe in it. To the arch-formalist, the work is utterly irrelevant to truth statements; to the fundamentalist, it is indistinguishable from truth statements. It is the liberal who believes the novel to be speech that is not speech, politics that is not politics, form that exceeds the formal.

It is only this mind-set that could generate the contradictions with which Rushdie introduces his most eloquent and quasi-rationalist self-defense:

> At the centre of the storm stands a novel, a work of fiction, one that aspires to the condition of literature. . . . *The Satanic Verses* has been described, and treated, as a work of bad history, as an anti-religious pamphlet, as the product of an international capitalist-Jewish conspiracy, as an act of murder . . . , as the product of a person comparable to Hitler and Attila the Hun. It felt impossible, amid such a hubbub, to insist on the fictionality of fiction.
>
> Let me be clear: I am not trying to say that *The Satanic Verses* is "only a novel" and thus need not be taken seriously. . . . I do not believe that novels are trivial matters. The ones I care most about are those which attempt radical reformulations of language, form, and ideas . . . to see the world anew.[84]

In other words, fiction is not history, religion, political plot, violence, or immorality. At its best, it changes both language and our ideas of the world. But if we are attentive to what Rushdie has said elsewhere about the constructedness of reality, then in changing our *ideas* about the world it changes the *world*. And

since the world is history, religion, political plotting, violence, and immorality, it affects all these. Considering that the best that Western aestheticians have done to explain this paradox has been to comment on the confusions arising from likeness or iconicity, we should not be surprised to find that fundamentalists unschooled in the liberal ideology of fiction consider such statements unconvincing and even nonsensical.

In *The Satanic Verses,* Rushdie makes just this point. The poet Baal, hiding from Mahound's persecution in a brothel, suggests mischievously that the twelve prostitutes there take on the names of Mahound's twelve wives, who have recently been cloistered in a harem because of Mahound's proscription against licentiousness. The wives' seclusion has predictably made them widespread objects of licentious thought. Thus, for the soundest of business motives, the prostitutes adopt the venerated wives' names in order to satisfy their customers' fantasies.

The prostitutes are eventually jailed, but their blasphemous names remain a professional secret until Baal, disguised in skin dye and turban, begins singing love songs to them outside the prison walls. At first the people are so moved by the beautiful verses that they do not notice the names memorialized in song. But when they do, Baal finds himself "surrounded by angry men demanding to know the reasons for this oblique, this most byzantine of insults. At this point, Baal took off his absurd turban. 'I am Baal,' he announced. 'I recognize no jurisdiction except that of my Muse; or, to be exact, my dozen Muses.' Guards seized him" (*SV,* p. 391). One can proclaim the jurisdiction of the Muses, and try to live in it, but that does not prevent those who recognize no magic peripheries around the kingdom of art from invading it at will.

Baal was declaring a lot more than the authority of the Muses. In the midst of the *fatwa* crisis, Iran's legislative speaker, Ali Akbar Hashemi Rafsanjani said that "The ground has been laid for a vast battle between Islam on the one hand and paganism and arrogance on the other."[85] For Westerners, his "paganism and arrogance" should be rewritten as "free speech and liberalism." The attack on *The Satanic Verses,* says *The New Republic,* is a typical attack on secular humanists,[86] and this secularism involves, axiomatically, the freedom to question orthodoxies and hence to give offense. "What is freedom of expression?" asks Rushdie. "Without the freedom to offend, it ceases to exist."[87]

Even moderates have criticized Rushdie for being gratuitously rude and insensitive, for speaking "fighting words" that could have provoked only retali-

ation.[88] The Bradford Council of Mosques put the point more bluntly: "There is a community of two million Muslims in the United Kingdom who have been offended for financial gain, and they have no legal protection against this abuse."[89] " 'But but but what is the point of giving persons Freedom of Speech,' declaimed Butt the Hoopoe [in Rushdie's *Haroun and the Sea of Stories*], 'if you then say they must not utilize same? And is not the Power of Speech the greatest Power of all? Then surely it must be exercised to the full' " (p. 119). In 1991, after his "one thousand days in a balloon," Rushdie would push this defense of free speech to the limit: " 'Free speech is a non-starter,' says one of my Islamic extremist opponents. No, sir, it is not. Free speech is the whole thing, the whole ball game. Free speech is life itself."[90]

It is painful for liberals to defend such an absolute stance. The advantage of the recent American aesthetic controversies is that they did not force liberals to go quite so far. When a cartoonist in the *Arizona Republic* compared the *fatwa* to the attempted suppression of *The Last Temptation of Christ* by conservative Christians, Senator Gorton was moved to object. The two works may be similarly offensive, he claimed, "but the difference in the reaction . . . is the difference between the exercise of free speech . . . versus the abuse of free speech to incite others to murder those with which they disagree."[91] (The senator quickly added that, after reading "several reviews" of *The Satanic Verses,* he had no interest in purchasing or reading the novel.)

Senator Gorton's distinction is indisputable, and one might go even further and point out that though *The Last Temptation of Christ* was reviled throughout the Christian world, it was banned only in India, a non-Christian country. Trying to persuade others not to read a book or see a movie is different from making it impossible for them to do so.

In a country like Iran, public order is an embodiment of divine will, so that any violation in word or deed is apostasy. According to Abdulaziz A. Sachedina, "the act of apostasy was regarded as an act of sedition that had caused discord and had threatened the unity of Islamic community."[92] Censorship, under such conditions, is essential for maintaining the fit between the divine and human worlds. But there are always flaws in the perfection of public order, and hence, according to PEN, an estimated 350 writers currently suffer in the jails of fundamentalist countries around the world.[93]

In nations of mixed or transitional ideologies, censorship can result in bewildering contradictions. According to Farrukh Dhondy, Commissioning Edi-

tor for Minorities on London's Channel 4, "The regime of Benazir Bhutto, the first democratic regime in Pakistan for ten years, had to ban [*The Satanic Verses*] as its first tactical act of survival and had then to order its police to shoot down demonstrators who were using *The Satanic Verses* to challenge all liberality."[94]

Essential to liberalism is the belief that the norms of a foreign culture should be treated with respect, and judged on their own terms. When this "ethnographic approach" reveals policies inimical to liberalism, the ethnographical liberal fights back with the tools of reason. In the Rushdie case, these never had a chance. What does the liberal do then? To insure his right to say what he wants, he must limit others' right to live in the ideological world of their choice—i.e., one without dissenters or relativists.

The perennial liberal paradox arises here: in a state controlled by fundamentalist ideas a liberal cannot speak, but in a state controlled by liberal ideas a fundamentalist cannot act. The ideas of a fundamentalist are exclusionary and performative, i.e., valid only when turned into actions; an article of faith is not a mere topic of discussion to the believer. Thus, the liberal, in insisting on tolerance, is insisting on not only his idea but his practice. In the considerable commentary about the Rushdie affair in America, the absolute value of tolerance or free speech emerges as a point of dogmatic blindness for some and a logical embarrassment for others. Leon Wieseltier states without irony, "Let us be dogmatic about tolerance,"[95] but for Norman Mailer the issue is not so easy: "We believe in freedom of expression as an absolute. How dangerous to use the word absolute."[96]

At this point, reason often turns to irony and open hostility. "The news that fun-loving literary critic Ayatollah Ruhollah Khomeini has ordered the entire Muslim world to murder author Salman Rushdie suggests a few long-overdue thoughts about the once-fashionable notion of 'cultural relativism,'" wrote Jeff Greenfield, former political aide to Robert F. Kennedy and John Lindsay. "It is about time that we recognized that . . . the premises of freedom are not subject to boundaries of geography or tradition. . . . Ask the good people of Amnesty International . . . whether such impulses are limited by culture. . . . The assault on Salman Rushdie and *The Satanic Verses* is not a case of Western cultural elitism. It is, rather, a sign that there is in the world a substantial body of opinion that says only its thoughts can be permitted free expression. That body of opinion . . . is wrongheaded, dangerous and immoral."[97] So much for tolerance. It functions, apparently, only until threatened in deed; otherwise, its

sphere is purely verbal. Tolerance applies when people do not care enough about a point of view to fight over it; once they do, the game is up.

The Rushdie affair has produced paeans of praise for blasphemy and satire. Christopher Hitchens credits blasphemy for "every advance in human civilization," hailing it as "the birthpang of democracy." "Remember that Europe was once a stifled, theocratic, feudal, crusading society . . . , and it was blasphemy that pushed open the shutters."[98] Likewise, Michael Foot, a Labour MP and chairman of the 1988 Booker Prize judges, points to liberalism as "one of the real miracles of western civilisation," ending all those centuries of hopeless warring between Christian and Muslim or Protestant and Catholic. "It was certainly not the work of the fundamentalists on either side. . . . How much wiser and braver were the Montaignes, the Jonathan Swifts, the Voltaires, the Salman Rushdies who knew that if such insanities were to be stopped, they must be mocked in the name of a common human decency with a claim to take precedence over any religion."[99]

The claim of a common human decency superseding any religion is just the claim that the religious wish to deny. Thus, the Archbishop of York argued that to abolish the blasphemy law "would be to signal . . . that our society holds nothing sacred, apart from the freedom of writers to write whatever they like."[100] For the faithful, religion comes first, and any religion, such as Christianity, that succumbs to this humanistic over-faith undoes itself in the process. As Shabbir Akhtar, a member of the Bradford Council of Mosques, wrote in the *Guardian,* "Many writers often condescendingly imply that Muslims should become as tolerant as modern Christians. After all, the Christian faith has not been undermined. But the truth is, of course, too obviously the other way. The continual blasphemies against the Christian faith have totally undermined it. Any faith which compromises its internal temper of militant wrath is destined for the dustbin of history, for it can no longer preserve its faithful heritage in the face of the corrosive influences."[101] Tolerant liberals, like the devils in Blake's *Marriage of Heaven and Hell,* write their messages with a corrosive pen.

In considering the Rushdie affair, Michael Ignatieff produces an elegant argument that freedom and tolerance are "contestable concepts," the limits of which are constantly being renegotiated. But even he admits that tolerance has its limits. The principles of tolerance, he claims, are "never to substitute force for persuasion in changing the opinions of human beings, and never to believe that God or reason gives you a monopoly on truth." But he continues, "There

is nothing sacred about toleration—we're not obliged to tolerate those who threaten us because of our opinions. . . . [We may] fight, as a last resort, when intolerance will not listen to reason." [102] Of course, one is left feeling that the only compelling reason for intolerance to listen to reason is to avoid a fight, and intolerance is often too idealistic to do so. Tolerance, relieved at times to find it has a bottom line, can state, like Rushdie, "Free speech is life itself," and discover that this is literally the case.

Rushdie himself examined the absolutism of tolerance in an essay written after the *fatwa* called "Is Nothing Sacred?" It is a magisterial exercise in self-conversation, the mind following the pros and cons of an issue—convinced by a claim, compelled by its counter—until we understand why the essay is the essential form of liberal thought and one of the great sources of the modern polyphonic novel. Rushdie reports that though he was trained as a child to revere books, to the point of kissing them if they accidentally fell to the floor, he would have said as an adult that nothing was sacred, that everything should be open to question, and that the idea of the sacred is essentially conservative, "because it seeks to turn other ideas—Uncertainty, Progress, Change—into crimes." [103] But, considering the recent course of events, he asks himself whether freedom of expression has not become for him a kind of sacred value, a "secular fundamentalism." [104] "Can art be the third principle that mediates between the material and the spiritual worlds; might it, by 'swallowing' both worlds, offer us something new—something that might even be called a secular definition of transcendence? I believe it can," he answers. "I believe it must. And I believe that, at its best, it does." [105] Of all the arts, literature is the freest, he continues, for its costs least to enjoy and involves least interference in either the author's vision or the audience's participation. The novel in particular, with its conflicting characters and ideologies, takes the "'privileged arena' of conflicting discourses *right inside our heads*." [106]

But just as convincingly, Rushdie reverses himself. No, he says, literature provides too provisional a view to be revered as sacred. "Nothing so inexact, so easily and frequently misconceived, deserves the protection of being declared sacrosanct. . . . We must not become what we oppose." [107] And at this point, Rushdie takes refuge in the inevitable liberal paradox. "The only privilege literature deserves—and this privilege it requires in order to exist—is the privilege of being the arena of discourse, the place where the struggle of languages can be acted out." [108] This privilege must be protected, he concludes, not to

give writers freedom but because it is a necessary space—this little room of discourse—*for everyone*. Not sacred but essential, innately flawed but privileged—literature is a fine set of paradoxes.

Rushdie's essay is a powerful restatement of liberal dogma and, as such, one of the least appealing arguments possible for a fundamentalist. Such a person does not need and certainly does not want this "little space." The arena of free play, of trial and error, of all possibilities and no consequences is an arena that is not a universally recognized good. The claim that play and dreaming and artistic experience are pan-human and essential to mental and social well-being does not convince everyone that the freedoms of the dream should be protected in public art. The point is that Rushdie's position is a matter of dogmatic faith. From my way of thinking, it is an especially good faith. If Rushdie answers fundamentalist hate, as he says, with a "declaration of love," [109] it is a declaration that deserves to be protected with the same zeal as that supporting the rights to life, liberty, and the pursuit of happiness in another Declaration. But as I say this, I cannot hide the fact that I am affirming liberalism as a faith militant, and this does not make me happy.

Thus, condemned to death on Valentine's Day, Rushdie is a man whom even liberals find it hard to love. Such is the fate of satirists. Though Rushdie described *The Satanic Verses* as "a love-song to our mongrel selves" (*SV,* p. 31), and claimed in that book that "It all boiled down to love" (*SV,* p. 397), the least affecting and convincing episodes involve the love affairs of his characters. In *Midnight's Children,* "the word" is spoken with more conviction, and perhaps we like this novel so much more as a result, though there the love is familial rather than romantic. But for Rushdie, immersion in love seems incompatible with political engagement. "The idea that *the opposite of history is love* is worth hanging on to, like a lifebelt, like a raft," [110] he says in an emotional moment. But how can love save him if he is and always has been tied to history?

Nevertheless, at the risk of sentimentalizing this embattled moralist or minimizing his obvious recklessness and egotism in producing the provocation of *The Satanic Verses,* one should not deny Rushdie's artistic integrity—the gift of love in his presentation of the truth as he sees it. At the end of *Midnight's Children,* his hero becomes manager of a pickle factory, where, like a baker of Proustian madeleines, he preserves the past. "One day, perhaps, the world may taste the pickles of history. They may be too strong for some palates, their smell may be overpowering, tears may rise to the eyes; I hope nevertheless that it will

be possible to say of them that they possess the authentic taste of truth . . . that they are, despite everything, acts of love." [111]

Though madeleines might be a more palatable legacy than Rushdie's sour art, one hopes that he will live to see the day when the world accepts it in the spirit he offers it, and that we will all be able to live less vexed by the inevitable paradoxicality of art. As we shall see in the next chapter, however, that day, for those of us in the academy, seems depressingly far away.

CALIBAN IN THE IVORY TOWER

You have taught me language, and my profit on't
Is, I know how to curse.

William Shakespeare

For the American right, the millennium's rough beast slouches toward Bethlehem clutching a laptop computer and a research grant. His way is lit by Marxism, feminism, deconstruction, and the New Historicism, and his lips curl in a philistine grin as he contemplates the demise of English literature and the entire liberal arts tradition. The beast is the American humanities professor.

As he plods his ponderous way across verdant campuses, the beast tramples over freedom of thought, civil liberties, and the West's Great Books, leaving a wasteland of ignorant, untrained undergraduates. There can be no other explanation for the New Illiteracy. It cannot be blamed on students' families, who raise them from birth; on the schools, who educate them throughout their youth; on the popular media, who fill up their imaginations from the years of *Muppet Babies* to *Beavis and Butthead*. No, the villains are the liberal academics, who sink their claws into children between the tender ages of eighteen and twenty-two, and in the process undo all of Western civilization.

Sometime during the past two decades, America decided that its children were ignorant, passive, and victimized. The country was coincidentally running itself into debt at this time, failing to keep poor people off the streets or sick people in hospitals, and turning politics into a struggle among the incompetent, the dishonest, and the self-serving. Could it all be traced back to those 1960s babyboomers, grown up and become professors?

Perhaps. Their poison was certainly at work in the academy. These "privileged beneficiaries of the spiritual and material achievements of our history," says Roger Kimball, "out of perversity, ignorance, or malice, have chosen to turn their backs on the culture that nourished them and made them what they are . . . have defiled reason with sophistries . . . [and] defrauded their students of knowledge." [1] As a result, "the academic study of the humanities in this culture is in a state of crisis" (ibid., p. xi).

As a babyboom humanities professor, I find this accusation disturbing. However outrageous Jesse Helms's denunciation of Serrano and Mapplethorpe, the Ayatollah's *fatwa,* or the Dworkin-MacKinnon anti-pornography movement may be, they can be met by a liberal critique. And if educators are in any way implicated in these scandals, theirs is only a sin of omission: they have failed to make their viewpoint sufficiently clear to the general public. But the rightist assault on the university denies the very probity of liberal educators. Of all the controversies we have considered, the political correctness scandal is the most overt attack on the experts.

POLITICAL CORRECTNESS

Whichever side of the fence one stands on, "Political Correctness" is an intellectual virus spewing out mind-numbing contradictions—an ideological gene gone wrong. Controls on speech, for example, however well intentioned, should have no place within a university dedicated to freedom of inquiry and expression. "The hypocrisy of justifying intolerance on grounds that it will create tolerance," writes the political satirist Russell Baker, "is a comic theme fit for Molière, and the conservatives are having a picnic exploiting it as evidence that liberalism has turned into tyranny." [2]

The excesses of politically correct behavior certainly deserve this derision. But rightists lump humanities professors together as if they were all PC extremists. They are accused of enforcing an "academic fundamentalism" [3] in the university, hiring only PC professors, giving A's only to PC ideas, and censoring all but PC words. Far from a place where liberty of thought and speech is guaranteed, universities become "islands of repression in a sea of freedom," [4] and professors, "Visigoths in tweed," [5] fascists of the Left, [6] liberal McCarthyites, [7] "professorial Untouchables," [8] and "thought police" (Berman, p. 19) promoting an "environment of intimidation." [9] Where once we had Mr. Chipps, we now have Big Brother.

From the liberal standpoint, critics of political correctness are just as guilty of contradiction. Professor Larry Gross of the University of Pennsylvania's Annenberg School of Communications complains that conservatives "wish to preserve a double standard whereby they can continue to calls us dykes and fags but it's PC fascism if we call them heterosexists. It's academic freedom if they define us as sick or immoral, but it's indoctrination if we argue our right to define ourselves." [10] Far from an academic fascism, says Molefe Kete Asante, "political correctness" is the name that "has been given to the major advances in our liberal democratic pluralist society over the past twenty-five years." [11]

The origins of the term "PC" contain just such reversals of meaning, and they are obscure, as befits a word to conjure by. Dinesh D'Souza (pp. xiv–xv) claims that "political correctness" began as a synonym of leftism: early twentieth-century Marxists used it "to describe and enforce conformity to preferred ideological positions," but then it dropped out of use, only to reemerge in the 1980s as the name for the leftist doctrines of the late 1960s and 1970s. According to the lexicographer William Safire, "political correctness" originated with Chairman Mao's 1963 polemic "Where Do Correct Ideas Come From?" and had its first American use in a 1975 statement by the National Organization for Women. [12] And for Paul Berman (p. 5), the term zigzags in meaning, from leftist approbation for someone toeing the party line, to leftist irony against "someone whose line-toeing fervor was too much to bear," to the current usage of the term by nonleftists who castigate any line-toeing whatsoever.

From approval to disapprobation, from leftism to rightism, from inside to outside, the changing allegiances of "political correctness" reflect a general ambivalence toward ideological commitment. For the political correctness debate enshrines the ever-present conflict in our culture between individualism and group solidarity. Interestingly, the Western university is built on this same conflict. It is not surprising, then, that each side in the PC debate accuses the other of violating the "very idea of liberal education."

THE IDEA OF THE UNIVERSITY

The Western university is based on the principles of liberal education, and these are in every way designed to foster individualism. Etymologically, "a liberal education is an education for freedom," A. Bartlett Giamatti writes, since Latin *liber* means "free." [13] In *The Idea of a University: Defined and Illustrated,* Cardinal Newman contrasted the liberal sphere to the servile, which involves "bodily

labour, mechanical employment, and the like, in which the mind has little or
no part . . . liberal education and liberal pursuits are exercises of mind, of rea-
son, of reflection." [14] The liberally educated student

apprehends the great outlines of knowledge, the principles on which it rests, the scale of its
parts, its lights and its shades, its great points and its little. . . . Hence it is that his education
is called "Liberal." A habit of mind is formed which lasts through life, of which the attributes
are freedom, equitableness, calmness, moderation, and wisdom; or what . . . I have ventured
to call a philosophical habit." (pp. 101–2)

It is these traits and habits, Newman argues (p. 113), that constitute the
philosopher, and his status is exclusionary: "Not to know the relative disposi-
tion of things is the state of slaves or children; to have mapped out the Universe
is the boast, or at least the ambition, of Philosophy." As only a small proportion
of Britain's young men were able to attend university in Newman's day, the
university's values were definitionally elitist, producing a tiny class who knew
how the universe worked, and ignoring a vast population of the servile and the
childlike (the working class, the poor, and women) whose concerns were lim-
ited to the physical and the parochial. Newman's university educated students
in freedom who were already liberated by their class, sex, and race.

In America, though liberal education extends to a much larger portion of
the population, anti-PC forces repeat the ideals of nineteenth-century ruling-
class education as if they had been formulated in Milwaukee just last week.
Dinesh D'Souza repeats Newman's words on freedom and then comments:
"The term *liberal* derives from the term *liberalis,* which refers to the free
person, as distinguished from the slave. It is in liberal education, properly de-
vised and understood, that minorities and indeed all students will find the
means for their true and permanent emancipation." Liberal knowledge, for
D'Souza, "liberates and prepares us for a rich and full life as members of soci-
ety," not just because it broadens our intellectual horizons, but because it allows
us to rise economically and socially.[15] D'Souza recommends education as the
path minorities should take if they want to achieve equality and a Lincolnesque
emancipation.

Nowhere in Newman's treatise, however, do we find education presented
as a means of social advancement or class mobility. Newman's notion of knowl-
edge would make such an idea unintelligible. He specifically contrasts liberal
education to education toward a practical goal: "that alone is liberal knowl-
edge, which . . . is independent of sequel, expects no complement, refuses to

be *informed* . . . by an end, or absorbed into any art." Quoting Aristotle, New-man terms this knowledge not fruitful but enjoyable: "By fruitful, I mean, which yield revenue; by enjoyable, *where nothing accrues of consequence beyond the using.*"[16]

As for the connection between education and justice or morality, Newman insists that "Knowledge is one thing, virtue is another," and that "liberal education makes not the Christian, not the Catholic, but the gentleman." "Quarry the granite rock with razors, or moor the vessel with a thread of silk; then may you hope with such keen and delicate instruments as human knowledge and human reason to contend against those giants, the passion and the pride of man."[17]

The separation of knowledge from practicality, morality, and action has always been an essential aspect of the idea of liberal education. Allan Bloom argues that "the university began in spirit from Socrates's contemptuous and insolent distancing of himself from the Athenian people"[18] and was virtually destroyed when Heidegger tried to annex philosophy to the practical aims of Nazism. The ancient Proclus credits the Pythagoreans with the creation of liberal studies, Thomas Short argues, because they taught mathematics as a liberation from the body. The truths revealed in mathematics are universal, "and neither served any particular party's self-interest nor depended on any particular person's perspective. . . . The Christian scholar may believe that complete self-transcendence is impossible without faith, but . . . the liberal arts continue to serve that end."[19]

Later accounts of the origins of liberal study are equally insistent on its separation from practice. "*Humanism* as a term," A. Bartlett Giamatti explains, "was invented in 1808 by a German educator named Friedrich Niethammer when he defended the teaching of Greek and Latin in secondary school curricula, all in an effort to stave off what he viewed as an increasingly practical and vocational secondary schooling."[20] When Johns Hopkins was established as the first American university modeled on German research institutes, Josiah Royce praised it for preaching "the gospel of wisdom for its own sake."[21]

The concept of academic freedom developed over many centuries to protect the independence of the scholar from partisan or practical interests. If true knowledge is universal, as educators from Plato to Newman have argued, then scholars must be free of any constraints or assumptions imposed by the accident of their context. The goal of scientific objectivity reinforced the argument for

academic freedom, as did the notion of romantic individualism, in which the mind of the thinker, like that of the poet or artist, is gloriously unfettered by accidental contingencies. These assumptions in part account for the conservative hostility to studies of race, sex, and class, as when Denis Donaghue says, "I think that [contextualizing] refutes and subverts the fundamental character of the imagination, that unique capacity of a human being to envision being different." [22]

The university trains the student to be a free individual, in this view, by imparting a knowledge unconstrained by the pressures of the outside world, a knowledge with no practical outcome and that is valuable for its own sake. Thus, the right finds multiculturalism and canon-revision subversive to "the idea of the university." "Behind the demand that history be rewritten," says Stephen H. Balch, president of the anti-PC National Association of Scholars, "lies the reemergence of the concept of lineage, in which one's ancestry rather than one's individuality bestows status." [23] The NAS's Thomas Short goes so far as to link group identity to that old antithesis of liberalism, servility: "The new, 'multicultural' curriculum is . . . a curriculum for those who will remain slaves to their origins, to their sex, race, age, class, handicap, or other peculiarity," rather than achieving "that self-transcendence without which life is less than human." [24]

However noble the idea of self-transcendence may sound, the separation of liberal thought from the practical sphere has made academics perennial objects of ridicule. William F. Buckley speaks of "that undiscriminating fellow, the liberal," and quotes Richard Weaver's definition of the liberal as "someone who doubts his premises even while he is acting upon them." [25] During the 1988 presidential campaign, we recall, Governor Dukakis went out of his way to insist that he was not a liberal. And for all the connection between liberal education and freedom from servility, Edith Wharton reminds us that "the cultured Greeks to whom Roman citizens used to entrust their sons' education had the legal status of slaves." [26]

Cardinal Newman himself understood the vulnerability and derisiveness of the liberal philosopher: "from the time that Athens was the University of the world, what has Philosophy taught men, but to promise without practising, and to aspire without attaining. What has the deep and lofty thought of its disciples ended in but eloquent words? Nay, what has its teaching ever meditated, when it was boldest in its remedies for human ill, beyond charming us to sleep by its

lessons, that we might feel nothing at all?"[27] No wonder that a figure with such specifically political ends as Andrea Dworkin singles out liberals as objects of hatred for their false promises and cruelly unrealizable hopes.[28]

The separation of liberal knowledge from the practical world, its promotion of "disinterested interest," its end in pure pleasure and a delicious anaesthesia from life are parts of a vocabulary of transcendence that animates the traditional "idea of the university." "We attain to heaven by using this world well," Newman says,[29] and quotes Cicero to the effect that the pursuit of knowledge is to be undertaken for its own sake (p. 103). As in the slogan "art for art's sake," which would become the catchword of Aestheticist movements of the late nineteenth century, Newman's "knowledge for its own sake" was loaded with the baggage of the Kantian sublime. "Your cities are beautiful, your palaces, your public buildings . . . and their beauty leads to nothing beyond itself. There is a physical beauty and a moral . . . and in like manner there is a beauty, there is a perfection, of the intellect" (p. 122).

This nineteenth-century aestheticization of knowledge—with its roots in deepest antiquity and its flowering in anti-PC rhetoric—is a version of the decadent and modernist fetishizing of art. Beauty, pleasure, individual transcendence, and self-sufficient value have been the promise of both art and education.

Such ideas are vestiges of an aristocratic mindset. The late William K. Wimsatt, one of the leading New Critics, reflected this fact in remarking that "literature is a gentleman's agreement." Allan Bloom, likewise, wrote that because students are unconcerned with material acquisition they can give themselves up to ideals. "These students are a kind of democratic version of an aristocracy," he writes, adding that the university is the *only* site available in a democracy for such aristocratic transcendence.[30]

THE OTHER IDEA OF THE UNIVERSITY

Unlike the liberal training in freedom and individualism, a second "idea of the university" is the promotion of group solidarity and social cohesion. It lurks unspoken behind the most Newmanesque pronouncements. We have already seen hints of it in D'Souza's mistaken equation of Newmanesque "liberty" with Lincolnesque "emancipation," and the contradiction runs all through his *Illiberal Education,* that book so sure that all it takes to emancipate minorities is four years at a liberal arts institution.

Illiberal Education, which is a full-blown attack on political correctness, be-

gins with a pastoral image. "Across the lawns the scholars come and go, talking of Proust and Michelangelo. Tributes to the largesse of democratic capitalism, American universities are nevertheless intellectual and social enclaves, by design somewhat aloof from the pressures of the 'real world' " (p. 1). In this image, D'Souza paints the familiar Newmanesque picture of the academic ivory tower.

In doing so, he echoes the refrain from T. S. Eliot's poem, *The Love Song of J. Alfred Prufrock:*

> In the room the women come and go,
> Talking of Michelangelo.

Insofar as the allusion is meant to convey a peaceful scene of coeducational cultural exchange, however, D'Souza entirely misses Eliot's meaning. For Eliot's "women," milling about and talking culture, are not intellectuals but socialites. They are a source of torture for Prufrock, an aging man of imagination who has heard the call of the sirens, but has not had the courage to answer. Instead of a transcendent contact with beauty, passion, or art, the women offer Prufrock cocktail chat; he measures out his life in "coffee spoons" rather than asking the "overwhelming question," and keeps his rounds of social engagements in a world where culture is unthreatening and "smart."

Surely this is not what D'Souza means by a liberal arts education, and on both interpretive and rhythmical grounds we might wish that he had paid more attention in his English classes. But his misreading reveals—however inadvertently—the desperate flaw in the right's idea of the university. Like Caliban on Prospero's island, or Prufrock at the cocktail party, the outsider has found his way into the privileged university pastoral. But simply getting there has not set him free.

Perhaps D'Souza's insensitivity to the social outsider can be explained by the confusion of claims in Newman's idea of the university. For hidden in every characterization of knowledge for its own sake is an acknowledgment that the university does have its ulterior purposes, that the promotion of individualism also serves group interests. In England, where education and elitist values were openly equated in the nineteenth century, this "complication" was an easy matter to negotiate. Newman could argue not only that knowledge was without use, but that "mental culture is emphatically *useful.*" It will not turn out a lawyer, orator, or statesman per se, but it will allow the student to take up any of these callings successfully. Moreover, a liberal education spreads its benefits across the whole society. A university training "aims at raising the intellectual

tone of society, at cultivating the public mind, at purifying the national taste, at supplying true principles to popular enthusiasm."[31] This trickle-down theory of educational efficacy could work in Newman's day because the university-educated came from the class of social leaders to begin with.

In America, however, the situation has not been so straightforward, and people confuse the intrinsic value of learning with social advancement, as if no contradiction were involved. After the Civil War, writes the historian Page Smith, "Americans were seized by the conviction that education was 'a good thing' in and of itself. Above all, it was a good way to 'get ahead.' . . . In the words of John Jay Chapman, 'The terrible, savage hordes of Americans waked up in 1870 to the importance of salvation by education.' "[32]

In our day, this same contradiction is in play. The arch-conservative editor of *Commentary,* Norman Podhoretz, argues that the humanities have intrinsic value. But almost in the same breath, he claims that their chief function is to create a "common culture" by instilling the values of the democratic tradition.[33] These values, according to William J. Bennett, emanate from "Enlightenment England and France, Renaissance Florence, and Periclean Athens. . . . we as Americans—whether black or white, Asian or Hispanic, rich or poor—share these beliefs,"[34] and if we do not, presumably a university education will *make* us share them.

These twin uses of liberal education—to promote social mobility and social cohesion—are as deeply a part of American educational philosophy as the contradictory claim that the university is a place where knowledge is imparted for its own sake. In the American context, the idea that liberal knowledge is universal, concerned with truths that are independent of specific times and cultures, has supported the argument for democratic education. Knowledge is accessible to and true for everyone, and therefore capable of raising students of any background to a common wisdom. This is why so much of the rhetoric of American educational debate evokes a kind of Horatio-Algerism, a second-generation desire to assimilate and climb.

On this point, all political parties seem to concur. Sheldon Hackney, the liberal president of the University of Pennsylvania during the Mapplethorpe controversy and now head of the National Endowment for the Humanities, proclaimed that the purpose of a university is "to enable individuals to transform themselves."[35] Dinesh D'Souza, who objects strenuously to affirmative action on the grounds of race, supports it just as vigorously on economic grounds: "if you give a kid a break because he or she comes from a poor family

or suffered disadvantage in the past, I think that's a thoroughly American prin-
ciple of justice."[36] Robert Hughes, neither a leftist nor a rightist, seconds
D'Souza on this point.[37]

Since education promotes economic and social advancement, D'Souza
cannot understand why liberal arts professors have turned on the very institu-
tion that raised them up. "Comfortable, well-fed, and obviously intelligent,
their conspicuous embitterment with and alienation from American society
were hard to comprehend."[38] Apparently, the only Prufrocks for D'Souza are
the economically disadvantaged, and one of the great values of education is to
transform them into happy chatterers at the socially enhancing cocktail party of
the university.

Social and economic advancement constitutes a hidden political agenda in
liberal education. The fact that there *is* an agenda is of no particular concern,
since even the most transcendent spheres—religion, art—have served practical
purposes. It is the hiddenness that gives one pause. When Allan Bloom argues
that a democratic education produces democratic citizens but that learning in
university about one's own culture amounts to an undemocratic closure to
ideas,[39] we detect an unsettling mixture of frankness and mystification. Sud-
denly, "knowing thyself" is denying democracy. The premise of "non-
mainstream" students who want their history and culture included in the uni-
versity curriculum, says Bloom, "is that 'where you come from,' your culture,
is more important than where you are going . . . [that] you do not go to college
to discover for yourself what is good but to be confirmed in your origins."[40]
Instead, students should become assimilated into an ethnically unmarked
"Americanness," or better still, a universal "humanness." But all the while,
Bloom's unmarked Americanness does privilege one culture—ancient
Greece—however unavailable its liberties were to slaves, women, and children.

The presentation of liberal education as a neutral, value-free realm that
happens to coincide with and indeed promote the value-laden political system
of the West is a contradiction that seems not to bother the critics of PC. For
them, knowledge is scientific, objective, dispassionate, and ideologically neu-
tral, and the trouble with PC liberals is that they try to contaminate all that with
politics.[41] Pulling out all the rhetorical stops, they assert that politically correct
liberals are just like the Nazis when they went about accusing Einstein and
Heisenberg of practicing a "Jewish physics."[42]

In the presence of such verbal pyrotechnics, it takes courage to assert that a
liberal education inculcates no predictable values at all, and that a vision of

education as indoctrination is a perversion of the meaning of culture. Katha Pollitt, for example, argues that "Books do not shape character in any simple way, if indeed they do so at all. . . . Books cannot mold a common national purpose, when, in fact, people are honestly divided about what kind of country they want. . . . The way books affect us is an altogether more subtle, delicate, wayward, and individual, not to say private, affair. And that reading, at the present moment, is being made to bear such an inappropriate and simplistic burden speaks to the poverty both of the culture and of frank political discussion in our time." [43]

As in Salman Rushdie's defence of literature, education is portrayed as both a realm of individual, self-enclosed pleasure and an active force in changing reality. And both sides say both things. For the right, leftists are too political: they destroy the neutrality of the classroom and the independence of the sphere of art. For the left, rightists are too political: they promote a value system in the university that perpetuates the status quo and disadvantages minorities. For the right, leftists are too ivory-tower: professors have too much freedom to pursue ideas that will not benefit students or society. For the left, rightists are too ivory-tower: they want to ignore the special needs of minorities, to treat the university as if it had no relation to society at large. Sometimes, being political and being ivory-tower are hard to tell apart. Education, like art, has a peculiarly paradoxical relation to reality.

My point is that the conception of the university that we have inherited is contradictory, characterizing the intellectual world as at once hermetically sealed from reality and centrally constitutive of it. For this reason, the professor is proverbially a powerless social misfit, whom society ridicules or ignores, and an omnipotent leader shaping "the destiny of the world." [44] The truth, of course, lies somewhere in between, but the paradox is part of the same ambivalence—sometimes panic—that our culture feels at the peculiar status of art. As with art, the real danger comes when the paradox is collapsed into one of its extremes—when educators either dissociate themselves from reality entirely or try to merge with it, or when society forces them into one of these postures. The value of the university, like art, lies in its simultaneous relevance and irrelevance to reality, in a balance that we continually renegotiate.

THE CRITICS OF POLITICAL CORRECTNESS

What makes our current struggles with this paradox so painful? First, the general state of society is troubled, wracked with economic and social problems

and adjusting to a rapidly shifting international situation. The recent rise of nationalism in Europe and its accompanying racism and violence form a disquieting analogue to the educational debates at home.

Education has been a convenient diversion from these political problems. It is no accident that the PC controversy escalated with the approach of the American presidential elections in 1992. A survey of major newspapers registers 101 PC entries in 1988, 306 in 1989, 638 in 1990, but 3,877 by November 15, 1991.[45] President Bush attacked political correctness in a commencement speech at the University of Michigan in May 1991 aimed at protecting the freedoms of "enterprise, speech, and spirit" against the "inquisition, censorship, and bullying" of political correctness. Suddenly the university begins to sound like the old Soviet Union. "The speech . . . reflected the influence of the President's new head speech writer, Anthony Snow, . . . who was hired to bring a harder edge and ideological spirit to Mr. Bush's speeches as he moves toward the 1992 election."[46]

The university could serve as such an easy scapegoat for political anxieties because of major changes it had recently undergone. Beginning in the 1970s, American humanities departments embraced "theory," an all-purpose term for philosophical approaches to the arts that differed significantly from the earlier, entrenched formalisms. The new theories were esoteric, paradoxical, and verbally opaque to an unprecedented degree. They decisively removed the academic discussion of art from the ken of the layperson. By the 1980s, the hip, flamboyant divas of the theory movements had become big news—featured in the *New York Times Magazine, Harper's,* and other mainstream publications that had previously shown little interest in the academy. Instead of humbly edifying the nation's youth, humanities professors seemed suddenly an ideological force in their own right, and one apparently unsympathetic to the values of the voting public.

As the image of the humanist shifted from the kindly genius to the unintelligible media guru, the right was setting up a network of institutions to counter the efforts of liberal humanists. According to Scott Henson and Tom Philpott, "Support for the right-wing attack [on PC] comes from the ultra-rightist Reverend Sun Myung Moon, a variety of conservative publications and think-tanks, numerous New Right luminaries, and even the [Republican] White House."[47] Dinesh D'Souza, for example, worked as a "Domestic Policy Analyst" under Reagan after editing the rightist *Dartmouth Review,* which is funded by the conservative Institute for Educational Affairs and the Olin Foundation.[48]

He wrote *Illiberal Education* with support from Olin and the American Enterprise Institute, as Allan Bloom wrote *The Closing of the American Mind* with help from Olin and the Earhart Foundation.

In 1988, Allan Bloom and William Bennett established the Madison Center for Educational Affairs, which reportedly spent "$330,617 in 1990 subsidizing right-wing college newspapers and grooming young journalists."[49] In 1982, Midge Decter founded an ultraconservative group called the Campus Coalition for Democracy, which held conferences and published articles attacking the leftist politicization of scholarship. This group evolved into the National Association of Scholars, established in opposition to the Modern Language Association, the official professional organization for literary scholars in the United States and Canada. The NAS now has chapters in at least twenty-one states, and receives six-figure support from the Olin Foundation alone.

The typical right-wing intellectual activist coming up in the Reagan years, according to Henson and Philpott, "edited or wrote for a Madison Center newspaper in college, spent two summers interned with a right-wing think-tank or magazine in New York City or Washington, D.C., and then became a professional intellectual or political operative . . . [for] the Reagan administration, conservative journals, or the ubiquitous research centers. This process amounts to an alternate credentializing system . . .—one that bypasses graduate school and doctoral dissertations."[50] All this effort has produced a phalanx of spokespeople and institutions capable of countering PC abuses with skilled media-management techniques. The left, in contrast, has appeared an inept combatant in a struggle it hardly knew was underway.

Of course, this is not how things appear to rightists. For them, the entire liberal educational system of America is the political preserve of leftism. According to Thomas Short, in a position paper for the NAS's *Academic Questions,* "the politicized minority gained power precisely because it is politicized and the rest of the professoriate is not."[51] Having won the day in this open political field, the left professoriate controls the university, and must be countered by the forces of freedom.

The dismay of liberal professors at this portrayal could not be greater. They "see conservatives who claim to be more liberal than the liberals, and cultural critics who talk about insulating culture from politics but who wield the literary canon like a club, knocking heads whenever their own political preferences come under attack."[52] In this struggle over ivory-tower purity, the two sides

fling accusations of politicization back and forth like hot potatoes, competing for starring roles in a "romance of victimization and false martyrdom."[53]

William Simon, of the Institute for Educational Affairs, provides the most blatantly political explanation for the development of the right's alternative credentialing. "Business," he says, "must cease the mindless subsidizing of colleges and universities whose departments of economics, government, politics, and history are hostile to capitalism."[54] This openly partisan statement echoes the position taken by William F. Buckley in 1951 in *God and Man at Yale*. In this book, Buckley inveighed against "one of the most extraordinary incongruities of our time: the institution that derives its moral and financial support from Christian individualists and then addresses itself to the task of persuading the sons of these supporters to be atheistic socialists."[55]

According to Buckley, he who pays the piper should call the tune, and academic freedom is a red herring. What about the freedom of a parent to have his child educated in the values he holds dear, asks Buckley, or the overseer's right to see that the money he raises or contributes supports the promulgation of a system he believes in? Education is a transaction between buyer and seller. The parent "is he who is exchanging his money, which represents his goods and services, in exchange for the teacher's services," and so "in the last analysis, academic freedom must mean the freedom of men and women to supervise the educational activities and aims of the schools they oversee and support."[56] In such statements, the liberal academic gives way to the servile employee, and the university "overseer" begins to sound like a character in *Uncle Tom's Cabin*.

The idea that academic freedom of speech and thought belong to the "overseer" rather than the professor would necessitate a like-minded faculty, for the very verb "to profess" implies that a professor speaks out of conviction. When Buckley argues that teachers cannot be dispassionate but must be moved by their subject and show their emotion,[57] or when critics lash out against the impersonal "knowledge industry,"[58] they are insisting on the engagement of professors in their professings. The reward structure of academia is founded on this principle, with the rise in seniority and success reflected more in the opportunity to teach and research what one likes than in material benefits. A university modeled on Buckley's or Simon's position would exclude many professors, or it would force them into a hypocrisy subversive to everything the word "professor" means. In either case, it would destroy the idealistic pastoral of academic freedom that Bloom or D'Souza depicts, a state in which, with only

such controls as the faculty itself imposes, one has absolute freedom to pursue any idea and express any point of view.

SPEECH CODES

At this peculiar historical juncture, academic extremists of all stripes are arguing for limitations on freedom of expression. Eugene D. Genovese, a Marxist historian, urges authoritarian controls on any democratic consensus seeking "the total politicization of our campuses." [59] The relativist Stanley Fish, sympathetic to the "sensitivity politics" that so alarms Genovese, argues against the absolutism of the First Amendment on the grounds that it may interfere with the university's essential function: "the investigation and study of matters of fact and interpretation." "[I]n some circumstances," says Fish, "freedom of expression may pose a threat to that purpose, and at that point, it may be necessary to discipline or regulate speech, lest . . . the institution were to sacrifice itself to one of its accidental features." [60]

To consider free speech an "accidental feature" of the university is a surprising move, considering the widely held view that "Universities cannot censor or suppress speech . . . without violating their justification for existence." [61] In fact, Fish's position involves the same collapsing of speech and action as the Dworkin-MacKinnon assault on pornography. In the case of the university, the voicing of racist or sexist attitudes in hate speech is said to create a situation in which women and minorities do not have equal access to education. The "ethnoviolence" that one in five minority students experiences each year [62]—whether physical or verbal—constitutes a hostile environment in which learning is supposedly inhibited. Here the First and Fourteenth Amendments stand in conflict. Rushdie's "power of description" turns the university into a prison ward of outsiders who would like to have been students. Curbing that power turns the university into a prison ward too, but one tricked out in the guise of paradise.

In *Kindly Inquisitors,* Jonathan Rauch links these limitations on academic speech to a general climate of constraint. French laws passed in 1990 outlaw any questioning of the factuality of the Holocaust. In 1989 Australia banned public racial vilification, and in 1992 Austria declared it illegal "to deny, grossly minimize, praise or justify" Nazi crimes. [63] The speech codes that over 60 percent of American universities have developed to protect the learning environment are thus part of a general assault on the differentiation of speech and conduct—an assault that underlies all the controversies in this book.

The extremes of PC speech have been endlessly spoofed in the press. Every hint at inequality in life requires linguistic excisions, from a "lame excuse" to a "nip in the air" and "body English." Not only must sexism and racism be shunned but we must walk on eggshells to avoid the verbal pratfalls of ageism, lookism, ableism, and ethnocentrism, whether we speak in earnest or in jest. And sometimes it is not words alone that must be censored. The University of Connecticut code bans "inappropriately directed laughter."[64] At the same time that identity politics—the equation of self with social group—provides the rationale for multiculturalism and diversity policies, it seeks to control and homogenize reactions to social difference. The stereotype or cliché, as a result, violates the "cult of sensitivity"[65] and the "right not to be offended."[66]

The problem of hate speech arises in every area of society, but it is exacerbated by the university's double ideology. Because of academic freedom, the proposal to limit academic speech meets the most outraged opposition. But because the university is supposed to embody the ideals that form it—equality, courtesy, wisdom, and the whole of Newman's teaching—it must rule out even symbolic injustice. Thus, Barbara Johnson, a Harvard professor of English, claims that "professors should have less freedom of expression than writers or artists, because professors are supposed to be creating a better world."[67] In contrast, for the politically *in*correct Camille Paglia, this better world is not a utopia but an infantilizing protection from reality. "The campus is now not an area of ideas but a nursery-school where adulthood can be indefinitely postponed."[68] Utopia or womb, the American university, for better or for worse, has overwhelmingly admitted controls on symbolic expression.

Many intellectuals greet the imposition of speech controls with genuine distress, but at the same time, they cannot help but feel a certain glee. For suddenly, political struggle has been transformed into a struggle over symbolism. Controlling words may not be the same as controlling wages, but the struggle is equally real in either case, and the feeling of power equally intoxicating.

Besides, for many academics, political struggle is always a matter of symbolism. The current PC warfare validates a host of theories about the symbolic construction of reality.[69] The semiotician, for example, teaches that we never experience reality except mediately, through signs and sign systems. For the communications expert, language and the media create our world. For the Wittgensteinian, truth is a matter of language games, and for psychologists like Gregory Bateson, even insanity is a matter of encountering crazy and crazy-making messages. Previously limited to the academic world, this thinking has

now entered politics, where social injustice is a matter of unjust speech. And
the world has taken such theories as threatening acts. The fatuous professor is
now suddenly a political strongman.

Thus, it is to no real purpose to point out to proponents of speech codes
that the Victorian ban on foul language never improved men's characters, cured
misogyny, or relieved the plight of women,[70] or that the "crusade to drive evil
out of men's hearts"[71] is always doomed. So what if PC is "a marionette theater
of the political"[72] or "an etiquette as elaborate as a Japanese tea ceremonial"?[73]
These are precisely the kind of "interventions" that academics are trained to
carry out. It may be that English professors "are taught how to identify tropes,
not how to eliminate racist attitudes," so that to ask them to eradicate racism
"is to ask someone equipped to catch butterflies to trap an elephant."[74] But no
one seems any good at elephant-hunting these days, and in a world of lepidop-
terists the academic is king.

The extraordinary achievement of PC—whether intentional or not—has
been to extend the academic preoccupation with language and symbolism to
the public at large. For the first time in a long time, Americans' energy seems
more invested in ideas than in practical reality, and now academics, as experts
in such shadow politics, can play a leading rather than an ancillary role. They
change the world by changing curricula; they terrorize the right by blacklisting
words. They create such apoplexy among conservative politicians that the right
invests vast resources in creating a counterculture of newspapers, institutes, and
books. And though all this opposition and the whiff of grapeshot in the air are
a little frightening, what a triumph it is to have co-opted a whole society into
the "struggle for mastery over symbols"![75] Nowadays you cannot trap elephants
anyway: they are endangered. To keep up an ivory tower you have to set the
whole country to work on tropes and figures.

MULTICULTURALISM AND CANON REFORM

Multiculturalism is important in breaking down the barrier between the ivory
tower and the "real world." The search for "diversity" transforms the university
from a world apart into a world in small, a model reality containing all the
problems of the larger sphere. Because it believes itself to be what Catharine
Stimpson calls an "ethical community,"[76] the university fancies itself a potential
utopia.

In the past, it has not much resembled a utopia, but instead a realm of
privilege—for men, whites, Christians, the urban, and the moneyed. The gen-

eration that taught me in graduate school—Charles Feidelson, Geoffrey Hart-man, Harold Bloom—were among the first Jews tenured in the Yale English Department, and the sole tenured woman in the department at that time has few female colleagues to this day. Student admissions quotas have capped certain populations—Jews in the past, Asians nowadays—protecting access to the university for the powerful elite. By admitting a limited number of highly qualified "others," however, the academy has always gestured toward the notion that it was primarily a haven for the intelligent.

University admissions in America have long involved a trade-off between intellectual elitism and social elitism. But now, with affirmative action, the meaning of quotas has changed. Hateful to the left for sacrificing excellence to elitist clout, quotas are now hateful to the right for sacrificing excellence to populist clout. Insofar as the university accepts its identity as both a site of excellence and a model of social diversity, these trade-offs are unavoidable.

What liberals hope is that diversity and excellence will finally coincide, that after families have been university-educated for a few generations, their ethnicity will not be a factor in their children's ability to excel. When PC critics like Dinesh D'Souza insist that academic excellence should be the only criterion for university admission, they ignore the fact that higher education is a long-range socialization that begins at birth and extends forward into the generations to come.

Multiculturalism concerns not just who is admitted to universities and who teaches there, but what they teach or learn. In Newman's idea of the university, or in the idea of the scientific, positivistic academy, this is a nonissue. There, knowledge exists independently of the knower. The makeup of the student body—provided they are sufficiently intelligent and prepared—should exert no effect on the curriculum. Thus, the anti-PC movement habitually cites Matthew Arnold to the effect that the humanities should teach "the best that has been thought and said." William Bennett shakes his finger at academics, asking, "Does the curriculum of your campus ensure that a graduate with a bachelor's degree will be conversant with the best that has been thought and written about the human condition?" [77] and Roger Kimball quotes Arnold against the likes of Harvard philosopher Stanley Cavell and Penn African-Americanist Houston Baker—two of the most distinguished academics in the country—to complain about their neglect of the traditional curriculum, "excoriated as sexist, racist, or just plain reactionary." [78]

Arnold's defense of culture, as Michael Bérubé points out, was in fact meant

to rescue it from what Arnold considered the anarchy of democracy. Far from protecting a tradition constituting the ideals of democratic culture, Arnold was advocating a very un-Kimballesque elitism. "Kimball's defense of 'tradition' is thus cracked in its very foundation."[79] And just as with D'Souza's misrepresentation of Eliot, Arnold did not even say what the anti-PC forces think he said. What he wrote, Alexander Nehemas reminds us, is that the business of the critic is "to know the best that is known and thought in the world."[80] The frequency of this right-wing misquotation—"the best that *has been* known and thought," or "thought and said"—is important not only for showing that many right-wingers are sloppy scholars. It also reveals a persistent blindness in their understanding of humanistic scholarship. However elitist and authoritarian Arnold might have been, he still understood that criticism is in large part about the present state of knowledge, however historical its object. Scholars not only read texts from the past but try to keep up with the main intellectual and artistic currents of their own day—the two together constituting the best that *is* known and thought in the world. Culture is a contemporary field of voices speaking about both the past and the present.

Until recently, contemporary culture was not a university subject at all. Now there is hardly an American English department without an expert in contemporary literature, and sometimes several. But upholders of the canon almost always omit recent art in their zeal to preserve the past. The philosopher John Searle, for example, writes, "there is a certain Western intellectual tradition that goes from, say, Socrates to Wittgenstein in philosophy, and from Homer to James Joyce in literature, and it is essential to the liberal education of young men and women in the United States that they should receive some exposure to at least some of the great works in this intellectual tradition."[81]

Essential as this exposure may be, it cannot stop in the past. Students need exposure to the second two-thirds of the twentieth century as well, and the academic humanities are a vast processor of this period, sifting it for excellence and influence, testing its historical valence, trying to form a picture of contemporaneity through it. This task cannot be left to the popular media, although reviewers and cultural commentators are vital to the process. The special strength of the university is that it can examine recent art in a context of historical inquiry. The conservative fixation on the traditional canon ignores the vital role of contemporary knowledge and thought in shaping our understanding of the past, and the wealth of insight that immersion in the past brings to

the daunting enterprise of canonizing the present. This processing of the present is a task that life sets for all students, however incurious or disaffected they may be, and the university would be remiss in not facilitating it.

Canon reform, of course, is not a matter merely of adding new works but of removing or deemphasizing earlier ones. And here lie real grounds for resistance. For the right, in assuming that knowledge is universal and free of accidental contingencies, also believes it to be permanent. The idea that the world's great books are a finite, permanent repository of literary value, however, has no basis in history. The canon is constantly changing, and so are university curricula.

As an example, we might consider the contrasting fortunes of Ernest Hemingway and Zora Neale Hurston. Twenty-five years ago, it would have been unthinkable to offer a course in modern fiction without teaching Hemingway, whereas Hurston was totally unknown. Now such courses go on all the time without Hemingway, and more and more of them are likely to include Hurston. What has happened? Has aesthetic quality been sacrificed to a feminist or black agenda, as the conservatives would claim? I think not. Hemingway is good, but so is Hurston. There are, in fact, a great many very good twentieth-century writers, certainly too many to read in a lifetime, never mind teach in a fourteen-week English course. Inclusion in a syllabus or a curriculum or a canon always depends on factors other than goodness alone, and many aesthetically irrelevant factors account for the fall of Hemingway and the rise of Hurston. Most innocuously, Hemingway has been overexposed, whereas Hurston has only recently been discovered.

Hemingway and Hurston are both part of a great modern undertaking—the exploration and questioning of the relations between the sexes. One does not have to be an ideological critic to make this claim, or to feel that a novel's role in that debate is relevant to its appearance in a literature course. Hemingway's contribution to this struggle was to depict the condition of men living in a culture in which traditional values are dead. His characters respond by ritualizing traditional maleness, performing the rites of hunting, fishing, drinking, fighting, and loving as if they still meant what they used to mean. But despite his heroes' fidelity to the past, they are defeated by reality—they encounter war without morality, love without permanence, desire without potency, earnestness without aim.

Hemingway's expression of this predicament is unforgettable: he ritualizes

language itself in his desperate attempt to conquer existential nullity. Famous at an early age, Hemingway quickly became an American classic. By our day, however, his virile chest-thumping and despair have become clichéd, and both gender debates and existentialism have developed beyond where he took them.

A contemporary of Hemingway's, Zora Neale Hurston has held a very different place in literature. Though black and not well-off, Hurston earned a Ph.D. in anthropology at Barnard, studying voodoo and Caribbean folkways. She also wrote novels, but did not achieve the recognition of her friends in the Harlem Renaissance. In fact, she spent a good deal of her adulthood working as a maid, died in poverty, and was quite forgotten until her 1937 masterpiece *Their Eyes Were Watching God* was discovered in the 1970s and introduced into the modern canon.

This novel became a classic almost overnight. Full of beautifully conceived symbols, it pictures a woman's progress toward self-determination and love, and in the process, her achievement of the right to tell her own story. *Their Eyes* reads like a prototype for many feminist novels of the 1970s and 1980s. Though reality is as cruel to her as to Hemingway's heroes, she achieves a certain victory by the end, and this, too, links her to characters in post-1970 novels, who turn away from existential defeat. The fortunes of this book—utterly ignored and then dredged up from the past and celebrated—anticipate a plot common in such women's fiction as *The Color Purple* and *The Women of Brewster Place,* in which the untold lives of women—"my mother's garden," as Alice Walker calls them—are finally brought to light.

The fates of Hemingway and Hurston show that shifts in the canon are part of an ongoing cultural processing that is neither sinister nor avoidable. It is easy to see why Hurston seems so important today. This is not to say that we should not read Hemingway, but in a fourteen-week course there might be other writers who compel a professor's attention more. Hemingway will not disappear just because he does not figure in a given syllabus; he remains in print, and reading does go on outside the classroom.

One hardly recognizes this gentle process of canon and curricular reform, however, in anti-PC diatribes. They picture professors "shortchanging" students in an "epidemic of indifference,"[82] leaving the humanities an "unclaimed legacy"[83] and filling courses with a "curriculum of enforced cultural amnesia"[84] resembling something "designed by a game show host."[85] Bennett and Sykes and D'Souza all try to shock us with lists of subjects a student can graduate from

college without knowing, and E. D. Hirsch seeks to fill these gaps with a collection of cultural tags that he calls our "common culture."[86] We hear that multiculturalism is programmatically opposed to high culture, that its roots are in ethnic separatism and black nationalism,[87] and that it is all part of a "victims' revolution"[88] in which women and minorities become a Moral Minority[89] impatient for revenge against the dominance of Dead White European Males (DWEMs) who must be kicked out of the academy. Every time professors waver between Hemingway and Hurston, their deliberations take place amidst this din.

The caricature of victimized minorities and vilified DWEMs obscures the actual situation behind PC canon reform, which involves the same contradictions that mark the "ideas of the university." On the one hand, canon reform is an opportunity to undo symbolically the social injustice of the past. Just as admitting minority students symbolically corrects those centuries of exclusion, admitting into the canon works by women and minority artists corrects those centuries in which they could not publish, teach, or be taught. The right raises the same argument against canon-justice as admissions-justice: that the only criterion should be quality. But since the newly canonized works are often very good, and since quality has never been the sole criterion for literary canonization or university admissions, this objection is a mystification.

Canon reform demonstrates the fetishism of cultural debates in our day. To believe that there is an unchanging canon of Great Books is to assume that aesthetic value inheres in the artwork, independently of the people who read it. Thus, Tracy Brown is right to claim that "[Allan] Bloom's fetishization of the liberal arts experience, his careful glorification of the university as an arena capable of disconnection from society, points to a . . . process of fetishization in his narrative. The canon as locus of truth and timeless value is a fetishized canon."[90] But the canon is no less fetishized when it changes. As with all areas of value, a change in the object fetishized does not eliminate fetishism.

As proof of this idea, we need only observe the language critics use to justify canon revision. Catharine Stimpson, for example, writes that "literature permits the other, Hegel's slave, to speak,"[91] and Barbara Herrnstein Smith objects that "the teaching of literature has become . . . the teaching of an aesthetic and political order, in which no women and people of color were ever able to discover the reflection or representation of their images, or hear the resonances of their cultural voices."[92] Paula Rothenberg issued this statement when her

anthology of diverse writers was removed from the curriculum of the freshman writing program at the University of Texas on the grounds that it might politicize the classroom:

> The traditional curriculum teaches all of us to see the world through the eyes of privileged, white, European males and to adopt their interests and perspectives as our own. It calls books by middle-class, white, male writers "literature" and honors them as timeless and universal, while treating the literature produced by everyone else as idiosyncratic and transitory. The traditional curriculum . . . reduces the true *majority* of people in this society to "women and minorities" and calls it "political science.". . . . The curriculum effectively defines this point of view as "reality" rather than as a point of view itself, and then assures us that it and it alone is "neutral" and "objective." [93]

Exposing the mystification in preexisting fetishes and surrounding their own values with powerful rhetoric, these critics show the process of aesthetic fetishism at work in canon reform.

The argument of these reformers seems eminently acceptable. Canon revision, they claim, will allow female and minority students to hear voices like their own in art, and thus both to learn about themselves and to be validated in the process. This claim, surprisingly, has provoked a host of objections. Self-esteem, says Robert Hughes, does not result from a revised curriculum but "from doing things well, from discovering how to tell a truth from a lie, and from finding out what unites us as well as what separates us." [94] Katha Pollitt argues that Chekhov can talk to a black woman as much as to a white man,[95] and Hughes that one can learn from Picasso without being a phallocrat.[96] Irving Howe finds the idea patronizing that minorities need minority art to respond to whereas middle-class whites can take on any curriculum.[97] And for Dinesh D'Souza, "The problem with the idea of ethnically determined 'perspectives' is that it condemns us to an intellectual and moral universe in which people of different backgrounds can never really hope to understand each other." [98] By insisting that difference really divides us, these critics fear, the multiculturalists are in fact denying the viability of a diverse university.

This, too, is the great lurking fear behind the idea of democracy, certainly behind the idea of America, with its "E Pluribus Unum." Still, it does seem excessive to assume that everytime one adds a minority text to the canon one is threatening the premises of human understanding and the American way. By the same token, we could say that white, middle-class male students should be able to understand works by diverse authors, and that the predominantly white

male curriculum should be altered so as not to patronize them. How patronized they must have felt all these centuries!

In fact, as any humanities professor will tell you, texts by "others" are *not* easy to understand. Teachers must provide a vast amount of cultural backing and filling to make clear the assumptions, histories, and environments that condition such works. One learns a great deal about foreign cultures in this process, but it is certainly worthwhile and pleasurable to learn about one's own culture as well, to have one's own assumptions brought to consciousness, to see how one's own history and surroundings can be represented.

Of course, Allan Bloom disdains this procedure as wallowing in the parochial rather than transcending it into the universal empyrean beyond. But anyone who has ever taught contemporary culture—by white men or anyone else—can testify to the fact that even the parochial is not necessarily accessible, even to students steeped in the relevant parochialism, and that discerning meaning and value—whether local or universal—is a skill that develops only after long experience with literary works and with oneself as an interpreter. Changing the canon does not make the study of literature easier for female and minority students; it just makes it more rewarding. As Aimé Césaire writes, "No race possesses the monopoly of beauty, of intelligence, of force, and there is a place for all at the rendez-vous of victory." [99]

From a pedagogical point of view, it is not canon reform that is the problem but the practical absurdities arising from rapid change. In my own department, doctoral students must pass an oral examination on the canon. In the past ten years, responsive to PC debates, the exam has gone from a set of fifty prescribed texts to thirty-five prescribed and fifteen chosen by the candidate, to forty chosen from a pool of 350 possibilities and ten at the student's prerogative. Guidelines for the exam insure that the choices are spread over time, ethnicity, and gender. But since the traditionally trained faculty know primarily the old canon and their particular area of expertise, they are unlikely to have read a good portion of any given student's elections. We could all take a year off from research and speed-read the essential works we somehow missed, but when a faculty of professionals are incompetent to test the canon, it might be more reasonable to assume that they are not testing a canon at all. The violent adjustments we make in the name of social justice sometimes undermine the feasibility of an academic discipline.

Many of the right's—and the left's—complaints about the university are based on ridiculous assumptions about what a liberal arts education can achieve.

For example, the stern traditionalist William Bennett chastises liberal professors with Montaigne's list of teaching objectives: "A pupil should be taught what it means to know something, and what it means not to know it; what should be the design and end of study; what valor, temperance, and justice are; and the difference between ambition and greed, loyalty and servitude, liberty and license; and the marks of true and solid contentment." [100] If professors knew all this themselves they might be able to teach it to students, but we apparently live in a much murkier world than Montaigne's, and the loyalty, liberty, and contentment of his program are precisely the disputed areas of contemporary university culture. As Gerald Graff insists, we have lost the consensus upon which traditional liberal-arts education was based, [101] and for us to go on mouthing platitudes about virtue and valor would not be a service to our students. The problem is how to operate in an institution—the university—founded on a greater consensus than now exists and reifying certain principles of stability (through grading, honors, tenure) when standards in general are in a state of flux.

From a social point of view, the problem is "how to establish a community of learning for diverse participants . . . how to foster a collaboration among strangers who know too little about one another and suspect too much." [102] This concern creates the PC prescription for social justice through education. But this solution is as unrealistic as Montaigne's prescription for morality through education. As Louis Menand asserts, "universities cannot arbitrate disputes about democracy and social justice, or govern the manner in which people relate socially to one another, or police attitudes; and that is what they are being asked to do today." [103]

Education is not coercion. Both the left and the right seriously overestimate the power a professor has. It may be that every time one teaches Hurston or Hemingway one is attacking either the phallocracy or PC fascism. But the decision is a matter of one book out of fourteen in a course, in one course out of thirty-two in a bachelors' degree, in one four-year period out of a student's whole lifetime. Students may not even read the book if they do not like it or have time for it or care about the course in the first place. The problem with the PC debate on both sides is that it lacks perspective.

Yet professors, who are the last ones to downplay the importance of the education they provide, agonize over the problem of "Hurston versus Hemingway." "[A]t a time when radicals of any persuasion have little ability to affect events off-campus," writes Maurice Isserman, "many of us have succumbed to

the temptation to create a separate utopian community within the university. Debates over the canon, free speech, affirmative action, even the wording of catalogue copy, have often come to replace meaningful engagement with the real political world." [104] We have seen how this shadow politics has drawn the public into the PC debate, how the American media, government, and general population have become obsessed with symbolism, stereotypes, and naming. And yet, all the time that the public are engaged in this politicization of culture, they deplore any hint of politics in the university.

THE ATTACK ON ACADEMIC RESEARCH

With the growing professionalism of humanities research, the popular opinion of academics has sunk to new lows. Research is "modern-day alchemy in which mumbo-jumbo is transformed into gold"; universities are "vast factories of junkthink" [105] written up according to a "cult of dullness" [106] in prose "somewhere between a sleeping-pill and a scandal." [107] The various theoretical approaches (structuralism, semiotics, poststructuralism, deconstruction) are "extravaganzas of cynicism" in which the individual has no freedom and "the world [is] permeated by giant, hidden, impersonal structures." [108] If the goal of liberal education is the pursuit of truth, deconstruction (which, according to Dinesh D'Souza, spurns truth) [109] is necessarily subversive. In short, "the vast majority of what passes for research/publication in the major universities of America is mediocre, expensive, and unnecessary, does not push back the frontiers of knowledge in any appreciable degree, and serves only to get professors promotions." [110]

In addition to "the meretriciousness of most academic research," critics complain about the fact that it distracts professors from teaching. "Every dollar that can be charged, directly or indirectly, to research, represents an equivalent charge on the cost of instruction," says Page Smith. [111] The academy argues precisely the opposite: by actively discovering and creating knowledge, professors have more of a stake in what they teach to undergraduates and can better advise and inspire graduate students.

According to the traditionalists, this is total nonsense. They trace the fall of liberal arts teaching to the transplanting into America of German-style research universities such as Johns Hopkins, which routed the academic mission away from service and students and toward scholarship. The doctorate arose at the same time, much to the disgust of such professors as William James, who considered it a step toward the mandarinization of the university. "There seems

little doubt," says Page Smith, "that the introduction of the Ph.D. as the so-called union card of the profession was, if not a disaster, an unfortunate and retrograde step." [112]

Specialization, the rise of departments, the institution of the academic major, all led, in this view, to the fragmentation of knowledge and education and the neglect of the liberal arts undergraduate. Professors were allowed to teach less and less so as to have more free time for research, and with the institution of "publish or perish," their very survival depended on their putting scholarship first. And yet the truth of the matter, according to Charles J. Sykes, is that "60 percent of all college faculty members have never written or edited a book and one-third have never published even a single journal article."

> The system that undergirds the entire academic enterprise and on which the professors have built their elaborate and costly network of status and prestige—which they use to justify their abandonment of the classroom and their endless hunt for new grants; the system that is the excuse for their perks, their privileges, leaves, sabbaticals, travel, and their cushy and enviable lifestyles is, at bottom, *little more than an elaborate myth.* [113]

Sykes's claims constitute a damning indictment of the humanities. But match his picture to the situation of the average assistant professor of humanities, whose starting salary in 1990, after ten years of higher education, might have been as high as $35,000 and who might look forward to earning double that amount as a professor ten years later, or three times as much in the unlikely event that he or she emerges as an academic superstar. In a given term, this assistant professor may teach hundreds of demanding undergraduates who are often ill-prepared and not especially respectful; she must revise and publish her dissertation and write another book within six years of entering her profession if tenure is to be probable; and she may be at the same time raising a family. In addition, she must make decisions every day about Hemingways and Hurstons and be told by leftists that she is failing her social mission, and by rightists that she is slighting the tradition.

Where are those perks and privileges, that cushy and enviable lifestyle? Even if the assistant professor gets tenure, earns a little more money, and has more control over her time and teaching, she is beset with committee meetings, administrative responsibilities, doctoral advisees, and the stress of research and writing. The academics I know are not bathed in the flush of privilege but mired in the guilt of underachievement, never having time to do their best at the tasks they are required to perform.

But even if we assent to every one of the criticisms leveled against the university—that its scholarship is pointless and unreadable, its teaching neglectful, and its attitude cynical and lacking in social responsibility—the indictment as a whole is unfair. Every field of professionals, from bankers to oil painters, has only a small percentage of practitioners who perform at an optimal level, the level that defines the ideal of the field. Many others are competent but no more, and a great many do their job with unfortunate failings. Academia is no exception. If we consider the recent history of American government, banking, and health-care delivery, the crushing attack on humanities professors seems at best a case of the pot calling the kettle black.

CRITICAL FREEDOMS

On one point, however, the academy must not defer to its critics, and that is the genuineness of the dilemma that confronts it. For whatever historical reasons, the university is both riven from within and at odds with society over the nature of culture. The Mapplethorpe, Rushdie, and pornography controversies show how seriously confused the notion of representation has become and how angry the public are with the experts. Is art a world of its own apart from reality? Or does it determine reality? And what are the implications of either position for teaching and criticism?

On the one hand, we have politically engaged academics such as Laura Mulvey or Fredric Jameson, who, fearing the conservative effects of art, actively try to demystify it. Jameson argues that pleasing, exciting, beautiful stories promote "acquiescence to, and even identification with, the relations of domination and subordination peculiar to the late-capitalist social order." "Nothing can be more satisfying to a Marxist teacher," he goes on, "than to 'break' this fascination for students."[114] Like Mulvey trying to dispel the pleasure of narrative film through her analyses, Jameson assumes that art is an ideologically charged seduction so compelling that it fools us into trading away justice and our own best interests. The whole purpose of literary criticism under these circumstances is to uncover the message hidden under the high gloss, to shade the dazzle in students' eyes. The pleasure and fascination of art must be eliminated at any cost.

Paradoxically, the right's criticism of scholars like Jameson and Mulvey shares their view of the critic's power. When professors subordinate literature to politics, Roger Kimball argues, "what threatens to be lost is not only the integrity of the individual text . . . but the whole idea of literature as a distinc-

tive realm of expression and experience with its own concerns, values, and goals."[115] Kimball's view of aesthetic power, just like Jameson's, depends on the assumption that criticism has the power (which it therefore either should or should not exert) to destroy the fascination of art.

Awe at art's power and beauty is ages old, but, as we have seen, modernism took this feeling very far, holding that art could function as an alternate, self-valuable reality. Denis Donoghue quotes the high-modernist T. S. Eliot, that "When you read literature, it is as literature you must read it and not as another thing." Donoghue founds his own formalism on this assumption: "A poem is a structure; it is a form of words, a highly elaborate, complex structure which must not be reduced to the kind of thing you would talk about in a pub."[116] Roger Kimball takes the matter back to a Kantian ideal of disinterested interest. The effect of ideological interpretation, he says, is "to transform a concern with literature into an obsession with one's race, one's sex, one's sexual preferences, one's ethnic origin. What one gains is a political cause; what one loses is the freedom of disinterested appreciation."[117]

The freedom of disinterested appreciation faces off against the freedom to escape late-capitalist or phallocratic indoctrination. And everyone wants to be free. Critical practice would appear to determine whether art can function for or against freedom, however differently freedom is construed in each case.

The picture of art that this book has been striving to present differs from that of Jameson and Mulvey or Kimball and Donoghue. The work of art is, instead, a virtual reality which we invest with value. We do so because of who we are and what therefore gives us pleasure, and we are able to do so because the work has such a paradoxical makeup. Critics are not in a position to control aesthetic response, but only to add their reactions to the pot. It is neither desirable nor possible for them to cut the text off from reality, since that connection is one source of the work's meaning and value. Neither should they disdain the text's formal beauty, for that is equally valuable. Alert to meaning and to pleasure, we go to art for an enlightened beguilement, exercising our freedom throughout. The critic's job is to facilitate that self-realization in art by showing how people who give a great deal of attention to art have read it in the past and are reading it today, and what led them to their interpretations in the first place.

We might test out this view on an actual work of art, to see whether it is possible to read disinterestedly on the one hand, and to avoid fetishistic entrapment on the other. The text I choose is both very short and very sweet—a title

and two lines of nonpropositional imagery that together constitute a tiny poem
begun in 1913 by Ezra Pound. Here is the 1916 version:

> In a Station of the Metro
> The apparition of these faces in the crowd:
> Petals, on a wet, black bough.

Responsive to Kimball, I hope to read this poem as an example of a "distinctive
realm of expression and experience with its own concerns, values, and goals."
Responsive to Jameson, I intend to preserve my ideological freedom in reading
it. Between the Scylla of vulgar ideologism and the Charybdis of mystified en-
thrallment, I shall pursue a middle way.

Obedient to Kimball's wishes, I shall begin with features of the poem that
set it apart from nonliterary reality: its patterning of sound, syntax, and versifi-
cation. The formal features of Pound's poem conspire to create two major ef-
fects, the first of which is the highlighting of certain elements against a neutral
background. For example, the stressed syllables contrast with the rushes of un-
stressed syllables between them: "of the," "in the," and so on. They are also
linked by sound, and thus stand out from the surrounding syllables: "Pet-"
rhymes with "wet" and "Met-"; "black" alliterates with "bough"; "faces" and
"Station" assonate, as do "crowd" and "bough." Most of the stressed syllables
are nouns chained together by prepositional phrases that draw us from one to
the next: "In a station"—which station?—the station "of the Metro"; "The
apparition"—which apparition?—the apparition "of these faces"—which
faces?—the faces "in the crowd"; "Petals"—which petals?—petals "on a wet,
black bough." The poem contains no verbs and therefore no complete sen-
tences; instead of an idea postulated, asked, or hypothesized, it gives us a series
of nouns and adjectives floating in and out of our attention like "the apparition
of these faces" itself.

Pound's other formal strategy is the creation of an equivalence between the
two lines. This pairing, enhanced by the colon at the end of the first line, creates
a parallelism or even an equation between the ideas in each line. It is hard, in
fact, to imagine a reading that does not posit an unspoken "is" or "is like"
between the two. The need to "read between the lines" is thus part of both the
poem's structure and its meaning. The unspoken simile is a gap filled by the
sudden recognition of equivalence, a superimposition of two images. This two-

line verse structure built on equivalence is inspired by the Japanese haiku; Pound in fact tells us that "In a Station of the Metro" is "hokku-like."[118]

Pound's two devices thus convey through formal, specifically literary means the ideas the poem expresses. The stressed nouns and adjectives emerging from the background syllables mimic the faces emerging from the undifferentiated crowd. And the parallelism of the two lines forces us to discover the similarity of the faces to flower petals.

So far, we have kept within the literary boundaries of this poem, in the spirit of Roger Kimball's exhortations. But much as we might admire Pound's technique, such an analysis is like the formalist testimony at the Mapplethorpe trial: it does not get to the real issues. What is the poem about? Why does it deserve our attention? Staying within the "distinctively literary" sphere may reveal the virtuosity of an artist, but it seldom gives us the whole story.

But now, standing as it were at the gate of sense, I find myself uncertain. Can I indeed remain faithful to Donoghue's critical directive, that we interpret works of literature as a complex structure "which must not be reduced to the kind of thing you would talk about in a pub"? I can certainly discuss the poem's figures of speech legitimately—the implied simile between the two lines, for example—for tropes and figures are very much a part of the distinctively literary realm. And I can talk about allusions to other poems—haikus, for instance—since echoes of meaning from other works of art still keep us within the distinctively literary realm. But as soon as I pass beyond the meanings of individual words, I exceed the strictly literary. I feel the purity of my undertaking imperiled, in danger of descending into a smoky world of kidney pies and ploughman's lunches. But at this point there is no way to turn back.

We begin, then, with the title, which plunges us directly into a setting—a Parisian subway station. In this underground world, faces keep appearing, emerging like ghosts out of the undifferentiated crowd. The faces look like flower petals—white, pink—clinging to a tree bough blackened by rain. The delicacy of the faces, their ephemerality and paleness, are compelling—spectral, vivid, beautiful (perhaps like the exquisite images of nature in Japanese watercolors). The poem says less than this overtly; even the equivalence is unstated. The minimalism of this moment of recognition has as its concomitant the eternality of its tenseless, moodless, unrealized verb.

But why would a poet bother to present such a tiny moment of recognition in a poem, or, to change perspectives, what could this moment mean to the reader? Here we can only speculate, and at this point the possibilities are vir-

tually endless. We have all had vivid visual perceptions and recognitions of surprising equivalence. These are valuable, in part, for their contrast to normal, instrumental experience. We have all hurried through city crowds, anonymous, perhaps alienated, only to have some little epiphany that compensates for the emptiness or redeems the possibility of individuality in the press of urban existence. A crowd milling about underground gives way to a point of focus with the clarity and perfection of a Japanese watercolor. From the depths of depression, hope bursts forth into a blaze of new possibility. Like a Persephone exiled in the depths of Hades we emerge into the sunshine of a more perfect world. Such changes of state imprint themselves upon our imaginations with the fast-receding brilliance of an apparition.

As a teacher, I have thought it necessary to take such expansive liberties with Pound's meaning, though he exhorted his readers to stop at the image itself. Most students would not be satisfied, however, with an interpretation that said, "Some faces in a crowd appeared like petals on a bough," nor would I think well of a critical essay that said no more. And yet, in considering the extended meaning of Pound's poem, I have opened the floodgates to the very violations of poetic purity that Kimball and Donoghue wish to exclude.

These violations and secret assumptions can legitimate virtually any critical approach. A reader suspicious of modernist aestheticism, for example, might observe that my words "epiphany" and "redeems" belong to the vocabulary of religion and that the poem is thus another case of artistic perception serving as pseudo-religion. My word "depression" opens the way for psychoanalytic critics of various stripes; "Persephone" and "Hades" are the stuff of myth criticism; and the ambiguity between the idea of a ghostly "apparition" and the brilliant vividness of *these* apparitions is precisely the sort of crack in meaning that would accommodate a deconstructive wedge.

One could even argue that this exquisite poem is a manifestation of racism, if one were so inclined. "In a Station" depends on our visualizing the faces in the crowd as white, pink, or perhaps yellow in order for the petal metaphor to work. Thus, Pound is equating "faces" with "Caucasian faces" (and maybe Oriental ones) and assuming (rightly) that we will do the same. The poem could then be seen as embodying and reinforcing a mindset in which the darker races are excluded.

For a Marxist, the alienating city crowds and the rapid technology of the subway, speeding workers back and forth between home and work, might turn the station of the Metro into a capitalist station of the cross. In this world of

economic and sensory deprivation, Pound's little moment of aesthetic bliss is presented as a transcendence: soul-destroying reality redeemed by aesthetic perception. By thrusting readers into this metamorphic experience, having them "go through" it by figuring out the poem's riddle and feeling the equivalence of faces and petals, Pound is not only saying that art compensates for reality but making that delusory compensation a reality for the reader. For a fetish-basher, this would be the moment to denounce the poem as a typical modernist confusion of art and life.

I am not advocating any of these readings, but my decision not to do so is a matter of taste rather than interpretive "accuracy." For as soon as we consider the poem's meaning, we open it to all these interested construals and many more. And even if we decide to stop at the initial formal analysis, we must take note of the interpretive possibilities we have excluded.

Some might argue that our only recourse is to limit the poem's meaning to Pound's intentions. And here, fortunately, Pound has left us a good deal of guidance. He writes that poetry is a realm of heightened reality. "It is not enough for it to furnish a meaning to philosophers," he said in his edition of Ernest Fenollosa's *The Chinese Written Character as a Medium for Poetry.* "It must appeal to the emotions with the charm of direct impression, flashing through regions where the intellect can only grope."[119] Pound's name for this poetic immediacy was the "principle of Primary apparition." The "apparition" in "In a Station of the Metro" can thus be read as a metaphor for nondiscursive poetry, poetry that means "in itself" and not as an adjunct or substitute for nonliterary meaning. Like Donoghue, Pound argued that "the author must use his *image* because he sees it or feels it, *not* because he thinks he can use it to back up some creed or some system of ethics or economics." Otherwise, the image, "which presents an intellectual and emotional complex in an instant of time," becomes mere ornament. "The point of Imagisme is that it does not use images *as* ornaments. The image is itself the speech. The image is the word beyond formulated language."[120]

A manifestation of modernist antiornamentalism, the imagist poem is intended as a reality in itself. As in Pound's notion of Chinese ideograms, where "*thing* and *action* are not formally separated," or the sentence, which expresses truth as "the *transference of power,*"[121] the poem is power in action, manna, with nothing extraneous or "ornamental," nothing nonliterary: a compression or a "vortex" of energy, as Pound would come to term it.

In his *Gaudier-Brzeska, A Memoir,* Pound explains how he transferred a mo-

ment in his own experience into the poetic vortex of "In a Station of the Metro."

> Three years ago in Paris I got out of a "metro" train at La Concorde, and saw suddenly a beautiful face, and then another and another, and then a beautiful child's face, and then another beautiful woman, and I tried all that day to find words for what this had meant to me, and I could not find any words that seemed to me worthy, or as lovely as that sudden emotion. And that evening, . . . I found, suddenly, the expression. I do not mean that I found words, but there came an equation . . . not in speech, but in little splotches of colour
>
> The "one-image poem" is a form of superposition, that is to say, it is one idea set on top of another. I found it useful in getting out of the impasse in which I had been left by my metro emotion. I wrote a thirty-line poem, and destroyed it. . . . Six months later I made a poem half that length; a year later I made . . . [a] hokku-like sentence. . . . In a poem of this sort one is trying to record the precise instant when a thing outward and objective transforms itself, or darts into a thing inward and subjective.[122]

But even with such an extensive account of a poet's intentions, we cannot control a poem's interpretation. Contradictory responses still arise. Voila! a Kimball will exclaim: a formula for essential literature! Voila! says a Jameson: a formula for fetishistic mystification!

And where does *my* freedom lie? I see no way to avoid either point of view. One must take an analysis of meaning and form wherever it leads, which is always to the realm of the social and always to the realm of the aesthetic. I cannot limit, forbid, disqualify, or invalidate either the awe and pleasure the poem evokes in me or any of the ideological readings it provokes. I can prefer one interpretation or dislike another, but here I am showing more about my predilections and prejudices than the poem's. If I find the revelations of ideological taint in the poem absurd, I need only contemplate Pound's later career as a fascist propagandist to see a possible end to the quest for aesthetic purity. But I cannot deny the allure of that quest. Finding that the beauty and power of this poem and the sensibility and striving that underlie it may be implicated in evil or self-mystification is much like discovering that the world is fallen. Beauty may be surrounded by ugliness and even implicated in it, but that fact does not make it less beautiful.

An analysis that ignores these facts or brackets off context in order to preserve literary purity would be a poor piece of advocacy, implying that literary criticism performs its task by hiding or denying a work's relation to reality. I may exercise my freedom to experience disinterested interest by judging the

work in itself, as a structure of language, but I want to do so with my eyes open, knowing the cost of the blinkers I might put on. And if I decide that there are moments of transcendence that redeem the oppression of late capitalism (or of extremely late Marxism), I do so knowing that redemption is a relative matter and that my fetishizing of art is a joyful and uncoerced rebellion against an oppressive world. Art is *of* reality and it is not. *I* am of reality and I am not. My freedom lies in the paradox.

CHAPTER FIVE

LA TRAHISON DES CLERCS

> I learned to make my mind large, as the universe is large, so that there is room for paradoxes.
>
> Maxine Hong Kingston

George Orwell was not far wrong in projecting 1984 as a dangerous year for liberal freedoms. The attack on the universities and the anti-pornography movement had already begun by then, and within five years the Mapplethorpe and Rushdie controversies erupted. At the same time, a generation of academic superstars was passing. They were dying literally—Roland Barthes in 1980, Paul de Man in 1983, Michel Foucault in 1984, Louis Althusser in 1990—but they were also suffering symbolic deaths in a series of exposés that shook academia to the core. This "trahison des clercs" has provided yet another weapon for the general assault on "the experts."

In 1987, Victor Farías published *Heidegger and the Nazis,* a book that documented the long involvement of one of the century's greatest thinkers with Nazism. Though this information did not come as news to philosophers, particularly those in Germany, "l'affaire Heidegger" became a mini-Dreyfus affair in France, where Heideggerianism had penetrated every area of thought. In the same year, Ortwin de Graaf, a Belgian graduate student, discovered that Paul de Man had written for a collaborationist newspaper between 1940 and 1942, publishing at least one overtly anti-Semitic article and suppressing this episode in his life ever afterward. The ensuing investigation unearthed proof of his bigamy, sharp business practices, and petty lying, until the greatest figure in American deconstruction appeared little better than a reformed con-man. Critics hos-

tile to deconstruction seized on the "damning force of the revelations"[1] with glee, while the generation of scholars trained by de Man grappled with their pain and tried, as did the French Heideggerians, to understand the relevance of the collaboration to their critical principles.

Meanwhile, Lacan's Ecole Freudienne de Paris had collapsed, French feminism ceased to be "dans le vent," and figures with the stature of Julia Kristéva entered the 1990s as writers of schlock romances. Foucault not only supported the Khomeini regime for a brief time, but James Miller's *The Passion of Michel Foucault* (1992) documented his "personal odyssey"—with riding crop and chains—into "new forms of pain and pleasure" in California bathhouses. When Louis Althusser's autobiography, *L'Avenir Dure Longtemps,* was posthumously released in 1992, the public learned that this "last thinker in France who made us think revolution was possible"[2] had suffered dementia throughout his adulthood, murdered his wife, and perhaps not read much Marx.

It is not just that one would think twice before inviting the era's intellectual giants home to mother. And it is not just that their demise marked the end of a whole style of theorizing—the age of the "intellocrats," as John Sturrock terms "those hardened professionals whose job it was to direct the thoughts of their fellow citizens"[3] and set the intellectual agenda for the West. The Orwellian exposés destabilized the status of the intellectual at a time when it was already under siege. Moreover, the scandals undermined their basic teachings. For these scholars had claimed that life and thought were separate. The "death of the author" was a leading idea in postmodern literary studies, for example, and in the case of Althusser, "the irony is not lost . . . that the longest (and most successful) book of a philosopher who considered the human personality an illusion should be a confessional autobiography" (Fox, p. 27). To discover that certain thinkers professed ideas quite different from the political ideologies they supported created both outrage against them and uncertainty about the relation between theory and theorist. Are ideas rooted in the personalities of their authors? And if so, is the follower of a theory not contaminated by the venom— anti-Semitism, fascism, elitism, amoral opportunism, sadomasochism, and outright insanity—that drove the theorist's life? "L'affaire Heidegger," "l'affaire de Man," "l'affaire Althusser," etc., are scandals specifically because we cannot wholly detach ideas from their human sources, because thinking, like art, is both autonomous from the world and not autonomous from it. Intellectual life participates in the same anti-fundamentalist paradox that characterizes all the struggles documented in this book.

To profess: the verb that generates the title of the professional thinker (and the word "professional" as well) means to teach what you believe. It calls for a unity of being and acting, an embodying of ideas, a revelation of self in the process of revealing the other. The process of teaching, in this view, succeeds because students model themselves upon their teachers and thus "take on" the values (and, hopefully, the information and skills) their role models impart. The figure of the beloved teacher—Mr. Chips, the Robin Williams role in *The Dead Poets' Society,* or, archetypally, Socrates—are images of this totalizing, seamless fusion of self and subject matter. Plato's philosopher-king rules society because of his perfect mastery of both knowledge and himself.

The failure of teachers to live up to their precepts is the subject of countless fictions, but the danger of "professing" lies equally in succeeding too well. When students learn to love an idea, they sometimes cannot tell the idea from the one who imparted it to them, and then all possibility of critical distance disappears. Thus, Jerome Christensen identifies seduction and recruitment as standard ways for teachers to "win students over." The sentimental language idealizing the professor, he suggests, is often a blind for such sexual domination, including the right wing's recent insistence on a return to humanistic pedagogy. "[I]t is testimony to the strong, pervasive, and profoundly unthought cultural identification of teaching with either seduction or recruitment," says Christensen, "that the vividly homoerotic ethos of [Allan Bloom's] *The Closing of the American Mind* has gone unremarked . . . by its right-thinking, straight-shooting promoters." [4] No wonder that so many books and films present the ignoble image of the over-sexed, sex-sublimating, sex-starved, or sex-duped professor—*The Blue Angel, Educating Rita, Lolita,* Richard Nelson's *Some Americans Abroad.*

The role of educators is a delicate balancing act. They must care about students without corrupting them with desire, profess ideas without propagandizing, and participate in the "marketplace of ideas" without becoming a huckster, a wheeler-dealer, or a megalomaniac. Professors must believe in what they say but be tolerant of opinions they find false or unsophisticated. Muzzled, hobbled, they trim the wick of their passion to make the flame of learning glow.

It is little wonder, then, that most nonacademics look upon professors as figures of fun, contempt, or disgust. As early as Aristophanes' *The Clouds,* or the splitting of the active from the contemplative life in Stoic thought, the thinker has been divorced from practicality. "Those who can't, teach" is the unkind way to put it, as is the claim that the literary scholar is a "handmaiden"

to the author or a "parasite" on art. The absent-minded professor and the "nutty professor" turn up in Chaucer, whose "Clerk" is so intent on examining the stars that he falls into a hole in a field; Thales, the legendary founder of philosophy, was another fallen stargazer. Practical incompetence becomes romantic incompetence in Shakespeare's ridiculous Holofernes, Washington Irving's bony Ichabod Crane, and George Eliot's passionless Casaubon. Shakespeare's Henry VI is too absorbed in the life of the mind and spirit to have any success as a ruler, and Hamlet must free himself from the habit of thinking in order to avenge his father's death. In *The Tempest,* Prospero's preference for books over the affairs of his dukedom propels him into a land of the mind—the island—where he must learn long and painfully the importance of balancing contemplation with action. The quixotic nature of the life of the mind causes David Lodge and A. S. Byatt to cast their academic researchers as heroes of quest romance, pressing on and on toward an ever-retreating meaning. Swift's swipes at the Royal Academy in *Gulliver's Travels* and Petronius's attacks on the "huge flatulent rhetoric" of scholars in *The Satyricon* are less gentle rebukes.

To give up power and real-life efficacy so totally one must be either foolish or well compensated. Wealth and academia, however, seem to be mutually exclusive, and so this compensation is normally pictured as a different sort of power—over ideas, or over the young. When William F. Buckley, Jr. says that the professor shapes "the destiny of the world" and the university is "the nerve center of civilization,"[5] he is conjuring up one version of this immaterial power. The question is always, what did the thinker have to give up to acquire this might?

The Faust myth has supplied an archetypal answer. Just as Eve "fell" for knowledge, Faust sells his soul to the Devil for all the world has to offer. He gives up morality, human kindness, and all hope of salvation for the promise of immediate wisdom and power. The Faust story is in a sense an allegory of intellectualism, the retreat into an abstract or virtual sphere which one manipulates or creates through the will, abandoning, at least temporarily, the chastening limitations of morality and practicality. In our own day, novels frequently deplore the price in humanity that scholars have paid for knowledge—the "objective" historian in Gloria Naylor's *Linden Hills* who refuses to use his information to help anyone ("After such knowledge, what forgiveness?"); the "Schoolteacher" in Toni Morrison's *Beloved* who studies the human versus the animal properties of a slave as his pupils assault her in a barn; or the ambitious

feminist academics in Andrea Dworkin's *Mercy* who sell out the cause of women.

In short, the literary image of the scholar is generally negative, or at least derisory. It is also thoroughly contradictory: the scholar is comically inefficacious and inept; the scholar is preternaturally powerful. The teacher is a self-sacrificing martyr; the teacher is a cold, self-serving amoralist. The academic is a sexual incompetent; the academic is a sexual marauder. The intellectual aspires to truth; the intellectual is a fake. The professor yearns to rule the world; the professor yearns to rule the common room. In Charles Sykes's description, the "Academic Man" is "this strange mutation of twentieth-century academia who has the pretensions of an ecclesiastic, the artfulness of a witch doctor, and the soul of a bureaucrat."[6]

Most academics, given half a chance, would picture their contradictions in a more glamorous image—that of the double. Their hearts thrill to the anthropologist-adventurer Indiana Jones, the philosopher-diplomat Brother William of Baskerville, the scholar-detective Sherlock Holmes, or any of the mild-mannered intellectuals who cross jungles, defeat villains, and get the girl (or guy). James Joyce said that those concerned with language must live by silence, exile, and cunning;[7] academics cultivate these survival strategies against the day when they will meet their Moriarty. Scratch any academic and you will find a fantasy spy, an adventurer whose pedagogical persona is only a respectable cover. The scandal of a Heidegger or a de Man is small-time compared to the imaginings of the average university professor.

Often, however, this double identity is not just a matter of fantasy. A surprising number of Yale English professors, for example, have been actual spies. Norman Holmes Pearson, who was one of my dissertation readers, headed U.S. counterintelligence operations in London during World War II and remained active long afterward. Professors Eugene Waith, Louis Martz, Richard Ellmann, Ted Hilles, Joseph Toy Curtiss, and the bibliographer Donald Gallup were OSS agents during the war. Pearson recruited James Jesus Angleton, who headed counterintelligence until the 1960s, and knew the counterspy Kim Philby.

According to the historian Robin W. Winks, Yale was a traditional feeder for the CIA from the Second World War on. As students, we used to joke about spies in our midst—the real CIA and its shadow down the street, the Culinary Institute of America. Those trained in English literature at Yale, a bastion of the New Criticism at that time, were particularly useful recruits because they knew

how to read, "really *read,* closely, without interruption, how to interrogate a manuscript to see what an author intended as opposed to what was written."[8] "Scholarly method suited the demands of intelligence gathering," Jerome Christensen points out; "the New Criticism, designed by poets to break the complex codes of other poets, was a form of counterintelligence."[9]

Teaching also develops useful espionage skills. According to Winks (p. 57), "the scholar who teaches must teach with the whole personality. This requires considerable self-awareness. . . . one must also observe others with care. One must know not only, as teacher or researcher, how to ask the right question, one must know when to ask no question at all. . . . One must know how to wait. A quality of quiet watching is essential."

Scholarship not only affected the course of espionage during World War II, but espionage wrought crucial changes in the humanities. E. H. Gombrich, for example, attributes some of his insights into aesthetic perception to his wartime experience with aerial reconnaissance photos.[10] And according to McGeorge Bundy, "In very large measure the area studies programs developed in American universities in the years after the war were manned, directed, or stimulated by graduates of the OSS—a remarkable institution, half cops-and-robbers and half faculty meeting." The OSS has been described as the very first area studies program;[11] on left it for Yale, where in 1963 he became chair of American Studies.

Since these spies were on the same side as their universities, no one seems upset or even surprised that academics had this "other identity." Moreover, the ideological bias they introduced into area studies was overt and patriotic. Pearson taught that in classic American literature "even the most hostile writing showed love for America because it was 'goading her toward the achievement of an idea.' "[12] In no sense were he and his colleagues conscientiously separating literature from ideology or protecting their students from the influence of their private political convictions.

Interestingly, Pearson admitted to having been "nearly Nazi in my mind" for a short time in Berlin in 1933, when it seemed that National Socialism might be just what Germany needed.[13] Though he changed his opinion, he was not alone in his Nazi sympathies. European intellectuals of the interwar years seem seldom to have championed democratic centrism. Tzvetan Todorov notes that "whereas over the past two centuries Western countries have embarked on the path of democracy, their intellectuals—theoretically the most enlightened segment of the population—have systematically opted for violent and tyranni-

cal political systems." [14] Hannah Arendt assumes as much in excusing Heidegger's totalitarianism as a typical intellectual "déformation professionale." [15] Certainly, if one looks into the life of almost any interwar European intellectual, their affiliations—open and secret—seem to have been fascist or communist. "Why, in the twenties and thirties was there such a rejection of democracy on both Right and Left?" Philippe Lacoue-Labarthe asks. "Why this preoccupation with the nation? Why was there such certainty both within Germany and outside it, that Europe was heading for catastrophe? And why such anxiety, shared just as much by Valéry and Bergson, Blanchot and Husserl, Bataille and Heidegger, Benjamin and Malraux, to mention but a few?" [16]

Lacoue-Labarthe does not answer these questions, but for our purposes it is enough to note this widespread anxiety. After World War II, while leading literature departments and area studies programs were stocked with American agents—retired and active—we can be confident that the European emigrés who also formed a goodly proportion of those postwar faculties had political affiliations of a very different sort. The same is true in Europe. The surprise is not that such figures as Anthony Blunt, Martin Heidegger, or Paul de Man existed, but that there were not a great many more of them.

Given the fact that the teachers of the current academic establishment were formed in the interwar and war periods, we will surely be confronted with scholar-spies and clashes between theory and autobiography for years to come. Perhaps we might learn from some of these academic doubles, whose experience so belies the popular image of the professor as an impractical wimp cut off from the world of affairs. Three cases of treason and textuality seem particularly instructive, for they involve a variety of disciplines and nations: the English art historian Anthony Blunt, the German philosopher Martin Heidegger with his many followers in France, and the Belgian-American literary theorist Paul de Man.

ANTHONY BLUNT

In Alan Bennett's *A Question of Attribution,* Anthony Blunt instructs Her Majesty the Queen about pictures. "Because something is not what it is said to be, Ma'am, does not mean it is a fake." When she asks what it is, Sir Anthony gingerly suggests: "An enigma?" [17] Here as in Tom Stoppard's play *Hapgood,* the figure of the spy symbolizes the irreducibility of human and aesthetic mystery, the contradictions that all personalities enshrine, the confusion that no amount of pedantic energy can resolve. The Blunt case, which became public knowl-

edge in the 1970s, also reveals how troubled the status of the intellectual has become. If an American figure of Blunt's prestige and influence were exposed as a Soviet agent today, the fuss would be monumental, and the soul-searching of academics endless.

In the twenties, as a schoolboy at Marlborough, Blunt embodied the aesthetics of Pure Form. At Cambridge in the thirties, he signed on as a Soviet spy, one of the "Homintern" that included Guy Burgess. During the forties he doubled as an MI5 agent and a Soviet mole, became Surveyor of the King's Pictures, and directed the Courtauld Institute. Awarded a knighthood in 1956, found out in 1963 but granted immunity, he was publicly exposed in 1979, during which year the queen revoked his knighthood and he voted for the Tory Margaret Thatcher. Blunt is an enigmatist's enigma.

The English imagination has responded strongly to this compounding of spycraft, scholarship, homosexuality, and royal scandal. Blunt's 1979 exposure and his death in 1983 occasioned books, plays, and films. He figures in virtually every item in the seemingly endless literature on British espionage, and Bluntiana have already outstripped Blunt's own prodigious oeuvre. But one constituency has remained more or less silent about him: the academy. George Steiner's searching *New Yorker* essay in 1980 provoked no particular response from art historians and theorists. The British Academy debated Blunt's expulsion after his exposure, but despite rancorous arguments and the dramatic resignation of A. J. P. Taylor, their proceedings did not lead to publications, conferences, lectures, or any of the other manifestations of a scholarly *cause célèbre*.

One has only to compare the recent furor over Martin Heidegger and Paul de Man to see how slight an impact the Blunt affair has had on the British academic community. In those cases, the worry is that there must be some connection between theory and politics. Postmodernists, deconstructionists, and Marxists alike believe in the ideological subtext, convinced, like Fredric Jameson, that "there is nothing that is not social and historical . . . [and] 'in the last analysis' political." [18] Having rejected the positivist claim that scholarship can be independent of ideology, we read everything *ad hominem*. Moreover, we fear contagion. Have we inadvertently ingested fascist poison with our deconstructive milk?

It is the connection between ideology and scholarship that is on trial in the current academic debates: this and the belief in the consistency of identity, the self as a seamless web. But what do we do with Anthony Blunt? Here was no mere proponent of Marxism but a secret agent of an enemy power whose com-

mitment lasted not for a few months but for his entire adulthood. Here was a
man whose influence over scholars, students, and art professionals was both pro-
found and frighteningly discreet—so discreet, in fact, that a good part of the
art-historical establishment of England is content to brush him aside as a distin-
guished pedant with an amusingly piquant set of secrets. Blunt represents the
limit case for academic freedom: the ultrarespectable scholar with treasonous
affiliations.

If we accept that all scholarship is a product of ideology, Blunt's power
should give us pause. He was in attendance at the birth of English art history. It
is not sufficiently well-known how young the discipline is in Britain. No
courses in the field existed until 1931 when the Courtauld Institute was estab-
lished, and before then one studied the subject, as Blunt did himself, by "read-
ing." Blunt began lecturing at the Courtauld in the second year of its existence.
He became an assistant director a few years later, and director in 1947. By all
accounts, he transformed the Courtauld from a high-class finishing-school to a
world center for the training of academics and art professionals, with no insti-
tution in competition until the 1960s. As time went on, Blunt had wide influ-
ence in every aspect of the administration of culture in England. There is hardly
a British art historian who was not trained by him or by one of his students.

Yet Blunt did not use this power to promote any discernible political ide-
ology. Colleagues, students, and publishers insist that there was nothing Marxist
about his art history and that he never tried to influence people politically.
Indeed, to the committed Marxist of our day, Blunt was ideologically retro-
grade. Paul Overy, for example, claims that Blunt was responsible for depoliti-
cizing art history: "the director of the [Courtauld] Institute . . . was Anthony
Blunt, a long-standing Soviet spy. To provide a convincing cover for his later
activities . . . the Courtauld was devoted to a conception of art history which
was formalist and value-free." [19]

This view would probably have bewildered Blunt. From his standpoint, he
was anything but a formalist. He was committed to the principle that art history
is the study of works in their historical settings: not the esoteric interpretation
of the iconographers, specifically not the formalist appreciation of the Pure-
Formers, but a Marxist-informed contextualism. "[C]an it be true that people
have stood in front of Toulouse-Lautrec's brothel scenes or van Gogh's peasant
studies and have asserted that these works affected them only as lines and col-
ours?" [20] "For since art is produced by men living in society and not in an ivory
tower it cannot but reflect and express the ideas of the society and of its time." [21]

This position, which Blunt enunciated in the thirties, was the basis of his work thereafter.

If one did have to locate a common factor in the spy and the scholar it would be anger against authority, which began with Blunt's early exposure to modern art. At Marlborough, he and Louis MacNeice bounced rubber balls across the playing fields, held elaborate teas and generally thumbed their noses at their games-playing peers. Blunt disdained politics, "preferred Things to People,"[22] and immersed himself in the writings of Roger Fry and Clive Bell. He hung modern pictures in his room and published an article in the rebel school magazine the *Heretick,* arguing that "to call a work of art immoral is like calling an ink pot sympathetic."[23] This amorality so scandalized one parent that he threatened to have his son removed from the school if the *Heretick* were not suppressed. Blunt's response to Marlborough was that "if this represents the establishment, I shall conspire to destroy the establishment."[24]

For a sixteen-year-old schoolboy to be writing that "modern art should be judged by the same standards as Persian rugs," by "the formal qualities of pattern and colour,"[25] indicates not only an astonishing aesthetic precocity but an equally extreme anti-authoritarianism. By the thirties, however, when the Post-Impressionists had become the favorites of the smart world, one could not dismay the establishment by extolling avant-garde line and color. Marxism was harder for them to swallow. At this point, swept along in the communist surge at Cambridge, Blunt did an aesthetic about-face. Matisse became a slick sensualist of color for him, and Picasso was "clogged in a love of the obscure and the unusual"—"the last refinement of a dead tradition" glorifying the artist's individuality.[26] Pure Form was suddenly an unimaginable conviction, given Blunt's "ingrained belief that a painting can be altogether of greater importance than even the best Persian carpet" ("Brussels Exhibitions"). The rebutting of his own words here suggests that in his defiant scorn for the bourgeoisie he was entering into combat with himself.

Blunt was converted to Marxism and espionage in 1933 or 1934. From 1932 to 1938 he was art critic of the *Spectator,* and in his almost weekly essays one can see his aesthetic and political transformation in the making. At first, in often forgettable reviews of exhibitions and art books, Blunt expresses an orthodox Bloomsbury line. He is against the idea that photographic realism is the goal of art, does not care what impels an artist to paint as long as the result is formally satisfying, and thinks the communist use of the word "bourgeois" is unreflecting. By July 28, 1933, however, he writes that "art and life are, God

knows, different, but they are not wholly unrelated to each other." He takes
the Pre-Raphaelites to task for trying to drag the working man into a dream of
medievalism without improving his material existence. He inveighs against Ital-
ian Futurism as fascist propaganda, and in the November 2, 1934, *Spectator,* he
composes a rather strained parable called "The Beaver and the Silkworm," the
moral being that a proper creator is like a beaver assembling bits of reality rather
than a silkworm spinning art out of itself. After a trip to Russia in 1935 came
three enthusiastic articles, and by October of that year Blunt exclaimed: "How
did we ever believe in significant form!" ("Brussels Exhibitions"). The next
week, in a piece entitled "Sleepers Awake!" he revealed that "the intellectual is
no longer afraid to own to an interest in the practical matters of the world, and
Communism is allowed to be a subject as interesting as Cubism." [27] His Marx-
ism was open. He wore a red tie.

In the years that followed, Blunt called for a new pictorial realism, artists'
unions, and the transformation of museums from pleasure gardens into class-
rooms. He disdained individualism in favor of communal aesthetics on the
model of medieval (or Soviet) art, and differentiated Nazi control of culture
from that of the Communists. Pure Form is pernicious and surrealism a subver-
sion of the populist and realist goals of society; the critic's duty is not to say
what is formally good or bad but to explain art as an "expression of man." [28]

In September 1938, this Marxist program culminated in a three-part dis-
quisition on value entitled "Standards." Here Blunt argued that the only sci-
entific basis for artistic judgment was history. The critic's job was to place the
work in a movement and determine whether the movement aimed at producing
the maximum material good. If it did, the work was good; if not, it was bad.
The next step was to investigate how the painting expresses these values, and
this involves an analysis of content and form so complex that it may elude a
purely logical explanation. Nonetheless, since the difference between a Christ
by Giotto and one by a minor follower is evident to many people, this stage in
evaluation is a matter of common judgment, a communal sense of value. The
last step is the critic's voicing of his or her personal reaction to art. Like the
work itself, this is to be seen as a historical fact, but not one of any great value.
With "Standards" Blunt ended both his regular contributions to the *Spectator*
and the airing of his personal taste.

He now turned full-time to scholarship (and espionage). Those who view
his art history as a cover, however, exaggerate the discontinuity between it and
his journalism. In his books and essays, Blunt performed the deep contextual-

izing which he had advocated, in a thorough, workmanlike, and often rather dull fashion. The only moments of authorial warmth appear in descriptions of artists. Blunt speaks with admiration of Rouault's hatred of his society, of Poussin and Borromini's disdain for the material rewards of pleasing patrons, of Alberti's unwillingness to be manipulated into passivity by Lorenzo de Medici. He scorns the likes of Vasari for transforming the vital independence of humanist painting into courtly good manners and a kowtowing to authority, or the Précieux of seventeenth-century France for being so disempowered by Henry IV that conversation took the place of action.

Blunt's 1959 depiction of Blake is particularly striking. The fervent Jacobin of the 1780s became the disappointed humanist of the 1790s, horrified at the Terror abroad and the political oppression at home. Blunt saw Blake turning more and more inward towards "mental strife," seeking solutions in philosophy and religion rather than political action. He was not a madman, as the nineteenth century tended to depict him, but a superbly traditional artist, influenced by the formal clarity of Michelangelo and Raphael and disdaining the chiaroscuro and sfumato of the Venetians. Politically and aesthetically, he was a "minority fighter" who "defied the world"; "his complete individualism and his bold defence of personal liberty have clear topical significance today . . . his passionate sincerity, his uncompromising integrity, his 'hundred-per-cent' quality command respect and admiration." [29]

We might discern more than a little identification in these portraits of artist-rebels, and if so, the internal contradiction Blunt sees in them between passionate principle and cold reason is revealing. In all his favorites, this conflict is the burden of the description. The arch-exemplar is his "first love," [30] the rationalist Poussin, whose art and life Blunt portrays as embodiments of Stoic philosophy. Blunt's fascinated descriptions of Poussin at work suggest, too, an eerie image of the spy as puppet-master. Poussin formed his compositions by arranging and rearranging wax figures on a little stage until their disposition suited him, manipulating them—in Blunt's fervid similes—like chessmen, a corps-de-ballet, a dramatis personae. [31] This is a fitting—perhaps a fittingly sinister—image of the spy, but also a wistful image. "It is easier," he wrote, ostensibly of Poussin, "to be strictly rational in theory than in practice." [32]

In short, Blunt had the power and the conviction to inculcate in the art-historical establishment of England a "hidden agenda." He himself believed that all cultural products carried such baggage, and he would be in sympathy with

the attempt to understand his own scholarship as a product of its context. Yet
he left an interpretive enigma. A "master of compartmentalization," he pro-
duced a scholarly corpus which could have belonged to any disenchanted for-
malist. At the same time, his involvement with Marxism in the thirties was a
matter of public record and the historicism and anti-formalism of his work are
quite apparent. We cannot explain his art history as either a cover for or a re-
flection of his Soviet sympathies. In Blunt's careers as spy and scholar we find
the connection between text and ideology strained to the breaking-point by a
proponent of that very connection.

In what way, we might ask, would we expect a Soviet agent's ideology to
manifest itself in his art history? What would constitute ideological baggage:
would it be the urging of a people's art, for example, or the tying of creative
achievement to class? In fact, both are to be found in Blunt's writing, but one
sees equally an attunement to aesthetic form and artistic intensity. Throughout
Blunt's oeuvre there is this split between formalist and left-historicist view-
points, which Blunt presented as a sequence: "From Bloomsbury to Marxism"
was the title he gave to a glib memoir published in 1973. An ideological reading
of Blunt's work recovers irresolvable contradictions at every step. But if this is
the scholarly manifestation of a Soviet agent's belief system, it is also the mental
set of thousands of humanists nowadays who have passed from the extreme for-
malism of their early training to the contextualism of feminism, the New His-
toricism, African-American studies, or Marxist criticism.

Blunt's life and writing, like those of the artists he admired, evoke a series
of paradoxes. One can locate neither a convincing ideological stance in his life
nor a definitive political subtext in his work, but merely an autobiography of
contradiction, anti-establishment reaction, and formidable self-control. His
case strains the coherence of such principles as academic freedom and political
loyalty. It would be nice if we could state uncategorically, as Beethoven is sup-
posed to have done, "I despise treacheries. Do not visit me again"; but almost
no one associated with Blunt has been able to connect these two sentences—
the general and the personal condemnation.

Just as Blunt's life reveals this blank in our morality, his career reveals our
tattered confidence in intellectualism itself. "Art," he said, "is produced by men
living in society and not in an ivory tower." We recognize an echo of Picasso's
more eloquent words, which Blunt had occasion to quote: "How would it be
possible to feel no interest in other people and by virtue of an ivory indiffer-

ence to detach yourself from the life which they so copiously bring you? No, painting . . . is an instrument of war for attack and defence against the enemy." [33] To break out of ivory indifference but not to deny the love of the mind, to understand how one's work—whether painting or scholarship—could be an instrument of war, to know what the war is and who is the enemy, to question the relation between text and ideology, the coherence of personality, and the meaning of academic freedom, and to appreciate the complexity and discontinuity of ideologies coexisting in every person and every aesthetic product: these are the challenges that Blunt's life bequeaths us.

In 1989, Alan Bennett published a remarkable play about this scholar called *A Question of Attribution,* which showed before packed houses first in the West End and then at the Royal National Theatre. Most of the play is set in the old Courtauld Institute, shifting among scenes of Blunt's administering, lecturing, and interrogation by a Scotland Yard detective. The Courtauld—his office, school, and home—allowed his lives as art historian, spy, and homosexual to be superimposed in a single polyvalent space.

The play opens with Blunt instructing his restorer to clean a portrait of two men which was formerly thought to be by Titian. The cleaning will reveal a hidden third figure, whom Blunt is to identify. At the same time, a police agent, Chubb, shows slides of men associated clandestinely with Blunt, whom he must identify, too. Blunt provides no information to Chubb, but does impart a good deal of art history. By the time the play is over, Bennett has developed a thoroughgoing parallelism between art history and police investigation, and hence, between the scholar and the spy.

Blunt's research leads him to identify the third figure in the painting as Titian's son. But Xrays soon reveal a Fourth Man, and "if we rotate the Xray we find behind the original pair and the third and fourth man the rather more substantial figure of a fifth man. The fifth man, you will doubtless be relieved to learn, is the last of the sitters lurking in the somewhat overpopulated canvas." [34] One scholarly discovery opens up another, just as the discovery of Blunt as the Fourth Man led immediately to the positing of a Fifth.

The question Blunt asks his audience—for he is now standing at a podium before his students—is what difference any of this makes, why one should worry about the identity of any of the figures, for "this is not an important picture, just a murky corner of sixteenth-century art history." His answer is that the painting offers a lesson: that a life spent teasing out such riddles produces "a barrenness of outlook, a pedantry that verges on the obsessive, and a farewell

to common sense . . . paintings—we must never forget—are not there primarily to be solved. A great painting will still elude us, as art will always elude exposition." [35]

At this point, the scene of instruction dissolves into a scene of interrogation between Blunt and Detective Chubb. Chubb informs Blunt that the police are not going to be able to keep his espionage a secret, that he will be "named," "attributed." "And as a fake," says Blunt, "I shall, of course, excite more interest than the genuine article." Chubb asks for the identity of the man behind it all, but Blunt shifts the conversation to the identity of the figures in the fake Titian. "But who are they? I don't know that it matters. Behind them lurk other presences, other hands. A whole gallery of possibilities. The real Titian an Allegory of Prudence. The false one an Allegory of Supposition. It is never-ending." [36] The play concludes with these words, the evocation of an interpretive regress ad infinitum for both scholarship and espionage. There is no surety, no singleness, no identity, and the figure of Blunt epitomizes the pathos of postmodern undecidability, that paradoxical middle ground inhabited by artists, scholars, and spies.

MARTIN HEIDEGGER

"The trouble with treachery nowadays," Bennett wrote in the introduction to *A Question of Attribution*, "is that if one does want to betray one's country there is no one satisfactory to betray it to" (p. ix). When the play was shown on *Masterpiece Theatre*, the host, Sir Alistair Cooke, appended a furious rebuttal. For the patriotic Cooke, Bennett's flippant attitude toward treason was appalling. But Sir Alistair's fury was atypical, and Blunt's respectability as a scholar in Britain has been completely untouched by the revelations of his covert activities. As the American Robin W. Winks notes, "One might conclude that the nations simply thought about treason somewhat differently." [37]

This difference is apparent in the case of Martin Heidegger. When Victor Farías's exposé, *Heidegger and Nazism*, appeared, the Freiburg historian Hugo Ott declared that "In France a sky has fallen in—*the sky of the philosophers*." [38] Heidegger's unrepented Nazi sympathies made headlines in the news sections of papers all over Europe and North America. The man whom Hannah Arendt called the "uncrowned king of the empire of thought" [39] was saluted in a Paris *Libération* headline with the words, "Heil Heidegger!" (fig. 26).

George Grange calls Heidegger the "most important philosopher since Hegel and certainly the greatest thinker of modern times. His work has set the

26. Martin Heiddeger. (Photo:
Bildarchiv Preussicher Kulturbesitz,
Berlin.)

terms of debate in literary theory, biblical hermeneutics, theological discourse,
cultural philosophy, and philosophical method. . . . [P]ostmodernism derives its
rationale and motivation directly from his work. Likewise, deconstruction, the
ultimate postmodern method, is a direct descendent of his theory of the his-
tory of Being and the end of traditional philosophy as a worthwhile human
activity." [40]

In the very speech that inaugurated his rectorship and aligned the goal of
research with Nazism, Heidegger provided an eloquent statement of postmod-
ern uncertainty. If Nietzsche was right that "God is dead," he argued, "and if
we must be serious about this forsakenness of modern human beings in the
midst of what is, then what is the situation of science?" His answer was that all

science can achieve is "a completely uncovered exposure to the hidden and uncertain: that is, the questionable. Questioning is then no longer merely a preliminary step that is surmounted on the way to the answer and thus to knowing; rather, questioning itself becomes the highest form of knowing."[41] How can we reconcile this humanistic doubt and pathos with the strutting certainties of National Socialism?

Responding to the "crisis of Europe" after World War I,[42] Heidegger, like so many other European thinkers, looked to the coming of a god or hero—temporarily Hitler—who would return meaning to the world. In the philosophical equivalent of Samuel Beckett's *Waiting for Godot,* he describes life as the preparation for this advent. "Only a god can save us," he wrote. "I think the only possibility of salvation left to us is to prepare readiness, through thinking and poetry, for the appearance of the god or for the absence of the god during the decline; so that we do not, simply put, die meaningless deaths, but that when we decline, we decline in the face of the absent god."[43] Heidegger's task was to explore this absence and expectancy, the alienation wrought by technology, the contextuality of thinking, the condition of Being as such.

About his Nazi involvement he was uncommunicative, saying only enough to establish a hazy exculpatory account of his doings. He claimed to have agreed to serve as rector at Freiburg so that a party functionary would not be given the job and disrupt the mission of the German university. He broke with the Nazis and left the rectorate ten months later, he said, when he realized their true motives, for he was never a racist and, in fact, had helped some Jews during the war. Nazism was in no way essential to his beliefs, and his goals throughout his career were not political but philosophical.[44] Though many philosophers doubted this story, Heidegger's politics seemed a secondary enough issue to push safely into the background.

Since Farías's book, Heidegger's account has become untenable, for Farías amasses a great deal of incontrovertible—if unbalanced—evidence to prove that Heidegger's involvement with Nazism was deep and lifelong. "When Heidegger decided to join the National Socialist Party, he was following an already-prepared path," writes Farías,

whose beginnings we will find in the Austrian movement of Christian Socialism, with its conservatism and anti-semitism, and the attitudes he had found in his native region (Messkirche and Konstanz) where he had begun his studies. By considering the historical context and the texts he wrote in his youth . . . , we can see the progressive connections in a thought

process nourished in traditions of authoritarianism, anti-semitism, and ultranationalism that sanctioned the homeland in its most local sense. . . . [T]his development is linked to Heidegger's reflections in *Being and Time* (*Sein und Zeit,* 1927)—on historicity, "authentic" being-in-community, and his own links with the people, the hero, and the struggle—and his rejection of democratic forms of social life.[45]

Farías shows that Heidegger not only joined the Nazi Party in 1933 when he was made rector, but continued to pay his dues until 1945. He became rector not to protect the university from the Nazi Party, but to become the "Führer of the Führer," the philosophical leader of the Nazi state; Jacques Taminiaux compares his stance in the rectoral address with that of Plato's philosopher-king.[46] Heidegger failed in this attempt because he allied himself with Ernst Röhm and his Storm Troops (the S.A.), in opposition to the biological line of thought of Alfred Rosenberg and Ernst Kriek. When Hitler eliminated Röhm in June 1934, Heidegger felt the party had moved away from true National Socialism and he quit or was forced out of the rectorship. But he remained active in the party throughout the war, received no official criticism, and exercised influence by denouncing such Jewish intellectuals as Edmund Husserl and Eduard Baumgarten. He also developed plans for a militant Academy of Professors of the German Reich, whose aim was "To rethink traditional science in terms of the strengths of National Socialism" and "To understand effectively that tomorrow's university is a *community of educative life* based on a homogeneous notion of the world."[47]

One of Heidegger's first acts as rector was to eliminate academic freedom on the grounds that "It means no more than taking it easy, being arbitrary in one's intentions and inclinations, taking license in everything."[48] And even after the war, he stuck by his view that academic freedom was basically negative: "the *freedom from* the effort of getting involved in the reflection and contemplation scholarly study demanded."[49] As rector he also expelled all Jews from the teaching staff, refused financial aid to Jewish and Marxist students, obliged all faculty to sign an oath proclaiming their racial purity, and organized a department of racial issues to be directed by the S.S. He was, by all accounts, an extraordinarily compelling teacher, and the basis of his support came from students.

Even as early as *Being and Time,* Farías argues, Heidegger had equated inauthenticity with individual existence and the authentic with the communal. He had also adopted many of the romantic categories central to Nazism: "the

We, struggle, destiny, the historical mandate of the people, community, and, above all, the exemplary leader who . . . is expected to point out the path that the people will follow." In 1933, when the philosopher Karl Jaspers asked Heidegger how he could imagine so coarse a man as Hitler as ruler of Germany, Heidegger answered, "Culture is of no importance. Look at his marvellous hands!" And later that year Heidegger wrote in a student newspaper, "The Führer himself, and he alone, is the German reality of today, and of the future, and of its law." [50]

Though Heidegger lost his infatuation with Hitler, Farías claims that he continued to see Nazism as an attempt to help people reconcile themselves to technology. After the war, he defended his position on the Holocaust to Herbert Marcuse. "I expected from National Socialism a spiritual rejuvenation of all life, a reconciliation of social antagonisms, and a rescue of Western existence from the danger of communism." In the same letter to Marcuse, Heidegger refused to acknowledge the enormity of the "Final Solution": "To the severe and justified reproach that you express 'over a regime that has exterminated millions of Jews, that has made terror a norm and that transformed everything connected to the concepts of spirit, freedom, and truth into its opposite,' I can only add that instead of the 'Jews' one could put the 'East Germans,' and that is even more the case for one of the Allied Powers." [51]

In a 1949 speech, Heidegger again described the Holocaust as just another case of violence and oppression, no different in kind from the rest. "Agriculture," he warned, "is now a motorized food industry, in essence the same as the manufacturing of corpses in the gas chambers and concentration camps, the same as the blockade and starvation of the countryside, the same as the production of the hydrogen bombs." [52] And even in 1953, he saw fit to publish lectures he had written in 1935 that refer to "the inner truth and greatness of the movement [Nazism] (namely the encounter of planetarily determined technology and modern man)." [53]

These quotations are repeated over and over again in "l'affaire Heidegger." They have led scholars to despair of the very possibility of philosophy. For philosophy has traditionally meant more than just ideas or theories, but the search for the true and the quest to empower the good. The idea of a great Nazi philosopher therefore seems a contradiction in terms, and, as Farías suggests, "we ourselves, reading and applying Heidegger as we seem bound to do, are also placed in moral question." [54] Yet the implications of Farías's revelations are not clear. Once we have discovered that Heidegger was a Nazi, of whatever degree

of culpability—and of course there is much disagreement as to just how "bad" his Nazi involvement really was—what should our response be? What difference does it make—as with Blunt—to learn that an influential thinker was also the exponent of an ideology beyond the pale?

If Heidegger the man is discredited, does Heideggerian philosophy fall, too? Long anathema to analytic philosophers because of his idiosyncratic prose—"immensely loquacious, ponderous, repetitive, heavy and Teutonic"[55] —Heidegger has been described as "apt to create a twilight of uncritical semi-understanding among the gullible."[56] Now one can add to his stylistic crimes the sin of a subtle fascist indoctrination. When Tom Rockmore finds French intellectuals paralyzed in judging Heidegger, he blames their immersion in Heideggerianism for this incapacity: "to the extent that Heidegger's thought forms the horizon of contemporary French philosophy, it cannot examine Heidegger's link to Nazism without putting itself into question: that is, without simultaneously rejecting the Heideggerian position. In a word, Heidegger's French connection prevents French thinkers from perceiving the emperor's new clothes."[57] The implication, unstated by Rockmore, is that to avoid such a moral impasse one should avoid Heidegger, that the only way to read his philosophy is as a source of pollution to be imbibed with suitable precautions. Believing in it, founding ideas on it, is tantamount to "perpetuating a very sophisticated and radical form of Nazism."[58]

Thus, Jacques Derrida, in his inflammatory way, claims that "Ever since the first week after the publication of Victor Farías's book in French, some have been very quick to say, 'Heidegger is over with. It's not necessary to read him anymore.' They almost said, 'Let's burn him!'"[59] In part, at least, Derrida is afraid that the end of Heidegger will mean the end of deconstruction. As Michael E. Zimmerman suggests, "In slaying grandfather Heidegger, so some French mandarins hope, they can also slay the current father-figure, Derrida, thereby making way for a postdeconstructionist discourse more to their own liking."[60] The same fear has grown up around the revelations about Paul de Man—that they will be used to stop not only *his* work from being read, but that of the entire deconstructive movement.[61] To forestall this development, Karsten Harries urges that we read Heidegger to understand his political choice and its significance,[62] and Derrida prescribes "the vigilant but open reading of Heidegger" as an indispensable condition for understanding why "I have always condemned Nazism, in the horror of what . . . has ever been able to give in to it."[63]

Under the circumstances, it is perhaps inevitable that "l'affaire Heidegger" would degenerate into an "affaire Derrida." From January to April, 1993, the *New York Review of Books* published an angry interchange over an interview with Derrida about Heidegger printed in *Le Nouvel Observateur* in 1987. Richard Wolin received permission from this journal to translate and publish the interview in his collection *The Heidegger Controversy,* which appeared from Columbia University Press, one of Derrida's publishers as well. When Derrida discovered by chance that his interview, "Philosophy's Hell," had been printed in a setting meant, as he saw it, to discredit Heidegger, he threatened to have the next printing seized if his piece were not removed. Wolin then removed the interview and redrafted his preface to explain its absence, but Columbia allowed the book to go out of print rather than publish the offending preface. Wolin then took the book to M.I.T. Press, who printed it with the preface intact.

In the *New York Review of Books* on January 14, 1993, Thomas Sheehan revealed this history, and three months of letters to the editor followed, with Sheehan and Wolin insisting on their side of the story, Columbia denying it, and Derrida insisting that he had withdrawn the text because of the execrable quality of the translation. "Why doesn't Derrida come clean?" Wolin demanded. "The real reason he's so upset is that . . . in both 'Philosophy's Hell' and *Of Spirit* he deconstructs into nonexistence the gravity of Heidegger's Nazism—above all, its relation to Heidegger's thought—and has been caught with his pants down."[64] No less a scholar than Hélène Cixous wrote to enumerate the faults in Wolin's translation, and twenty-five of the West's most prominent literary scholars drafted a collective note in support of Derrida. Sheehan called them a bunch of acolytes following a "cult of personality,"[65] and soon after, the pointless interchange came to an end.

Many scholars, in contrast, believe that the revelations concerning Heidegger's wartime politics have *no* relevance to his writing at all. Heidegger's Nazism is no secret, they argue, and each time the story flares up—and there have been several such flare-ups—the common sense of his readers and the inherent interest of his thought have made the political issue seem separable and ultimately irrelevant. After all, as Heidegger himself frequently argued, quoting Valéry, "Qui ne peut attaquer le raisonnement, attaque le raisonneur."[66]

This argument is most popular in Germany and America, among both philosophers and nonspecialists. Paul Berman expresses this tolerance for the splittability of author, text, and reader: "Heideggerians of one sort or another dominate almost every field of modern French philosophy and by extension much

of modern thought. Could it be that half of contemporary intellectual life is therefore tainted in some manner with reactionary prejudices, that Sartre, the deconstructionists, the Marxist-Heideggerians, the left as well as the right, are compromised? The absurdity of such a claim would seem to make the argument fall of itself." [67] Michael E. Zimmerman holds the same view, reminding us that Heidegger's Jewish students (e.g., Herbert Marcuse and Hannah Arendt) were shocked that he could have taken a principled Nazi position, and that exponents of Marxism and even democratic centrism have proceeded from Heidegger's ideas. His "political activities during the 1930's help to answer Plato's question about the relation between knowledge and virtue . . . there is no necessary relation between the two." [68]

But attractive as this position might be, it has its problems. As Hans-Georg Gadamer writes, "It has been claimed, out of admiration for the great thinker, that his political errors have nothing to do with his philosophy. . . . Wholly unnoticed was how damaging such a 'defence' of so important a thinker really is." [69] The splitting of politics and theory contradicts Heidegger's notion that ideas are rooted in their contexts, that "every individual is a *child* of his own time." [70] To "save" Heidegger by claiming that his work is somehow autonomous, independent of its era, place, and author, would be to sacrifice him in the process. We end up locked in the paradox, as Joseph Margolis presents it, that "the positive force of Heidegger's thought is collected at least in the ubiquitous notion that all conceptual work is historically perspectivized, horizoned, interested, prejudiced, contexted, resourceful, and transient. It is hard to see how to give that notion up in opposing Heidegger, or in vindicating Nuremburg." [71]

Heidegger's politics are thus neither simply separable nor simply inseparable from his philosophy. The question then becomes how to behave in the presence of such a paradox. In *Heidegger and "the jews,"* Jean-François Lyotard sets himself just this problem, which he formulates as four specific requirements. [72] First, Heidegger's greatness must be acknowledged. One must equally admit that his involvement with National Socialism was "deliberate, profound, . . . persistent." And third, one cannot eliminate one of these principles in favor of the other, as in the formulation, "if a great thinker, then not a Nazi; if a Nazi, then not a great thinker." Heidegger was great *and* a Nazi, and the two propositions cannot be taken as mutually exclusive. But, fourth, one cannot claim either that Heidegger was split in two—one side noble, the other ignoble.

With these severe restrictions, Lyotard constructs a complicated (often opaque) argument around the idea of "the jews." Not precisely identical to the race or people, "the jews" embody and memorialize a loss which can never be spoken or even remembered, except as what is forgotten. "They are what cannot be domesticated in the obsession to dominate, in the compulsion to control domain, in the passion for empire. . . . 'The jews,' never at home wherever they are, cannot be integrated, converted, or expelled. They are also always away from home when they are at home, in their so-called own tradition" (p. 22). For Heidegger, *Dasein* (Being) is bound to place, origin, and people (*Volk*), and so "the jews" stand as a constant irritant, a sign of failed purity and authenticity. They guarantee what Rushdie calls a "mongrel" world.

Lyotard reasons (p. 89) that since Heidegger thought "the jews" remained unreconciled to authority, they had to be suppressed. But here he was stepping out of his system. For Heidegger to take this step was uncanny, in the Freudian sense of the word (*unheimlich*), because he was trying to suppress what was by definition "unforgettable" (p. 56). Heidegger usually advocated, instead, a middle position. For example, in the rector's speech, Lyotard sees him contesting both the vulgar politicization of knowledge in Nazism and the principle of academic freedom that politics is irrelevant to knowledge.

Here Lyotard supplies us with a classical statement of the paradoxical relation between philosophy (or art) and political reality. Thought exceeds its context, but is not independent of it: "it explores and questions its dependence from [its context] with such obstinacy that it diverts the former's ordinary efficiency and, in this diversion, emerges as the event that it is" (p. 59).

According to Lyotard, however, Heidegger at this point misconstrued the relation between the philosophical problematics he developed and the question of the Nazi state, taking it as a necessary relation. But the eradication of "the jews" was not a necessary move; thought could exceed its context. (We might note that Jean-Paul Sartre, for example, also saw the Jew as an outsider, but that difference, far from requiring elimination, made the Jew a model of authenticity.) In any case, though anti-Semitic assumptions can be found in Heidegger's work, Lyotard judges the proposal to eradicate "the jews" accidental to it. In this way, he tries to save Heidegger's philosophy while still meeting the four conditions he set himself.

Lyotard's attempt is heroic, but not altogether convincing. For Heidegger's fall into totalizing philosophy was not limited to the matter of "the jews." It turns up in his writing on art as well. In general, as Lyotard points out, Heideg-

ger linked the outsider status of "the jews" to that of modern art. In the twen-
tieth century, art no longer bears witness to transcendence, he says, but to the
sense of unacknowledged loss and its concommitant pain. "It does not say the
unsayable, but says that it cannot say it . . .—Celan 'after' Kafka, Joyce 'after'
Proust, Nomo 'after' Mahler, Beckett 'after' Brecht, Rothko and Newman 'af-
ter' Matisse, these second in line, incapable of the achievements of the first in
line. . . , but capable because of their very incapacity" (p. 47). The historically
later figure in each of these pairings initiates the postmodern debunking of the
aesthetic fetish, undercutting the wholeness, sublimity, purity, perfection, and
transcendent power of the work of art. For Heidegger, contemporary art
achieves its effect by testifying to the alienation of a technological world that
can barely imagine authenticity or redemption.

It is this stoic existentialism and the whole philosophy of "unfoundedness"
that formed the basis, as we shall see, of deManian deconstruction. But Heideg-
ger also admitted a very different experience of art. In his study of the German
romantic Hölderlin, this poet came to represent the possibility of a perfect unity
of word and world, being and meaning. "I do not think Hölderlin is just any
poet, whose work is a subject . . . for literary histories. I think Hölderlin is the
poet who points toward the future, who expects the god, and who therefore
cannot remain simply a subject for Hölderlin research in the literary historical
imagination."[73] Heidegger repeatedly stresses Hölderlin's discontinuity from
the rest of literature; he becomes the poet in whom art can redeem the deca-
dence of the modern world, in whom art becomes, in effect, a fetish.

The need for this redemption is acute, for Heidegger believed that "We
have only purely technological conditions left. It is no longer an earth on which
human beings live today." "From our human experience and history, . . . I
know that everything essential and great has only emerged when human beings
had a home and were rooted in tradition. Today's literature is, for instance,
largely destructive."[74] In Hölderlin, however, one experiences "the world-
forming power of the work of art."[75] Thus, Philippe Lacoue-Labarthe claims
that in the rectoral address and the lectures on Hölderlin, Heidegger was im-
planting a "Heideggerianism" into reality, attempting to unify philosophy and
practice. In these moments, he moved beyond his "strict questioning" into
what he called an "other kind of thought."[76] He did the same in positing a
primordial connection between the German language and reality, origin, and
Being. If the "beginning was Greek, to reclaim it we must use an instrument
adjusted to that end, which could only be the German language. The French

assure me of this truth . . . : when they begin to think they speak German."[77]

This equation of the German language with truth, like the expansion of philosophy or art over political reality, is fundamentalism in its very essence. The boundaries between representation and reality fall before the imperative for coherence, consistency, wholeness, and systemic purity. In such a mindset, the demands of systemicity override all other concerns, and a blindness sets in, in which the Holocaust can be analogous to the mechanization of agriculture, and anti-Semitism is just an "incidental cost" of the glory of Nazism.[78] "That is how it was in 1945," Jürgen Habermas writes, "and that is how Heidegger always repeated it: abstraction by essentialization. Under the levelling gaze of the philosopher of Being even the extermination of the Jews seems merely an event equivalent to many others."[79]

In this vision of a world made art, where language speaks truth, Heidegger does begin to sound like a Nazi. Lacoue-Labarthe sees National Socialism, in fact, as a "national aestheticism," an aestheticization of politics in which the party constantly reinforced national identity and Nazi dogma through symbolic gestures. The Nazi model of politics, says Lacoue-Labarthe, is Wagner's *Gesamtkunstwerk,* "where a people, gathered together in their State, provide themselves with a representation of what they are and what grounds them as such." The Second World War then becomes a kind of "big budget war film" projected as a newsreel in Hitler's bunker every night.[80]

Thus, because of the ideal of a totalized state of Being, scholars have argued that Heidegger's Nazism is not an accident. Lacoue-Labarthe quotes Adorno's judgment that Heidegger's "philosophy is fascist right down to its most intimate components," concluding that Heidegger's political commitment "must be considered a wrong . . . an offence against thought."[81]

Yet, Lacoue-Labarthe ends by insisting that the only way to come to grips with the meaning of these facts is to read Heidegger rigorously. And surely we must agree. Reading is not automatic indoctrination, and thought exceeds the context upon which it depends. But at the same time, Heidegger's shameful history does make a difference to his work. It leads us to look for other areas of his thought in which his totalizing emerges, and to wonder at the discipline required for alienation when the nonalienated state is held up as such a value. It should also make us leery of any thinker for whom theory or art becomes so compelling as to govern reality. Indeed, this insight is part of Heidegger's legacy—both from the bad examples of his lapses into dogmatism and from his theorizing to the contrary, that art is definitionally distinct from the world. Like

art, like education, like all cultural fetishes—Heidegger's thought does not deprive us of freedom. *He* may have fetishized art and theory in a demonic literalism, but we need not do so.

PAUL DE MAN

The final instance of twentieth-century "treason and textuality" is Paul de Man, who made the sky fall in America, as Heidegger did in France. I should say from the start that I am not nor have I ever been a follower of Paul de Man or of deconstruction. I entered graduate school at Yale the same year de Man arrived, 1970, and my experience of the Great Man was part and parcel of my experience of the Great Institution. Yale can be very hard on its graduate students. The early 1970s was truly a time when professorial giants walked the campus, and they made their power felt. By the time I got to Paul de Man's class, full to overflowing with aspiring acolytes, I had no stomach for his excruciating dissection of the butterfly passage in Proust, the one in which metonymy says metaphor till we cannot decide.

Yale's "manna" in the 1970s and 1980s is legendary. Both champions and detractors commented on its "DeManology,"[82] "critical terrorism,"[83] "Derridadaism";[84] its "charismocrats of deconstruction,"[85] "boa deconstructors,"[86] "Zen masters of Western philosophy";[87] its "hermeneutic mafia" who made people offers they could not understand.[88] When de Man's collaboration became known, however, the dismay of his followers was no laughing matter. Nor was it purely a question of self-concern. Nothing would have been easier than to have denounced their teacher and gotten on with their deconstructing. But they did not. Their identity as deconstructionists was tied to the movement's greatest pedagogue, Paul de Man.

By all accounts, de Man did not encourage this adulation. "He never sought followers," Barbara Johnson said on the occasion of his death; yet "people followed him in droves. He was ironic toward discipleship; the country is dotted with his disciples."[89] "Piety toward the work or toward the man capable of such strong irony seems as inevitable as it would be wrong," wrote E. S. Burt. "We ought to be true to his spirit, to resist that piety as hard as some have resisted his theories. But how can we?"[90] Peter Brooks remembered de Man's kindness and generosity, but before that the impression of being in the presence of a magician: "To be given to understand that there was this kind of drama available in the reading of texts, that what was at stake in the study of literature was as difficult and demanding and unsettling as Philosophy or any

other mode of discourse—this was an enthralling revelation."[91] Shoshana Felman called de Man a "liberator," and J. Hillis Miller went so far as to assert that the future of literary studies depended on our continuing to read Paul de Man.[92] This ironist, whose greatest aim was to subvert desire, became the "dream father his followers desired."[93] The love affair between de Man and Yale is one of academia's saddest contradictions.

The testimonials quoted above date from de Man's death in 1983. In 1987—the same year as Victor Farías's exposé of Heidegger, and just after Reagan had visited the S.S. cemetery in Bitburg, Klaus Barbie was captured, Kurt Waldheim was implicated in wartime atrocities in Yugoslavia, and the various arts scandals were heating up—a Belgian graduate student named Ortwin de Graaf discovered a raft of journalistic articles that Paul de Man had written for collaborationist newspapers between 1940 and 1942.

One of these articles, "The Jews in Contemporary Literature," was openly anti-Semitic. It argued that because aesthetic evolution is independent of even the most momentous events, European art has not become "enjuivé." Jews have infiltrated every aspect of European life, but the arts remain healthy, and if Jews were deported en masse to a colony somewhere, this act would merely rid the continent of some second-class personalities. European culture would continue to develop as before, according to its great evolutionary laws.[94]

"The Jews in Contemporary Literature" appears on a page of anti-Semitic articles by other journalists. Caricatures of Jews punctuate the essays—ugly and grotesquely suffering figures—and in a box, a quotation falsely attributed to Benjamin Franklin states that Jews should be excluded from the Constitution because they are a danger to any country they enter. After all, "A leopard can't change its spots" (p. 273). On this "position page" of Le Soir, the newspaper with the largest circulation in occupied Belgium, the Jews are blamed for everything from capitalism to cubism, from a thirst for domination to decadence, sadism, nihilism, and pornography.

De Man never sounds so anti-Semitic again in the 170 articles he wrote between December 1940 and November 1942 in Le Soir, the ten in Het Vlammsche Land, and the hundred short notes and essays in other venues. Yet, though not specifically anti-Semitic, these pieces advocate a "cultural nationalism."[95] Essay after essay examines the character of a given European literature—an extraordinary feat for a person in his early twenties—and in each case, de Man concludes that a nation's art has developmental laws independent of any historical events. Fascism, for example, which he at one point terms a "regime of

social justice" (*Wartime Journalism,* p. 54), has not interfered with artistic free-
dom in Italy, Belgium, or France (pp. 32, 149). In these articles, de Man wrote
enthusiastically about collaborationist authors: Robert Brassilach, Bertrand de
Jouvenel, Alfred Fabre-Luce, Pierre Drieu La Rochelle, and agreed with the
revisionist view that judged Versailles not a German defeat but "an accident in
a historical evolution which points clearly to increasing dominance" (p. 52).

De Man's ideas on character at this time are revealing. Though he found
André Gide's word an exact reflection of his intimate life (p. 11), he claimed
that such was seldom the case, that as with Mozart, an artistic genius is usually
an otherwise quite ordinary person (p. 151). This idea is the theme of several
articles, as is the idea that character is multiple, changeable, and inconstant. The
novel of ideas fails, de Man says, because ideas are coherent and rigorous,
whereas people are not (p. 109). Man is "essentially mobile, continually over-
turned by new aspirations, always in search of an equilibrium or busy losing the
one he has provisionally acquired. . . . In reality he is constituted out of several
dissimilar characters which, moreover, change over time" (p. 17). Unstable,
imperfect, a writer may be attacked for stylistic failings, "but never for weak-
nesses or lacks in his moral personality" (p. 168).

De Man wrote over and over that a work of art—or any cultural product,
including criticism—is utterly autonomous from its fluid creator. "Literature is
an independent domain which has a life, laws, obligations which belong only
to it and which do not depend in any way on the philosophical or ethical con-
tingencies that move around it. . . . the artistic values that rule the world of
letters are not mixed up with those of Truth or Goodness, and anyone who
should lend these criteria to this region of human consciousness would system-
atically err in his judgments" (p. 168).

In many respects, this wartime journalism is an arrestingly accurate predic-
tion of de Man's theorizing and of his life, for there has never been a critic who
so thoroughly and subtly explored the meaning of literary autonomy, and few
whose life was so full of inconsistency and moral mediocrity. How inappropri-
ate a person to invest with one's faith and admiration! The "lesson of Paul de
Man," which academics have been seeking piously since his death and subse-
quent exposure, may be the very lesson that his writing always advanced: that
in equating a person's value with the value of his work—or in taking a sign for
its meaning—one is making a perilous error.

After the revelations by Ortwin de Graaf, scholars pieced together de Man's
early life, which had been largely unknown to his American friends and col-

leagues. De Man grew up in comfortable circumstances in Antwerp. His brother was run over by a train when de Man was sixteen and his mother committed suicide one year to the day later. De Man's uncle, Henri (or Hendrik) de Man, was a prominent Socialist politician who turned Nazi collaborator during the war. He committed suicide exactly sixteen years after the first such death in the family. This conjunction of symbolism and suicide has been frequently noted; its importance is a matter of conjecture.

Paul de Man attended the Free University of Brussels and lived with a woman called Anaïde Baraghian. The two fled to France after the German blitzkrieg in May 1940, but, unable to cross the Spanish border, they returned in August, and de Man began writing for *Le Soir* in December. In January 1941, their first child was born—there would be two more sons—and in September of that year de Man was denounced in a student journal for working at *Le Soir*. He stopped his journalism in late 1942, just before the German surrender at Stalingrad. Though he had worked for a racist paper, he is said to have sheltered Jews in his home on occasion, and never betrayed his friend Georges Goriély, who was a member of the Resistance.

De Man and Baraghian were married in May 1944 in Antwerp, where they had gone to live with de Man's father. De Man occupied himself with translations, including the first rendering of *Moby Dick* into Flemish. He was denounced again by a student organization, but in May 1945 representatives of the Auditeur Générale ruled that he should not be charged with war crimes. He then established Editions Hermès, a publishing house for luxury art books. This promptly failed. De Man left a string of bad debts, bankrupting his father in the process. His friend Goriély described him as "a charming, humorous, modest, highly cultured man," but a scoundrel; "swindling, forging, lying were, at least at the time, second nature to him." [96]

In 1948, de Man went to America and sent his family to Argentina, where his wife's parents lived. He worked in a Doubleday bookstore in Grand Central Station, met cultural figures such as Mary McCarthy, and through contacts, obtained a lectureship in September 1949 at Bard College. There he rented the house of his chairman, who was away on sabbatical in Europe, but stopped paying rent after two months. "By December, de Man had married one of his advisees, . . . and when the first Mrs. de Man turned up with her three young boys . . . in the spring of 1950, Patricia de Man was pregnant." [97] Fired from Bard, he and his new wife briefly picked strawberries to earn some money.

The pair ended up in Boston, where de Man taught French at a Berlitz

School. After impressing some local professors, he was chosen for a prestigious Junior Fellowship at Harvard. Soon after, an anonymous letter reached the Society of Fellows exposing his wartime activities. De Man wrote back denying all wrongdoing, saying that he had been fully exonerated at the end of the war, that he was being blamed for his "father" Hendrik's misdeeds—Hendrik was, of course, his uncle—and that during the war "I did what was the duty of any decent person."[98] In later years, de Man again lied about "his war," saying variously that he had spent it in England or as a member of the Resistance.

The Society of Fellows dropped the matter and de Man gradually found his way into academia. A contributor to the *New York Review* and *Commentary,* he moved to appointments at Cornell and Zurich, and then in 1968 he was made a professor of humanities at Johns Hopkins University. He arrived at Yale as a Sterling Professor of French and Comparative Literature in 1970, and remained there until his death in 1983.

De Man met Jacques Derrida at a Johns Hopkins conference in 1966, and the two developed a close and collegial friendship as deconstruction took hold in the 1970s. One of the movement's central documents was de Man's first book, *Blindness and Insight,* published in 1971 when he was over fifty. It was followed by *Allegories of Reading* in 1979 and the posthumous *Rhetoric of Romanticism* in 1984. All were collections of essays, and after de Man's death, scholars gathered his other essays in the important book, *The Resistance to Theory,* and at least two other miscellanies. The work published during de Man's lifetime was not voluminous, but it changed the course of romanticist scholarship and, indeed, of literary studies as a whole.

The question then becomes, what difference does it make that this criticism was produced by a man who was so split, so much a double—a propagandist and an accomplished student of culture, a bigamist and an inspiring pedagogue, a petty cheat and a Sterling Professor, a Nazi collaborator and a humanist? As with Heidegger and Blunt, there is endless debate as to how damning de Man's political misdeeds actually were, but the fact remains that this man who shaped the cultural attitudes of a generation of American scholars cooperated with the German Occupation in more than a perfunctory fashion. One cannot wish away what Derrida, with exquisite subversiveness, terms the "indelible wound" of de Man's complicity (fig. 27).[99]

For many scholars, however, de Man's personal inadequacies have nothing to do with the value of his criticism. As Michael Sprinker argues, "The links between de Man's youthful journalism—and it was just that; he was not yet 23

27. Mark Tansey, *Derrida Queries de Man* (1990). Oil on canvas, 83¾″ ×
55″. © 1990, Mark Tansey. Collection: Mike and Penny Winton. Courtesy
Curt Marcus Gallery, New York.

when he resigned from *Le Soir* in November, 1942—and his mature theoretical work are . . . tentative at best." [100] Moreover, we tolerate many views as tainted with fascism as de Man's. Geoffrey Hartman compares de Man's anti-Semitism to T. S. Eliot's: "the Jews do not fit into Christian culture (Eliot) or into the 'content of the European idea' (de Man)." [101] Eliot's writing—never mind Pound's—contains more, and more virulent, anti-Semitic remarks than all of de Man's journalism put together. Yet the New Critics allowed themselves to be influenced by Eliot and Pound regardless of politics. Some among them were also "Fugitive Poets" whose sympathies lay with the traditionalism and antebellum nostalgia of the Southern Agrarian Movement. The New Critics' absorption in art as "a well wrought urn," a self-enclosed world immune from the disorder of reality, may well be seen as an expression of that aristocratic yearning for the "bad old days." In America there has never been as influential a movement as the New Criticism, and yet we do not agonize over *its* political affiliations.

Moreover, this defense goes, European intellectual life is overrun by anti-Semites. "What would remain of the Académie Française," writes Zeev Sternhell, "if it were to be purged of all its members who had made anti-Semitic statements? What would be left of the universities, the press, the arts, the theater, the cinema, if all those who had sung the glories of the National Revolution or worse were removed?" [102]

Many people are not so much concerned with de Man's morality as with the possibility that his theories are tainted with fascism. Derrida mocks this fear of Nazi contamination from deconstruction. "The 'whole' de Manian text is available as a boobytrapped resource for symptomatologists in training," he says, "but, after all, what does deconstruction . . . have to do with what was written in 1940–42 by a very young man in a Belgian newspaper?" [103]

Richard Rorty calls the idea that a theory is reducible to the political stance of its author "philosophical fundamentalism." In "Taking Philosophy Seriously," he states:

Many people think that there is something intrinsically fascistic about the thought of Nietzsche and Heidegger, and are suspicious of Derrida and Foucault because they owe so much to these earlier figures. . . . Aristotle's casual acceptance of slavery as natural and proper is taken to be central to his "history of Being"; Nietzsche's elitist swaggering is taken as central

to his ethic of self-creation; "deconstruction" is condemned on the basis of the young Paul de Man's opportunistic anti-Semitism. Such attempts to simplify the thought of original thinkers by reducing them to moral or political attitudes should be avoided, just as we should avoid thinking of Hemingway as simply a bully, of Proust as simply a sissy, of Pound as simply a lunatic, of Kipling as simply an imperialist.[104]

De Man would have agreed. Throughout his career he reiterated his early idea that literature is independent of life. He is mildly sarcastic about the propensity of French intellectuals to experience reality through the inner crises of their writers.[105] "One would think that, after some of the experiences of this century, the complexity of the relationship between thought and action would be better understood," he wrote in 1966 in the *New York Review of Books.* "Nazi Germany is a case in point. The discrepancy between intellectual values and actual behavior has rarely been so baffling as in this case." [106]

By the time of *Blindness and Insight,* de Man had worked this discrepancy into one of the basic ideas of deconstruction. In this passage from "Form and Intent in the American New Criticism," he explains how the split between author and text comes about: "Considerations of the actual and historical existence of writers are a waste of time from a critical viewpoint," he argues, because when the author begins to write he loses reality in order to enter a poetic state of mind. This loss, this emptiness, gives the text its "allegorical" dimension. De Man quotes Walter Benjamin's definition of allegory as a void "that signifies precisely the non-being of what it represents," and claims that the allegorical dimension "appears in the work of all genuine writers and constitutes the real depth of literary insight." [107] The work of art proceeds out of the difference between life and text, and continually thematizes this difference.

By the end of his life, de Man had developed these ideas about the relation between art and reality considerably. The distinction between autobiography and fiction is undecidable, he declared in "Autobiography As De-Facement." It is not that every text can be read through its author's life or even that an autobiography provides dependable self-knowledge—"it does not." But autobiography reveals especially vividly the impossibility of a totally coherent, founded, univocal text. No matter how much it "says" its author's life, textuality always intercedes. Autobiography is as much a masking as a revealing, a "giving and taking away of faces, with face and deface, *figure,* figuration and disfiguration." For this reason, autobiography can be seen as a rhetorical figure for reading and

understanding, and occurs to some degree in all texts.[108] Thus, autobiography is a paradigm of textuality in that it (subversively) purports to render the actuality of its author.

Critics argue that a splitting of theory and author such as Rorty's denigrates the moral value of philosophy, and that de Man's own splitting was a little too self-serving.[109] History has shown de Man to be not only a scoundrel but a bad theorist, they claim, for the discrepancies in his past are not a matter of textuality but of lying:[110] the " 'referent' did exist. History was not a subjective text."[111] The antibiographical theory was undone by a biographical fact that could not be ignored. "In the sad drama of a man who in his youth misread not text but history," wrote Malcolm Bradbury, "the cumulative moral, political, and linguistic crises of our agonizing century are returned to us. This is surely the contemporary meaning of the story of Paul de Man; it calls . . . for reconstruction—or the Birth of the Author."[112]

Other critics have not been as sympathetic as Bradbury. A certain *Schadenfreude* is evident in news reports and scholarly commentary on de Man. Endless articles delighted in "Deconstructing de Man,"[113] announcing the fall of an idol and the "death of deconstruction,"[114] quipping that "the dogma of deconstruction has had its day."[115] Where de Man had chastised critics for their "resistance to theory," they could now chide him for his inadequate "Resistance."[116] As to the argument that deconstruction and de Man are two different matters, Jeffrey Mehlman examined the proverbial image of "*Ecclesia super cloacam:* the church remains no less splendid for being built over the sewer of European history. . . . [T]o 'save' deconstruction by subsuming the relation between de Man's deconstruction and his 'collaboration' with the Nazis to that between 'art' and 'life' it would redeem is to affirm a dialectical configuration pre-eminently vulnerable to deconstruction."[117] Opponents of deconstruction enjoyed the revenge of hoisting it on its own petard.

The cause was not helped by the spate of well-intentioned but unintelligible deconstructive defenses of de Man made by his followers. Ortwin de Graaf, for example, who had made public the wartime journalism in the first place, identified de Man's failure to confess his past as an instance of the rhetorical figure, anacoluthon. "[T]his line of reasoning," he wrote, "more than seems to entail that we are radically turning the tables by in fact affirming that, in this case at least, it is morally more admirable not to confess than to publicly testify to one's own 'shameless past.' I must say that I feel extremely reluctant about such a move, as it appears to surreptitiously reintroduce the ideology of

authenticity into a discourse of defacement, but at the same time I cannot afford to pretend not to be forced to take such an interpretation into consideration"![118]

With de Man's good character destroyed and deconstruction perceived as an obscurantist recipe for moral irresponsibility, de Man's supporters entered into a polemical exchange with his detractors that—eight years later—still rankles. The deManians cast this as a struggle between scholarship and journalism, and launched into endless tirades against know-nothing hacks and their even more pernicious abettors, academics who publish in the mass-circulation press. The irony that the deManians themselves were publishing in this same press was not lost on commentators,[119] and David Lehman, one of their chief antagonists, pointed out with relish that Derrida and J. Hillis Miller had spent more words denouncing the journalists who had reported de Man's collaboration than they had denouncing the collaboration itself.[120] Whole articles appeared, describing the deconstructivists' attack on the media.[121]

We can see in this dispute, as in the others chronicled in this book, the public's disaffection with the experts and their "sterile academicism." "The public man of letters, the eclectic amateur, and the free-lance intellectual have disappeared," said Lehman; "the clerks and bureaucrats of academe have taken their place."[122] Louis Menand, himself an academic, ponders the loss of "this disciplinary looseness, this sense of participation in a wider culture . . . [so that] today there is almost no real intercourse between academic criticism and the culture at large. . . . [N]ot literature, but what professors do with literature has become the subject of literary study."[123]

The media, in denouncing deconstruction, were able to vent their anger against all of academic criticism, and the American university as a whole. For Paul de Man's collaboration fit perfectly into the scenario that had been constructed by the enemies of political correctness. Allan Bloom had argued, for example, that deconstruction promoted relativism, and relativism is the major cause of "the closing of the American mind."[124]

Catherine Gallagher outlines the "story" that the press was telling. "Some time in the 1960s, literature departments forgot that their job is to preserve, appreciate, explicate, and provide for the orderly communication of 'our cultural heritage.' Deconstruction seemed in this story to resemble Marxism, feminism, ethnic studies or anything else that challenged Arnoldian assumptions of value, but deconstruction . . . seemed to make all discussions of value obsolete. . . . The end of the story either was upon us or was soon to be: social chaos,

cultural disunity, widespread illiteracy, and a general inability to distinguish right from wrong. . . . [After the de Man revelations,] deconstruction was no longer just the harbinger of outrages against humanity; it actually originated in such outrages." [125]

Gallagher's story is no exaggeration. In fact, it sounds tame compared to the plot that Peter Shaw advanced in the pages of *Commentary*. "Deconstruction helped to break down the consensus of reality, and to undermine the belief that language and literature can reliably convey truth. As deconstruction's influence spread from literary studies to the rest of the humanities, the law, even architecture, it played a key part in the disintegration of the traditional curriculum, another supposed bastion of 'bourgeois' privilege. Into the vacuum thus created moved the minions of the politically correct, ready, precisely on the deconstructionist model of vilification, to 'unmask' and anathematize any who resisted the new regime as racist, homophobic, anti-female, Eurocentrist. In short, as Neal Kozodoy wrote . . . , 'were it not for the labors of the deconstructivists, gaily precipitating the crash of entire edifices of humanist learning, today's hard-eyed Marxists would never have been able to establish so easily their squatters' rights over the rubble." [126]

With such fantastic scenarios abroad, and such hostility to the entire academic enterprise, it is not surprising that some of de Man's supporters were shaken. Saying that philosophy and life were separate simply made the situation worse, and so they formulated a much bolder defense. Far from a covert fascism, de Man's theories constitute, in fact, a weapon against fascism. They are "indispensable," wrote Peggy Kamuf, in "*effectively* exposing" totalitarianism.[127] If, as Jonathan Culler claims, Nazism is a program for a "pure" Aryan nation that sets up Jews as the "impure" and annihilates them, "deconstruction seeks to undo (to deconstruct) oppositions that in the name of unity, purity, order, and hierarchy try to eliminate difference." [128]

In this defense, de Man emerges as a pedagogical moralist. "De Man provided his students with a set of tools for reading," wrote Deborah Esch, "the most important function of which may be the unmasking of ideology. What we call ideology, he showed, entails taking a linguistic construct for a natural reality. This questioning of the authority of language yielded the most subversive pedagogy I know." [129] For this reason, J. Hillis Miller claimed that the deconstructive critique of ideology is essential to a healthy democratic culture,[130] and many of de Man's followers said that his critical procedure makes fascism im-

possible. Deconstruction is an atonement for de Man's youthful error and an attempt to prevent his students from falling into the same mistake.[131]

This argument struck many of de Man's opponents as foolish and even dis-ingenuous, a typical example of deconstructive self-deception, a "Yuppie radi-calism." [132] I have no doubt, however, that it was sincere. Deconstruction suited a generation "that came of age amid credibility gaps, hype campaigns, and spin doctors," [133] that questioned the claims to truth of authorities who had tried to shove Vietnam and Watergate down the throats of a credulous population.[134] Lindsay Waters places himself within this generation as he explains de Man's appeal. "This 'never-ending reflection' of de Man's, always repeating, always changing, always concerned with this failure caused by 'the excess of interi-ority,' . . . is precisely what made him acutely important for a set of young people who were also struggling to understand what the future might be for them given the failure of chiliastic hopes in the recent past and the present. There was a particular sort of dead end into which many of us wandered after the 'glorious dawn' of 1968. . . . This dead end was in effect due to an excess of interiority." [135] How sad that these people, in finding a theory for their skepti-cism, jettisoned that skepticism when it came to the one authority figure who most deserved it.

It seems unlikely that de Man intended his theories as a secret expiation for his earlier sins, but the claim that deconstruction is antitotalitarian is entirely plausible, as long as one believes that the tools capable of uncovering an ide-ology help to defeat it. Leftists may criticize deconstruction for "mirror[ing] the effacement of ideology" [136] in an Aestheticist retreat from reality.[137] But such claims are simplistic, as are David Lehman's that deconstruction eliminates history, "turns literature into a play of words, robbing it of any broader signifi-cance," [138] or teaches that there is no truth, "that words mean what we want them to mean and nothing else." [139] For de Man, literature is full of significance, in particular the lesson that we cannot make works mean whatever we want, no matter how hard we try. A text is an attempt to stabilize meaning and at the same time a series of checks and frustrations on that attempt. A deManian read-ing is a history of the reading of the text at hand, and the history of literature is a chronicle of the clash between the desire for referential closure and the literary foiling of that desire.

De Man argued that this is why neither a referential nor a formalist criti-cism is adequate. "On the one hand, literature cannot merely be received as a

definite unit of referential meaning that can be coded without leaving a residue. The code is unusually conspicuous, complex, and enigmatic; it attracts an inordinate amount of attention to itself. . . . On the other hand—and this is the real mystery—no literary formalism . . . is ever allowed to come into being without seeming reductive. . . . [W]ith the structure of the code so opaque, but the meaning so anxious to blot out the obstacle of form, no wonder that the reconciliation of form and meaning would be so attractive." [140] We need look for no better statement of that split between reference and form, or politics and artistic self-enclosure, underlying the various conflicts described in this book.

The desire to find this unattainable "reconciliation" was what motivated the New Critics and all the "organicist" theories stemming from romanticism. For them, a work of literature was a whole, a system, a body in which meaning and form were one, in which every idea in the text was expressed through its structure, and the ideas "meant" the structure as well. Yeats's famous image of this aesthetic wholeness is the question, "How can we know the dancer from the dance?" This notion of art as overdetermined or hypersemantic, coherent throughout and therefore full of a condensed power, gave rise to the uncritical version of aesthetic fetishism found in modernism.

But for de Man, this belief in the totalized structure of the literary work is wishful thinking, a kind of blindness. Even the New Critics, he shows in *Blindness and Insight,* maintained their belief in the closure of the "well wrought urn" while still claiming that the text was "ironic," full of impossible contradictions. The unblinded critics knows that a work of literature is not a totalizing myth—and here we find de Man's typical move against naive fetishizing—but a fiction, "for it knows and names itself as fiction. . . . it is demystified from the start." [141] Semiology explodes the perfect correspondence of sign and referent, since there is always some slippage, some difference, between the two. For de Man, "the statement about language, that sign and meaning can never coincide, is what is precisely taken for granted in the kind of language we call literary. Literature . . . begins on the far side of this knowledge; it is the only form of language free from the fallacy of unmediated expression. All of us know this, although we know it in the misleading way of a wishful assertion of the opposite."

When we speak of literature as a fiction, we acknowledge the actual situation. "The self-reflecting mirror-effect by means of which a work of fiction asserts . . . its separation from empirical reality, its divergence, as a sign, from a

meaning that depends for its existence on the constitutive activity of this sign, characterizes the work of literature in its essence."[142]

Thus, the difference between literature and other language is not that literature is more complete in its meaning, but that it turns the incompleteness of meaning into a theme. The writer's language no more escapes duplicity, confusion, or untruth than anyone else's language, for "unmediated expression is a philosophical impossibility."[143] The critic's aim should be, then, not to list a text's incompatibilities, nor to mask or reconcile them, but to proceed through the text, describing the drama of their unfolding. De Man praises Derrida's treatment of Rousseau in *Of Grammatology* for just this procedure: "a truly hermeneutic reading, one that traces the contours of a field of significance by means of the logical points of resistance strewn throughout the text. . . . [W]e ignore Rousseau's chief riches by attempting to reduce him to strict coherence."[144]

Heidegger—when he was not discussing Hölderlin—was a crucial model for de Man as well. Heidegger considered the literary work as the understanding that a poetic consciousness has of its own autonomy. Each work, says de Man paraphrasing Heidegger, "asks the question of its own mode of being, and it is the task of the interpreter not to answer the question but to make explicit in what manner and with what degree of awareness the question is asked."[145] The intent of art is to give knowledge neither of empirical reality nor of transcendental Being, but of its own particular being. Thus, a literary narrative, for de Man, is always an allegory of its own reading.[146] It becomes analogous to criticism in this way, since criticism is also the reading of an artwork, and just as the literary text has its blindnesses, its "aporias" and "peripateias," so does the critical text. In the best deconstruction, criticism is just as undecidable as literature, and the barrier between the two dissolves. No reading can ever close the text, whether fictive or critical. After all, in the whole history of literary criticism, no reading of a work has ever said all there is to say about it for all time. And this is because the rhetoric of the text, its tropes and figures, makes closure impossible.

De Man thus "turns the literary text into the archi-scene of an endless auto-deconstruction, which resists both thematic and aesthetic readings and which ultimately allegorizes the incompatibilities of all possible readings. As a result, the text becomes a sort of deconstructive *perpetuum mobile,* an icon of unreadability . . . endlessly repeat[ing] its referential impotence."[147] In his minute

analyses of the major figures of romanticism and of high modernism—Keats, Nietzsche, Rilke, Proust, Yeats—de Man undermined the treatment of art-works as whole, ideally autonomous objects, and revealed instead their "dark, even opaque character as writing, black marks on white paper, . . . unrecuperable rhetorical discontinuity."[148] This procedure is in keeping with a Heideggerian or existential analysis of modernity in which the awareness of departed meaning is all one can aspire to.

The fact that all deconstructive readings lead to this same conclusion—and not a very exhilarating one at that—has made a lot of people impatient. To those like David Lehman, who claim that deconstruction is mechanical, predictable, and inhuman,[149] de Man had an answer: "Technically correct rhetorical readings may be boring, monotonous, predictable, and unpleasant, but they are irrefutable."[150]

And here is the real crux of "l'affaire de Man." De Man explored and explained as thoroughly as anyone ever has the paradoxical status of the work of art—that it is both autonomous and not autonomous, both seeking completion and subverting it, both referential and formal. He undermined the modernist fetishizing of art and yet preserved the special paradoxicality of aesthetic experience. And he did all this with a rigor and an erudition that have not been surpassed. Moreover, he trained an army of deconstructive followers who went forth to apply these insights to works in all the arts. Yet, deconstruction was an irrefutable truth that most people did not want to hear. It is not that Godfather de Man made them an offer they could not understand; he made them an offer they found distasteful. The sources of their resistance were two, and these will bring us not only to the end of this chapter's treason and textuality, but to the end of the struggles against art in this book.

First, though de Man advocated a rigorous distinction between literary art and reality, he allowed the realm of literature to keep making imperialist incursions into other spheres—into other forms of language and then into reality itself. De Man became, as a result, almost indistinguishable from the "foundational" or "totalizing" discourses that he had set out to undermine, for if those read literature as one with its real-world meanings, he read the real world as a text. He thus lost the messiness of context, readerly variability, and desire in his accounts of literature, proclaiming his antiformalism while reinventing formalism in an abstract, transcendent text-world.

The stages in de Man's textualization of reality are fascinating to observe.

By 1979, in *Allegories of Reading,* he declared the difference between literature and criticism "delusive." The distinction between literary and nonliterary language fell at this point, too, as de Man located in all language the clash between reference and self-reference—logic and rhetoric—that defined literature for him. Rhetoric, by which de Man meant the ancient tropes and figures of speech, "radically suspends logic and opens up vertiginous possibilities of referential aberration. . . . I would not hesitate to equate that rhetorical, figural potentiality of language with literature itself." [151]

In collapsing ordinary language and criticism into literature, de Man begins to sound like the modernists, whose totalizing views on art he tried so hard to undercut. He even echoes their anti-ornamentalism. The tropes and figures—the so-called "colors of rhetoric"—are not ornaments, he says; "the trope is not a derived, marginal, or aberrant form of language but the linguistic paradigm par excellence." [152]

De Man could collapse all language use into literature because he believed that rhetorical tropes were at work everywhere, subverting the text's relation to reality. Just as all literary narration is the story of its own reading, all language is about language. The "real" situation surrounding literature—the audience and narrator, for example—fall to this creeping totalization as well, becoming merely "the misleading figuration of a linguistic structure." [153] We have already seen how autobiography is drawn into this web, too, as the paradigmatic textualization of life.

History, as well, is composed of texts, not events: "the bases for historical knowledge are not empirical facts but written texts, even if these texts masquerade in the guise of wars or revolutions." [154] Of course, this statement has the panache of an essayistic finale—which, in fact, it was—and de Man clearly enjoyed making such shocking witticisms as "Death is a displaced name for a linguistic predicament." [155] But he also claimed that literature is "the truly political mode of discourse," and in a passage that was later damningly turned against him, he noted that "it is always possible to face up to any experience (to excuse any guilt), because the experience always exists simultaneously as fictional discourse and as empirical event and it is never possible to decide which one of the two possibilities is the right one." [156]

Though de Man keeps both possibilities in play here—fiction and empirical reality—it is not surprising that his followers often read reality as a text and that his enemies have taken his undecidability as a confirmation of his moral

nullity. De Man had a rigorous grasp of the nature of literature, but in extending rhetoric and textuality to all experience he created as nightmarishly nonsensical a world as did the Ayatollah Khomeini.

Many of de Man's followers would deny the validity of this claim, for to them, everything de Man taught involved the dismantling or debunking of such totalizing views. De Man criticized Heidegger specifically because he treated Hölderlin's poetry "as a believer cites Holy Writ"—as if it stated "the absolute presence of Being" [157] and de Man has been joined in his critique by such non-totalizing thinkers as Rorty, Derrida, and Lyotard. [158] De Man's long analyses of Rousseau are meant to reveal the blindness that can beset a thinker who believes in an ontology of unmediated presence. [159] He openly cautioned against a political reading of writers: "One can be attracted to Hölderlin for the wrong reasons, use him as an external pattern on which to transfer personal frustrations or anxieties. . . . This is more dangerous still when it happens on a collective, national scale and when Hölderlin is seen as an individual incarnation of the destiny of Germany. . . . words [of his] such as 'vaterländich' and 'nationell' . . . acquire highly disturbing connotations when they are used by some, in Germany, around 1940." [160]

De Man considered ideology a confusion of sign and substance. He blamed it on the rhetorical nature of language as such, but attributed the recent frequency of the confusion to a systematic misreading of Kant. [161] In Kant, art has only an analogous relation to politics, but according to Christopher Norris critics turned this analogy into an identity in the fetishizing aesthetics of the twentieth century: "Hegel's talk of the artwork as the 'sensuous embodiment of the Idea,' the New Critics' (likewise Hegelian) theory of the poem as a 'concrete universal' or a 'verbal icon'; the formalist—and also Leavisite—notion of poetry as a kind of 'sensuous enactment,' revitalizing language through its powers of vivid, quasi-visual or even tactile evocation." Norris adds to this list reception theorists and phenomenologists, and concludes that "de Man is claiming that *every major school* of present-day critical thought . . . can be traced back to that misreading of Kant by philosophers like Schiller and Hegel." [162]

For Kant, on the contrary, aesthetic experience has nothing to do with the sensuous embodying of ideas in language, but consists in "the free play of the faculties when raised to the highest power of self-knowledge or reflective critical awareness." [163] In a world of literalist readers and a critical tradition that self-mystifyingly fetishizes art, de Man felt the strain of having to state over and over again the paradox that "it is as apolitical force that the aesthetic still concerns

us as one of the most powerful ideological drives to act upon the reality of history." [164]

In short, de Man's entire theory of literature was an attempt to warn against the confusion of art and reality, and yet he himself systematically erased the distinction, equating literature with autobiography, criticism, referential language, and historical event. It is as if his insight into the paradoxical status of aesthetic meaning filled him with such exhilaration that he saw that paradox everywhere, so that all experience became aestheticized. Far from mistaking art for reality, as he criticized modernism for doing, he—sometimes—mistook reality for art.

Susceptible to this error, he consistently warned against its opposite: succumbing to the seductiveness of art's sensuous reality. For literature is built on the "temptation of immediacy." [165] On the stage, he says, it is "impossible to know" when feigned death or eroticism will become actual violence or copulation: "the possibility that this might happen . . . creates the tension between aesthetic contemplation and voyeurism without which neither theater nor ballet would be in business." He claims, therefore, that the "ultimate textual model . . . of all texts" is the trap, "as unavoidable as it is deadly." [166]

Diligently trying to avoid the trap, de Man divides Keats's poems into the formally perfect (*The Eve of St. Agnes,* "Ode to Autumn") which are "lesser," and the all-inclusive but formally unsatisfactory (*Endymion,* the two *Hyperions*) which are therefore "greater"; he is not quite sure on which side the odes belong! [167] In short, aesthetic perfection is a danger, a seduction, a trap, an inadequacy—"a seductive notion that appeals to the pleasure principle, a eudaemonic judgment that can displace and conceal values of pleasure and pain." [168]

The reason that art is so dangerous is that it may "offer its own sensory richness as a substitute for the void that it signifies." [169] De Man thus warns against the aesthetic sign for precisely the same reasons as the postmodern antifetishists we have already considered. Paraphrasing René Girard, he writes, "certain claims to authenticity attributed to literature are in fact expressions of a desire that, like all desires, falls prey to the duplicity of expression. The so-called idealism of literature is then shown to be an idolatry, a fascination with a false image that mimics the presumed attributes of authenticity when it is in fact the hollow mask with which a frustrated, defeated consciousness tries to cover up its own negativity." [170]

To ward off this idolatrous temptation, de Man hoists the shield of "critical

vigilance." Christopher Norris finds in this act a lesson de Man learned from the war. "What de Man came to realize, having himself fallen prey to that delusion [of presence] in his wartime articles, was that thinking can indeed resist such forms of seductive aesthetic ideology, but only insofar as it maintains the kind of critical vigilance that comes from a refusal to identify language . . . with the voice of authentic Being and truth."[171]

This was a useful lesson, and it was good of de Man to teach it to others, if indeed that was what he was trying to do. But treason and textuality are different territories, and those like de Man who have once stepped over the border may police it more rigorously than the average citizen requires. Whether de Man's resistance to aesthetic fetishism was motivated by his personal history or not, it is interesting that he thought it necessary to hold the line so firmly against art's claims to reality, but saw nothing wrong with treating reality as art. In the process, he produced an aestheticized criticism in which real context, the complication of historical change and contradiction, and the varied pleasures of actual readers could have no place.

The strain and sterility involved in de Man's defense against aesthetic pleasure constitute the second major reason for the failure of deconstruction. For a major "blindness" lay at the heart of de Man's rhetorical criticism. He declared that "rhetoric" meant the study of tropes and figures "and not . . . the derived sense of comment or of eloquence or persuasion."[172] But by ignoring the allure of eloquence and persuasion in rhetoric, he produced an ineffectual and often repellent criticism.

Seduced briefly by the same Nazi aestheticism that attracted Heidegger, de Man kept interposing a barrier of theory against the allure of belief, closure, and beauty (as his followers, all the while, idolized him). But if Heidegger succumbed to Nazism and Hölderlin, de Man's failure came in not succumbing, in not accepting the fact that a certain degree of abandon is essential to aesthetic experience. Steeled against the pleasures of art and thought, his criticism is an allegory of denial and deprivation.

His followers have institutionalized that denial. The deconstructive scholarship that de Man inspired flees artistic pleasure as if it were a mortal danger. Its prose is often so convoluted as to empty the critical act of pleasure altogether, its appeal to the reader that of a barbed-wire masochism encircling a fellowship of unerring ascetics. No provision is made for the ability to pretend, to be mixed up in fantasy, to enjoy vicariously, suspend disbelief, enter a realm of make-believe. When Geoffrey Hartman praises de Man for supplying "no

sublime moments, only perplexed readings,"[173] we can only sigh. Perplexity is
the commonest effect of criticism, sublimity its rarest achievement.

So determined was de Man not to succumb to art that his theories offer
only a negative account of aesthetic pleasure—seduction—and only an aca-
demic source of critical pleasure—the discovery, with each new work, that the
wholeness of the text has been marred. It takes a real devotee to be satisfied
with such a revelation. Though de Man's discovery of complexity and paradox
is often breathtakingly ingenious, we do not value a criticism that has only this
story to tell. Likewise, we do not value literature only because it foils closure,
however brilliantly it may do so. Rather, that foiling of closure is what makes
the work virtual, what both cuts it off from reality and allows us to read our
own version of reality into it. Value lies not in the fact that the work contains
spaces, but in the ways we come to fill them.

De Man's theorizing demonstrates the same denial of pleasure that we saw
with the experts in the Mapplethorpe trial, the Islamic fundamentalists who
could not tolerate Rushdie's wicked fun, the feminists who fear pornography's
"rape" and the cinema's fetishism, and the Marxists who denounce beauty as
co-optation. Moreover, despite de Man's insights into aesthetic paradox, the
fact that he read all of reality as a rhetorical text is a kind of reverse-fundamen-
talism that produced results almost as derisory as the real thing. In these two
respects, he symptomatizes the cultural errors of our time, being more like some
of his totalizing detractors than he or they would care to admit.

But de Man's own life, like that of the other "doubles" in this chapter,
offers us a more important lesson. It shows that ideas may have a very indirect
relation to the beliefs of the scholar who propounds them, and their value may
have little to do with the moral value of that scholar's life. In other cases, of
course, this relation may be much more direct, and a good fit between criticism
and critic or idea and context is as significant to the theory in question as the
bad fits we have been observing. The scholar-doubles merely dramatize the
perennial situation with art/philosophy/criticism and its context: the two are
not identical, but neither are they utterly unrelated. Deciding what the relation
is in each case is part of the act of interpretation.

If life and work are contradictory, as in the case of Blunt or Heidegger or
de Man, that very lack of relation becomes part of the history and meaning of
the work. And it will probably be the way we understand de Man's value to us,
for the paradox that we appreciate deconstruction while simultaneously dis-
agreeing with Nazi collaboration is now our problem. Does de Man's contri-

bution to our understanding of art outweigh his personal shortcomings? Does continuing to teach and learn from de Man mean that we are compromising our desire to think about art in a socially responsible way? Or do the "doubles" perhaps reveal that that question is, in good part, absurd? The fact that there will be much variance in the answers to these questions is merely another indication of the irreducibly subjective nature of the problems of value art raises.

CONCLUSION
ENLIGHTENED BEGUILEMENT

> For me a work of fiction exists only insofar as it affords me what I shall bluntly call aesthetic bliss, that is a sense of being somehow, somewhere, connected with other states of being where art (curiosity, tenderness, kindness, ecstasy) is the norm.
>
> Vladimir Nabokov

This book has surveyed the battleground of contemporary culture, a landscape littered with the remains of vilified artworks and discredited orthodoxies, where a resentful and uncomprehending public faces off against experts whose ranks and spirits are broken. One sometimes suspects, moreover, that this battleground is much larger than the parochial sphere of American and British culture—a worldwide confrontation, instead, between liberals and fundamentalists, which cuts across the categories of expert and layman. Does the recent assault on artistic and intellectual freedoms presage a greater rout to come?

It is hard to avoid these millennialist anxieties in a time of such disorder. For the struggles outlined in this book seem to reach no resolution, but merely entrench each faction more firmly in its point of view. True, the Contemporary Arts Center in Cincinnati and its director won their case in court, and Mapplethorpe's photographs continue to be exhibited and sold. But did the jury or the general public learn why this outcome was just and desirable? Mercifully, Salman Rushdie is still alive and *The Satanic Verses* still in print. But the delicate paradox the novel embodies, as both a virtual and a subversive reality, is not well understood by its Western readers, never mind its Islamic enemies. In the welter of attacks on aesthetic gratification and fetishistic gazing, the fact that pornography has not yet been outlawed seems a minor, if remarkable, victory. But what kind of art will be created and disseminated if experts and audience alike deny the value of virtuality and pleasure? And though humanities professors

still have jobs and students, the political correctness debates and the scandals surrounding great figures in the field take up more and more of our attention. In the blind proliferation of partisan and aesthetically shallow ideologies, there is no "business as usual" these days in either academia or art.

In assessing the experts' responsibility in this crisis, it is tempting to believe that they have cheated the public, and themselves, by waiting too long to explore an aesthetics of content. They have been too susceptible to the legacy of the decadents and modernists—for whom "all art is good which is good art" [1]—to produce a theory of value that explains in what manner art impinges on reality and why it is important that it do so. Perhaps the expert establishment is still a prisoner of formalism, arguing that a Mapplethorpe is art—and good art—because of its diagonals or its central images, and ignoring the content of those images and their resonance beyond the world of art. Like the judge who said that he did not know what pornography was but knew it when he saw it, the experts are left, after the long dominance of formalism, unable to provide a convincing account of what art is, but expecting the public to accept their authority on the grounds that they "know it when they see it."

But if all that was missing were a content-oriented aesthetics, the Marxist, feminist, African-American, and postcolonialist criticism of recent years would surely fill the bill. These have, in fact, reconnected criticism to its preformalist days. Before modernism burst into Western culture with the imperative to "make it new," the various "humanistic" movements in criticism constituted a general orthodoxy, valuing art for demonstrating the triumph of human striving—in the defeating of enemies, the withstanding of misfortunes, the creation of lasting social values, the achievement of freedom. When formalism came along, it blasted humanism as a hangover of Victorian piety and prudery, and rejected its focus on content.

But however much formalism concentrated on technique and structure, it had its content, too. Modernist art and criticism variously tell the story of art's discovering its ontological difference from reality, of the artist's understanding his or her beautiful exile, or of the audience's finding in art no triumph, no surety, no refuge. These plots and themes of isolation, alienation, and stoic defeat made humanism seem innocent and old-fashioned by comparison, as modernism matched its technical rigor with an existential realism in its themes.

The various ideological criticisms of late also oppose humanism, but not because it was too concerned with content, or too conventionally pious. They find the triumphal stories of humanism exclusionary (so, for that matter, were

the modernists' tales of angst). There was nothing wrong with these plots per se; they simply were not available to everyone. Only certain kinds of people were allowed to triumph or suffer heroically, whereas others—women, workers, nonwhites—were consistently oppressed or omitted. The new stories of victimization and liberation being told in women's and minority art and criticism are, in fact, an extension of humanism, in a kind of universal aesthetic suffrage. Liberals, at least, who have no stake in limiting the sphere of freedom, should find no difficulty in accepting new actors in perennial plots of self-realization.

But the rise of the various content-oriented ideologies has not produced a coherent aesthetics or a new rapprochement between the experts and the public. One cannot expect to promote a new subjecthood for some by stereotyping others, and neither can one account for art by denying its artifice, its beauty, and its allure. Aesthetic value is not captured in its content, in the stories it tells. Art is too often pictured by content-oriented theorists as a force for good or for evil, and the critic as a moralist with a purely political mission.

The truth is otherwise. Art occupies a different moral space from that presented in identity politics, because art is virtual. We will not be led into fascism or rape or child abuse or racial oppression through aesthetic experience. Quite the contrary—the more practiced we are in fantasy the better we will master its difference from the real. What we need is a situation in which art and the life of the mind can be enjoyed with a knowing pleasure, one that thrills to every richness art can offer, yet does not shrink from the issues art can raise. The greatest artists of the moment are undermining the dire rigors of recent criticism and the fundamentalism and literalism of extremists. It is time for the rest of us to join them—to acknowledge both the power and the pleasure of art, aware at the same time that it is still art and not something else. No longer needing a modernist "religion of art" or the frightened demystification of that move in postmodernism, we might indulge in a little aesthetic bliss, I reckon, secure in the belief that whatever similarities art may have to reality will not determine either us or that reality, and whatever pleasures it provides will hurt no one.

For art's relation to reality is paradoxical. It serves to open thought rather than close it down. It helps us entertain possibilities—enriching or threatening—which may "bring newness into the world." It dramatizes to us what we like and care about, and how we relate to others who are moved the same way or not—those Mapplethorpean devils. It allows us to understand without as-

senting, to go over to the other side and still stay home, to be violated and yet in control. It appeals to our freedom and individualism and in the process to our investment in collectivities. It may allow us, in our timid fashion, to indulge a certain taste for the sublime.

Maintaining an openness to such contradictions, instabilities, and psychic challenges is a test of each person individually and of the culture as a whole. It takes candor to acknowledge the self-revelation in our own interpretations, and generosity and respect to open ourselves to the interpretations of other people. The presence of art in a democracy always involves this kind of stress. But "that is the point of paradoxes," according to Ian Hacking: "harsh confrontation, painful rethinking, new speculation, trial and lots more error." [2] Unfortunately, the "trials" surrounding art have been rather too literal of late. We must learn to respond with more subtlety, tolerance, and pleasure to the paradoxes art poses.

Introduction

1. Christopher Martin, "Second Chance," *Architectural Design: Prince Charles and the Architectural Debate,* vol. 59, no. 5/6, 1989, pp. 7, 9. This attitude is by no means limited to Britain. Roger Kimball writes in *Tenured Radicals* (New York: Harper & Row, 1990), p. 132: "Think of it: an office building that reminded one of *Waiting for Godot* or *Endgame,* a home as unsettling as a Magritte painting, a factory as zany as a film by Charlie Chaplin."

2. Richard Rogers, "Pulling Down the Prince," *Prince Charles and the Architectural Debate,* p. 66.

3. Judith Tannenbaum, "From the ICA: The Mapplethorpe Show and Its Aftermath," *University of Pennsylvania Almanac,* September 5, 1989, p. 6.

4. "Discussion," *Prince Charles and the Architectural Debate,* p. 23.

5. William H. Honan, "Helms Amendment Is Facing a Major Test in Congress," *New York Times,* September 13, 1989, pp. C17, C19.

6. Quoted in Sheldon Hackney, "The Arts Battle," *University of Pennsylvania Almanac,* September 12, 1989, p. 4.

7. Allan Bloom, *The Closing of the American Mind* (New York: Simon and Schuster, 1987).

8. Christopher Norris, *Paul de Man: Deconstruction and the Critique of Aesthetic Ideology* (New York: Routledge, 1988), p. 2.

9. George Steiner, "The Cleric of Treason," in *George Steiner: A Reader* (Harmondsworth: Penguin, 1984), p. 191.

Chapter One

1. Kim Masters, "Cincinnati art center faces obscenity trial," *Philadelphia Inquirer,* September 7, 1990, p. A1.

2. Isabel Wilkerson, "Test Case for Obscenity Standards Begins Today in an Ohio Courtroom," *New York Times,* September 24, 1990, p. A4.

3. Stephan Salisbury, "Arguing obscenity," *Philadelphia Inquirer,* October 1, 1990, p. 7-D.

4. Robert Hughes, "Art, Morals, and Politics," *New York Review of Books,* April 23, 1992, p. 21.

5. William H. Honan, "Artist Who Outraged Congress Lives Amid Christian Symbols," *New York Times,* August 16, 1989, p. C13.

6. "Photograph's title stirs boycott campaign," *The New Art Examiner,* June 1989, p. 11: "The American Family Association, under the leadership of the Reverend Donald Wildmon of Tupelo, Mississippi, has issued a public statement charging Andres Serrano with committing blasphemy with his photograph *Piss Christ.* . . . The photograph in itself is not provocative, depicting a plastic crucifixion immersed in amber liquid; according to Reverend Wildmon, however, the title is."

7. Donald Kuspit makes this defense in William H. Honan, "Artist Who Outraged Congress," p. C13.

8. William H. Honan, "Congressional Anger Threatens Arts Endowment's Budget," *New York Times,* July 20, 1989, p. C15.

9. William H. Honan, "Artist Who Outraged Congress," p. C20: " 'By 1987', he said, 'I had red and white and, quite frankly, I needed a third color to add to my palette. In keeping with bodily fluids I turned to urine. It gave me a quite vivid and vibrant color.' "

10. Frank Kuznik, "NEA Under Siege," *Museum and Arts Washington,* November/December 1989, p. 55.

11. Helle Bering-Jensen, "The Cultural Politics of Controversial Art," *Insight,* July 17, 1989, p. 8.

12. Letter dated May 18, 1989, sent by Senator Alphonse D'Amato (R.—N.Y.) to Hugh Southern, acting chairman of the NEA.

13. Hilton Kramer, "Is Art Above the Laws of Decency?" *New York Times,* July 2, 1989, p. A7; "Arts Endowment Funding of Controversial Photograph: Background Sheet," American Arts Alliance, June 1989.

14. *Congressional Record,* May 31, 1989. p. S5805.

15. "When Art Imitates Garbage," editorial, *The Arizona Republic,* May 11, 1989.

16. Daniel S. Moretti, *Obscenity and Pornography: The Law Under the First Amendment* (New York: Oceana Publications, 1984), p. 59.

17. Isabel Wilkerson, "Dilemma for Chicago Art Institute," *New York Times,* July 3, 1989, p. 42.

18. Tom Mathews, "Fine Art or Foul?" *Newsweek,* July 2, 1990, p. 48.

19. Patrick Buchanan, *Washington Times,* pp. D1, D4.

20. William H. Honan, "Artist Who Outraged Congress," p. C13.

21. Thom Nickels, "Mapplethorpe and the Ayatollah," *Welcomat* (Philadelphia), August 16, 1989.

22. John Robinson, "Show is canceled, roiling art world," *Boston Globe,* June 14, 1989, p. 1.

23. Barbara Gamarekian, "Crowd at Corcoran Protests Mapplethorpe Cancellation," *New York Times,* July 1, 1989, p. 14.

24. In Frank Kuznik, "NEA Under Siege," p. 55, Christina Orr-Cahal is quoted as saying that "The first time [Helms's office called] they basically expressed displeasure that we had withdrawn. I have to conclude they really wanted that exhibition in Washington, so it would fuel their fire."

25. Louise Sweeney, "A Tempest Over Tax Dollars for Controversial Art," *Christian Science Monitor,* July 17, 1989, p. 11.

26. Elizabeth Kastor, "Senate Moves to Expand NEA Grant Ban," *Washington Post,* July 27, 1989, p. C1.

27. "Artists Mugged by Reality," editorial, *Wall Street Journal,* July 28, 1989.

28. Wilkinson, cartoon, *Philadelphia Daily News,* July 28, 1989.

29. Over article by David A. Ross, "An Attempt to Regulate Art Politically," *New York Newsday,* 1989.

30. Elliott Negin, "Dicking Around," *The City Paper* (Washington, D.C.), June 23, 1989, p. 16.

31. Michael Oreskes, "Senate Votes to Bar U.S. Support of 'Obscene or Indecent' Artwork," *New York Times,* July 27, 1989, p. C19.

32. *Chronicle of Higher Education,* September 6, 1989, p. A48.

33. Charles Babington, "Jesse Riles Again," *Museum and Arts Washington,* November/December 1989, p. 59.

34. Brian Wallis, "Fallout from Helms Amendment," *Art in America,* October 1989, p. 29.

35. Leslie Phillips, "Lawmakers tackle the funding of art," *USA Today,* September 12, 1989.

36. Sandy Grady, "House Brushes Off 'Art Critic' Helms," *Philadelphia Daily News,* September 14, 1989.

37. Alan Fram, "NEA funding limits are tolerable, arts advocates say," *Philadelphia Inquirer,* October 5, 1989, p. 6-C.

38. Judd Tully, "Mapplethorpe Sale Smashes Expectations," *Washington Post,* November 1, 1989, p. D1.

39. Jim Adams, "Nominee to head NEA opposes Helms amendment," *Philadelphia Inquirer,* September 23, 1989, p. 4-C.

40. Elizabeth Hess, "NEA Shoots Itself," *Village Voice,* November 21, 1989, p. 63.

41. Isabel Wilkerson, "Trouble Right Here in Cincinnati: Furor Over Mapplethorpe Exhibit," *New York Times,* March 29, 1990, p. A1.

42. Associated Press, "Ohio poll: Most back exhibit," *Philadelphia Inquirer,* April 15, 1990, p. 6-A.

43. William H. Honan, "Arts Endowment Backers Are Split on Strategy," *New York Times,* May 16, 1990, p. C13.

44. Richard Bernstein, "Arts Endowment Opponents Are Fighting Fire with Fire," *New York Times,* May 30, 1990, p. C13.

45. Al Salvato, "Businesses, arts battle over photo show," *Cincinnati Post,* March 24, 1990.

46. William Safire, "Why the Flag-Waving?" *New York Times,* June 19, 1990, p. C14.

47. Stephan Salisbury, "NEA panel votes against funds for two ICA projects," *Philadelphia Inquirer,* May 15, 1990, p. 1-C.

48. Mary Cantwell, "Annapolis and Karen Finley," *New York Times,* May 25, 1990, p. A26.

49. Kim Masters and Elizabeth Kastor, "One-Year NEA Extension Weighed," *Washington Post,* May 15, 1990, p. C2.

50. Richard Bernstein, "Subsidies for Artists," *New York Times,* July 18, 1990, p. C11.

51. Mathews, "Fine Art or Foul?" p. 48.

52. "Mapplethorpe a Hit in Staid Hartford," *Philadelphia Inquirer,* October 23, 1989, p. 2-E.

53. Kathleen M. Sullivan, "A Free Society Doesn't Dictate to Artists," *New York Times,* May 18, 1990, p. A31.

54. Robert Brustein, in "Dialogue: Art and the Taxpayers' Money. Corcoran: Courage or Cowardice," *New York Times,* June 23, 1989, p. A29.

55. Robert Brustein, "Hitler, on Art," *New York Times,* July 28, 1989, p. A27.

56. Matthew Hilk and Lynn Westwater, "D.C. art gallery cancels photo exhibit organized by University," *Summer Pennsylvanian,* June 15, 1989, p. 5.

57. Hughes, "Art, Morals, and Politics," p. 21.

58. Stephan Salisbury, "Cincinnati museum and director are found not guilty of obscenity," *Philadelphia Inquirer,* October 6, 1990, p. 8A. Joseph Veach Noble, past president of the American Association of Museums and director emeritus of the Museum of the City of New York, perhaps inspired this fairy-tale reference in a letter to the editor, *New York Times,* August 27, 1989: "Merely because some people say that something is a work of art does not necessarily make it so. If the emperor has no clothes on, someone has to have the courage to say it."

59. Kim Masters, "Cincinnati art center faces obscenity trial," p. A1: "This court finds that each photograph has a separate identity; each photograph has a visual and unique image permanently recorded."

60. "Lawyer Jim Fitzpatrick, president emeritus of the Washington Project for the Arts and a First Amendment expert, said applicable legal principles 'should have led the court to just the opposite conclusion.' The Mapplethorpe exhibit 'was designed as an integrated whole,' he said" (ibid.). Stephan Salisbury, "Cincinnati's novel trial of art museum," *Philadelphia Inquirer,* September 24, 1990, p. 4-A: " 'No one has had to address the question of whether an exhibition of art is taken as a whole or not,' said attorney Floyd Abrams, an expert in First Amendment law. 'If there had been a film of the exhibition . . . it's unarguable that the film would be judged as a whole.' "

61. See Stephan Salisbury, "Jury selected in museum obscenity trial," *Philadelphia Inquirer,* September 28, 1990, p. D3, and Isabel Wilkerson, "Jury Selected in Ohio Obscenity Trial," *New York Times,* September 28, 1990, p. A10.

62. Kim Masters, "Art Trial: Obscenity Or Slice of History?" *Washington Post,* September 29, 1990, p. D1.

63. Isabel Wilkerson, "Curator Defends Photo Exhibition," *New York Times,* October 4, 1990, p. A19.

64. Isabel Wilkerson, "Obscenity Jurors Were Pulled Two Ways," *New York Times,* October 10, 1990, p. A12.

65. Isabel Wilkerson, "Clashes at Obscenity Trial On What an Eye Really Sees," *New York Times,* October 3, 1990, p. A22.

66. David A. Hoekema, "Artists, Humanists, and Society: Conservatives Have the Wrong Answers, and Liberals Ask the Wrong Questions," *Art Journal,* Fall 1991, vol. 50, no. 3, p. 46.

67. Rachel Bowlby, *Shopping with Freud* (London: Routledge, 1993), p. 43.

68. Walter Kendrick, *The Secret Museum: Pornography in Modern Culture* (New York: Penguin, 1987), p. 95.

69. Moretti, *Obscenity and Morality,* p. 6.

70. Barbara Hoffman, "The Thought Police Are Out There," *Art Journal,* Fall 1991, vol. 50, no. 3, p. 41.

71. Jan Hoffman, "TV Shouts 'Baby' (and Barely Whispers 'Abortion')," *New York Times,* May 31, 1992, sec. 2, p. 27.

72. Arthur Danto, "Art and Taxpayers," *The Nation,* August 21 – 28, 1989, pp. 192 – 93.

73. Amy Adler, "Post-Modern Art and the Death of Obscenity Law," *Yale Law Journal* 99 (1990), p. 1359, cited in Barbara Hoffman, p. 42.

74. Rochelle Gurstein, "Current Debate: High Art or Hard-Core?" *Tikkun,* November/December 1991, p. 70.

75. Carole Vance made this statement in the question period of her lecture at the Philadelphia Institute of Contemporary Art in 1992.

76. Kendrick, *The Secret Museum,* p. 219.

77. Rudolf Arnheim, "On the Nature of Photography," *Critical Inquiry* 1 (September 1974), p. 157.

78. Andy Grundberg, "Blaming a Medium for Its Message," *New York Times,* August 6, 1989, sec. 2, p. 1.

79. Andy Grundberg, "Cincinnati Trial's Unanswered Question," *New York Times,* October 18, 1990, p. C17.

80. Susan Sontag, *On Photography* (New York: Doubleday, 1977), p. 168.

81. Sir Kenneth Clark, *The Nude: A Study in Ideal Form* (New York: Doubleday, 1956).

82. Richard D. Altick, *The Shows of London* (Cambridge: Harvard University Press, 1978), p. 346.

83. Mark Twain, quoted in Paul Richard, "The Debate on the Disgusting," *Washington Post,* April 15, 1990, p. G7.

84. Carole S. Vance, "Photography, Pornography and Sexual Politics," *Aperture: The Body in Question,* no. 121, Fall 1990, p. 52.

85. Robert Hughes, "The Decline of the City of Mahagonny," *The New Republic,* June 25, 1990, p. 32.

86. Walter Kendrick, "Increasing Our Dirty-Word Power: Why Yesterday's Smut Is Today's Erotica," *New York Times Book Review,* May 31, 1992, p. 36.

87. David Wojnarowicz, untitled text, *Aperture: The Body in Question,* no. 121, Fall 1990, pp. 26 – 27.

88. Eleanor Heartney, "Pornography," *Art Journal,* Winter 1991, p. 19.

89. Bowlby, *Shopping with Freud,* p. 30.

90. Grundberg, "Cincinnati Trial's," p. C17.

91. Mary-Charlotte Domandi, "Dorit Cypis: Singing the Body Eclectic," *Aperture: The Body in Question,* p. 68.

92. Carolee Schneemann, "The Obscene Body/Politic," *Art Journal,* Winter 1991, p. 33.

93. Sally Mann, *At Twelve: Portraits of Young Women* (New York: Aperture, 1988), p. 14.

94. Ibid., p. 9.

95. Ibid., p. 10.

96. Ibid., p. 7.

97. Paula Span, "Mapplethorpe didn't exploit children, say parents involved in photos," *Philadelphia Inquirer,* May 11, 1990, p. 5-C.

98. Lawrence A. Stanley, "Art and 'Perversion,'" *Art Journal,* Winter 1991, p. 25.)

99. Vince Aletti, "Child World," *Village Voice,* May 26, 1992, p. 109.

100. Sally Mann, *At Twelve,* p. 38.

101. Richard Marshall, *Robert Mapplethorpe* (New York: Whitney Museum of American Art, 1988), p. 14: "Mapplethorpe engages the viewer by including a mirror as one panel of a piece. The viewer, reflected in the mirror, is brought directly into the picture. This can be especially startling when one sees oneself flanked by two erect penises . . . or surrounded by flowers . . . Mapplethorpe wants to make viewing both participatory and confrontational."

102. Quoted in Emily Friedman, "Robert Mapplethorpe: Exhibit to open by photo artist," *Daily Pennsylvanian,* December 6, 1988, p. 4.

103. For example, Edward J. Sozanski, "Distinctive Artistry in Photorgraphs," *Philadelphia Inquirer,* December 18, 1988, p. 6-V.

104. Tommi Avicolli, "Mapplethorpe Exhibit Is Truly a Must-See," *Philadelphia Gay News,* December 1988.

105. Wilkerson, "Obscenity Jurors Were Pulled Two Ways," p. A12.

106. Grundberg, "Cincinnati Trial's," p. C17.

107. Stephan Salisbury, "Defense begins in art trial," *Philadelphia Inquirer,* October 2, 1990, p. D1.

108. Wilkerson, "Curator Defends Photo Exhibition," p. A19.

109. Wilkerson, "Obscenity Jurors Were Pulled Two Ways," p. A12.

110. Grundberg, "Cincinnati Trial's," p. C17.

111. Kim Masters, "Jurors View Photos of Children," *Washington Post,* October 3, 1990, p. C2.

112. Stephan Salisbury, "Museum director defends exhibit," *Philadelphia Inquirer,* October 4, 1990, p. 10-C.

113. Stephan Salisbury, "Defense begins in art trial," *Philadelphia Inquirer,* October 2, 1990, p. D1.

114. Wilkerson, "Jury Selected in Ohio Obscenity Trial," p. A10.

115. Testimony of Evan Turner in *State of Ohio* v. *Contemporary Art Center and Dennis Barrie,* case nos. 90CRB11699A,B and 90CRB11700A,B.

116. Andy Grundberg, "Photography View: The Allure of Mapplethorpe's Photographs," *New York Times,* July 31, 1988, p. 30.

117. Elizabeth Friar Williams, letter to the editor, *New York Times,* August 6, 1989.

118. Camille Paglia, "The Beautiful Decadence of Robert Mapplethorpe: A Response to Rochelle Gurstein," *Tikkun,* November/December, 1991, p. 80.

119. Tom Kalin, "Prodigal Stories: AIDS and Family," *Aperture: The Body in Question,* no. 121, Fall 1990, p. 25.

120. Peter Schjeldahl, "The Treason of Clerks," *Seven Days,* August 2, 1989.

121. Frank Rizzo, "In His Own Words," *The Hartford Courant,* October 21, 1989, p. B1.

122. Paul Theroux, *Chicago Loop* (London: Hamish Hamilton, 1990), pp. 40–41, 42.

123. Ibid., p. 123.

124. Ibid., p. 169.

125. Frank Kuznik, "NEA Under Siege," p. 54.

CHAPTER TWO

1. Letter to the *Michigan Daily* quoted in ACLU News Release, November 16, 1992: "Anti-Censorship Feminists Condemn Suppression of Art Exhibit; Michigan Incident Illustrates Dangers of MacKinnon/Dworkin Tactics."

2. Joyce Price, "Feminists in free-speech spat," *Washington Times,* November 13, 1992, p. A6.

3. Dave Hickey, *The Invisible Dragon: Four Essays on Beauty* (Los Angels: Art issues. Press, 1993), p. 39.

4. Paula Giddings, "The Last Taboo," in Toni Morrison, ed., *Race-ing Justice, En-gendering Power* (New York: Pantheon, 1992), p. 463.

5. Claudia Brodsky Lacour, "Doing Things with Words: 'Racism' as Speech Act and the Undoing of Justice," in Morrison, *Race-ing Justice, En-gendering Power,* pp. 130–31.

6. Toni Morrison, "Introduction: Friday on the Potomac," in Morrison, *Race-ing Justice, En-gendering Power,* pp. xvi–xvii.

7. Gregory M. Matoesian, *Reproducing Rape: Domination through Talk in the Courtroom* (Cambridge, England: Polity Press, 1993), p. 10.

8. Ibid., pp. 13, 34.

9. Helen Benedict, *Virgin or Vamp: How the Press Covers Sex Crimes* (New York: Oxford University Press, 1992), p. 147.

10. Matoesian, *Reproducing Rape,* p. 34.

11. Barbara Ehrenreich, "The Challenge of the Left," in Paul Berman, ed., *Debating P.C.: The Controversy over Political Correctness on College Campuses* (New York: Bantam Doubleday Dell, 1992), p. 336.

12. Robert Hughes, *Culture of Complaint: The Fraying of America* (New York: Oxford University Press, 1993), pp. 17–18.

13. Catharine A. MacKinnon, *Feminism Unmodified* (Cambridge: Harvard University Press, 1987), p. 216.

14. Catharine A. MacKinnon, "Pornography: Not a Moral Issue," *Women's Studies International Forum,* vol. 9, no. 1, 1986, p. 76.

15. MacKinnon, *Feminism Unmodified,* p. 208.

16. Lockheart Commission on Obscenity and Pornography, *Report,* (Washington, D.C.: GPO, 1970), p. 52.

17. Attorney General's Commission on Pornography, *Final Report* (Washington, D.C.: GPO, 1986).

18. Marlise Simons, "The Sex Market: Scourge of the World's Children," *New York Times,* April 9, 1993, p. A3.

19. Carole S. Vance, "New Threat to Sexual Expression: The Pornography Victims' Compensation Act," SIECUS Report, February/March, 1992, p. 20.

20. MacKinnon, "Pornography," p. 72.

21. Susan Brownmiller, *Against Our Will: Men, Women and Rape* (New York: Simon and Schuster, 1975), p. 394.

22. MacKinnon, *Feminism Unmodified,* p. 128.

23. Ibid., pp. 201, 218, 144.

24. Hughes, *Culture of Complaint,* p. 10.

25. Conference on Sexuality at Barnard College, 1982.

26. Susan Kappeler, *The Pornography of Representation* (Minneapolis: University of Minnesota Press, 1986), pp. 2–3.

27. MacKinnon, *Feminism Unmodified,* pp. 221, 173.

28. MacKinnon, "Pornography," p. 66.

29. Sheila James Keuhl, quoted in Howard Hampton, "When in Videodrome: Travels in the New Flesh," *Artforum,* February 1993, p. 74.

30. Jane Heap, quoted in Edward de Grazia, *Girls Lean Back Everywhere* (New York: Random House, 1992), epigraph.

31. MacKinnon, *Feminism Unmodified,* p. 173.

32. Ibid., pp. 199, 66, 203.

33. Quoted in Walter Kendrick, *The Secret Museum: Pornography in Modern Culture* (New York: Penguin, 1987), p. 235.

34. MacKinnon, *Feminism Unmodified,* p. 198.

35. Quoted in Tamar Lewin, "Anti-Pornography Proposal Reemerges," *New York Times,* March 15, 1992, p. A16.

36. Andrea Dworkin, letter to the editor, *New York Times Book Review,* May 1, 1992, p. 15.

37. Quoted in Michael Moorcock, *Casablanca* (London: Gollancz, 1990), p. 134.

38. Andrea Dworkin, *Mercy* (New York: Four Walls Eight Windows, 1991), p. 333.

39. MacKinnon, *Feminism Unmodified,* p. 138.

40. Kendrick, *The Secret Museum,* p. 236.

41. Charles Morris, "Esthetics and the Theory of Signs," *Journal of Unified Science* 8 (1938), p. 134.

42. John Milton, *Areopagitica and Other Prose Works,* Introduction, K. M. Burton (London: Dent, 1955), pp. 24, 30.

43. John Locke, *Treatise of Civil Government,* ed. Charles L. Sherman (New York: Irvington, 1965), p. 56.

44. In describing this development, James Bunn shows the paradox within the word "import" as both goods brought into a foreign context and intrinsic meaning, and argues that mercantile acquisition inevitably resulted in a formalist approach to art. "Since each curio has been remaindered from its originating environs, it no longer signifies in a figure-ground relationship." "To neglect ground, to ignore the real power which informs signs, is to be preoccupied with the niceties of formal relationships." Bunn traces from this formalism the modernist position on aesthetic power. "Because the source of power in ground has been suppressed, each object seems thereby to stand forth and display itself as if each were in itself a source of power. But the extent to which a curio seems self-referring is a measure of it as a parodic adjunct of latent power." James H. Bunn, "The Aesthetics of British Mercantilism," *New Literary History* 11 (1980), pp. 304, 309, 314.

45. Robert Browning, "The Plundering of Nationhood," *Times Literary Supplement,* July 25, 1986, p. 805.

46. Ibid.

47. As if to intensify this duality, the Pergamon friezes in Berlin are presented both concavely and convexly, with the originals facing in, in the protected museum arrangement, and with casts of them arranged facing out around a mock-up of the temple.

48. James Knowles's reply to Frederic Harrison in the parliamentary record, 1891, quoted in Christopher Hitchens, *The Elgin Marbles: Should They Be Returned to Greece?* (London: Chatto & Windus, 1987), p. 69.

49. Hal Foster, "The Art of Fetishism: Notes on Dutch Still Life," in *The Fetish,* vol. 4 of the *Princeton Architectural Journal* (New York: Princeton Architectural Press, 1992), p. 7.

50. Georges Canguilhem, "Histoire des religions et histoire des sciences dans la théorie du fétichisme chez Auguste Comte," *Etudes d'histoire et de philosophie des sciences* (Paris: J. Vrin, 1983), p. 94.

51. Karl Marx, *Capital,* vol. 1, trans. Samuel Moore and Edward Aveling (Chicago: Charles H. Kerr, 1926), pp. 81–93; Sigmund Freud, "Fetishism," *Standard Edition of the Complete Psychological Works of Sigmund Freud,* ed. James Strachey, vol. 17 (London: Hogarth Press, 1964), p. 154.

52. Foster, *The Art of Fetishism,* p. 7.

53. Paul Eluard, *A Pablo Picasso* (London: Secker & Warburg, 1947), p. 33 (my translation).

54. Clive Bell, *Art* (London: Chatto & Windus, 1914), p. 37.

55. For a detailed treatment of these ideas, see my article, "The Case for Unclear Thinking: The New Critics Versus Charles Morris," *Critical Inquiry* 6 (Winter 1979), pp. 257–69.

56. Emily Apter, "Specularity and Reproduction: Marx, Freud, Baudrillard," *The Fetish* (New York: Princeton Architectural Press, 1992), pp. 25–26.

57. *Andy Warhol: A Retrospective,* ed. Kynaston McShine (New York: Museum of Modern Art, 1989), p. 434.

58. Fredric Jameson, "Postmodernism and Consumer Society," *American Studies* 1 (1984), p. 56.

59. Linda Hutcheon, *A Poetics of Postmodernism: History, Theory, Fiction* (New York: Routledge, 1988), p. 211.

60. John Hawkes, *Whistlejacket* (London: Secker & Warburg, 1989), p. 3.

61. Froma Zeitlin shows that this complex of ideas is as old as Longus's *Daphnis and Chloe* in "The Poetics of Eros: Nature, Art, and Imitation in Longus' *Daphnis and Chloe,*" in *Before Sexuality: The Construction of Erotic Experience in the Ancient World,* ed. J. J. Winkler, David Halperin, and F. I. Zeitlin (Princeton: Princeton University Press, 1990); I have discussed these issues at length in *Pictures of Romance* (Chicago: University of Chicago Press, 1988).

62. Michel Leiris, *Manhood,* trans. Richard Howard (London: Jonathan Cape, 1968), p. 56.

63. James Joyce, *Ulysses: The Corrected Text* (London: Penguin, 1986), p. 165.

64. Philip Fisher, "The Future's Past," *New Literary History* vol. 6, no. 3 (1975), p. 591; "That we walk through a museum, walk past the art, recapitulates in our act the motion of art history itself, its restlessness, its forward motion, its power to link. . . . The rapid stroll through a museum is an act in deep harmony with the nature of Art, that is, art history and the museum itself."

65. Harold Rosenberg, "The Erect Odalisque: Transcendence plus Liberation," *Discovering the Present* (Chicago: University of Chicago Press, 1973), p. 38.

66. John Fowles, *The Collector* (London: Jonathan Cape, 1963), p. 123.

67. Laura Mulvey, "Visual Pleasure and Narrative Cinema" (originally published in 1975 in *Screen*), in *Visual and Other Pleasures* (Bloomington: Indiana University Press, 1989), p. 17.

68. George Etherege, *The Man of Mode* (London: Methuen, 1988), act 5, scene 1, p. 51.

69. Toni Morrison, *Beloved* (New York: Knopf, 1987), pp. 26–27.

CHAPTER THREE

1. Hendrik Hertzberg, "Secular Sermon," *The New Republic,* March 20, 1989, p. 4.

2. "Dialogue: Art and the Taxpayers' Money," *New York Times,* June 23, 1989, p. A29.

3. J. Anthony Lukas, "In Chicago, A Holy War over the Flag," *New York Times,* March 16, 1989, p. A31.

4. Interview with Shrabani Basu in *India,* September 18, 1988, repr. in Lisa Appignanesi and Sara Maitland, *The Rushdie File* (Syracuse: Syracuse University Press, 1990), p. 32.

5. Marc Duvoisin, " 'Verses' Propels Iranian Offensive," *Philadelphia Inquirer,* March 5, 1989, p. E1.

6. Appignanesi and Maitland, *The Rushdie File,* p. 68.

7. Amy E. Schwartz, *Washington Post,* February 19, 1989, p. D7.

8. Stephan Salisbury, "From Rushdie to Mapplethorpe, the arts are under siege," *Philadelphia Inquirer,* September 10, 1989, p. F4.

9. Norman Tebbit, "Salman Rushdie," *Independent on Sunday, Magazine,* September 8, 1990, p. 54.

10. Craig R. Whitney, "Iran and Britain Move Near Break," *New York Times,* February 28, 1989, p. A10.

11. Steve Lohr, "Rushdie Expresses Regret to Muslims for Book's Effect," *New York Times,* February 19, 1989, p. 18.

12. Lohr, "Rushdie Expresses Regret," p. A1.

13. Youssef M. Ibrahim, "Europeans Recall Envoys from Iran over Rushdie Case," *New York Times,* February 21, 1989, p. A8.

14. Editorial, *Philadelphia Inquirer,* February 21, 1989, p. A10.

15. Tariq Ali and Howard Brenton, "Note," *Iranian Nights* (London: Nick Hern Books, 1989), n.p.

16. "Transition," *Newsweek,* July 22, 1991, p. 51.

17. Lloyd Grove and Charles Trueheart, "Few Writers Raise Voices to Defend Rushdie," *Philadelphia Inquirer,* February 19, 1989, p. A18.

18. Rick Lyman, "Authors Rally for Rushdie," *Philadelphia Inquirer,* February 23, 1989, p. A1.

19. William E. Smith, "The New Satans," *Time,* March 6, 1989, p. 38.

20. "Words for Salman Rushdie," *New York Times Book Review,* March 12, 1989, p. 29.

21. Jonathan Yardley, *Washington Post,* February 27, 1989, p. B2.

22. Tim Brennan, for example, writes, "I could not help feeling myself a casualty of this fight . . . because of what Rushdie *signifies* rather than what I actually wrote about Rushdie," in "Rushdie, Islam, and Postcolonial Criticism," *Social Text* 31/32 (vol. 10, nos. 2 and 3), 1992, p. 271, in response to Aamir Mufti's "Reading the Rushdie Affair: An Essay on Islam and Politics," *Social Text* 29 (vol. 9, no. 4), 1991, pp. 95–124.

23. Richard Cohen, "The Myth of the Cowardly Intellectuals," *Washington Post,* February 28, 1989, p. A23.

24. "Midnight's Conversion," *The New Republic,* January 21, 1991, p. 9.

25. Letter to the editor, *Independent,* January 6, 1991.

26. Salman Rushdie, "In Good Faith," *Independent on Sunday,* February 4, 1990, p. 19.

27. Salman Rushdie, *The Satanic Verses* (London: Viking, 1988), p. 3. References hereafter will appear in the text proper as *SV* with pagination following.

28. Salman Rushdie, "Imaginary Homelands," in *Imaginary Homelands: Essays and Criticism, 1981–1991* (London: Granta, 1992), p. 11.

29. Srinivas Aravamudan, " 'Being God's Postman Is No Fun, Yaar': Salman Rushdie's *The Satanic Verses,*" *Diacritics,* vol. 19, no. 2 (Summer 1989), p. 15.

30. According to Gerald Marzorati, "Salman Rushdie: Fiction's Embattled Infidel," *New York Times Magazine,* January 29, 1989, p. 100, "Bostan" is the Farsi word

for garden and the title of a poem by the thirteenth-century Persian, Sadi, proclaiming the virtues of justice, self-restraint, gratitude, and penitence. For a discussion of the cultural significance of the number "420," see Srinivas Aravamudan, "'Being God's Postman Is No Fun, Yaar,'" *Diacritics,* vol. 19, no. 2 (Summer 1989), pp. 6–10.

31. See Marzorati, "Salman Rushdie: Fiction's Embattled Infidel," p. 100, and Paul Berman, "Shame," p. 33 *The New Republic,* October 8, 1990, p. 33.

32. John Leo, *U.S. News and World Report,* March 6, 1989, repr. in Appignanesi and Maitland, *The Rushdie File,* p. 250.

33. "The Star," *The Koran,* trans. N. J. Dawood (Harmondsworth: Penguin, 1971), p. 113.

34. Salman Rushdie, "Thomas Pynchon," *Imaginary Homelands,* p. 352.

35. *The Koran,* p. 113. Paul Berman in "Shame," p. 33, his review of Daniel Pipes, *The Rushdie Affair* (Birch Lane Press, 1990), says of the *Satanic Verses* affair: "Rushdie thought he had dug up this embarrassing and largely buried incident from a legitimate Koranic source, al-Tabari (d. 923), who reported the affair. But according to Pipes, the novelist has merely pried his story out of the scholarly work of Western investigators, who themselves pried it out of Tabari. The crucial words 'Satanic verses' never appeared in Tabari's canonic report. Those words derive from the British writer William Muir in his 1861 *Life of Mahomet.* 'Satanic verses,' in short, is an orientalist, not a Muslim, phrase. . . . And because 'verses' is liable to be translated into the Islamic languages with a term that connotes all 6,236 lines of the Koran and not just the controversial two lines intruded by Satan, a Muslim coming across Rushdie's title may well interpret it to mean 'The Satanic Koran,' which does have an unfriendly implication, especially for someone who adores the Koran and thinks Satan is all to real."

36. *The Koran,* p. 113.

37. Ibid.

38. Salman Rushdie, "In Good Faith," p. 19.

39. Syed Shahabuddin, "You did this with satanic forethought, Mr. Rushdie," *Times of India,* October 13, 1988, repr. in Appignanesi and Maitland, *The Rushdie File,* p. 38.

40. Professor Syed Ali Ashraf, *Impact International,* October 1988, repr. in Appignanesi and Maitland, *The Rushdie File,* p. 18.

41. John Allemang, *Toronto Globe and Mail,* February 18, 1989, repr. in Appignanesi and Maitland, *The Rushdie File,* p. 218.

42. Shahabuddin, in Appignanesi and Maitland, *The Rushdie File,* p. 37.

43. Edward W. Said, statement from New York rally held February 22, 1989, repr. in Appignanesi and Maitland, *The Rushdie File,* p. 165.

44. Shabbir Akhtar, *Guardian,* February 27, 1989, repr. in Appignanesi and Maitland, *The Rushdie File,* p. 228.

45. Sayed Ali Ashraf, in Appignanesi and Maitland, *The Rushdie File,* p. 20.

46. Ralph Ellison and Joseph Brodsky, in "Words for Salman Rushdie," *New York Times Book Review,* March 12, 1989, p. 28.

47. Rushdie, "In God We Trust," p. 376.

48. John Gray, in "Salman Rushdie: hiding from himself," *Toronto Globe and Mail,* February 18, 1989, repr. in Appignanesi and Maitland, *The Rushdie File,* p. 4, writes that "For most of his 41 years . . . Mr. Rushdie has been in hiding—hiding from himself and pursuing himself at the same time."

49. Salman Rushdie, "One Thousand Days in a Balloon," *Imaginary Homelands,* p. 431.

50. Rushdie, "In Good Faith," p. 20.

51. Christopher Hitchens, *New York Times,* February 17, 1989, p. A39.

52. Marc Kaufman, *Philadelphia Inquirer,* February 19, 1989, p. C1.

53. Interview recorded by Bandung File on January 27, 1989, repr. in Appignanesi and Maitland, *The Rushdie File,* p. 23.

54. The fine catalogue of the more recent exhibition is *Fake? The Art of Deception,* ed. Mark Jones (London: British Museum Publications, 1990).

55. Queenie Leavis, "The Englishness of the English Novel," her last public address, made at the 1980 Cheltenham Festival.

56. Timothy Garton Ash, "Hold tight, old John Bull," *Independent,* August 2, 1990, p. 21.

57. A. S. Byatt, *Possession, A Romance* (London: Chatto & Windus, 1990), pp. 186–87.

58. Rushdie, "In Good Faith," p. 18.

59. Fredric Jameson, "Postmodernism and Consumer Society," in Hal Foster, ed., *Postmodern Culture* (London: Pluto Press, 1985), p. 115.

60. Rushdie, "In Good Faith," p. 18.

61. Salman Rushdie, *Shame* (London: Picador, 1984 [Jonathan Cape, 1983]), p. 28.

62. Ibid., p. 29.

63. Salman Rushdie, "Where the Art Is," *Independent on Sunday,* May 3, 1992, p. 27.

64. Rushdie, "Imaginary Homelands," p. 10.

65. Salman Rushdie, *Midnight's Children* (London: Picador, 1982 [Jonathan Cape, 1981]), p. 95.

66. Salman Rushdie, "Gunter Grass," *Imaginary Homelands,* p. 280.

67. Jonathan Yardley, "Wrestling with the Angel," *Washington Post Book World,* January 29, 1989, p. 3.

68. Berman, "Shame," p. 34.

69. Ibid., p. 33.

70. Marzorati, "Salman Rushdie: Fiction's Embattled Infidel," p. 26.

71. Rushdie, *Midnight's Children,* p. 9.

72. Ibid., p. 112.

73. Salman Rushdie, *Haroun and the Sea of Stories* (London: Granta, 1990), p. 20.

74. Rushdie, "Imaginary Homelands," p. 12.

75. Salman Rushdie, "Outside the Whale" (1984), in *Imaginary Homelands,* p. 92.

76. Ibid., p. 99.

77. Rushdie, "In Good Faith," p. 19.

78. Salman Rushdie, response to Jeff Greenfield, host of ABC's *Nightline,* reported in Laura Shapiro, "At Stake: The Freedom to Imagine," *Newsweek,* February 27, 1989, p. 36.

79. Salman Rushdie, "My Book Speaks for Itself," *New York Times,* February 17, 1989, p. A39, an article addressed to Rajiv Gandhi.

80. Rushdie, "In Good Faith," p. 20.

81. Georg Konrad, in "Words for Salman Rushdie," p. 29.

82. Graham Swift, letter to the editor, *Independent,* March 7, 1989, repr. in Appignanesi and Maitland, *The Rushdie File,* p. 201.

83. Ben Okri, address at London ICA, March 19, 1989, repr. in Appignanesi and Maitland, *The Rushdie File,* p. 180.

84. Rushdie, "In Good Faith," p. 18.

85. *Philadelphia Inquirer,* February 25, 1989, p. A10.

86. Hendrik Hertzberg, "Secular Sermon," *The New Republic,* March 20, 1989, p. 49.

87. Rushdie, "In Good Faith," p. 18.

88. Christopher S. Taylor, "Salman Rushdie's Insensitivity," *Christian Science Monitor,* March 3, 1989, p. 18.

89. Liaquat Hussain, quoted by Julian Baum, *Christian Science Monitor,* March 3, 1989, p. 3.

90. Rushdie, "One Thousand Days in a Balloon," p. 439.

91. *Congressional Record,* February 22, 1989, p. S1508.

92. *Baltimore Sun,* February 26, 1989, repr. in Appignanesi and Maitland, *The Rushdie File,* p. 223.

93. "Midnight's Conversion," *The New Republic,* January 21, 1991, p. 10.

94. Farrukh Dhondy, address at London ICA, March 19, 1989, repr. in Appignanesi and Maitland, *The Rushdie File,* p. 184.

95. Leon Wieseltier, quoted by John Leo, *U.S. News and World Report,* June 3, 1989, p. 249.

96. Norman Mailer, in "Words for Salman Rushdie," p. 29.

97. Jeff Greenfield, "That Different-Cultures-Different-Values Line Doesn't Work in Rushdie Case," *Philadelphia Inquirer,* February 18, 1989, p. A8.

98. Christopher Hitchens, "Two Cheers for Blasphemy," *The New Republic,* March 13, 1989, p. 7. Similarly extravagant claims have been made for pornography by John Tierney, "Porn, the Low-Slung Engine of Progress," *New York Times,* January 9, 1994, pp. 1, 18.

99. Michael Foot, *Guardian,* March 10, 1989, repr. in Appignanesi and Maitland, *The Rushdie File,* pp. 232, 233.

100. *Philadelphia Inquirer,* March 7, 1989, p. D1.

101. *Guardian,* February 27, 1989, repr. in Appignanesi and Maitland, *The Rushdie File,* p. 229. In "The Divine Supermarket," *Imaginary Homelands,* p. 369, Rushdie reviews a book on fundamentalism and quotes Malise Ruthven: "Any form of learning is,

at heart, inimical to fundamentalist certitudes"; i.e., the very basis of liberalism—the right to education—is understood as subversive to orthodoxy.

102. *Observer,* April 2, 1989, repr. in Appignanesi and Maitland, *The Rushdie File,* pp. 255, 256.

103. Salman Rushdie, "Is Nothing Sacred?" *Imaginary Homelands,* p. 416.

104. Ibid., p. 418.

105. Ibid., p. 420.

106. Ibid., p. 426.

107. Ibid., p. 427.

108. Ibid.

109. Ibid., p. 416.

110. Salman Rushdie, "Julian Barnes," *Imaginary Homelands,* p. 242.

111. Rushdie, *Midnight's Children,* p. 461.

CHAPTER FOUR

1. Roger Kimball, *Tenured Radicals: How Politics Has Corrupted Our Higher Education* (New York: Harper & Row, 1990), p. 207.

2. Russell Baker, "Observer—Supreme and P.C. Court," *New York Times,* sec. 1, p. 19.

3. Page Smith, *Killing the Spirit: Higher Education in America* (New York: Viking, 1990), p. 5.

4. The words of the political scientist Abigail Thernstrom, quoted in Dinesh D'Souza, *Illiberal Education: The Politics of Race and Sex on Campus* (New York: Vintage, 1992), p. xiv.

5. Dinesh D'Souza's phrase, quoted in Michael Bérubé, "Public Image Limited: Political Correctness and the Media's Big Lie," *Village Voice,* June 18, 1991, p. 31.

6. Paul Berman, ed., *Debating P.C.: The Controversy over Political Correctness on College Campuses* (New York: Bantam Doubleday Dell, 1992), pp. 2–3.

7. Hilton Kramer, "The Prospect Before Us," in Paul Berman, ed., *Debating P.C.,* p. 320.

8. William F. Buckley, Jr., *God and Man at Yale: The Superstitions of Academic Freedom* (Chicago: Henry Regenery, 1951), p. viii.

9. Christina Sommers, quoted in John Elson, "Academics in Opposition," *Time,* April 1, 1991, p. 68.

10. Larry Gross, "There They Go Again," *Journal of Communications* 42 (2) (Spring 1992), p. 111.

11. Molefi Kete Asante, "The Escape into Hyperbole: Communication and Political Correctness," *Journal of Communications* 42 (2) (Spring, 1992), p. 147.

12. William Safire, "Linguistically Correct," *New York Times,* May 5, 1991, pp. 18–19.

13. A. Bartlett Giamatti, *A Free and Ordered Space: The Real World of the University* (New York: Norton, 1988), p. 110.

14. John Henry, Cardinal Newman, *The Idea of a University: Defined and Illustrated* (London: Longmans, Green, 1896), pp. 106 – 17.

15. D'Souza, *Illiberal Education,* p. 23.

16. Newman, *The Idea of a University,* p. 109 (Newman's emphasis).

17. Ibid., p. 120.

18. Allan Bloom, *The Closing of the American Mind* (New York: Simon & Schuster, 1987), p. 311.

19. Thomas Short, "What Shall We Defend?" *Academic Questions,* vol. 4, no. 4 (Fall 1991), p. 24.

20. Giamatti, *A Free and Ordered Space,* p. 131.

21. Smith, *Killing the Spirit,* p. 55.

22. Denis Donoghue, "The Reader and Critic: Comments by Denis Donoghue and Morris Dickstein," in *Ideas* 1, 2 (Winter 1993), p. 58.

23. Stephen H. Balch, editorial, *NAS Update* (National Association of Scholars), p. 2.

24. Short, "What Shall We Defend?" pp. 25, 24.

25. Buckley, *God and Man at Yale,* pp. 183, 176.

26. Edith Wharton, *The Buccaneers* (New York: Viking, 1993), p. 359.

27. Newman, *The Idea of a University,* pp. 115 – 16.

28. Andrea Dworkin, *Mercy* (New York: Four Walls Eight Windows, 1991), p. 167: "You have a right to hate liberals; they make promises they cannot keep. They make you believe certain things are possible: dignity in the world, and freedom; but especially equality."

29. Newman, *The Idea of a University,* p. 123.

30. Bloom, *The Closing of the American Mind,* pp. 49, 253 – 54.

31. Newman, *The Idea of a University,* pp. 166, 177.

32. John Jay Chapman, quoted in Smith, *Killing the Spirit,* p. 50.

33. Norman Podhoretz, quoted in Kimball, *Tenured Radicals,* p. 60.

34. William J. Bennett, *To Reclaim a Legacy: A Report on the Humanities in Higher Education* (Washington, D.C.: National Endowment for the Humanities, 1984), p. 30.

35. "5,000 at Penn Hear Koppel on Learning," *New York Times,* May 22, 1991, p. B2.

36. Dinesh D'Souza, *Firing Line,* August 28, 1991, PBS transcript, p. 16.

37. Robert Hughes, *Culture of Complaint: The Fraying of America* (New York: Oxford University Press, 1993), p. 63.

38. D'Souza, *Illiberal Education,* p. 210.

39. Bloom, *The Closing of the American Mind,* p. 26.

40. Allan Bloom, *Giants and Dwarfs* (New York: Simon & Schuster, 1990), p. xvii, n. 2.

41. Short, "What Shall We Defend?" p. 23.

42. George Bornstein, "The State of Letters: Can Literary Study Be Politically Correct?" *Sewanee Review* (vol. 100, no. 2), 1992, p. 285.

43. Katha Pollitt, "Why Do We Read?" in Paul Berman, *Debating P.C.,* pp. 210 – 11.

44. Buckley, *God and Man at Yale,* p. 192.

45. D. Charles Whitney and Ellen Wartella, "Media Coverage of the 'Political Correctness' Debate," *Journal of Communications* 42 (2), (Spring 1992), p. 86.

46. Maureen Dowd, "Bush Sees Threat to Flow of Ideas on U.S. Campuses," *New York Times,* May 5, 1991, p. 1.

47. Scott Henson and Tom Philpott, "The Right Declares a Culture War," *The Humanist,* 52, 2 (March/April 1992), p. 10.

48. Jon Wiener, "What Happened at Harvard," *The Nation,* September 30, 1991, pp. 384 – 88.

49. Henson and Philpott, "The Right Declares a Culture War," p. 11.

50. Ibid., p. 13.

51. Short, "What Shall We Defend?" p. 19.

52. Berman, *Debating P.C.,* p. 21.

53. Michael Kinsley, "P.C. B.S.," *The New Republic,* May 20, 1991, p. 50.

54. Henson and Philpott, "The Right Declares a Culture War," p. 12.

55. Buckley, *God and Man at Yale,* pp. xv – xvi.

56. Ibid., pp. 185, 190.

57. Ibid, p. 6.

58. Charles J. Sykes, *Profscam: Professors and the Demise of Higher Education* (Washington: Regnery Gateway, 1988), p. 21.

59. Eugene D. Genovese, "Heresy, Yes—Sensitivity, No," *The New Republic,* April 15, 1991, p. 34.

60. Stanley Fish, "There's No Such Thing as Free Speech and It's a Good Thing, Too," in Paul Berman, *Debating P.C.,* p. 238.

61. Barbara Dority, "Civil Liberties Watch: The PC Speech Police," *The Humanist,* March/April, 1992, p. 31.

62. "Taking Offense," *Newsweek,* December 24, 1990, p. 49.

63. Michiko Kakutani, "Please, Just Don't Tell Me What to Say or Think or Write," *New York Times,* April 23, 1993, p. C30.

64. Dority, "Civil Liberties Watch," p. 31.

65. Glen Loury, *Firing Line,* transcript of August 28, 1991, PBS broadcast, p. 10.

66. Kakutani, "Please," p. 39.

67. Kimball, *Tenured Radicals,* p. 68.

68. Camille Paglia, "The Nursery-School Campus," *Times Literary Supplement,* May 22, 1992, p. 19.

69. Michael Burgoon and William Bailey, "PC at Last! PC at Last! Thank God Almighty We Are PC at Last!" *Journal of Communications* 42 (2), (Spring 1992), p. 101.

70. Frank Kermode, "Whose History Is Bunk?" *New York Times Book Review,* February 23, 1992, p. 3: "Older speech codes banned from civilized society the street language of sex, but this inhibition does not seem to have improved sexual behavior or the status of women."

71. Sykes, *Profscam,* p. 290.

72. Henry Louis Gates, Jr., "Whose Canon Is It, Anyway?" in Paul Berman, *Debating P.C.,* p. 192.

73. Richard Goldstein, "The Politics of Political Correctness," *Village Voice,* June 18, 1991, p. 39.

74. Louis Menand, "What Are Universities For? The Real Crisis on Campus Is One of Identity," *Harper's Magazine,* December 1991, vol. 283, p. 56.

75. Gross, "There They Go Again," p. 110.

76. Catharine Stimpson, *Firing Line,* PBS transcript from August 28, 1991, p. 22.

77. Bennett, *To Reclaim a Legacy,* p. 31.

78. Kimball, *Tenured Radicals,* p. xiii.

79. Michael Bérubé, "Public Image Limited: Political Correctness and the Media's Big Lie," *Village Voice,* June 18, 1991, p. 34.

80. Alexander Nehemas, "Serious Watching," in *The Politics of Liberal Education,* ed. Darryl J. Gless and Barbara Herrnstein Smith (Durham: Duke University Press, 1992), p. 163.

81. Kimball, *Tenured Radicals,* p. 203.

82. Sykes, *Profscam,* p. 46.

83. Bennett, *To Reclaim a Legacy,* p. 1.

84. Charles J. Sykes, *The Hollow Men: Politics and Corruption in Higher Education* (Washington: Regnery Gateway, 1990), p. 14.

85. Sykes, *Profscam,* p. 4.

86. E. D. Hirsch, Jr., *Cultural Literacy: What Every American Needs to Know* (Boston: Houghton Mifflin, 1987).

87. Kimball, *Tenured Radicals,* p. 63.

88. D'Souza, *Illiberal Education,* p. 14.

89. Giammati, *A Free and Ordered Space,* p. 44.

90. Tracy Brown, "The Poem and the High-Heeled Shoe: Fetishization and Narrative," in *The Fetish,* vol. 4 of *The Princeton Architectural Journal* (New York: Princeton Architectural Press, 1992), p. 48.

91. Catharine R. Stimpson, "On Differences," MLA Presidential Address, 1990, in Paul Berman, *Debating P.C.,* p. 49.

92. Barbara Herrnstein Smith, "Cult-lit: Hirsch, Literacy, and the 'National Culture,'" in Gless and Smith, *The Politics of Liberal Education* (Durham: Duke University Press, 1992), p. 111.

93. Paula Rothenberg, "Critics of Attempts to Democratize the Curriculum Are Waging a Campaign to Misrepresent the Work of Responsible Professors," in Paul Berman, *Debating P.C.,* pp. 265–66.

94. Hughes, *Culture of Complaint,* p. 151.

95. Pollitt, "Why Do We Read?" p. 204.

96. Hughes, *Culture of Complaint,* p. 92.

97. Irving Howe, "The Value of the Canon," in Paul Berman, *Debating P.C.,* pp. 169–70.

98. D'Souza, *Illiberal Education,* p. 186.

99. Aimé Césaire, quoted in Edward W. Said, "The Politics of Knowledge," in Paul Berman, *Debating P.C.,* p. 181.

100. Bennett, *To Reclaim a Legacy,* pp. 3 – 4.

101. Gerald Graff and Reginald Gibbons, eds., *Criticism in the University* (Evanston: Northwestern University Press, 1985), p. 80.

102. Stimpson, "On Differences," in Paul Berman, *Debating P.C.,* p. 52.

103. Menand, "What Are Universities For?" p. 53.

104. Maurice Isserman, "Travels with Dinesh," *Tikkun* 6, no. 5 (September/October 1991), p. 84.

105. Sykes, *Profscam,* p. 5.

106. Smith, *Killing the Spirit,* p. 111.

107. Hughes, *Culture of Complaint,* p. 69.

108. Berman, *Debating P.C.,* p. 7.

109. D'Souza, *Illiberal Education,* p. 179.

110. Smith, *Killing the Spirit,* p. 199.

111. Ibid., pp. 1, 192.

112. Ibid., p. 108.

113. Sykes, *Profscam,* p. 128.

114. Fredric Jameson and James Kavanagh, "The Weakest Link: Marxism in Literary Studies," in *The Left Academy II* (New York: Praeger, 1984), pp. 3 – 4.

115. Kimball, *Tenured Radicals,* p. 41.

116. Denis Donoghue, "The Reader and Critic," in *Ideas* 1, 2 (Winter 1993), pp. 57 – 58.

117. Roger Kimball, "The Periphery v. the Center: the MLA in Chicago," in Paul Berman, *Debating P.C.,* p. 74.

118. Ezra Pound, *Gaudier-Brzeska, A Memoir* (New York: New Directions, 1970), p. 89.

119. Ernest Fenollosa, *The Chinese Written Character as a Medium for Poetry,* ed. Ezra Pound (San Francisco: City Lights Books, 1936), p. 21.

120. Pound, *Gaudier-Brzeska,* p. 86, 88.

121. Fenollosa, *Chinese Written Character,* p. 12.

122. Pound, *Gaudier-Brzeska,* pp. 86 – 87, 89.

CHAPTER FIVE

1. Dinesh D'Souza, *Illiberal Education* (New York: Vintage, 1992), p. 191.

2. Elisabeth Roudinesco, a friend of Althusser's, quoted in Edward Fox, "A Marxist Murderer," *Independent,* July 11, 1992, p. 22.

3. John Sturrock, "The Last Days of the Intellocrat," *New York Times Book Review,* January 10, 1993, p. 1.

4. Jerome Christensen, "From Rhetoric to Corporate Populism: A Romantic Critique of the Academy in an Age of High Gossip," *Critical Inquiry* 16 (Winter 1990), p. 453.

5. William F. Buckley, Jr., *God and Man at Yale* (Chicago: Henry Regnery, 1951), p. 193.

6. Charles J. Sykes, *Profscam* (Washington: Regnery Gateway, 1988), p. 4.

7. Robin W. Winks, *Cloak and Gown: Scholars in the Secret War, 1939–1961* (New York: William Morrow, 1987), p. 325.

8. Ibid., p. 258.

9. Christensen, "From Rhetoric to Corporate Populism," p. 466.

10. Sir Ernst H. Gombrich, *Art & Illusion* (Princeton: Bollingen, 1961), p. 2.

11. Winks, *Cloak and Gown,* p. 115.

12. Ibid., p. 317.

13. Ibid., p. 254.

14. Tzvetan Todorov, *Times Literary Supplement,* June 17–23, 1988, p. 684.

15. Hannah Arendt, quoted in Gunther Neske and Emil Kettering, *Martin Heidegger and National Socialism,* trans. Lisa Harries (New York: Paragon House, 1990), pp. 216–17: "the inclination toward the tryannical could be demonstrated theoretically in many of the great thinkers (Kant is the great exception). . . . It finally does not matter where the storms of their centuries carried these few. For the storm that blows through Heidegger's thinking does not originate from the century he happened to live in. It comes from the primeval, and what it leaves behind is something perfect that, like all that is perfect, returns home to the primeval."

16. Philippe Lacoue-Labarthe, *Heidegger, Art and Politics: The Fiction of the Political,* trans. Chris Turner (Oxford: Basil Blackwell, 1990), p. 127.

17. Alan Bennett, *A Question of Attribution,* in *Single Spies* (London: Faber & Faber, 1989), pp. 46, 55.

18. Fredric Jameson, *The Political Unconscious: Narrative as a Socially Symbolic Act* (Ithaca: Cornell University Press, 1981), p. 20.

19. Paul Overy, "The New Art History and Art Criticism," in A. L. Rees and F. Borzello, eds., *The New Art History* (London: Camden Press, 1986, p. 135.

20. Anthony Blunt, "Brussels Exhibitions," *Spectator,* October 4, 1935, p. 507.

21. Anthony Blunt, "Scientific Picture Galleries," *Spectator,* September 6, 1935, p. 354.

22. Louis MacNeice on Blunt during their Marlborough days, in Andrew Boyle, *The Climate of Treason,* 2d ed. (London: Hutchinson, 1982), p. 67.

23. Barrie Penrose and Simon Freeman, *Conspiracy of Silence: The Secret Life of Anthony Blunt* (London: Grafton Books, 1986), p. 31.

24. Bevis Hillier, *Young Betjeman* (London: John Murray, 1988), p. 119.

25. John Costello, *Mask of Treachery* (New York: William Morrow, 1988), p. 85.

26. Anthony Blunt, "Picasso, 1930–1934," *Spectator,* April 9, 1937, p. 664.

27. Anthony Blunt, "Sleepers Awake!" *Spectator,* October 11, 1935, p. 548.

28. Anthony Blunt, "Artist v. Critic," *Spectator,* April 10, 1936, p. 676.

29. Anthony Blunt, *The Art of William Blake* (London: Oxford University Press, 1959), pp. 54–55, 93–94, 95–96.

30. Anthony Blunt, *Nicolas Poussin* (New York: Bollingen, 1967), p. ix. It is interesting to note that Blunt, so split between his scholarship and his politics, assumed that explaining Poussin's ideas was a way to account for his artistic career (p. 5): "I would ask the reader to bear with me patiently and not to condemn my argument till he has

followed it through to the end. If it has any validity, this depends on the fact that it presents—or so I believe—a consistent view of the artist which can explain the development of his thought throughout the whole of his career, except the early experimental years, before he had found his real bent as an artist."

31. Blunt describes Poussin's method of composition in *Art and Architecture in France 1500–1700* (London: Penguin, 1953), p. 176.

32. Ibid., p. 209.

33. Anthony Blunt, *Picasso's "Guernica"* (London: Oxford University Press, 1969), pp. 56–57.

34. Bennett, *A Question of Attribution,* p. 58.

35. Ibid., pp. 58, 58–59.

36. Ibid., pp. 60, 61.

37. Winks, *Cloak and Gown,* p. 407.

38. Hugo Ott, quoted in Tom Rockmore and Joseph Margolis, eds., *The Heidegger Case* (Philadelphia: Temple University Press, 1992), p. 384.

39. Hannah Arendt, quoted in Victor Farías, *Heidegger and Nazism,* trans. Paul Burrell (Philadelphia: Temple University Press: 1988), p. 75.

40. George Grange, "Heidegger as Nazi—A Postmodern Scandal," *Philosophy East and West* 41: 4 (October 1991), p. 515.

41. Gunther Neske and Emil Kettering, *Martin Heidegger and National Socialism,* trans. Lisa Harries (New York: Paragon House, 1990), pp. 8–9.

42. Fred Dallmayr quotes Otto Pöggeler in Rockmore and Margolis, ed., *The Heidegger Case,* p. 188: "Heidegger's persistent concern, he writes, was 'to respond philosophically to the crisis of Europe as it had been revealed by the First World War.'"

43. Neske and Kettering, *Heidegger and National Socialism,* pp. 56–57.

44. Farías, *Heidegger and Nazism,* p. x.

45. Ibid., p. 4.

46. Rockmore and Margolis, *The Heidegger Case,* p. 203.

47. Ibid., p. 198.

48. Ibid., p. 103.

49. Neske and Kettering, *Heidegger and National Socialism,* p. 44.

50. Farías, *Heidegger and Nazism,* pp. 67, 118.

51. Ibid., pp. 284, 285.

52. Ibid., p. 287.

53. Neske and Kettering, *Heidegger and National Socialism,* p. xv.

54. Farías, *Heidegger and Nazism,* xviii.

55. Anthony Gottlieb, "Heidegger for Fun and Profit," *New York Times Book Review,* January 7, 1990, p. 22.

56. Herbert Spiegelberg, quoted in ibid.

57. Rockmore and Margolis, *The Heidegger Case,* p. 397.

58. David Carroll, speaking against this point of view, in the foreword to Jean-François Lyotard, *Heidegger and "the jews,"* trans. Andreas Michel and Mark S. Roberts (Minneapolis: University of Minnesota Press, 1990), p. xvi.

59. Neske and Kettering, *Heidegger and National Socialism,* p. 146.

60. Michael E. Zimmerman, "Philosophy and Politics: The Case of Heidegger," *Philosophy Today* 33: 1 (Spring 1989), p. 4.

61. See J. Hillis Miller, "N.B.," *Times Literary Supplement,* June 17–23, 1988, p. 676: "The real aim [of critics of de Man] is to discredit that form of interpretation called 'deconstruction,' to obliterate it, as far as possible, from the curriculum, . . . to put a stop to the 'influence' of 'deconstruction.'"

62. Karsten Harries, in Neske and Kettering, *Heidegger and National Socialism,* p. xii.

63. Jacques Derrida, "Comment Donner Raison?" *Diacritics* (Fall–Winter 1989), p. 8.

64. Richard Wolin, letter to the editor, *New York Review of Books,* March 25, 1993, p. 66.

65. Thomas Sheehan, letter to the editor, *New York Review of Books,* April 22, 1993, pp. 68–69.

66. Lacoue-Labarthe, *Heidegger, Art, and Politics,* p. 14.

67. Paul Berman, "Nazi Rector," *Village Voice,* September 13, 1988, p. 38.

68. Zimmerman, "Philosophy and Politics," p. 3.

69. Hans-Georg Gadamer, "Back from Syracuse?" *Critical Inquiry* 15 (Winter 1989), p. 428.

70. Rockmore and Margolis, *The Heidegger Case,* p. 233.

71. Ibid., p. 409.

72. Lyotard, *Heidegger and "the jews,"* pp. 52–53. (Subsequent citations of this work will be by page number in the text.)

73. Heidegger, in Neske and Kettering, *Heidegger and National Socialism,* p. xxxvii.

74. Ibid., pp. 55, 56.

75. Rockmore and Margolis, *The Heidegger Case,* p. 52.

76. Lacoue-Labarthe, *Heidegger, Art, and Politics,* p. 12.

77. Farías, *Heidegger and Nazism,* p. 298.

78. Lacoue-Labarthe, *Heidegger, Art, and Politics,* p. 33.

79. Jürgen Habermas, "Work and Weltanschauung," *Critical Inquiry* 15 (Winter 1989), p. 453.

80. Lacoue-Labarthe, *Heidegger, Art, and Politics,* pp. 64, 63.

81. Ibid., p. 128.

82. Werner Hamacher, Neil Hertz, and Thomas Keenan, eds., *Responses: On Paul de Man's Wartime Journalism* (Lincoln: University of Nebraska Press, 1989), p. 285.

83. David Lehman, *Signs of the Times: Deconstruction and the Fall of Paul de Man* (New York: Poseidon, 1991), p. 76.

84. Geoffrey Hartman, quoted in ibid., p. 30.

85. Howard Felperin in Peter Brooks, Shoshana Felman, and J. Hillis Miller, eds., *The Lesson of Paul de Man, Yale French Studies* 69 (1985), p. 266.

86. Geoffrey Hartman's description of de Man as a "boa deconstructor," "merciless and consequent," is in ibid., p. 140.

87. Geoffrey Hartman, quoted in David Lehman, *Signs of the Times,* p. 30.

88. Lehman, *Signs of the Times,* p. 79.

89. Brooks, Felman, and Miller, *The Lesson of Paul de Man,* p. 10.

90. Ibid., p. 12.

91. Ibid., p. 5.

92. Ibid., pp. 9, 4.

93. Walter Kendrick, "De Man That Got Away," *Village Voice Literary Supplement,* April 1988, p. 8.

94. Paul de Man, "Les Juifs dans la littérature actuelle," *Le Soir,* March 4, 1941, in *Wartime Journalism, 1939–1943,* ed. Werner Hamacher, Neil Hertz, and Thomas Keenan (Lincoln: University of Nebraska Press, 1988), p. 45 (my translations, here and throughout de Man's wartime journalism). (Subsequent citations from this collection of de Man's wartime journalism will be by page number in the text.)

95. Geoffrey Hartman, "Blindness and Insight," *The New Republic,* March 7, 1988, p. 26.

96. Lehman, *Signs of the Times,* p. 187.

97. David Lehman, "Paul de Man: The Plot Thickens," *New York Times Book Review,* May 24, 1992, p. 1.

98. Hamacher, *Responses,* p. 476.

99. Jacques Derrida, "Like the Sound of the Sea Deep within a Shell: Paul de Man's War," *Critical Inquiry* 14 (Spring 1988), p. 631.

100. Ibid., p. 370.

101. Hartman, "Blindness and Insight," p. 29.

102. Zeev Sternhill, *The New Republic,* March 6, 1989, p. 31.

103. Derrida, "Like the Sound of the Sea," pp. 644, 646–47.

104. In Lehman, *Signs of the Times,* pp. 228–29.

105. Paul de Man, "Sartre's Confessions" (1964), in his *Critical Writings 1953–1978,* ed. Lindsay Waters (Minneapolis: University of Minnesota Press, 1989), p. 117.

106. Paul de Man, "The Literature of Nihilism" (1966), in *Critical Writings 1953–1978,* p. 163.

107. Paul de Man, *Blindness and Insight: Essays in the Rhetoric of Contemporary Criticism* (New York: Oxford University Press, 1971), p. 35.

108. Paul de Man, *The Rhetoric of Romanticism* (New York: Columbia University Press, 1984), pp. 71, 76, 70.

109. Lehman, *Signs of the Times,* pp. 230, 220.

110. Ibid., pp. 158–59.

111. Jeffrey Hart, "Words in Search of Meaning," *National Review,* March 18, 1991, p. 54.

112. Malcolm Bradbury, "The Scholar Who Misread History," *New York Times Book Review,* February 24, 1991, p. 9.

113. Jon Wiener, "Deconstructing de Man," *The Nation,* January 9, 1988, pp. 22–24.

114. Luc Herman, Kris Humbeeck, and Geert Lornout, eds. *Discontinuities: Essays on Paul de Man* (Amsterdam: Rodopi, 1989), p. 21.

115. Lehman, *Signs of the Times,* p. 140.

116. Ibid., p. 221.

117. Jeffrey Mehlman, in Hamacher, Hertz, and Keenan, *Responses,* pp. 324–25.

118. Ortwin de Graaf, in Herman, Humbeeck, and Lornout, *Discontinuities,* p. 67.

119. Walter Kendrick, "Blindness and Hindsight: Dispatches From the de Man Front," *Village Voice Literary Supplement,* October 1988, p. 27.

120. Lehman, *Signs of the Times,* p. 216.

121. Jon Wiener, "Debating de Man," *The Nation,* February 13, 1989, pp. 204–6.

122. Lehman, *Signs of the Times,* p. 263.

123. Louis Menand, "The Politics of Deconstruction," *New York Review of Books,* November 21, 1991, p. 44.

124. Allan Bloom, *Giants and Dwarfs* (New York: Simon and Schuster, 1990), p. viii.

125. Catherine Gallagher, in Hamacher, Hertz, and Keenan, *Responses,* p. 204.

126. Peter Shaw, "The Rise and Fall of Deconstruction," *Commentary,* December 1991, p. 53.

127. Peggy Kamuf, in Hamacher, Hertz, and Keenan, *Responses,* p. 225.

128. Jonathan Culler, "It's Time to Set the Record Straight," *Chronicle of Higher Education,* July 13, 1988, p. B1.

129. Deborah Esch, in Wiener, "Deconstructing de Man," p. 23.

130. J. Hillis Miller, in Hamacher, Hertz, and Keenan, *Responses,* p. 342.

131. In Herman, Humbeeck, and Lornout, *Discontinuities,* p. 32.

132. Lehman, *Signs of the Times,* p. 74.

133. Ibid., p. 70.

134. Mark Edmundson, "A Will to Cultural Power," *Harper's Magazine,* July 1988, p. 70.

135. Lindsay Waters, in Hamacher, Hertz, and Keenan, *Responses,* p. 399.

136. John Brenckman, "Deconstruction and the Social Text," *Social Text* (1979), p. 43.

137. Minae Mizumura, "Renunciation," in Brooks, Felman, and Miller, *The Lesson of Paul de Man,* p. 256: "More or less explicit in the work of such marxist or leftward commentators as Hayden White, Frank Lentricchia, Fredric Jameson and Terry Eagleton, is the view of deconstruction as regressive, a throwback . . . to the dandyist aestheticism of the nineties, a displaced religion of art."

138. David Lehman, "Deconstructing de Man's Life," *Newsweek,* February 15, 1988, p. 63.

139. Lines from "The Professor" by Louis Simpson, quoted in David Lehman, *Signs of the Times,* p. 33.

140. Paul de Man, *Allegories of Reading: Figural Language in Rousseau, Nietzsche, Rilke, and Proust* (New Haven: Yale University Press, 1979), pp. 4–5.

141. De Man, *Blindness and Insight,* pp. 28–29, 18.

142. Ibid., p. 17.

143. Ibid., p. 9.

144. De Man, *Critical Writings, 1953 – 1978,* p. 215.

145. Paul de Man, *Romanticism and Contemporary Criticism,* ed. E. S. Burt, Kevin Newmark, and Andrzej Warminski (Baltimore: Johns Hopkins University Press, 1993), p. 55.

146. De Man, *Blindness and Insight,* p. 76.

147. Herman, Humbeeck, and Lernout, Introduction, *Discontinuities,* p. 22.

148. Paul de Man, in Brooks, Felman, and Miller, *The Lesson of Paul de Man,* pp. 255 – 56.

149. Lehman, *Signs of the Times,* p. 55.

150. Paul de Man, *Resistance to Theory* (Minneapolis: Minnesota University Press, 1986), p. 19.

151. De Man, *Allegories of Reading,* p. 10.

152. Ibid., p. 105.

153. Ibid., p. 162.

154. De Man, *Blindness and Insight,* p. 165.

155. De Man, *The Rhetoric of Romanticism,* p. 81.

156. De Man, *Romanticism and Contemporary Criticism,* p. 293.

157. De Man, *Blindness and Insight,* p. 250.

158. Theodore Kissiel, "Heidegger's Apology," in Rockmore and Margolis, *The Heidegger Case,* p. 38.

159. De Man, *Blindness and Insight,* p. 116.

160. De Man, *Romanticism and Contemporary Criticism,* p. 124.

161. Ibid., pp. 136 – 37.

162. See Christopher Norris, "Complicity and Resistance: Heidegger, de Man, and Lacoue-Labarthe," *Yale Journal of Criticism* 4: 2 (1991), p. 155.

163. Ibid., p. 154.

164. De Man, *The Rhetoric of Romanticism,* p. 264.

165. De Man, *Blindness and Insight,* p. 152.

166. De Man, *The Rhetoric of Romanticism,* pp. 282, 290.

167. De Man, *Critical Writings, 1953 – 1978,* p. 42.

168. De Man, *Resistance to Theory,* p. 64.

169. De Man, *Blindness and Insight,* p. 127.

170. De Man, *Romanticism and Contemporary Criticism,* p. 13.

171. Norris, "Complicity and Resistance," p. 159.

172. De Man, *Allegories of Reading,* p. 6.

173. Hartman, in Brooks, Felman, and Miller, *The Lesson of Paul de Man,* p. 7.

CONCLUSION

1. Julian Symons, "Editorial Note" to the first issue of the *Savoy,* quoted in Edmund White, *The Burning Library* (London: Chatto & Windus, 1994), p. 236.

2. Ian Hacking, "What's Best," *London Review of Books,* January 27, 1994, p. 17.

INDEX

Abortion, 28
Abrams, Floyd, 216 n. 60
Abstraction, 42, 56
Académie Française, 194
Ackroyd, Peter, 110, 112
Adaptations, 113
Adler, Amy, 36
Adorno, Theodor, 89, 187
Advertising, 66, 67
Aestheticism, 10, 82, 134,
 199, 236 n. 137
AFA. *See* American Family
 Association
Affirmative action, 145, 153
African-American Studies,
 79, 175, 210
AIDS, 17, 25, 43, 56
Akhtar, Shabbir, 124
al-Tabari, 224 n. 35
Albanese, David J., Judge,
 32, 35
Albee, Edward: *The Zoo
 Story,* 102
Alberti, Leon Battista, 174
Alger, Horatio, 136
Ali, Tariq, 99
Alienation, 159, 179, 186–
 87, 210
Allegory, 186, 95, 201
Allen, Roger, xi
Althusser, Louis, 163–64;
 L'Avenir Dure Longtemps,
 164

Altick, Richard D., 41
Ambiguity, 75
American Enterprise Insti-
 tute, 140
American Family Associa-
 tion (AFA), 11, 27, 28, 43,
 214 n. 6
American Poetry Review, 29
American Repertory The-
 ater, 30
Amis, Kingsley, 112
Amis, Martin, 112
Amnesty International,
 123
Analyse de texte, 85
Analytic philosophy, 182
Angleton, James Jesus, 167
Anti-Catholicism, 13, 16
Anti-pornography move-
 ment, 64–75, 82, 85, 129,
 142, 155, 163
Anti-Semitism, 163–64,
 179–80, 185, 187, 194–
 95
Apuleius, 116
Aquinas, Thomas, Saint, 80
Archbishop of Canterbury,
 98
Archbishop of York, 124
Architecture: and Prince
 Charles, 3; neoclassicist,
 112; postmodern, 112
Area studies, 168–69

Arendt, Hannah, 169, 177,
 184, 232 n. 15
Aristophanes: *The Clouds,*
 165
Aristotle, 132, 194
Armey, Dick, Representa-
 tive, 20
Arnheim, Rudolf, 40–41,
 51
Arnold, Matthew, 145–46,
 197
Art: ambiguity in, 37; for
 art's sake, 36, 86, 134; defi-
 nitions of, 52–59; efficacy
 of, 60–93, 155; as enter-
 tainment, 35, 36; and life,
 195, 232 n. 30; as meta-
 morphosis, 11, 40, 160;
 obscenity in; 37; paradox
 in, 60, 75–80; pleasure in,
 60; and politics, 13; and re-
 ality, 104, 119, 205; shift
 toward visual, 42; as state-
 ment, 35, 36, 60; value in,
 55–59, 208, 210–11; vir-
 tuality of, 39–40
Art Deco, 10
Art Emergency Day, 16
Art Institute of Chicago, 14
Art Institute of Chicago,
 School of, 13, 14, 36
Artists' Space, 25
Asante, Molefe Kete, 130

Ash, Timothy Garton, 113
Ashraf, Syed Ali, 107
Attila the Hun, 120
Audience, power of, 2–3,
 81, 203
Auschwitz, 72
Authenticity, 180, 185–86,
 197, 205
Autobiography, 164, 195–
 96, 203, 205
Autonomy, of art, 190, 201–2

Babes on Broadway, 10
Baker, Houston, 145
Baker, Russell, 129
Balch, Stephen H., 133
Baraghian, Anaïde, 191
Barbie, Klaus, 189
Barnes and Noble, 97
Barrie, Dennis, 9, 26, 32,
 55–56
Barth, John, 104
Barthes, Roland, 163
Bataille, Georges, 85, 169
Bateson, Gregory, 143
Baumgarten, Eduard, 180
Beattie, Ann, 44, 48
Beaufret, Jean, 194
Beauty: as absolute value, 16;
 allure of, 206; as apolitical,
 13, 134; in art, 33, 211; as
 cooptation, 207; critique
 of, 3, 91; formal, 156; for
 Hitler, 30; and ideology,
 161; in Mapplethorpe's
 work, 51, 55–56; and
 pleasure, 9
Beavis and Butthead, 128
Beckett, Samuel, 186; Wait-
 ing for Godot, 179
Beethoven, Ludwig van,
 175
"Being," 178–79, 186–87,
 195, 201, 204, 206

Bell, Clive, 172; "significant
 form," 83–84
Benedict, Helen, Virgin or
 Vamp, 62
Benjamin, Walter, 195
Bennett, Alan, A Question of
 Attribution, 169, 176–77;
 Single Spies, 113
Bennett, William J., 4, 136,
 140, 145, 148, 152
Bergman, Ingmar, Cries and
 Whispers, 59
Bergson, Henri, 169
Berkeley Art Museum, 26
Berkeley, Busby, 10
Berman, Paul, 130, 183;
 "Shame," 224, n. 35
Bernstein, Leonard, 25
Bérubé, Michael, 145
Bhabha, Homi K., xi, 94
Bhutto, Benazir, 102, 123
Bible, 37, 106, 108
Bill C-128, 75
Binary oppositions, 3
Birkenau, 72
Bitburg Cemetery, 189
Black, Hugo, Justice, 38
Blake, William, 93, 174; The
 Marriage of Heaven and Hell,
 124
Blanchot, Maurice, 169, 194
Blasphemy, 11, 104, 107,
 121, 124, 214 n. 6
Bleckner, Ross, 20
Bloom, Allan, 5–7, 132,
 134, 137, 149, 151, 197;
 The Closing of the American
 Mind, 140–41, 165
Bloom, Harold, 145
Bloomsbury, 172, 175
Blue Angel, The, 165
Blunt, Anthony, 169–77;
 "The Beaver and the Silk-
 worm," 173; "Brussels Ex-

hibitions," 172–73; con-
 tradictoriness of, xi, 6–7,
 113, 182, 207; influence of,
 171; life of, 170–75; on
 Poussin, 174, 232 n. 30; se-
 riousness of treason of,
 192; "Sleepers Awake,"
 173; "Standards," 173
Bonnie and Clyde, 65
Booker Prize, 112, 117, 124
Boorman, John: Deliverance,
 59
Borges, Jorges Luis, 116
Borromini, Francesco, 174
Bowlby, Rachel, 34
Bradbury, Malcolm, 196
Bradford Council of
 Mosques, 122, 124
Bradford, 96
Brassilach, Robert, 190
Brecht, Bertolt, 186
Brennan, William J., Justice,
 34
Brennan, Tim, 223 n. 22
Brenton, Howard, 99
British Academy, 170
British Library, 99
British Museum, 78
Brodsky, Joseph, 107
Brookner, Anita, 112
Brooks, Cleanth; "heresy of
 paraphrase," 85
Brooks, Peter, 188
Brown, Christopher, 20
Brown, Tracy, 149
Brownmiller, Susan, 66
Brustein, Robert, 30, 95
Buchanan, Pat, 14, 16, 20,
 28, 61, 98
Buckley, William F., 133,
 166; God and Man at Yale,
 141
Bundy, McGeorge, 168
Bunn, James, 221 n. 44

Burgess, Guy, 170
Burt, E. S., 188
Bush, George, President, 28, 98, 139
Byatt, A. S., 166; *Possession,* 112

CAC. See Contemporary Arts Center
Caligula, 35
Cambridge University, 170, 172
Camp, 87
Campus Coalition for Democracy, 140
Canon reform, 4, 133, 144–53. *See also* Great Books
Capitalism, 81, 89, 135, 141, 155–56, 159, 189
Capote, Truman, 71
Captain Kangaroo, 49
Caravaggio, 22
Carroll, Lewis, 108, 116
Carter, Jimmy, President, 98
Casaubon, 166
Castration, 91
Cavell, Stanley, 145
Celan, Paul, 186
Censorship, 4–5, 37–38, 49, 122
Césaire, Aimé, 151
Chaplin, Charlie, 213 n. 1
Chapman, John Jay, 136
Charles, Prince of Wales, 3, 111
Charter 88 group, 98
Chatterton, Thomas, 110
Chaucer, Geoffrey, 166
Chekhov, Anton, 150
Child exploitation, 5, 22, 24, 31–32, 44, 50, 211
Christensen, Jerome, 165, 168
Christian Socialism, 179

CIA, 167
Cicero, 134
Cincinnati Bengals, 26
Citizens for Community Values, 26
Citizens for Decency through Law, 26
Civility, 63
Cixous, Hélène, 183
Clark, Kenneth, Sir, 41
Classicism, 56
Cliché, 62–63, 65, 143, 153
Coalition for Traditional Values, 28
Cohen, Richard, 101
Coleman, E. Thomas, Representative, 24
Coles Bookstores, 97
Columbia University Press, 183
Commission on Obscenity and Pornography, 38, 65
Communism, 169, 172–73
Comparative religion, 81
Compartmentalization of intellectual life, 7
Conceptualism, 42
Contemporary Arts Center (CAC), Cincinnati, 9, 26, 28, 30, 32, 34, 56, 209
Content, aesthetics of, 210
Contextualism, 79–80, 91, 171, 174, 179, 184, 187
Cooke, Alistair, Sir, 177
Cooper, James, 16
Corcoran Gallery of Art, 19–21, 31
Corporation for Public Broadcasting, 30
Courtauld Institute, 170–71, 176
Crane, Ichabod, 166
Croce, Benedetto, 13, 36
Cubism, 173, 189

Culinary Institute of America, 167
Culler, Jonathan, 198
Curtiss, Joseph Toy, 167
Cypis, Dorit, *Yield the Body,* 44

D'Amato, Alphonse, Senator, 11, 25, 33, 41, 98
D'Souza, Dinesh, 130–31, 139, 141, 145–46, 148, 150, 153; *Illiberal Education,* 134–37, 140
Dahl, Roald, 98
Dallmayr, Fred, 233 n. 42
B. Dalton Bookstores, 97
Dannemeyer, William, 25
Danto, Arthur, 36, 37
Das Kapital, 71
de Graaf, Ortwin, 163, 189–90, 196
de Grazia, Edward; *Girls Lean Back Everywhere,* 67
de Jouvenel, Bertran, 190
de Man, Hendrik, 191–92
de Man, Patricia, 191
de Man, Paul, 188–208; "l'affaire de Man," xi, 164, 167, 170, 202; *Allegories of Reading,* 192, 203; antifetishism of, 86; "Autobiography As De-Facement," 195; *Blindness and Insight,* 192, 195, 200; on character, 190; collaborationist journalism, 6, 189–90; contradictoriness of, 7, 169; critics of, 234 n. 61; death of, 163; and deconstruction, 182, 186; and Derrida, 193 (fig. 27); "Form and Intent in the American New Criticism," 195; followers of, 164,

de Man, Paul, (*Continued*)
188–89, 203–4, 206;
"The Jews in Contempo-
rary Literature," 189; life
of, 190–92; *The Resistance
to Theory,* 192; *The Rhetoric
of Romanticism,* 192. *See
also* Deconstruction
De Palma, Brian, *Dressed to
Kill,* 90
Dead Poets' Society, 165
"Dead White European
Males," 149–50
Decadence, 134, 186, 189,
210
Declaration of Indepen-
dence, 126
Deconstruction, 159, 163,
188; and aestheticism, 236
n. 137; as atonement for
Nazism, 199; and contami-
nation, 170, 194–95; and
de Man, 186; flaws in,
206–7; hostility to, 6, 128,
153, 182, 196–97, 234 n.
61; and Heidegger, 178,
184; as political passivity, 6;
and undecidability, 201
Decter, Midge, 140
Deep Throat, 103
Defoe, Daniel, 102
Degas, Edgar, 76
DeLillo, Don: *White Noise,*
41
Democracy: and art, 8, 198;
and deconstruction, 198;
and education, 134, 136–
37; and exile, 116; and
Heidegger, 180, 184; intel-
lectuals' rejection of, 168–
69
Derrida, Jacques, 182–83;
192–94, 193 (fig. 27), 197,
204; "l'affaire Derrida,"

183; *Of Grammatology,* 201;
Of Spirit, 183; "Philoso-
phy's Hell," 183
Dhondy, Farrukh, 122
Didion, Joan, 100
Diversity. *See*
Multiculturalism
Domandi, Mary-Charlotte,
44
Donoghue, Denis, 133, 156,
158–60
Doubt, 116–17, 179. *See
also* Undecidability
Douglas, William O.,
Justice, 38
Drabble, Margaret, 112
Dreyfus Affair, 163
Duchamp, Marcel, 54
Dukakis, Michael, Gover-
nor, 133
Dworkin, Andrea, 62, 64,
66, 129, 134, 142; critique
of, 74–75; *Intercourse,* 66;
Mercy, 71–74, 167

Eagleton, Terry, 236 n. 137
Earhart Foundation, 140
Editions Hermes, 191
Educating Rita, 165
Ehrenreich, Barbara, 63
Einstein, Albert, 137
Elgin Marbles, 78 (fig. 18),
79 (fig. 19)
Eliot, George, 166
Eliot, T. S., 156, 194; *The
Love Song of J. Alfred Pruf-
rock,* 135, 146
Elitism, 145, 164
Ellison, Ralph, 107
Ellmann, Richard, 167
Eluard, Paul, 83
"Emperor's New Clothes,
The" 31, 182, 216 n. 58
Endgame, 213 n. 1

English National Opera
(ENO), 110–12, 111
(fig. 25)
"Enlightened beguilement,"
93, 156, 209
ENO. *See* English National
Opera
Esch, Deborah, 198
Essay, 125
Etherege, George: *The Man
of Mode,* 91
Euphemism, 64
Evans, Rowland, 28, 33
Exile, 114–16
Existentialism, 4, 16, 148,
186, 202, 210
Experts: attack on, 31–32,
34, 129, 163, 209; hostility
of public to, xi, 3–8, 155,
197, 211; isolation of, 39;
responsibility of, 210; role
in Mapplethorpe trial, 10,
33, 35, 53–56, 60, 207;
and theory, 139

Fabre-Luce, Alfred, 190
Fakes, 110, 113–14, 177
Farías, Victor; *Heidegger and
Nazism,* 163, 177, 179–82
Farquhar, George: *The Re-
cruiting Officer,* 113
Fascism, 161, 164, 169, 173,
189, 194, 198, 211
Fatima, daughter of Moham-
mad, 96
Fatwa, 61, 94, 96, 122, 125,
129
Faust myth, 166
Federal Communications
Commission, 36
Feidelson, Charles, 145
Felman, Shoshana, 189
Feminism: antifetishism of,
85, 89–91, 207; contex-

tualism of, 79, 175; and
Dworkin, 167; French,
164; hostility to, 128, 197;
language reform in, 63–
64; in *Liquid Sky,* 2–3;
and MacKinnon, 61; in
Mercy, 72; in the novel,
148; and Rushdie, 106
Feminist criticism, 6, 210
Fenollosa, Ernest, *The Chi-
nese Written Character as a
Medium for Poetry,* 160
Fetish, xi, 80–91; art as,
134, 155; and canon re-
form, 149–50; and de
Man, 204–6; and desire,
60; and entrapment, 156;
and film, 90, 207; of
homeland, 114–15; hos-
tility to, 160, 186, 209; and
modernism, 200, 202, 204;
and mystification, 161; and
postmodernism, 3
Finley, Karen, 29, 33, 43;
Victims, 18, 31
Finnegans Wake, 103
First Amendment, 29–30,
34–35, 64–65, 69, 142,
216 n. 60
Fish, Stanley, 142
Fisher, Philip, 90
Fitzgerald, Edward, 115
Fitzpatrick, Jim, 216 n. 60
Foot, Michael, 124
Form, in photography, 40
Formalism: and Blunt, 171–
72; collapse of, 10, 79,
175; and de Man, 199–
200, 202, 204; and decon-
textualization, 61, 221 n.
44; in Denis Donoghue,
156; as fetishism, 82, 84; as
literary analysis, 157, 160;
and Mapplethorpe, 9, 51,

54, 57, 158, 210; and
Rushdie, 120; and theory,
6–7, 139
Foster, Hal, 81
Foucault, Michel, 163–64,
194
402, Indian legal statue, 104,
224, n. 30
Fourteenth Amendment,
142
Fowles, John, 112; *The Col-
lector,* 90
Franco, Francisco, General,
37–38
Frank, Judge, 38
Franklin Furnace, 29
Franklin, Benjamin, 189
Freedom: academic, 130,
132–33, 141–44, 171,
175, 180, 185; artistic, 4,
25, 95, 100, 188, 190; of
interpretation, 155–56,
161; of speech, 97, 121–
23, 125, 142–44, 153; of
thought, 23, 128
Freud, Sigmund: fetish, 81,
82, 91; the uncanny, 82,
185
Friedman, Martin, 55
Frohnmayer, John, 25, 28–
29
Fry, Roger, 172
Fugitive Poets, 194
Fundamentalism: "aca-
demic," 129; alliance of
right and left, 61; equa-
tion of words and deeds
in, 63; and Heidegger,
187; Islamic, 99, 207; left-
ist, 60; *v.* liberalism, 33, 59,
120–21, 123–24, 126,
209, 211, 226–27 n. 101;
within liberalism, 100;
and pastiche, 114; perse-

cution of artists by, 122;
philosophical, 194; and
pornography, 39, 58; and
Rushdie, 105, 109, 125;
and virtuality, 38, 82
Futurism, 173

Gadamer, Hans-Georg, 184
Gallagher, Catherine, 197
Gallup, Donald, 167
Gandhi, Indira, 102, 116
Genovese, Eugene D., 142
Giamatti, A. Bartlett, 130,
132
Giddings, Paula, 61
Gide, André, 190
Ginsberg, Allen, 29
Giotto, 173
Girard, René, 205
Goldstein, Joshua, 30
Gombrich, E. H., 168
Goriély, Georges, 191
Gorton, Slade, Senator, 13,
122
Graff, Gerald, 152
Grange, George, 177
Grass, Gunter, 116
Great Books, 128, 147, 149,
See also Canon Reform
Greenberg, Clement, 84–
85
Greenfield, Jeff, 123
Gross, Larry, 130
Grundberg, Andy, 40, 44, 54
Guernica, 37, 38
Gunderson, Steve, Repre-
sentative, 27
Gurstein, Rochelle, 37

Habermas, Jürgen, 187
Hacking, Ian, 212
Hackney, Sheldon, 23, 136
Haiku, 158, 161
Hair, 26

Hamed, Alaa: *A Distance in Man's Mind,* 102
Hammonds, David: *How Do You Like Me Now?,* 25
Hampton, Christopher, 113
Handel: *Xerxes,* 110, 111 (fig. 25)
Harlem Renaissance, 148
Harries, Karsten, 182
Hartman, Geoffrey, 145, 194, 206
Harvard Society of Fellows, 192
Hate speech, 143
Hawkes, John, 89
Hawksmoor, Nicholas, 110
Heap, Jane, 67
Hegel, G. W. F., 149, 177, 204
Heidegger, Martin, 102, 177–88, 178 (fig. 26); "l'affaire Heidegger," 164, 181, 183, 189; *Being and Time,* 180; contradictoriness of, xi, 7, 167, 207; and de Man, 201–2, 204, 206; and fascism, 132, 169, 192, 194; and World War I, 233 n. 42
Heideggerians, 164
Heisenberg, Werner, 137
Helms Amendment, 22, 24–25, 61
Helms, Jesse, Senator, 23 (fig. 8); and censorship, 61; and the experts, 4–5; and homosexuality, 31; lobbying of, 23–24, 33; and Mapplethorpe, 11, 21, 129, 214 n. 24; and NEA, 27; and photography, 41; and Rushdie, 98; and Serrano, 37; and Wojnarovicz, 25

Hemingway, Ernest, 147–49, 152, 154, 195
Henry IV, King, 174
Henry VI, King, 166
Henson, Scott, 139–40
Heretick, 172
Hess, Elizabeth, 25
Het Vlammsche Land, 189
Hickey, Dave, 9, 61
Hijab, 104
Hill, Anita, 61–62
Hilles, Ted, 167
Hirsch, E. D., 149
Hitchens, Christopher, 100, 108, 124
Hitler, Adolf, 30–31, 120, 180–81, 187
Hobsbawm, Eric, 111
Hoekema, David, 33
Hoffman, Bill, 63
Hölderlin, Johann Christian Friedrich, 186, 201, 204, 206
Holmes, Sherlock, 167
Holocaust, 3, 142, 181, 187
Holofernes, 166
Homer, 146
"Homintern," 170
Homoeroticism: in art, 5, 22, 24
Homosexuality, 28, 31–32, 42, 170, 176
Howard, Richard, 57
Howe, Geoffrey, Sir, 97, 98
Howe, Irving, 150
Hughes, Holly, 43
Hughes, Robert, 10, 31, 37, 42, 64, 137, 150; *Culture of Complaint,* 71
Humanism: in scholarship, 132, 146, 175, 198, 210–11
Humanism, secular, 16, 121
Hurston, Zora Neale, 147–

49, 152, 154; *Their Eyes Were Watching God,* 148
Husserl Edmund, 169, 180
Hustler Magazine, 26
Hutcheon, Linda, 89
Hybridity. *See* Mongrelization
Hydrogen bomb, 181

ICA. *See* Institute of Contemporary Art, Philadelphia
Icon, in semiotics, 76, 89, 121
Iconography, 171
Identity politics, 143–47, 211
Ignatieff, Michael, 124
Imagism, 160
Individualism, 133, 159, 172–74, 180–81
Institute for Educational Affairs, 139
Institute of Contemporary Art, Boston, 26, 31
Institute of Contemporary Art, (ICA), Philadelphia, 4, 10, 22–24, 28–29, 95
International Guerrillas, 117
Interpretation, 8, 33, 37, 60, 80, 92, 161, 207, 212
IRA, 94
Iranian Nights, The, 99
Irving, Washington, 166
Ishiguro, Kazuo, *Remains of the Day,* 112
Islam, xi, 106, 207
Isserman, Maurice, 152
Ivory tower, 135, 140, 144, 175–76

Jacobsen, Carol, 61
James, William, 153
Jameson, Fredric, 89, 114,

155 – 57, 161, 170, 236 n. 137

Jaspers, Karl, 181

Jauss, Hans Robert, 194

Jews, 145, 180 – 81, 184 – 87, 189, 191, 194, 198

Johns Hopkins University, 132, 153, 192

Johnson, Barbara, 143, 188

Jones, Indiana, 167

Jones, James, 55

Jong, Erica, *Fear of Flying,* 11

Joseph, Stephen, 25

Journey to the Forbidden Planet, 112

Joyce, James, 116, 146, 167, 186

Kafka, Franz, 18 ɔ

Kamuf, Peggy, 198

Kant, Immanuel, 134, 156, 204, 232 n. 15

Kappeler, Susan, 67

Kardon, Janet, 9 – 10, 33, 51, 54 – 55, 57, 79

Katz, Leanne, 71

Keating, Charles, 26

Keats, John, 202; *Endymion,* 205; *The Eve of St. Agnes,* 205; *Hyperion,* 205

Kendrick, Walter, 34, 39, 42, 75

Kennedy, Robert F., 123

Keuhl, Sheila James, 60

Khayyam, Omar, *The Rubaiyat,* 115

Khomeini, Ruhollah, Ayatollah, 61, 95 – 98, 100 – 101, 123, 129, 164, 204

Kimball, Roger, 129, 145 – 46, 156 – 59, 161

King, Martin Luther, Jr., 13

Kingston, Maxine Hong, 163

Kipling, Rudyard, 195

Kirk, Jerry, Reverend, 26

Koch, Ed, 25

Konrad, Georg, 120

Koran, 96, 101, 105, 106, 108, 224 n. 35

Kozodoy, Neal, 198

Krebs, Rockne, 20

Kriek, Ernst, 180

Krier, Leon, 3

Kristeva, Julia, 164, 194

La Rochelle, Pierre Drieu, 190

Labour Party, 113

Lacan, Jacques, 164

Laclos, Pierre-Ambroise-François Choderlos de, *Dangerous Liaisons,* 113

Lacoue-Labarthe, Philippe, 169, 186 – 87

Lancret, Nicolas, 10

Lady Chatterley's Lover, 34 – 35, 43

Langer, Eli, 75

Last Tango in Paris, 26

Last Temptation of Christ, The, 122

Lavin, Irving: *Meaning in the Visual Arts,* xi

Le Carré, John, 98

Leavis, F. R., 204

Leavis, Queenie, 112

Lehman, David, 197, 199, 202

Leiris, Michel, 60, 85, 89

Lemieux, Annette, 20

Lentricchia, Frank, 236 n. 137

Leonardo Da Vinci, 22

Levin, Jennifer, 63

Liberalism: in aesthetics, xi, 8, 211; definition of, 131; and Dworkin, 73 – 74, 228

n. 28; in education, 128 – 38, 151 – 55, 163; *v.* fundamentalism, 33, 61, 209; and individualism, 130 – 32; and MacKinnon, 64; and paradox, 117 – 27; and Rushdie, 95, 117 – 27; and solidarity, 134 – 38; *v.* totalitarianism, 101, 109

Lincoln Savings and Loan scandal, 26

Lincoln, Abraham, 134

Lindner, Carl, 26

Lindsay, John, 123

Liquid Sky, 1 – 3, 2 (fig. 1)

Literalism, 61, 71, 82, 93, 118, 204, 221

"Literariness," 85

Lloyd's Building, 4

Locke, John, 77

Lockerbie disaster, 97

Lockheart Commission. *See* Commission on Obscenity and Pornography

Lodge, David, 166

Lolita, 165

Lovelace, Linda, 66, 68

Lucretius, 103

Lukas, J. Anthony, 95

Lyons, Lisa, 87

Lyotard, Jean-François, 204; *Heidegger and "the jews,"* 184 – 86, 189

M.I.T. Press, 183

MacKinnon, Catherine, 61 – 62, 64 – 69, 74 – 75, 129, 142

Mackinnon-Dworkin ordinances, 68 – 69, 71

MacLeish, Archibald, *Ars Poetica,* 83

MacNeice, Louis, 172

Madison Center for Education Affairs, 140–41
Madonna, 14
Magic realism, 107
Magritte, René, 213 n1; "Ceci n'est pas une pipe," 76
Mahfouz, Naguib, 99
Mahler, Gustav, 186
Mailer, Norman, 71, 100, 123
Manet, Edouard, 41
Mann, Sally, 44–51, 69; *At Twelve,* 44, 46 (fig. 11), 47 (fig. 12), 48 (fig. 13), 50 (fig. 14)
Mao Tse-tung, Chairman, "Where Do Correct Ideas Come From?" 130
"Mapplethorpe = Rushdie," 16, 20, 94
Mapplethorpe, Robert, 9–59, 209–11; and audience, 9, 44, 57, 69, 218 n. 101; child photographs, 51; controversy, xi, 4, 60, 73, 101, 136, 155, 163; death, 17; exhibitions, 16–17; fetishism of, 86–87; fisting, 79; flowers, 9, 51; genres, 16; and Helms, 129; *Jesse McBride,* 27 (fig. 9), NEA award, 22; *Orchid,* 53 (fig. 16); "The Perfect Moment," 4, 16, 17 (fig. 4), 19–20, 25–27, 30, 58–59, 95, 216 n. 60; price of work, 24; *Self-Portrait* (1978), *X Portfolio,* 9, 44, 45 (fig. 10), 57, 69; *Self-Portrait* (1988), 18 (fig. 5); slide exhibition on Corcoran, 20, 21 (fig. 7); *Thomas in a Circle,* 52

(fig. 15); *Tie Rack,* (fig. 23), 88; trial, 9–10, 26, 29, 31–35, 49, 52–56, 81, 95, 158, 207; *X, Y, Z Portfolios,* 19 (fig. 6). *See also* Sadomasochism
Marciano, Linda, *See* Lovelace, Linda
Marcuse, Herbert, 181, 184
Margolis, Joseph, 184
Marks, Edward, 53
Marlborough School, 170, 172
Márquez, Gabriel Garcia, 107
Married . . . with Children, 14
Martin, Christopher, 3
Martz, Louis, 167
Marx, Karl, 164; commodity fetish, 81, 82, 89
Marxist criticism, 6, 159, 210; anti-fetishism of, 85, 155, 207; and Blunt, 170–73, 175; and Heidegger, 180, 184; hostility to, 128, 197–98
Marzorati, Gerald, 117
Masks, African, 83
Massada, 72
Matisse, Henri, 172, 186
Matoesian, Gregory M., *Reproducing Rape,* 62
Maude, 36
McCarthy, Mary, 191
Medici, Lorenzo de', 174
Meese Commission, 38, 42, 65, 68
Mehlman, Jeffrey, 196
Menand, Louis, 152, 197
Mendoza, David, 61
Mercantilism, 77, 86, 89
MI5, 170
Michelangelo, 135, 174
Migration, 114–17

Millennialism, 128, 209
Miller v. California, 35–36
Miller, Arthur, 100
Miller, Henry, 73
Miller, J. Hillis, 189, 197–98
Miller, James, *The Passion of Michel Foucault,* 164
Milton, John, *Areopagitica,* 77
Minimalism, 42
Moby Dick, 191
Modern Language Association, 140
Modernism: and alienation, 80, 186; and de Man, 200–205; fetishism of, 82–85, 134, 156, 160, 200, 203; and formalism, 172; and Heidegger, 202; and humanism, 210; plots of, 210–11
Mohammad, 101, 104, 105, 109, 119
Molière (Jean-Baptiste Poquelin), 129
Mona Lisa, 111
Mongrelization, 109, 114, 126, 185
Monotheism, 105
Montaigne, Michel Eyquem de, 124, 152
Moon, Sun Myung, Reverend, 139
Moretti, Daniel S., 35
Morrison, Toni, 93, 115; *Beloved,* 92, 166; *Race-ing Justice, Engendering Power,* 62
Moscow Linguistic Circle, 85
Moynihan, Daniel Patrick, Senator, 23, 98
Mozart, Wolfgang Amadeus, 190

Muir, William: *Life of Ma-homet,* 224 n. 35
Multiculturalism, 5–6, 133, 143–53
Mulvey, Laura, 155–56; "Visual Pleasure and Narrative Cinema," 90
Muppet Babies, 128
Murphy, Patrick T., xi
Museum, 77, 80, 89–90, 109, 114, 173, 221 n. 47, 222 n. 64
Myth criticism, 159

Nabokov, Vladimir, 209
National Association of Scholars, 133, 140
National Campaign for Freedom of Expression, 61
National Endowment for the Arts; anti-obscenity clause, 29; appropriation for, 20, 23–24; content-review board, 29; and the experts, 4; and Frohnmayer, 25; and Helms, 11; and Mapplethorpe, 16; noninterference in artistic content, 13, 24; reauthorization for, 27; sanctions of, 28–29; and subcontracting of grants, 10, 21; tax dollars for obscene art, 29–30
National Endowment for the Humanities, 136
National Medal of the Arts, 25
National Organization for Women, 130
Nationalism, 139, 180, 189
Naylor, Gloria, *Linden Hills,* 64, 166
Nazism, 137, 142, 163, 168, 173, 177–87, 206–7. *See*

also Anti-Semitism: Fascism; Fundamentalism; Purism
NEA. *See* National Endowment for the Arts
Nehemas, Alexander, 146
Nelson, David K., *Mirth and Girth,* 13
Nelson, Richard, *Some Americans Abroad,* 113, 165
Nesbitt, Lowell, 20
Neusner, Jacob, 28
New Criticism, 85, 134, 167–68, 194, 200, 204
New Historicism, 6, 79, 91, 128, 175
New York Review of Books, 183
Newman, Barnett, 186
Newman, John Cardinal, 143, 145; *The Idea of a University: Defined and Illustrated,* 130–35
Nickels, Thom, 16
Niethammer, Friedrich, 132
Nietzsche, 178, 194, 202
Nixon, Richard, President, 39, 65
Nobel, Joseph Veach, 216 n. 58
Nomo, 186
Norris, Christopher, 204, 206
Novak, Robert, 28, 33
Novel, of ideas, 109, 125, 190
Nude, in painting, 41
Nuremberg rally, 10
Nuremburg trials, 184

O'Connor, John Cardinal, 25
Objectivity, 132, 137

Obscenity: in art, 9, 37, 69; self-evidence of, 24. *See also* Pornography
Obscenity law, 9, 55; wholeness criterion, 60, 216 n. 59. *See also* Pornography
Oh!, Calcutta!, 26
Okri, Ben, 120
Olin Foundation, 139–40
"One Tribe Nation," 43
Ornament, 160, 203
Orr-Cahall, Christina, 20–21
Orwell, George, 119, 163–64
OSS, 167–68
Ott, Hugo, 177
Overy, Paul, 171
Ovid, 103
Oxford Dictionary of Modern Quotations, 111

Paglia, Camille, 143; *Sexual Personae,* 57
Painting, obscenity in, 69
Papp, Joseph, 29
Paradox: in art, 10, 75–80, 87, 92, 94, 157, 161–62, 202; and liberalism, 117–27; in photography, 41; in postmodernism, 5; in scholarship, 164–69
Paradox: art as, 60, 117–27, 156, 204–5, 211–12; and de Man, 204–5, 207; in education, 130–38; and largeness of mind, 163; and liberalism, 117–27; in Rushdie, 117–27, 209; of scholar-spies, xi, 113
Parody, 2–3
Parthenon, 78
Pastiche, 3, 103, 109–17, 119

Pater, Walter, 10
Pearson, Norman Holmes, 167–68
Pergamon friezes, 221 n. 47
Petronius, *The Satyricon,* 166
Philby, Kim, 167
Phillips, Karen, 4
Philpott, Tom, 139–40
Photography, 40–51
Picasso, Pablo, 150, 172, 175; *Demoiselles d'Avignon,* 83, 84 (fig. 20)
Pipes, Daniel: *The Rushdie Affair,* 224 n. 35
Plato, 75, 132, 165, 180, 184
Playboy TV channel, 26
Playboy Magazine, 74
Pleasure: aesthetic, 5, 59, 75–76, 80–93, 134, 206, 211–12; and beauty, 9; of the body, 44; cost of, 3; of *Guernica,* 38; hostility to, 155–56, 209; in Mapplethorpe, 56–57; subjectivity of, 7
Plotkin, Mindy, xi
Plotnitsky, Arkady, xi
Podhoretz, Norman, 136
Pöggeler, Otto, 233 n. 42
Political Correctness, xi, 6, 73, 82, 129–31, 134, 137–53, 197–98, 210
Pollitt, Katha, 138, 150
Polytheism, 105
Pompidou Center, 4
Pop Art, 42
"Porn'im'age'ry: Picturing Prostitutes," 61
Pornography: and anti-Semitism, 189; bound between thought and deed in, 38; child, 14, 44–51; community standards for, 32; controversy, xi, 28, 209;

and Dworkin, 71–75; effects of, 38, 39, 65–66, 68; and feminism, 64–75, 207; free-speech defense of, 71; and Helms, 22, 24; law on, 32, 34–38; and NEA, 22; position among the arts, 68; and social progress, 226 n. 98. *See also* Anti-pornography movement; Obscenity
Portrait of the Artist as a Young Man, 67
Pose plastique, 41
Positivism, 65, 170
Post-Impressionism, 172
Postcolonialism, 109, 113–17, 210
Postmodernism: and anti-fetishism, 82, 85, 89, 186, 211; art-as-statement in, 36–37; and contextualism, 170; and "death of the author," 164; and doubt, 116–17, 177; and Heidegger, 178; issues in, 1–2; and Mapplethorpe, 26; and migration, 103, 116–17; and nostalgia, 103; and the novel, 116; and paradox, 71, 80, 93, 116–17; and pastiche, 103, 113; and pleasure, 91–93; and the romance, 3, 85; and social order, 4
Poststructuralism, 153
Pound, Ezra, 194–95; "In a Station of the Metro," xii, 157–61
Poussin, Nicolas, 174, 232 n. 30, 233 n. 31
Pre-Raphaelites, 173
Précieux, 174
Proclus, 132

Professor, image of, 128–29, 144, 153–55, 165–69
Prospero, 166
Protestantism, 81
Proust, Marcel, 126, 135, 186, 195, 202
Prouty, Frank, 9, 31–33
Psychoanalytic criticism, 159
"Pure form," 37, 170–73
Purism: in anti-Semitism, 185; in art, 84, 86, 158, 161; and fundamentalism, 109, 186–87; and Heidegger, 186–87; and Nazism, 198; and postmodernism, 186–87; and Rushdie, 114
Puritanism, 62, 80, 90
Pynchon, Thomas, 100, 104, 116; *V.,* 85; *Vineland,* 105
Pythagoreans, 132

Quotas, 145

Racism, 159, 211
Rafsanjani, Ali Akbar Hashemi, 121
Rape: and art, 2–3, 60; and feminism, 62, 66–74; and Finley, 28; myths in, 62–63; and pornography, 66–69, 72–74, 207, 211; and postmodernism, 2–3; reporting of, 62–63
Raphael, 174
Rauch, Jonathan, *Kindly Inquisitors,* 142
Reagan, Ronald, President, 65, 139, 189
Realism, 173
Rehnquist, William, Justice, 30
Reisman, Judith, 49
Relativism, cultural, 5, 123

Resistance, 191–92, 196, 201–2, 206

Revivals, in England, 110, 113

Rhetoric, 201, 203–4, 206–7

Rich, Adrienne, 63

Richardson, Samuel, *Pamela*, 103

Riga Treaty, 77

Rilke, Rainer Maria, 202

Rockmore, Tom, 182

Rogers, Richard, 4

Röhm, Ernst, 180

Rohrabacher, Dana, Representative, 24

Romance, literary, 89, 166; in postmodernism, 3, 85

Romanticism, 202

Rorty, Richard, 204; "Taking Philosophy Seriously," 194, 196

Rosenberg, Alfred, 180

Rosenberg, Harold, 90

Ross, David, 31

Roth v U.S., 34, 35, 38

Roth, Philip, 71, 104; *Goodbye Columbus*, 107; *Portnoy's Complaint*, 107

Rothenberg, Paula, 149

Rothko, Mark, 186

Rouault, Georges, 174

Rousseau, Jean-Jacques, 204

Royal Academy, 166

Royal Court Theatre, 99

Royal Opera Company, 112

Royal Society of Literature, 117

Royce, Josiah, 132

Rushdie, Salman, 94–127; controversy over, xi, 37, 73, 155, 163, 207, 223 n. 22, 224 n. 35; feminism of, 106; and fundamentalism, 226 n. 101; "In Good Faith," 114; *Haroun and the Sea of Stories*, 118, 122; "Imaginary Homelands," 102; "Is Nothing Sacred?" 125; and Mapplethorpe, 16, 20, 94; *Midnight's Children*, 102, 115, 117–18, 126; and mongrelization 185; "Outside the Whale," 119; and paradox, 138; response of intellectuals to, 97–98, 107–8, 117, 120; reward for, 96; riots over, 98–99; self-knowledge of, 225 n. 48; *The Satanic Verses*, 94–99, 111, 209; *Shame*, 102, 108, 114–15; translators for, 99

Rutherford Institute, 29

Ruthven, Malise, 226 n. 101

S.A., 180

S.S., 180, 189, 194

Sachedina, Abdulaziz A., 122

Sade, Comte Donatien-Alphonse-François de, 31

Sadi, 224 n. 30

Sado-masochism: in expert testimony, 56; and Foucault, 164; and Helms amendment, 5, 22, 24; and Mapplethorpe, 31–32, 41, 51, 87; in Theroux, 58

Safire, William, 28, 130

Salisbury, Stephen, 97

Salle, David, 20

Sarte, Jean-Paul, 184–85

Satan, 102, 104, 106, 166, 224 n. 35

"Satanic verses," 105–6

Satire, 124, 126

Schiller, Friedrich, 204

Schjeldahl, Peter, 57

Schneemann, Carolee, 44

Scorsese, Martin, *The Last Temptation of Christ*, 14, 16

Searle, John, 146

SECCA. *See* Southeastern Center for Contemporary Art

Seditious speech, 25

Self-portraiture, 44

Self-reflexivity, 85

Semiotics, 6–7, 76, 143, 153, 200

Serrano, Andres: bodily fluids, 11, 13, 214 n. 9; controversy, 4, 10–13; and Corcoran, 21; and Helms, 37, 129; *Ku Klux Klan* series, 69, 70 (fig. 17); and marginality, 43; NEA award, 22; *Piss Christ*, 11, 12 (fig. 2), 20, 31, 33, 36, 214 n. 6

Shakespeare, William, 112, 128, 166

Shaw, Peter, 198

Sheehan, Thomas, 183

Sheldon, Louis, Reverend, 28

Short, Thomas, 132–33, 140

Sidney, Philip, Sir, 36

"Significant form," 83–84

Simon, William, 141

Sims, Alice, 49; *Water Babies*, 14, 15 (fig. 3)

Smith, Barbara Herrnstein, 149

Smith, Page, 136, 153–54

Snow, Anthony, 139

Sobieszek, Robert, 54

"Social reality," 64

Socrates, 132, 146, 165

Le Soir, 189, 191

Sontag, Susan, 100; *On Photography,* 40
Southeastern Center for Contemporary Art (SECCA), 10, 13, 22, 24
Southern Agrarian Movement, 194
Southern, Hugh, 11, 12
Soyinka, Wole, 99
Spectator, The, 172–73
Speech codes, 142–44, 229 n. 70
Sprinker, Michael, 192
Stanley, Lawrence A., 49
Stein, Gertrude, 73
Steiner, George, 6, 170
Stereotype. *See* Cliché
Sternhell, Zeev, 194
Stimpson, Catharine, 144, 149
Stoicism, 165, 174, 186, 210
Stoppard, Tom, *Hapgood,* 113, 169
Structuralism, 6–7, 153
Sturgis, Jock, 14, 49
Sturrock, John, 164
Sullivan, Kathleen M., 30
Super-realism, 76
Surrealism, 24, 41–42, 107, 173
Swift, Graham, 120
Swift, Jonathan, 124; *Gulliver's Travels,* 166
Sykes, Charles J., 148, 154, 167

Tableau vivant, 41
Taminiaux, Jacques, 180
Tannenbaum, Judith, xi, 23, 28
Tansey, Mark, *Derrida Queries de Man,* 193 (fig. 27)
Taylor, A. J. P., 170
Tebbitt, Norman, 98

Technology, 179, 181, 186
Tempest, The, 11, 112, 166
Terry, Quinlan, 110 (fig. 24)
Textkritik, 85
Thales, 166
Thatcher, Margaret, 94, 98, 170
Theory: and aesthetic seduction, 206; inaccessibility of, 139; phenomenological, 204; and politics, 6, 184; of reception, 204; and theorist, 164, 190, 196, 207
Theroux, Paul, *Chicago Loop,* 57–58
Thomas, Clarence, 61–62
Thomas, D. M., 112
Times Literary Supplement, 94
Titian, 177; *Venus of Urbino,* 41
Todorov, Tzvetan, 168
Tory Party, 113
Totalitarianism, 16, 31, 109
Toulouse-Lautrec, Henri de, 171
Traditional Values Coalition, 27
Treason, 177, 202, 206
Twain, Mark, 41
20 June group, 97
2 Live Crew, 43; *As Nasty As They Wanna Be,* 29

Ullmann, Liv, 59
Ulysses, 32, 67, 90
Uncle Tom's Cabin, 141
Undecidability, 177, 179. *See also* Doubt; Postmodernism
Unesco, 65; Intergovernmental Committee for the Return or Restitution of Cultural Property, 78

Unified Science Movement, 7
Unions, artists', 173
University, assault on, 128–130
University of Pennsylvania, 23
Valéry, Paul, 169, 183
van Gogh, Vincent, 171
Vance, Carole, 38, 42, 65, 66, 71
Vasari, Giorgio, 174
Versailles Treaty, 190
Vietnam War, 199
Viking Penguin, publishers, 95–97, 99
Virtuality: in art, 8, 10, 38, 74, 76, 93, 118, 156, 211; and de Man, 207; and fundamentalism, 82; of intellectualism, 166; of *The Satanic Verses,* 209
Vitruvian Man, 51
Voltaire (François-Marie Arouet), 124
Vortex, 160
Voyeurism, 3, 44, 205

Wadsworth Atheneum, 25
Wagner, Richard, *"Gesamtkunstwerk,"* 187
Waith, Eugene, 167
Waiting for Godot, 213 n. 1
Waldenbooks, 97
Waldheim, Kurt, 189
Walker, Alice, *The Color Purple,* 64, 148
War and Peace, 76
Warhol, Andy, 89, 93, 115; *A la recherche du shoe perdu,* 87 (fig. 22); *Beauty is shoe, shoe beauty,* 86 (fig. 21); *Empire,* 1
Washington Project for the Arts, 20, 25

Washington, Harold, Mayor, 13

Waste Land, The, 83

Watergate scandal, 199

Waters, Lindsay, 199

Watteau, Antoine, 10

Weaver, Richard, 133

Wertenbaker, Timberlake, *Our Country's Good,* 113

Wharton, Edith, 133

Whitebread Prize, 95

White, Hayden, 236 n. 137

Whitney Museum of American Art, 23

Wieseltier, Leon, 100, 123

Wiggins, Marianne, 96, 100, 101

Wilde, Oscar, 82, 110

Wildmon, Allen, 59

Wildmon, Donald, Reverend, 11, 28–29, 59, 214 n. 6

Wilkerson, Isabel, 33

Wilkinson, Signe, 22, 23 (fig. 8)

William of Baskerville, Brother, 167

Williams, Elizabeth Friar, 57

Williams, Robin, 165

Wimsatt, William K, 134; "affective fallacy," "intentional fallacy," 85

Winks, Robin W., 167–68, 177

"Witnesses: Against Our Vanishing," 25

Wittgenstein, Ludwig, 143, 146

Wizard of Oz, The, 115

Wojnarowicz, David, 25, 28–29, 43

Wolin, Richard, *The Heidegger Controversy,* 183

Woman: as analogue to art, 89

Women Against Pornography, 75

Women of Brewster Place, The, 148

Wooley, Bill, 20

Woolsey, John M., Judge, 32

World at War, The, 59

Wright, Peter, 113

Yale University, 145, 167–68, 188–89, 192

Yardley, Jonathan, 100, 117

Yates, Sidney R., Representative, 21, 22, 29

Yeats, William Butler, 200, 202

Zimmerman, Michael E., 182, 184